To A
COUNTRY

Barbara Penner

TO A THIRD COUNTRY

Transcriptions of Khmer words have been guided by Franklin E. Huffman's Modern Spoken Cambodian (Cornell University, 1987).

Front cover photo and interior portraits by Marie Sedivy of Artistic Edge Photography. Used by permission.

ISBN: 978–1–77069–204–6

Printed in Canada.

Word Alive Press
131 Cordite Road, Winnipeg, MB R3W 1S1
www.wordalivepress.ca

Library and Archives Canada Cataloguing in Publication

Penner, Barbara Joanne
 To a third country / Barbara Penner.

ISBN 978–1–77069–204–6

 1. Cambodian Canadian women--Biography. 2. Women refugees--Canada--Biography. 3. Women--Cambodia--Biography. 4. Women refugees--Cambodia--Biography. 5. Women refugees--Thailand--Biography. 6. Cambodia--History--1975-1979. I. Title.

FC106.K451P45 2010 305.48'895930710922 C2010-907716-4

To My Father

Table of Contents

Acknowledgements

Stories like stars sail past us, unnoticed, in a world awash with words. Some sacred times, one falls into our silences; more rarely still do we find ourselves sailors in a sea of them. Shining like stars in the universe are Sareen, Chhorn, Chantha, Nareth, Kimsonn and Siem. Any brilliance on these pages reflects your faith that this book would come to be.

The metamorphosis from early drafts to a manuscript of sequence and style owes much to author Linda Goyette whose invitation gave me liberty to think of myself as a writer. Without the expertise of Caroline Schmidt, Jen Jandavs–Hedlin, Tom Buller and their colleagues at Word Alive Press, *To a Third Country* would not be in readers' hands today. Thank you.

Marie Sedivy's artistry truly portrays the personalities of her six subjects. The laughter of those autumn hours spent crossing and re–crossing the bridge for the cover image rings in our ears. We appreciate the fine work of Artistic Edge Photography.

"Any word on the book?" This question and similar queries alternately rankled or roused me to take another step toward publication as months rolled into years. To the friends who persisted in asking and who whooped with joy as the contract was inked, I am in your debt, in particular Barb, Julie, Iris and Liz.

The bedrock of this endeavor has been my family. You hold me up.

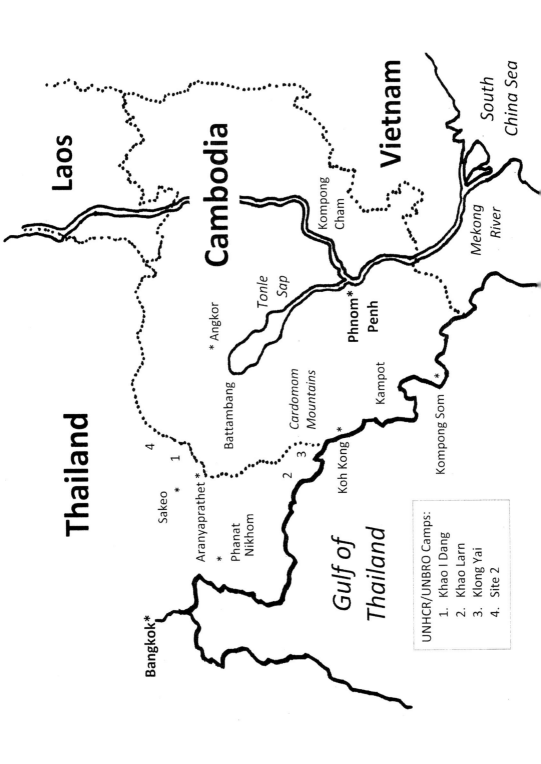

Chhlong Tonlé–
Crossing the Sea

Seven women take tables at a *Second Cup* coffee shop, order teas or lattés and pastries, and sit in the sunlight filtering through floor–to–ceiling plate glass. Amid tinkling china, voices rise and fall—laughter and sighs, answers to unasked questions interspersed with unanswered queries. Could their stories, recollections of six Canadians of Cambodian origin, speak across cultural and linguistic divides to other pilgrims, on other journeys?

Would words convey the essence of these lives to loved ones who no longer share their mother's tongue? Chantha, Chhorn, Kimsonn, Nareth, Sareen and Siem have eleven living daughters and thirteen sons between them. Of the twenty–four, only one reads Khmer. Memoirs, could they be written, would remain more mysterious to the next generation than their mother's speech. Oh, yes, there are household imperatives, stock phrases and the odd epithet which, resonating especially richly in Khmer, occasionally cross the lips of teenagers and little ones. Soul to soul, however, rarely speaks.

Incarnated, the soul enters a physical form which is birthed or, to use the Khmer metaphor, "crosses the sea" from a murky, muffled, closed place into a sensational space of wind, scent, sound and hue. Having come through a second sea, the blood, labour and loss of the Khmer Rouge, it is easy to be distracted by the engaging scenery

of Canada. These mothers are determined, however, that the din of the West will not silence their Eastern voices, voices of women, once girls—innocent, often presumed ignorant, almost always ignored.

We have been speaking together in twos or threes or as a whole since 1985. That October, I received approval by the Thai Ministry of the Interior to begin working under Youth With A Mission's Relief Services in Phanat Nikhom Transit Centre. H.E. Wilson's lectures in Southeast Asian history at the University of Alberta had nurtured my interest in IndoChina, sown earlier through neighbours transplanted to Edmonton after years in Thailand.

One hundred kilometres southeast of Bangkok, I pinned the laminated pink pass on my shirt and entered the domain of the United Nations High Commissioner for Refugees. Siem Seng was among the first Canadians–to–be whom I met in Phanat Nikhom. We spoke little, then; the lack of a shared language was a wall between us. Over the next few months, Kimsonn and Chantha also passed through Phanat. And Nareth arrived there. Sareen, Chhorn and I met after their families settled in Edmonton. Through the years, I listened to the women reminisce with growing awareness that my friends were entrusting to me untold treasures. So began the mingling of memories and minds that birthed this book, an anthology of Cambodian currents to a third country. Ours.

<div style="text-align: right">

Barbara Penner
Edmonton, 2011

</div>

Prologue: War Games

1966. Summer. Three girls roll down windows and loll about in the backseat of a two–toned blue Oldsmobile 88. Our big–bumpered sedan with its sad–eyed headlights hugs the curb of an avenue deep in the heart of Edmonton's burgeoning suburbs. A couple of mountain ashes, slim shadows of their future selves, provide camouflage for neighbourhood boys creeping over the carefully tended lawn. Our house–hunting parents walk up the curving sidewalk, immune to the imaginary grenades and torch–fused shells lobbed by Melmac–helmeted warriors.

My pre–school sisters and I, however, gaze out of The Car, unrecognized as a heavy artillery piece by the boys making a break for the cover of a spindly Russian olive. Grass–stained knees are the battle scars of these sweaty soldiers. Rat–ta–tak–takking worthy of a master ventriloquist bursts out of plastic M16 assault rifles, thudding big guns, grunts and groans, awesome explosions, boys' noise. Hurtling bodies, pummeling fists, the glint of the sun on a fake bayonet or Bowie knife, a death rasp, animated rigor mortis and then, resurrected with the certainty of a familiar cartoon coyote, the pseudo G.I. Joes rise to duel once more.

On that green, green lawn or over the line in Lyndon Johnson's domain, war is the game. Viet Nam is the name. Little boys, big boys, trigger–happy all the same. And, I surmise, insane. My sisters and

I aren't sweltering under the Canadian prairie summer sun; we are somewhere south of the 17th parallel. In our imaginations, our parents are about to purchase property in Hô Chí Minh's backyard.

Hô Chí Minh's backyard was then called Cambodia by North American speakers of English, bastardizing *le Cambodge* of the self–styled civilizing French who themselves had transliterated Kampuchea with their own inflections. Kampuchea, the name the Khmer give to their land, may well have etymological roots in the *kamboja* or princely descendants of Indo–Iranians who migrated to the fertile basin around the vast fresh water lake and the plains of that grand Indo–Chinese river, the Mekong. Six to eight centuries before the French proclaimed a Protectorate over this soil in 1864, the spires of the great Angkor temples were rising above towering teak, mahogany and fig forests northwest of the Tonlé Sap. Angkor's god–kings channeled the waters into vast irrigation systems; the rippling serpentine bodies of the *Naga*, or water god, adorned their massive monuments. However, a venomous undercurrent flowed beneath the Hindu–Buddhist gloss. Oppressive forced labour was eroding loyalty to the state; Thai and Vietnamese expansion toppled Angkor's beautiful ones by the end of the thirteenth century. It was ostensibly to protect the Thai–installed King Norodom from his anointers that the French colonizers occupied Kampuchea in the 1860s. Eighty years later, these protectors were themselves bowing to the Japanese, and within a decade, bowed out officially. But the French connection wasn't severed by Prince Norodom Sihanouk's declaration of independence. The marionette of a monarch–turned–president pulled the strings with imperial aplomb and served vintage burgundy. It was not the dregs of Cambodian society who resisted Sihanouk, but young scholars imbued with the socialist enthusiasms of their Parisian professors. There was no room for Khmer Rouge, or *Kmae Kahom*, leftist upstarts in a country whose neutrality was sorely tried by the American war escalating next door in Viet Nam.

Unwelcome in the capital of Phnom Penh, the defiant Ieng Sary, Son Sen, Saloth Sar (known as Pol Pot), and later Khieu Samphan, along with their cadres, regrouped in the hills. Resistance to the American–allied government surged in 1975; sycophants and servants of the superpower slunk out of bombarded Phnom Penh weeks ahead of their evacuation from Saigon. The faceless *Angka*, literally the Organization of the Red Khmer, turned Cambodia into a commune of unequalled loss. One of their first acts of "liberation" was to empty Phnom Penh that April. From mansions to hovels, hospital wards to monasteries, the Khmer Rouge shuffled the entire city population, swollen with refugees from rural warfare, into the provinces. The United Nations estimates that through starvation, disease or execution, 1.7 million people perished over the following four years. *Angka's* General Secretary, Saloth Sar, bequeathed his pseudonym to those wretched years. Pol Pot Time, the survivors call it.

Marxist Khmer and Vietnamese camaraderie unraveled through 1978. Cambodians began to abandon the land of their ancestors in droves; some 630,000 fled, mostly to neighbouring Thailand. Kampuchea, the country first in their hearts, had squelched them—body, mind and soul. Khmer of every political hue sought sanctuary in a second country. Asylum relied largely on the good graces of the Thai. Temporary relief depended also on the all–too–easily exhaustible empathy of the West. Resettlement in a third country, primarily the United States of America, France, Australia, or Canada, became the lot of a few hundred thousand Khmer over the next decade or so.

It's the late 1960s. In Canada, a girl thinks of war only as a boys' game; the aftermath can be handled by some new and improved detergent. Six small Khmer girls scattered about Cambodia are oblivious to the catastrophe looming over their homeland. Each will one day come to Canada, making her way from Hô Chí Minh's backyard into ours. Our paths will cross, women of the east going west and one westerner, far east. Our conversations beg to be chronicled, unsung stories

as ephemeral as the jet plumes that trace our swift passages against azure skies. So we paint on these pages a recollective collage of Chhorn Nhem, Nareth Mom Mueller, Siem Seng, Kimsonn Seng Tuon, Chantha Kong, and Sareen So Bou.

Each woman introduces herself in "A Prelude to Pol Pot", memories of childhood prior to the Khmer Rouge takeover. Readers travel with the storytellers through "Pol Pot Time", 1975–1979. "To a Second Country" chronicles the ways each found refuge in Thailand. Once given asylum, refugees passed months or years "Dreaming of a Third Country". Resettlement in the West hinged on becoming chosen people, on receiving the "Name–to–Go".

CHHORN NHEM

WEST, MEET EAST: PRELUDE TO POL POT

Beneath her tiny, bare feet, the powdery earth compressed and sent puffs of ochre swirling in dry eddies in her wake. Kmaw's footprints merged with many others who now, shoeless all, sat shifting in the open-aired *salaa*, or hall, of the local temple, *Wat Lahvea*. Across the courtyard, metres of damp saffron-coloured cotton billowed in the breeze as robes of Theravada Buddhists dried, flapping immodestly around the posts and rails of the monks' quarters. Eyes decorously averted, Kmaw did not notice the laundry but cast quick glances at the letters the *Kruu* had scratched in squeaky chalk on the blackboard. Along with her twenty or thirty classmates, she chanted the Khmer vowels, "*sra–aw, sra–ah, sra–eh, sra–ei, sra–uh, sra–er...*"

Kmaw was the childhood moniker of Chhorn Nhem. Precocious eldest granddaughter that she was, Kmaw learned quickly enough not to challenge the established order of things, including the underlying slur of being nicknamed "Black" in colour–conscious Cambodia. So very *riepsaa*, serenely polite, an ideal girl's public face belied all pains or passions. Affection, like other emotions, Kmaw locked up in the

armoire of her soul before heading to school. Rudimentary reading was inculcated by rote memorization and reinforced by thwacks of a metre–long rattan rod. Whereas little boys who pleased the master might receive a nod or a pat, any female touch would defile the monk. Therefore his only contact was in corporal punishment—indirectly, if indiscriminately, delivered. From her teachers, religious and secular, Kmaw learned to spout solutions someone else had thought up to questions she had never asked. From her peers, she learned to answer in unison. There were serious consequences for anyone who strayed above the equalizing mediocrity of that rural classroom.

Bright and eager to please, Kmaw had answered one too many math questions correctly. Little hearts harboured jealousy. Prize pencils disappeared from her desk. The rewarded notebook was spirited away, resurfacing only after Kmaw's record was blotted by demerits for incomplete assignments. To make matters worse, additional and incorrect sums had been scribbled into it. Could *Kruu* read between the lines of poorly forged penmanship? He called Kmaw to the blackboard, dictated a problem and approved the equation she executed, her palms still smarting from the rap of the switch. Teacher's announcement of "good work" did nothing to endear her to her classmates; indeed, his favour ensured her fall from grace. Without an older sibling to protect her, the tugs at her ponytail, the taunts and the thieving continued. Kmaw begged *Mae* to let her change schools, but her mother had no *riel* to buy a bicycle to ferry her farther away.

Every morning, Kmaw dressed in her uniform. Most days she stood at attention, navy skirt catching the breeze, bleached white blouse bright in the 7:30 a.m. sunshine, one of many in the rows around the flagpole. How her heart had surged with pride when Teacher chose her as one of the two children to raise the standard of the Cambodian monarchy. The image of monumental *Angkor Wat*, blazing white on a rich, red field centered on the royal blue canopy rose high above the temple grounds. Allegiance to this flag and this monarch, however,

2

would soon prove no greater than local commitment to continuing education. Despairing of another day of having her skull knuckle–rapped, of stolen supplies and of Mother moaning about no money to replace them, Kmaw started skipping school. Among fellow fugitives there was no vying for adult attention and therefore no vengeance to be meted out for distinguishing oneself. Kmaw evaded the one teacher who attempted to draw her back, calling from the window, waving a hand, saying, "Don't be afraid. Come tomorrow." The following day, however, Kmaw had not recovered from the loss of face at being dis–covered truant and so, more surreptitiously, slunk around the *salaa*'s pilings to peep at the new consonantal characters, something beyond initial *gha* and *kha*. Keeping out of sight, she memorized the chant of the children inside the hall to prepare herself for *Mae*'s daily query, "What did you learn today?" If Mother suspected her daughter's ab–sences from the house did not coincide with attendance at school, she never said.

Mae's welcome–home hugs stretched wider as second, third, fourth and fifth pregnancies expanded her girth. Kmaw legitimately left school at nine to rock the hammock while Mother transplanted rice seedlings; *Mae* began to enjoy the benefits of having a first–born female. She was pleased with her daughter's obeisance as much as her obedience; Kmaw knew never to meet the gaze of an elder and to keep her head down, literally lowering herself before a superior.

And so it was, three years later, that Kmaw didn't look up and see the American B–52s serving "Breakfast" east of the Mekong, west of the Cambodian–Vietnamese border. Breakfast was part of Operation Menu—over 3,000 bombing raids unsanctioned by America's Con–gress. As subsequent payloads rained death on Kompong Cham Prov–ince, Kmaw's mother ground fistfuls of dirt onto the top of her head. "If only Lord Earth would cover us!" Death came. As inconveniently as usual, for those left on this side of it. In haste, Grandfather's body was unceremoniously rolled in a floor mat and buried beneath shovel–

fuls of soil. Aside from a few smoking sticks of incense at the family shrine, there were no prayers, no priestly blessings, no funeral pyre and no ashes or charred bones interred in a stupa under tremulous toddy palms soaring above the spires of the *wat*.

Young Kmaw, in the company of Uncle, Auntie and Cousin, fled the perils of Kompong Cham's frontier. The Cham, whose Hinduized empire once flourished in what is now central and southern Viet Nam, had abandoned the lower Mekong as the Vietnamese Le dynasty advanced during the fifteenth century. Some Cham regrouped upstream. Centuries later, their descendants were stereotypically distinguished from the Khmer by darker complexions and more prominently–bridged noses. Males wore beards and skullcaps, while women modestly scarved their heads and dressed in long tunics. Identified as Muslims, their unorthodox practices mingled pre–Islamic beliefs with traditions introduced by Malay sailors. In prayer they genuflected and prostrated themselves before an unseen, single Creator rather than bowing at ancestral altars like the Teochiu–speaking Chinese, or appeasing animated spirits of the earth as their Khmer neighbours did. Now Kmaw was a neighbour no more but displaced as well, winding her way northwest toward the grand banks of the province accordingly called *Kompong Thom*.

WEST, MEET EAST: POL POT TIME

Bananas bloom but once in their lifespan. The bract, elegantly dipping its purple, petal–like leaf away from the stalk, bows to the damp earth that sustains it. Chhorn, shorn of her luxuriant long hair and also of her childhood nickname, Kmaw, eyed the flowering fruit wondering if ever she would blossom into the woman of her long–ago girlish flights of fancy. She kept these thoughts, indeed all her thoughts, to herself. Sixteen was old enough to keep one's own counsel in the second rainy season since *Angka*, the amorphous organization of the Khmer Rouge,

had dispatched Chhorn along with other teenagers to serve the state apart from the corrupting influences of their peasant parents. Her short–handled hoe hit the base of a banana that had borne its bunch. The dry stalk splintered as Chhorn hacked at the layers that clung to each other like sheaths of once–buttery phyllo pastry in a desiccated croissant. Calloused hands shredded broad leaves; leaves like these *Mae* used to wrap around sticky rice nestling duck eggs or spicy pork at the centers. Securing the leaves with strings of banana fibre, Mother would steam them to succulent perfection. A rivulet of sweat trickled over Chhorn's upper lip; her tongue lingered on the salt.

"The *chhruc* are hungry." Yuen's reminder gave Chhorn an excuse to straighten up and join Khon and Sok at the bamboo barn. Thirty curvaceous sows rooted around the trough as the girls dumped bucketfuls of mashed plant–matter in front of their snouts. Trekking back and forth from the well, Chhorn watered the hogs and checked on the chickens and ducks as well. "*Angka* will be pleased with your efforts to feed the nation." Yuen's now familiar propaganda beaded like water droplets on a duck's back; Chhorn flicked it effortlessly off her consciousness, but the team leader talked on. "Your toil will work wonders. In the future, mechanization will replace manual labour…"

Yuen relished her position over the three teenagers not much younger than she was. At noon she presided over the first of two daily meals, rations of rice and yams she had prepared in the relative comfort of the cool, concrete–block building where the original, fifty–member youth team had initiated Year Zero. When Chhorn was returned here to Phnom Bahtieh after a six–month stint scaling and slicing freshwater fish upstream at a fish sauce factory, there were only three other residents. These four slung their hammocks in the hall also housing two ponies and a couple of dogs. Nearby were the poultry and the pigs. The girls took turns at the least desirable duty, night watch.

Wild things roamed the rural community; warthogs, wolves and big cats scoured the countryside, as hungry as the human occupants.

"Your turn." Sok poked Chhorn in the ribs and handed her the rifle. Chhorn had the third watch. After two hours of circling the compound of barns and coops, she would nudge Khon and drop back to sleep. Twenty–one mosquito–netless months had inured her to the ubiquitous hum of those malaria–bearing pests. That throaty rumble of meat–seeking tigers kept Chhorn on edge, though. She stomped her bare feet on the clay and swatted bamboo saplings with the rifle butt. Something was purring mighty close to the chicken house. Quaking, Chhorn took a step nearer and square into the vision of two huge, gleaming eyes. Reflexively raising the gun, Chhorn fingered the trigger. She had never pulled it. "*Majakduk, majukdai, majakpreah*!" Creator of Water, Creator of Soil, Creator of Plantlife! "I don't want to die! Come! Come!" burst from her throat and in a flash the cat dashed into the bush. Yuen, Khon and Sok breathlessly examined the paw prints while Chhorn found feathers of one hen turned night luncheon meat. Several smashed eggs oozed albumin among the straw on the floor of the coop loud now with terrified fowl.

To guard against even greater loss, Chhorn and the others took up weaving a mesh of thorns which they secured around the duck and chicken shelters. Not long after, however, another nocturnal visitor charged the bamboo enclosure around the pigs; a wild boar in rut thrust his tusks through a wall, creating an escape hatch for one sow who trundled off into the night, squealing with—was that delight or fear? Fear, untempered, ate away at Chhorn when the daylight search through jungle scrub proved vain. Would the big boss now come and call her name? Others had been called never to return.

Chhorn was soon summoned, but Pheap, the female district supervisor, merely reassigned her. Along with a dozen young women, Chhorn was charged with guarding Pheap's quarters. While others cooked, laundry duty and waiting on the table often fell to Chhorn. Such close proximity to one who held the power of life and death terrified her. Two dangers lurked. One was that Pheap would find fault

with the way she placed the heaping plate of rice and side dishes of pan-fried vegetables and chunky chicken soup, not common broth, on the table. Chhorn kept her gaze glued to the floor, anxious to avoid both stumbling and seeing Pheap's face. "Work hard," the Khmer Rouge cadre counseled her scrawny server. "When you grow up, you can help me." But would she grow up? Chhorn was flat-chested at seventeen, one hundred thirty-five centimetres and hardly forty kilos. She tried to shrink out of sight of her teammates, too. Their rumours and gossip were the second and more volatile threat to her survival. Should one of them have got it into her tortured little mind that Pheap favoured Chhorn, false accusations could have sealed her doom.

Fate took an unanticipated turn. Yuen sent word that the prodigal pig had returned home, pregnant and producing twelve piglets. Then Pheap herself was called up, and like Ree and Rin and Rom and uncounted other compatriots, never seen again.

East, Meet West: To a Second Country

He wore a pistol on his hip. His gang of four, sprouting grenades from every clippable strip of clothing, toted long-barreled rifles and a mortar launcher. They called him Virah, so the girls did too. There were about forty not-quite-women, Chhorn being one.

The five well-armed men had shown up in Phum Chum Drah Doam and abruptly commandeered the teenagers as supply line coolies. Each girl laboured under one or two hefty rice sacks slung over her shoulders and back in sackcloth slings. They walked by day through fields and wooded patches, never on roadways. At night, under the shelter of a tree at best, Chhorn lay down bone-weary. Her anxious sleep was increasingly interrupted by boom-boom-booming of big guns. Wherever possible, she would raid unguarded gardens, foraging for food. A week into the march, the men still hadn't offered a single grain of rice to the girls. They met no one else at all. Houses

they passed were abandoned—doors and shutters unbarred, swinging and banging in the breeze. Where had all the people gone? And where were they going? Some girls surmised they were walking westward to Battambang, but the Reds never named a destination. Their directions amounted to instructions in self-destruction. When the shelling intensified, Virah issued each girl a grenade. If the Vietnamese came too close, she was to pull the pin and hold on for the ride. Shortly after, under fire, the group split. Virah rallied Chhorn and twenty others. After he led them clear of the combat zone, they tramped on for about ten days. At that point, relieving them of their loads, Virah ordered this brigade to keep trekking, without him. He left the girls an axe, a machete and one gun.

Monsoon winds sent rain-swollen clouds over the Cardomom Mountains. Wandering about in the wet jungle, the girl in the lead would swing the machete to clear a path of sorts. As the daily deluge drizzled out, an insufferable humidity filled the forests of Pursat Province. Chhorn slit vines trailing over teak trunks, slurping the pure liquid within. She nibbled all manner of jungle fungi, edible roots and fruit. On their trek, the girls forded creeks filling with the season's rain. They lost at least one of their number to the surging currents in a flooded gully where drowned animals floated by. Now ill and malnourished, Chhorn's hallucinations fed her steamed buns bursting with barbecued pork and mountains of fragrant rice. She cried out to her mother, her father, and to *Preah Aung*, the Lord, for food, water, life.

Death haunted her as one by one several more girls dropped off. Some simply never woke up. Chhorn suspected black snakes as thick as her thigh. Others, fevered and dazed, lost the group as they climbed up hillsides and down. At night, Chhorn swore she felt a tiger's breath, and in the morning big cat pawprints ringed the hollow where she had lain. Leaches, chocolate brown, latched onto soft body parts. Plucking the blood-suckers off left bruised and bleeding sores. Only phantoms

could feed on her now, Chhorn was sure. But there was no consolation in that when the dwindling number of girls stumbled across several hammocks strung beneath vast boughs. Men, sleeplike but skin stretched taut over bulging corpses, lay silent. There were no signs of violence. Life had slipped away without a fight.

People vanished in those mountains most mysteriously. Sometimes they appeared out of nowhere. Chhorn and a trio of the original party encountered one, two, then two more bewildered boys. Soon after, they found a forest camp, entirely empty, cooking ashes cool, stacks of hundred and five hundred Thai *baht* notes laid out like Ali Baba's banker's hall. No one touched a bill. Paper? You couldn't eat it. There was no tobacco to roll inside it for a mosquito–dispersing smoke. It burned too fast to roast the palm–sized birds someone snared. Cambodian currency had been useless since 1975. It was only afterwards that Chhorn kicked herself for not knowing the value of foreign money.

One of the girls guessed that Thailand must not be far off. A boy urged the others to go west. Pol Pot's people, he explained, were still fighting the Vietnamese. And the Vietnamese, well, didn't Chhorn know? They disemboweled Cambodians and stuffed organless pelvises with grass. Did she want to end her days as carrion?

It appeared as a jewel shimmering through the leaves of towering trees. None of the nine had ever seen it before. It drew them as it has always drawn wayfarers and wanderers. Chhorn glimpsed it from every ridge as the teenagers descended Pursat's heights. They crossed the distance from first sighting to the sea in a couple of days. Stumbling out of the forest onto a wide, wide white beach, Chhorn sank into the sand. Her bare feet, hard from months on the move, felt the sun's strength stored in the silt. Water. Water. Water. Chhorn tumbled into the tide, mouth wide, thirst coveting a quenching. Eyes stinging, lips spitting, tongue twisting, she was up and out of the waves. The salt stung her scabby, insect–pierced skin. It dried. She itched from scalp to sole.

The waifs slunk back into the shelter of the trees. Although they didn't know it, they had reached Trad Bay and Thai soldiers had them under surveillance. When Chhorn and the others saw men in military uniforms, they turned tail and ran. Smack into the rest of the unit. Encircled, the Cambodians shook with fear. Although the Thai talked, their words were meaningless. They tried sign language: "We're not Vietnamese. Don't run." But the youths were petrified beyond belief. A jeep pulled up to the unflinching huddle. The soldiers literally lifted the motionless Cambodians into the vehicle where they crammed together whispering of certain execution. "*Cheu alai, krub*?" one asked Chhorn, not unkindly curious about her name. He clarified that he expected a response by tapping her kneecap. "*Cheung keung*–Knee," she sputtered, naming that body part instead of herself. The soldier hoisted himself into the jeep as the driver took off on a bone–rattling ride.

So it was that the private introduced Chhorn as "Knee" to a Khmer translator they met at the end of the ride. The interpreter looked incredulous at such a name but found her story all too familiar. He questioned each of the young people separately, recording their proper names and places of origin. A medic gave them a cursory examination. He injected a very effective remedy into Chhorn's particularly swollen foot. The Khmer speaker assured the teenagers the Thai would provide them with food. Chhorn didn't think she could stomach a thing. Still in great distress, she clenched the other girls' hands in hers as they settled down in the jeep again. Dry heaves wracked her body. The soldiers delivered the illegals to the military mess. Chhorn hadn't eaten off a plate in months. She hadn't sat at a table in years. A spoon and a fork! A ladleful of rice and a side dish of shrimp paste stewed in coconut milk, plus condiments of fiery chilies and sweet and salty sauces, were served. Served. "Eat all you can," someone said. Chhorn did. And her belly ached.

Away from the Thai military site, a lower hillside was being cleared. Ribby, bare–chested men shod in flip–flops and dressed only

in *kramas*, the woven cloth wrapped around their hips like knee–length sarongs, felled logs and rooted out underbrush. A few thatched shelters had been built, but it would be six months before housing could accommodate the hundreds of Cambodians who received sanctuary there at Khao Larn under the auspices of the Thai Red Cross. Malaria, malnutrition and chronic ulcers plagued the people seeping out of Cambodia's accursed socialist experiment. Chhorn stepped down from the jeep. The pain in her swollen foot was already easing. The salt had been rinsed from her badly cut black bob. She had no shoes, one pair of tattered trousers and the shirt on her back. Chhorn owned nothing and no one owned her. She was a refugee.

Not Yet West: Dreaming of a Third Country

Toonsai was Khao Larn's commander, although he didn't know it—his Khmer nickname that is. Cambodian amateur phrenologists saw a peasant–heart beneath his princely demeanor. They commonly considered gait in conjunction with cranial features when assessing a subject's character. By general consensus, the commander was a rabbit. In the *Ream–kerti*, the Khmer version of the Ramayana, the rabbit is named *Toonsai*. The Thai *Toonsai* strode about his bailiwick at a pace approaching a hop; the authority vested in him made his charges revere him regardless of character traits they believed they detected in his physique.

To qualify for the rare option of permanent settlement in the country in which they first sought asylum, Cambodians needed to assert and support claims of Thai ethnicity. In Khao Larn, recognition of such heritage depended in part on the good graces of the Rabbit. Along the slender ribbon of soil that Thailand held west of Koh Kong province, there was quite a mix of Thai–born Cambodians and Cambodian–born Thais. The current border had been fixed in 1906, against Siamese wishes, west of where a previous frontier had stood.

An uncle of Chhorn's, her mother's brother, had crossed that line four years earlier than his niece. His timing couldn't have been better. In self–imposed exile, he and his wife, their son and daughter prospered. Meanwhile, their compatriots perished. Perhaps one in three Cambodians died during the forty–four months of the Khmer Rouge regime. Uncle felt fortune's smile should be reciprocated on any relatives he could locate in the spring of 1979. He found Chhorn. Although she was still a minor and unaccompanied by adult kin, *Toonsai* or other administrators determined Chhorn could not be added to her blood relative's identification card. Smuggling her through the fence around the camp wouldn't have been much of a problem, but paying off local officials time and time again would have cost a pretty penny. So eighteen–year–old Chhorn was on her own.

During those first months in Khao Larn, Chhorn overheard many schemes to spirit Cambodians out of statelessness. Some refugees felt being on the lam in Thailand was preferable to languishing in an insecure border encampment within range of Vietnamese artillery. Filling sandbags and digging trenches occupied many male refugees. Chhorn was initially set to digging out saplings to make room for shelters. She also laboured outside the camp, scything grass for thatch and drying it in preparation for weaving mats. Her international experience, such as it was, confirmed the basic Buddhist tenet that all life is suffering. For several months, her bed was a heap of straw under the stars and toil took up her days from sun–up to sun–down. One improvement over the Pol Pot period was the regular provision of rations. Thais in civilian garb distributed food once a week. After being daubed on an earlobe or thumbnail with indelible black ink, Chhorn received a measure of rice and a tin of sardines, chicken, beef or pork. A quota of salt was also issued although *merique*, ground pepper, was hard to come by. Increasingly the girl thought she heard *merique* sprinkled through snippets of conversations between other Cambodians, older or better connected than she was. This passion for pepper

turned out to be nothing of the kind; *A–merique* was what animated the grapevine. Khao Larn was awash with fairy tales of happily–ever–afters in the USA or *Australie*.

Chhorn didn't have a nasty stepsister, let alone a fairy godmother or a Prince Charming. Well–meaning neighbours, however, insisted that Chhorn get herself married. Evil lurked around the rim of the secluded camp. Soldiers were said to skulk about at night. They knew who slept where. Single girls were particularly enticing. Coupling with the boys they had met in the mountains, Chhorn's three original traveling companions declared themselves wed, a tactical deterrent to virgin–seeking prowlers. Chhorn saw herself as skinny, ugly, undesirable. When she passed the sandbag brigade, the men—big, brawny and boisterous—didn't look her way. None engaged her in flirtatious small talk and she, exceedingly shy, shuddered at the thought of contact. Fear of men was fed by fiction and by facts. For instance, there was that body of a beautiful young woman. Her waist–length hair, raven waves mashed with mud, couldn't cover her nakedness. She'd been found in the forest on the fringe of the camp. The refugees rolled her corpse in a reed mat and buried her. "This is what men might do…" Chhorn's older mentors cautioned. "You ought to have a husband." Some incentive.

Puu, meaning Uncle, she called him. Chhorn approached the man, whose name she didn't know, because he worked for the Thai gendarmerie. His limp went unremarked; his size made him an attractive addition to the labour pool that the military called on for grunt work. In the employ of the soldiers, Im Prim collected bonuses in the form of fresh fish, sweets, beer and better–milled rice. *Meeng*, an elder "auntie", had sent Chhorn over to beg for some of that rice. "Give Sister some," was all Prim said to Pon and Tuan, two little orphans who had attached themselves to the man. The boys scooped grain into Chhorn's basket. She was perturbed. "I'm NOT your sister," she muttered under her breath but not to him, oh no, not to him. He knew what *Meeng* was

up to. The old biddy's husband had already approached Prim about an arrangement. The girl looked too tiny to be, well, marriageable. The matchmakers claimed she was eighteen. "She'll help you," they had added. Help wasn't primarily what a man wanted in a woman.

Seven days later, *Meeng* was fastening fake gold anklets above Chhorn's well–scrubbed feet. Borrowed bangles clanged on her wrists. Metres of fabric were wrapped around her legs and tucked into the waist beneath a chunky chinked chain. Beneath the flowery blouse, bodice altered to fit a small frame, Chhorn's heart pounded. A veil masked her anxious eyes. Fifteen friends gathered outside, while next door the melodic strains of the *kloy*, a traditional flute and the *sko'ah*, a hand drum, banished thoughts that this costume was make–believe. Despite the incongruous setting, Chhorn was a princess. This was her wedding day. The clanging of cymbals announced the groom's arrival. With unrelated elders acting roles of parents, Prim called for his bride according to an unwritten script, which a bevy of self–appointed directors discussed and disputed as the ceremony proceeded. As there were no monks, one lettered man read a Buddhist text in unintelligible Pali. He spoke interminably. Not one word registered. Chhorn's mind was as numb as the feet she had been sitting on for hours. Finally, the guests circled the couple, sprinkling them with petals and coconut scented water. *Meeng* served a one–cauldron feast.

The finery came off. Rented garments were returned to the Chinese–Cambodian capitalist who catered to her ceremony–starved neighbours. Chhorn lay fully clothed in her own t–shirt and sarong. Prim's bed of bamboo rods under a single straw mat jarred her spine, accustomed as it was to the earth. She turned over onto her side. Her shin bumped his thigh. She pulled back. He rolled closer. This sleeping together wasn't what Chhorn had bargained on. Man and wife, they had said. Sharing a roof, yes, but a bed? Thunk. She rolled off the platform and landed on the dirt floor. Insomnia, it appeared, wasn't going to be cured by facing what one feared. Remedies came in all shapes and sizes.

The potion would restore the heat draining out of her through blood loss. Chhorn purchased rice wine inside Khao Larn and nameless black and pink capsules were procured at the camp's rudimentary pharmacy. The combination of drugs and drink masked her abdominal cramps quite effectively. Although the older women felt free to discuss reproductive health now that Chhorn was married, their assurances that this pain would quite normally occur each month for years and years were hardly promising. The daily tippling, on the other hand, proved quite enjoyable. It limbered her tongue. Eventually it took her over the edge of propriety. She prattled with other women who found fault with Prim over his limp and his lack of material wealth. Even though their own uncelebrated matches were hardly worth emulating, the gossips glibly suggested Chhorn divorce him. She carried the criticism home and served it with supper. When his wife badgered him about how he had injured his left leg, Prim's face darkened. "Why did you marry me?" His question hung in the air.

The argument, suspended but unsettled, reared its head from time to time. Chhorn talked too much, she knew that. Prim's patience irritated her. He never shouted, yelling curses as other husbands could be heard to do through walls of straw. He never hit her, slapping and kicking and shoving as other husbands did. Some wives gave as good as they got. Others whimpered and whined. When Chhorn's nagging rose to a dissonant pitch, Prim would offer to leave. But he never did.

Nor did she. Without paid work, women were without merit in the food supply system. Chhorn was fed on Prim's ration card. She spent her mornings idling around the market set up by local Thais. Kindling a fire on three stones, she exhaled expertly to fan the flame on which to boil *katom*, a common rural serving of sweet rice steamed while wrapped in palm leaves. Occasionally there were noodles. These dishes she prepared for her husband and herself, the first of two daily meals usually taken about noon and the second just before sunset. The couple owned two aluminum cooking pots, blackened with use. In the

one with the tightest fitting lid, Chhorn would steam rice for supper. Reserving a modicum of oil from slivers of pork rind, she fried stalks of choy in garlic if she could get some. Her husband never complained about her cooking. Prim would pat her on the head as she squatted by the fire. He worried that she was still so thin and insisted she serve herself first.

"When you have our baby, I'll love you even more," he teased her, and Chhorn blushed. Prim loved kids. He often piggy–backed the neighbours' rugrats around. Even a bare–bottomed infant's pee trickling over his shoulder or down his arm didn't faze him. Prenatal care in Khao Larn amounted to a dispensation of vitamins by a medic at the camp clinic and occasional visits by a midwife. Chhorn had nothing but trepidation as her pregnancy advanced. Contractions began at midnight. All through that long labour, the skinny girl with the big belly clenched her teeth but wouldn't yell. As waves of pain subsided, Prim brought her water and something to eat.

"I don't want it," she spat out. "I don't want this baby either. I'll strangle it for torturing me."

"Now you know what agony you caused your own mother," Prim rebutted, sponging Chhorn's head and neck.

"You too!" his wife shot back.

"But I was not the first born," Prim replied in self–satisfied self–defense.

"One kid is sufficient," Chhorn ruled. "No more, *Puu*."

"Uncle!" Prim burst out laughing. "You're still calling me Uncle! I'm not married to any old auntie."

The midwife arrived and heated a cauldron of water. Chhorn seemed so small, too weak to deliver a baby. In keeping with Khmer tradition, the *yiey mop* drew crosses on her patient's forehead and belly with an ash–covered stick. Chhorn's pain eased. She sluiced a cupful of water around her mouth and moistened her lips. A last momentous thrust carried the child through the waters, out of darkness

into light. A big, big baby. A boy. The proud papa bore him about, his eyes boasting where he was speechless with joy. Prim's Thai bosses gave gifts. Chhorn marveled at the bunch of mouth–watering grapes. What luxury! Cambodians pressed *baht* into the new parents' palms. A woman sponge–bathed Chhorn in hot water and massaged her aching body. She sipped wine to restore her humours. Intrinsic to Khmer traditional medicine was the balancing of "hot" and "cold". This restoration also required a charcoal brazier to be lit beneath the bed. Essential to the new mother's health, it was believed, was sufficient heat. Maintaining that dewy look had nothing to do with rebalancing the body. *Ang pleung,* or roasting the mother, required forty days of continual exposure to a heat source while simultaneously observing exacting dietary restrictions.

Chhorn erred by indulging in watermelon, a prohibited "cool" food. She woke up struggling to breathe, her jaw locked together. Prim rallied the neighbour women, who concocted a highly alcoholic brew they force–fed to the young mother. Rice wine, stoked with dried medicinal herbs, amber fire in a green tea demi–tasse, roared through Chhorn's throat, down, down, down into her belly, burning. When she could speak, the already–mother–experts berated her for disregarding the dietary rules. But how could Chhorn know what was hot and what was not? She hadn't had a mother since she was fourteen.

One night, both Chhorn and Prim were so exhausted that neither noticed the beneath–the–bed coals burning too, too close. One charred bamboo bed leg crumpled, dumping the new mom onto the floor. And that was the good news. Blisters on her backside precluded lying down. Breasts so full and suckled sore ruled out resting face down. Chhorn couldn't sit still for two days, but sitting and, heaven help her, standing were contrary to received wisdom. Any position other than horizontal too soon after delivery was believed to restrict the circulatory system. The consequent dark spots which appeared on Chhorn's face announced her ignorance of convention. Learning by

doing had its disadvantages.

Little Preng, named by a friend to sound similar to father Prim, slept tirelessly. He seemed to be storing up his energy for later, never squandering it on squalling or squirming.

August of 1981 passed into September. September into October. With the passing of the rains, the big guns returned. Shells showered down on Khao Larn. The Vietnamese closed in. The Thai sent trucks and orders. Move. One cooking pot, a few clothes, a mosquito net and a blanket. Prim could carry all his family's past over one arm. Chhorn carried their future in hers. Huddling low to the ground as mortars whistled, thudded, shredded trees and cratered the earth, a new fear filled Chhorn. Her head told her this battle was nothing compared to the assault she and Virah's other rice porters had survived in that coconut grove in Pursat. The final tally would be six casualties, five to survive. Her heart beat against Preng. She feared for him as she had never feared for herself. "Oh, Mother!" she pleaded to long–lost spirits. "Oh, Father!"

In daylight, the trucks delivered them to Kampot, a larger, cleaner, Khmer Rouge–dominated border encampment. Most of the displaced of Khao Larn settled in with karma–driven resignation. Some considered challenging fate. Prim whispered to his wife that he wanted out. Why not weasel one's way back into Cambodia? He hadn't run from Pol Pot's minions at home only to take orders from them in Thailand. Cambodia's fertile soil had given him life and could do so again. That soil held his ancestors. How could he venerate them from afar? What honour was there in queuing for handouts that lulled recipients into passivity? Chhorn didn't see things so clearly. She wasn't sure they could pick their way through the mine–strewn border. And even if they did, would it be safe on the other side? Would there be sufficient food? No, she wasn't going back.

Where could she go? Throughout her two years in Kampot, many Cambodians were processed by the great migration machine, which

scattered Southeast Asians around the globe. Weathered letters, no-tices of rewards in American dollars, names, addresses and Polaroid prints from various countries were plastered on bulletin boards out-side the office of the International Committee of the Red Cross. Reset-tled relatives hoped to locate long–lost kin, and camp folk fantasized about being found. Prim didn't want to settle in some riceless land. In any case, they had no blood or paper relatives who had gone ahead to sponsor them. Nor did they possess any professional or linguistic qualifications which would turn embassy heads. Chhorn had had one interview with American immigration officials. They hadn't bought her account of walking to Thailand.

Pressure from Khmer Rouge to return to Cambodia came in waves. Promises of houses and properties, two cows per family and a no–fire zone lured some Kampot neighbours. Prim and Chhorn's nastiest spats erupted over whether or not to gamble on going home. Chhorn felt justified in her disbelief when a letter from some return-ees reached them. "There is fighting all around us."

Still she sought portents and omens. Praying as she daily burned a stick of incense, Chhorn called upon the spirits of her parents, her source of life. "Father, Mother, help me. What should I do? Go? Stay? *Preah*," she invoked the Lord of the cosmos, "have pity on me."

"You're deluded," her husband would scoff if he caught her at prayer. Ancestors or avatars, their animate days were past. Cynicism had long defaced his faith.

For others, the sense of abandonment ate away at the will to live. *Kit chhraen*, a virulent strain of thinking too much, led some to drink insecticide. Suicide scared Chhorn stiff. Its victims were condemned to be reborn 500,000 times. How could The Highest One help one who loathed herself? A most repugnant case was that of a young woman, maybe sixteen or seventeen. An orphan, she had lived in the long-house set aside for homeless girls. It was whispered that men entered those rooms by night to fondle and worse. Her body was swaying from

a bough one sun–up. And there it hung as the curious came to gawk and gossip. Chhorn stayed away. Why meddle with fate?

Some refugees did dare to redefine their destiny. Beyond the control of the still haughty, herd–riding Reds, lay the land of the free. Prim's passable Thai and past links with border patrols gave him the wherewithal to sneak out of Kampot and into Thailand. He was hardly the first Cambodian to provide cheap labor there. Exploitation was nothing new to these illegal aliens. Payment in paper worth too much to roll around tobacco was enticement enough to risk jail on either side of the fence. Prim planned to work a fortnight and return with *baht* to feed his son and his wife properly.

After he left, Chhorn brooded about the dangers. The Khmer Rouge had shot other interlopers. The widows' longhouse reminded her that many men never returned. When fifteen days had come and gone, Chhorn believed herself one of the husbandless. A woman without a man went without. Anxious thoughts plagued Chhorn as she woke with the roosters. Her neighbours' mundane chicken–breeding venture seemed a much wiser pursuit of fortune than her husband's sortie into the tuber fields. After boiling enough rice for the day, and sweeping out the dirt–floored, one–room hut, Chhorn toddled along with Preng, now nicknamed Peng, toward the women's workshop. Over the months at Kampot, Chhorn had kept a routine of dropping in to learn sewing skills from Khmer and Thai instructors. Every Monday, Wednesday and Friday, she left Peng at the adjacent childcare centre for a couple of hours while she watched the teachers, waited for a turn at either of the two treadle machines and developed a quick, tidy handstitch. Designated tailors blocked patterns and sent flashing scissors slicing through bolts of fabric. Collars, bodice fronts and backs, sleeves, trouser legs and pocket pieces emerged. Chhorn always selected pieces for girls' blouses. She tucked the upper edge of each sleeve into the bodice to create an elegant puff over each shoulder. Boys' shorts or pants added pockets where those for girls did not.

Chhorn avoided pockets. Mostly she enjoyed the chance to learn and gratefully took some of her pieces home for Peng.

Dressing a little boy in girls' wear wasn't that unusual. Some parents sought to deceive son–seeking demons by disguising them as daughters. Others consoled themselves in the loss of female child by substituting a male. Anyone could pick out the girls by their pierced earlobes. A toddler may not have owned a single unpatched garment, but if the family had liquid assets, there would be gold in her ears. A band through a single lobe of a boy might be rebalancing lopsided testes. Such things the women chattered about as they sewed together. The chitchat distracted Chhorn less and less as Prim's absence stretched into a month. Rumors of relocating Kampot's residue, those refugees with seemingly no prospects for resettlement in the West, had been brewing for months. The refugee telegraph was pumping out gossip double–time.

For a fee of one hundred *baht,* which Chhorn would pay upon her husband's safe return, Chan agreed to follow Prim's trail into Thailand. Within twenty–four hours they were both back, and not a moment too soon. Prim hardly had time to express his annoyance at losing half his promised pay of 1,000 *baht*. 500 had been forfeited in exchange for release from his contract with a farmer. Now Chan was claiming one–fifth of that! No one was counting multi–coloured *baht* bills, though. Chhorn, Prim and Peng spent that very day standing or squatting in lines as officious refugee counters checked and rechecked the numbers. *Leah soum hai.* Good–bye Kampot. *Chum reap sur*. Hello Sakeo.

Once again, beings in a galaxy far, far away had redirected the course of Chhorn's life. Sakeo itself wasn't what gnawed at her soul. What grated was the knowledge that none of the moves over the past decade had been her doing. Decision–making was moot—hope masochistic.

Despair welled up worst when she was alone, so Chhorn idled away hours "going around". Strolling up and down the lanes, replaying childhood memories, watching an under–the–eaves barber clip locks,

eavesdropping on someone else's gossip, passing it on to whomever would listen. Boredom seeped into Chhorn's routine as initiative ebbed. "If I had a million *baht…*" was a familiar conversation starter. Prim and Chhorn often shot the breeze building an unreal conditional future. A wooden house, thick, solid planks; a metal roof, not thatch; a radio–cassette player; a plethora of tapes; a paucity of rats; a daughter—two kids would be manageable to feed and educate. Not that they could do anything to realize their dreams. Not that they intended to do anything.

A female public health nurse, Thai, ran a family planning program. Even with Khmer translation, basic concepts were lost. Husbands attended the first session. Prim went, got a sample condom, and as he walked home, blew it up like a balloon and gave it to some kids to play with. One man raged against the ineffectiveness of these colourful thumb casings. He had slipped one on prior to having sex with his wife but she still got pregnant. What good it might do on his thumb wasn't at all clear but he had fastidiously followed the nurse's demonstrations. Chuckles all around and hand–hidden giggles exposed the embarrassment of adults unaccustomed to dispassionate discussions of intimacy. When Chhorn arrived at the health centre for the lecture to women, she turned around and left. Anatomical diagrams and drawings were far too explicit to show an interest in, let alone to examine. Sex wasn't something to speak about with strangers in a brightly lit room. It wasn't even a pillow–talk topic for couples. Ribald humour aside, sex wasn't discussed—it happened, at the husband's pleasure. Custom kept wives quiet. No one could redress indignities everyone was too honourable to broach.

Public propriety was on rather shaky ground post–Pol Pot. Take the matter of religion. To be Khmer had been to be Buddhist in royal or republican Cambodia. Back in Kampot, the Buddhist religious order, the *sangha,* had been reestablished, not so much at the behest of the refugees who sniffed out divine rightists even among the smok-

ing joss sticks, but through international cultural revivalists. Chhorn attended functions at the *wat*. She particularly enjoyed highly melodramatic, traditional operas, tremulous tones wafting over amplifiers that cast their own warble. Enthralled by dance troops staging Khmer classics, Chhorn wasn't quite curbing desire. To be frank, she was fueling it. The monks weren't preachy though, unlike the Good–News aunties who made house calls in Sakeo. The first one to offer the gospel to Chhorn was polite enough. She did request permission to sit down on Chhorn's stoop and talk about *Seamitrei*. But the long–awaited bodhisattva wasn't a character Chhorn was comfortable chitchatting about. ""No." She turned away from the conversation. To get rid of this unwanted guest, Chhorn took an offered booklet. She shoved *God's Kingdom* into oblivion in the roof thatch. When the woman returned some days later with an invitation to join corporate worship in a house, Chhorn sent her packing. Why did people persist in dragging the divine out of Pali's sacred secrets and into the hurly–burly vernacular? God–with–us was as unsettling as the nurse with her oversized penis illustrations.

In preparation for Cambodian New Year festivities, money trees had been erected. Merit–making through financial contributions was incentive enough for Chhorn to join her neighbours folding green twenty *baht* notes into leaves. These they attached to a real sapling which had been stripped of natural foliage and decorated with billows of paper flowers. Each block of houses had a tree. Each tree would be presented at the temple. The offerings contributed to the daily support of the monks, for construction materials of halls and dormitories and for sundries such as oil and lamps. On the thirteenth, fourteenth and fifteenth of April, Chhorn tucked a bowl of raw rice under one arm and grasped Peng's long fingers. What did the future hold for this smiley little son of hers? Perhaps he would grow up to be a teacher, the most knowledgeable man in his village. Wearing a pressed white shirt unstained by sweat, Peng would be his mother's pride. Wending

their way along the dusty road, Chhorn couldn't help thinking about her own mother. Wise old women assured her that in recompense for presenting the monks with this life's goods, Chhorn would be reunited with her mother after death. At the *wat*, Chhorn slipped off her flip-flops and stepped out of the sunlight. When it was her turn, she approached a monk and offered her bowl, balanced on her outstretched right hand, supported at the wrist by her left. The grains rustled as they poured into the monk's bowl. "*Chochumran*," he murmured the consecration. "You'll be rich. You'll go to heaven." His blessing followed Chhorn as she backed away from his holiness and out the doorway.

If even this simple act of charity could garner credit for her spirit's next incarnation, then what a miserable, miserly, retrograde wretch she must have been in a previous existence. Among the genocidal scum of the earth that were her people, anyone could see her karma was shot through with demerits. Reincarnation, she dreamed, would be in lighter skin, with greater stature. How many times had Chhorn heard taunting voices, "You never bathe, that's why you're black"? To be dark-skinned was to be countrified, thus ignorant. The physical was taken as a mirror of the psychic.

Chhorn's mass of wavy hair reminded people of sheep, an impression reinforced by the skipping gait her short legs used to keep up with the longer limbed. Of little value, sheep were rare in Cambodia. Not a prize label. Of course, Chhorn herself took part in tagging others along phrenologic lines. Squatting in the shade of a friend's eaves, women would watch passersby. Was that lumbering one an elephant? The woman whose hips rolled as she waddled, a duck? Look, that horse sure can trot! Laughing through whispers about pigeon-toed or knock-kneed individuals went farther. The shape of the eye, small and squinty in a large face, indicated a dishonest character. Eyes that bulged abnormally revealed an untrustworthy nature; such a person couldn't disguise his propensity to thievery.

First impressions ran deep. Chhorn would never forget her

first sight of Khao I Dang, the vast United Nations camp near Aranyaprathet, its population of Cambodians second in size only to Phnom Penh. Underfoot, the crush of ochre and red laterite crunched as Chhorn threaded her way along the endless crisscrossing lanes; there were unbroken stretches of bamboo and thatch huts bleached by the tropical sun. Metal water containers, rows of rivets beaded with condensation, were propped up on more–or–less level stands. Barefoot, barely clothed kids sipped from dripping spigots or, king–of–the–castle–like, jostled to sit on top of the tanks. Lattice–work of split bamboo fenced off household vegetable plots. Towering above the rooftops was a mushroom–shaped water tower. Toward the Thai hinterland, Khao I Dang mountain rose craggy and green.

When the residents of Sakeo II were shuttled into this camp in 1982, Chhorn was amazed at the spread. Khao I Dang was the closest thing to a city she had ever seen in her twenty–two years. Among the 180,000 registered inhabitants, Chhorn found former crewmates from Pol Pot time. They too were married with children. Most reunions were happy and Chhorn found herself staring into every new face searching for familiarity. The Im family was assigned half a house in block thirteen; it was to be their home for almost three years. Prim soon went to work making water urns, one of which was alotted to each house. His pay was in kind, a carton of cigarettes, a couple sarongs or specially requested items.

Chhorn found a place for herself at an NGO, the World Concern Women's Workshop. In exchange for one shirt a month, she spent part of each morning sewing garments which were distributed to the poor or sold in Thailand. Between twelve and twenty women formed a team. They sat around a huge room stitching and, often, in stitches. The sense of belonging boosted their self–esteem as did the coordinator, the first westerner most of them met on a daily basis. As Chhorn chatted with her neighbour, they discussed Peng. Whereas Chhorn's health stablized in Khao I Dang, her son coughed a lot. It seemed that

she was taking him to the Out Patient Department every week. An administrator at Concern wrote up a permission slip for Peng to receive one boiled egg, a slice of bread and a cup of milk each day. The doctors told Chhorn through translators that she needed to put on a little weight too. Nursing Sokha, and pregnant a third time, Chhorn received her own biweekly supplementary ration card.

Regular rations were doled out in the standard condensed–milk measuring cans: one can of raw rice per kid per day, two cans per adult. Fish, dried, canned or fresh had to last a week. Fresh chicken or stringy bullock along with cabbage, choy, tomatoes, squash or beans were weighed out accordingly. One can of oil per person and a measure of salt were distributed, too. Of course, the Thai marketers allowed into the camp could sell you anything from brie to bullion, but empty pockets discouraged one from hanging about the market. One or two *baht* would buy a splash of pink grenadine dribbled over crushed ice and slivers of black jelly grass. Served in a plastic baggie enclosed by a deftly looped elastic band, *t'ik khaw chus* was a favourite treat.

Chhorn spent the cooler hours of the day at the community garden plots. Each family was assigned a two–by–three–metre space, although some sold their rights in exchange for a quick *baht*. Prim scraped up enough to buy a spade, a hoe and some seeds. He planted cucumber, lettuce, onions and squash. Although he collected the maximum number of litres of water per family member each morning from the water tanker, there wasn't much left after cooking and cleaning to irrigate the garden. For fifteen or twenty *baht*, it was possible to purchase a couple extra canfuls, but that equivalent of one American buck Prim and Chhorn didn't have. Nevertheless, their first crop of onions did particularly well. Three rows of greens waved in the breeze. "Sell me a kilo for fifteen *baht*," a stranger offered.

"No thanks," Prim answered much to his regret. The next morning they arrived to find every onion yanked. All their work had been for naught. Chhorn's pique pinched as much as her never–full stomach.

Although her expanding belly bode well for the baby, Chhorn couldn't keep much down during the pregnancy. When her water broke one morning, an elderly neighbour scurried off to fetch Prim from work. He arrived breathless by borrowed bicycle, onto which he hoisted his wife. Bouncing along side–saddle while Prim pushed the handlebars and ran as fast as possible, Chhorn shuddered with each contraction. At the hospital, labor subsided and returned. A nurse took Chhorn's vital signs while Prim made himself useful by heating up a rock to place on his wife's abdomen. Across her chest, the mid-wife laid a lovely little girl, but Chhorn was too exhausted to hold her. "Too much pain, I don't want to see her." They named her Sokhea, meaning lucky.

Sokhea's mother didn't feel all that fortunate. With an infant and two toddlers under five, Chhorn had her hands full. There was never enough water to wash, to keep the babies clean. Bare bottoms leaked and bowels moved on whatever was below. Often Chhorn's hip or lap. She would rinse out her sarong and wear it damp. Laundry was a has-sle. Kids would want to splash and play. Bathing them could be done outside after she hung out shirts and shorts. As for herself, she dipped her share of the bathwater over her sarong–draped body in the semi-privacy of a shower hut. The communal toilet facilities were decrepit by 1985. Flies buzzed drunkenly above the filthy pits. Even though waste management workers daily dusted the latrines with a powdery, white disinfectant and swept out the stalls, the toilets were nauseating to anyone with a short gag reflex. Chhorn never took her children there. She would dig holes near the house to bury their stool.

It was a lonely time. She didn't have sufficient breast milk for Sokhea. Sokha wanted attention, food and Sokhea's place. Peng want-ed whatever Sokha got and could grab it and make off with it at light-ning speed. Chhorn gave up sewing. How on earth could two hands tow three wrigglers to the workshop? She pined for relationships with someone who could walk and would talk.

Hope appeared through a neighbour who told Chhorn Peng was eligible to attend the nursery school where she worked. Big for his age, he could reach his arm over his head and touch his ear. Peng was a gregarious little guy and quickly made friends. The pencils, crayons and paints stimulated creativity and developed fine motor skills. A happily occupied boy made for a less–stressed mom. But preoccupation with her dead–end condition didn't die. Daydreams of her lost parents and siblings alternated with fantasies of a flight to France or Holland, an exotic–sounding place that had accepted some hardup cases Chhorn was familiar with.

Catnapping in a hammock in the shade provided the most peaceful moments of the day, or night. Throughout the late '80s, intruders routinely disrupted sleep in Khao I Dang. Sometimes, the refugees could go a week without gunshots rousting them out of bed, out of home and into some safer hiding place. Sleep deprivation influenced everybody when forays happened at a frequency of every two or three nights. By 1987, Prim was working at an aquaculture project funded by another NGO, Youth With A Mission. The families of the four Khmer hired to keep watch over the fish ponds slept in a house too near the camp's perimeter for Chhorn's liking. Security lights along the fence were ineffective deterents to bandits who shot their rifles into the air as they ran along the shadowy road from the surrounding forest into the thicket of indefensible bamboo huts. One retort and the mothers were off the sleeping platforms, a baby over one arm and a toddler in the other, pushing any other kids ahead of them across the dirt floor, out the door, over the earthen dike and down onto the muddy banks of the nearest fish pond. Palms stifling indiscrete squealing or wailing, Chhorn would peer through the darkness at the sprinting forms. Ten to twenty men armed with grenades, rifles and a machine–gun or two would career through the dark lanes of the camp, looting and assaulting unrestrained. However, in Chhorn's year–and–a–half at the fish farm, fear had been the only intruder to enter her hut.

Prior to living in that isolated house, night–raiders had knocked twice. Still pregnant with Sokhea, Chhorn had been sleeping with Peng and Sokha snuggled on either side of her when a boot kicked open the door of their one–room home. Prim had had the presence of mind to pull a shirt over his head rendering himself unrecognizable and, equally important, unable to identify the brigands. Chhorn sat bolt upright. Two men, whose eyes peered unseen through slits in *kramas* wrapped around their heads, barged in. One trained a rifle on her. The other barked out orders in Khmer. "Give me money. A watch. Gold!"

Too terrified to say anything but the obvious, Chhorn whimpered, "I don't have any." The would–be thieves glanced around the bare room and disappeared. "Oh, Mother! Oh, Father!" Chhorn prayed for protection by her ancestral spirits, trembling. A couple of months after the first incident, thugs burst from fantasy into reality again. That time they made off with Chhorn's rice ration, but left a preposterous suggestion. "Sleep. Don't be scared." Uh–huh. There was no value in valour. By 1987, just saying you didn't have anything was asking to be assaulted. Chhorn's neighbour, no better off than she was, had a rifle butt cracked over his head. Whacking axes at limbs or heads, robbers targeted men and women who were known to own. Remittances from overseas, jewelry or wads of *baht* noted by the wrong people in daylight would jeopardize the owner's safety at night. Many, many women camped out with their children at the hospital compound from sunset to sunrise. During the dry season, they dozed under a lone street light. In the rains, they moved *en masse* into the wards. The sick never had valuables on them—even thieves knew that. Out among the gnats and mosquitoes at the fish pond, Chhorn's pounding heart would settle to a less fearful pace. After an hour or two, the loudspeaker from the camp's center would crackle to life. "Robbers gone, go home."

Dawn broke through thousands of pillars of smoke rising from cooking fires. Kids awoke to splish–splash sounds of bucket–bathers,

which had replaced the frog–croaks and cricket–lullabies of yester-day's dusk. Morning was the best time to work. The fish–farm fath-ers fashioned bamboo frames for the fifty to seventy–litre urns they produced. A thick, gritty cement was hand–mixed and plastered to the frames. Once dry, the wiry, woody skeleton would be burned and the exteriors painted chestnut brown or mahogany with criss–crossed geometrical patterns in amber, black or white. Some stood taller than Chhorn and were as heavy as sin. In a plumbingless world, these cis-terns stood alongside every house, collecting and dispensing rain-water for bathing and laundry.

From Prim's shed, the vats were distributed throughout the UN-HCR's Khao I Dang, as well as to displaced people overseen by the United Nations Border Relief Organization at Site 2. By 1987, that conglomeration of several smaller camps housed 100,000 Khmer and some Vietnamese who had trekked across Cambodia. They were all slated for repatriation, not resettlement in the West. In exchange for his work, Chhorn's husband earned about three hundred *baht*–worth of self–selected stuff each month. Camp rules forbade cash wages, so refugee staff of aid agencies received payment in kind. There were packets of noodles, sarongs, and chicken to be had. Prim preferred cigarettes. Tobacco didn't supplement the bland but adequate rice ra-tions. It did, however, offer a man that rare feeling of bounty when he had several smokes in his breast pocket to share. While the men might squander hours squatting on their haunches listlessly puffing on ciga-rettes, Chhorn had a handful of children underfoot.

Camp kids could never be accused of passivity. They were almost entirely self–amused. Some of the games they played had been played by their parents in pre–Pol Pot Cambodia; others they created most resourcefully. Chhorn watched Peng excavate a circular hole, twenty–some centimetres in diameter. Little friends would gather with collec-tions of colourful elastic bands. One *baht* bought one hundred at the market. *Bao, sing, som*, a Sino–Khmer version of "rock, paper, scis-

sors", determined who began. The first player tossed a handful of elas-tics into the air. After they landed, fifty to one hundred centimetres from the hole, the player used his or her deftest one–handed shots to flick the bands into the hollow. A kid kept going until a shot failed to make it into the target. Before relinquishing one's turn, a player scooped up whatever elastics had been successfully launched. Turn–taking progressed until all the tossed bands were claimed.

There was no end of sandy roadway to be dug up for amusement. Another game required a more elaborate set–up. Two parallel rows of five shallow holes were dug. At either end of the rows, one larger well was prepared. In each hollow, players placed five finger–sized snail shells or perhaps tamarind seeds. The starter was again select-ed through *bao, sing, som*. She retrieved the five shells from her own well and, moving clockwise, added one in each of the next five holes. Empty–handed and confronted by an occupied well, she relinquished her turn. Continuing with the five shells in the opposite well, the next player deposited them one by one in the second row. Empty–handed when he arrived at the starter's well, he jumped over the empty *saa–oi*, or stinky hole, and scooped up the six shells in the subsequent hollow to end his play. Round and round the players would go, only claiming shells or seeds if they could leap over an empty space. To win, one had to collect the most tokens before there was an impasse in play. The loser had to blow the remaining snails out of their beds, a fate that resulted in dusty, red eyes and perhaps hyperventilation.

While seven–year–old Peng occupied himself in the dirt, Chhorn would cuddle one of her daughters and draw fish, flowers, carts or dogs in the mud. She chanted rhyming ditties to Sokhea:

Cockatoo, cockatoo, what do you do?

A dambong, a cactus fruit, that's what you chew.

You will fight and play, after you eat.

From the top of a tree, we'll hear you tweet tweet.

Some traditional lullabies sounded a little out of place under the sun:

So lovely, so lovely, the sky's full of light!

So lovely, so lovely, the stars of the night!

These belong to the angels, they're surely not ours.

How I love the stars! How I love the stars!

Melancholy melodies matched forlorn lyrics:

Star of wonder, when I reach you, far away you have wandered.

So I'll wish to see a pretty flow'r,

As I cannot hope to catch a star.

Blossoms too have blown away.

Alone I am, and here I'll stay.

There were gestures for moms to model and tots to mimic. Chhorn clapped her palms together and clapped her left hand to her daughter's right and her own right to Sokha's left as they sang:

Count the beans, one, two, three.

Piled upon the cow cart, can't you see?

If it breaks beneath the weight, you will have to walk.

Don't change your gait.

Look at the riders way up high, up on the elephant near the sky.

Look at you. After you jog, you may ride a pregnant mother dog.

32

The girls would squat with palms open upwards. Chhorn's index finger bounced from palm to palm while inane rhymes rolled off her tongue, replete with nonsense words:

Pour the juice of coconut, meelo, meelai, meelo, meelai,

OOPS! There's a catfish fin, mee neung ock, ai–yai!

The jar of ground–up betel paste is never in its sack.

Nor the bamboo handle ever by the scoop upon the rack.

As surely as a bald head is bared to open sky,

a defecating crow is sure to happen by.

For just as when it rains, water drips by and by.

At this point, a mother's voice rose to alert the little one to steel herself, just as *Mae's* fingers hopped up a forearm and tickled the toddler. Kids squealed in a mixture of ecstasy and mock agony. "*Moui tiet. Moui tiet.*" Again. Again.

A neighbour from a birth village far removed from Chhorn's recognized the last tune, but with still more ridiculous lyrics that left the mothers' sides splitting:

Rooster tails wearing a coat of crocodile.

The croc, on horseback, rides for a mile.

I prefer to ride Elephant for awhile.

When Croc upon the earth does stride,

I brave the water, deep and wide

Or if by ball and chain, I know he's tied.

With a needle, I give him a poke!

Croc lays an egg. Phew! It broke!

I laid one faster, that's no joke!

33

The laying of an egg was a euphemism for farting, a not un-common response of wee ones being simultaneously frightened and squeezed.

Every conceivable appendage was enlisted to clamp around twelve short, trimmed bamboo rods in another contest between older kids. A very round guava or lime was thrown straight up while the player scrambled to pick up the sticks, placing one in his mouth, another behind an ear, holding one under each armpit and so on. The loser, least able to grab and grasp, had his knuckles rapped with the bamboo switches as peer–inflicted punishment.

Boys and girls also engaged in competitions in which a couple of friends held opposite ends of ropes the kids had woven from innumer-able elastic bands. High–flying kicks worthy of martial artists flipped feet and legs over ever–rising ropes. Winner takes all was the *modus vivendi* in many matches. Contestants wagered their valued posses-sions: elastic collections or a Thai *satang* coin or two. Often the valu-ables became targets in a pseudo–shooting gallery. Cheap plastic flip–flops, if the kids wore any, became missiles aimed at clearing the deck.

If at least ten children gathered, Chhorn might watch five squat in a circle, holding hands. The other team sauntered around the per-imeter until one gave a secret signal, at which point all the outsiders attempted to jump inside. The circle–forming ones would stand or squeeze together to prevent any breaches. There were variations such as all getting one leg in and keeping one out. Much tumbling and trip-ping ensued.

Teams also challenged each other to face off across a patch of ground as a leader called out pre–assigned numbers. The appropriate players had to dash to the middle of the playground, pick up a bundle of leaves and hightail it back to their own line before getting tagged by an opponent. Chhorn found "Chicken" one of the most amusing games to observe. Kids would beg blankets off their mothers at dusk. "It" was the only one without a shroud. She had to approach a cov-

ered player and ask, "Who are you?" From within the cloak, a rooster's crow or hen's clucking would erupt. "It" tried to identify the chicken. If successful, one bird was out of the game.

So much of life was like that—a matter of elimination. Chance seemed to play the biggest part in the outcome of every encounter. By 1988, Chhorn had lost count of the number of times friends had vanished from her life. As her children grew, Chhorn desperately wanted something better for them. Sure, they were satisfied with non–stop, unrestrained running and jumping now. What they needed, she believed, was a formal education. The inertia of camp life was compromising their future, but it was Chhorn and Prim's middle ground. Her husband still looked east, homeward. Chhorn's afternoon naps filled her thoughts with ethereal imaginings.

One day, Chhorn's routine reverie was interrupted by door–to–door peddlers of one god. Although they did say they were from the church, the unmistakable structure near the *wat*, Chhorn linked this "there is one god" business to the *Cham*. For all she knew, *Kristeean* were Muslims under new management. Their no–drink, no–dance stance seemed to confirm her suspicions. The movie they had shown on a huge sheet at the football field in December had been a fine distraction for an evening, but not an attractive story. Imagine, venerating an executed, big–nosed, bearded *barang*. No dead gods wanted. No dead men either. She had seen more than her fair share of those already. What she hadn't seen enough of was wealth, and every little investment she made in monks' bowls now seemed to bring the same blessing, riches—next time around. Chhorn wasn't interested in testimonials of hot tempers made calm, nor swayed by endorsements of a life–changing Creator. The unalterable fundamentals of filial piety had worked just fine and would again if only life–giving ancestors were assiduously honoured for their devoted beneficence to their dutiful descendants.

A tract Chhorn had tossed with indifference turned up in the

bamboo slats around a toilet cubicle. A ruby–coloured heart filled with animals: a goat, a snake, and a tiger, puzzled her. In the privacy of the privy, Chhorn took another look. What was the significance of these creatures? The text quoted unknown scriptures about the origins of life. It sparked more questions than it answered. Chhorn decided to ask the Christians. As promised, they offered her a new t–shirt and some food when she came into their hall. Watching and listening to ordinary people praying and singing adoration in Khmer, accompanied by hand–drums and guitars, was like attending unrehearsed theatre. Chhorn couldn't remember a single word of the teacher's rambling homily when she got home.

A couple of days later, filmy sheets of onion skin paper blew across her path. Someone was tearing pages from the Christians' holy book to roll cigarettes. Retrieving them before they landed in the ditch, Chhorn recognized the same passage she had read on the heart pamphlet.

Why were these words following her around? Looking for meaning, Chhorn risked going into another church gathering. That night, her ancestors appeared to her, shocked at her betrayal. There was her mother, wagging her finger in her face. "Go to the Christians, and you will die!" The telltale headaches of *kit chhraen* wracked Chhorn for six months. Prim repeatedly told her to get down to the clinic.

When her grandparents returned in nightmares shrieking, "If you go to the church, I'll kill you!" a terrified Chhorn confessed her forays to her husband. Prim didn't think there was anything further to discuss. Stop flirting with the foreign god. Case closed. Not for Chhorn. She kept replaying her failings and faults. Her malcontent heart. Her feisty temperament. Her impatience with her children. Even a memory of stealing as a child. Pastor Chouk came calling. Might he petition heaven on her behalf? He held Chhorn's hand and prayed. Someone heard. That night, she dreamed of a star–filled sky traversed by a bridge. Over it, an old, old man came to grasp her hand and carry her up among the celestial lights.

The ghosts didn't return and Chhorn didn't go back to the temple. She could deal with her increasingly scornful neighbours. Someone else would just have to pick up her days on the block's monk–feeding rotation. A mocking husband was harder to handle. Headaches gone? A coincidence. Divine intervention? God, by any name you chose, couldn't be bothered by a woman's headache. *Preah Yesu*? Lord Jesus? Here a god, there a god, everywhere a god. Gawd, stop preaching!

How could her husband be so close–minded? During the day, when Prim was at work, Chhorn would read from the holy book the pastor had given her. In the evening she would try to explain to Prim that they owed gratitude to the Creator for their food. Hardly. The rations were scarcely enough to be happy about, and the garden produced only what he had sown, tended and harvested. Inevitably, the discussion would unravel into an argument. Irked at his intransigence, Chhorn would sulk or refuse to prepare Prim's supper. He was better at reconciliation than she. "I'll come along with you to the church next time," he would offer, brokering a meal now and breaking his word on Sunday. Chhorn felt manipulated, painfully unpersuasive and stupid.

At the base of a massive tree, Chhorn noticed ants, maggots and flies feasting on the propitiary offerings left by Buddhists, Animists and Ancestor worshippers. Prim never attempted to consult or appease the spirits himself, but he couldn't see harm in the practice. The incense, cigarettes, colas, platters of rice, noodles, curries, sweets, and fruit didn't disappear into thin air. He said ghosts came to carry off the oblations to ancestral spirits. Chhorn decided to question Pastor Chouk about providing for the dead. Spirits ascended to heaven didn't need earthly rice, according to him. Instead of serving the insects, Pastor handed out food to unregistered residents of Khao I Dang. Excluded from the rations alotted to card–holders, the illegals came to the church to receive, not to believe. Didn't Pastor see through the deception? Yes. Yes? Why would anyone in their right mind give to karmically inferior characters of no eternal influence whatsoever?

Chhorn became convinced she was missing something key.

Stepping off foundational notions is all but impossible when one's life balances upon them. The stooping Lord of Heaven apparently listened to Pastor, but would he deign to hear her? "Open your eyes to me," the lyrics came to Chhorn as she hummed the tunes of the church choir. Harping less on her husband and inquiring more of the Eternal, Chhorn again urged the elderly preacher to intercede for her. At his utterly ordinary words, Chhorn's heart pounded not in fright but in flight with the Presence. When Prim subsequently accompanied her to worship one Sunday, Chhorn was so ecstatic she ignored social norms and hugged the Pastor. However, Prim's responsibility for feeding sows and taking care of a dozen new piglets provided a ready excuse for not regularly attending two hour–long Sunday morning services. Public veneration remained to Chhorn's husband an orchestrated and ineffective approach to the fickle forces that bombarded more often than blessed.

True to form, destiny took another sudden twist. Documents filled out months prior to Chhorn's spiritual explorations suddenly yielded fruit. Mom and Sao, a couple of friends from Khao Larn days, had long resettled in Canada as government–sponsored refugees. Correspondence from Prim caught them at an opportune time. Flush with good fortune, the newly naturalized citizens were purchasing a home. Owning private property didn't release them from communal expectations. As personal wealth had to be publicly displayed to be appreciated, the astutely generous gave strategically, creating a network of obligations prophetically profitable. Sao and Mom filed sponsorship papers in Edmonton for the five members of the Im family. A delegation from the Canadian embassy would soon be interviewing hopeful candidates in Aranyaprathet. Prim couldn't resist goading his wife about an infected mosquito bite now swollen to gigantic proportions. "The Canadians won't accept you. One glimpse of your bad skin and they'll write you off as unclean." Could it be that the beastly qual-

ities pictured on the tract so dominated her soul that *Preah Vobedah*, the Supreme Lord, couldn't look upon her with pity? Chhorn felt the burden of her children's destiny heavy upon her heart. A sixth member of the family, unaccounted for on those utterly important papers, was growing within her. Would a fourth child jeopardize the futures of the first three? Chhorn's sense of inadequacy propelled her back to Preacher Chouk. In her presumed hierarchy of souls, his enlightened intercession on her behalf was bound to be more effective than her own. She found him at the *Kristeean's salaa* participating in a three-day fast.

"Grandfather," she begged, "pray for me." He did. Moreover, there was a baptism coming up; he thought Chhorn ought to consider proclaiming publicly the mercy of Christ. There was an interview coming up; Chhorn thought the Canadians ought to consider how blessed are the merciful.

Two weeks later, Chhorn went down into the reservoir. Life was suffering. Her twenty–nine years had demonstrated that humanity was adept at causing grief, even self–inflicted pain. Hell's myriad levels, descending endlessly beneath nirvana's elusive state, would be her certain destiny if not for the Promised One. Self–propelled salvation through her own unreliable goodness seemed a ludicrous alternative to the messianic incarnation Siddhartha had foretold. Heaven's helping, world–wounded hand was what Chhorn reached for in those waters. In an astounding change of heart, Prim reached out, too.

Their third daughter passed through the water on March 1, 1989. Sokhom was barely a week old when she was sufficiently documented to fill Chhorn's arms at the appointment with immigration officers from the Canadian embassy. Peng, Sokha and Sokhea played on the floor of the UNHCR office, behind the folding metal chairs on which their parents perched. Chhorn came to the interview completely uncoached. Some Cambodians paid English teachers to instruct them in question–and–answer routines likely to arise with embassy officials.

The idea of preparation hadn't occurred to Chhorn. She had heard the long–noses flung whatever queries they devised at whomever they pleased.

Both Chhorn and Prim required the services of a translator. A fellow refugee, the interpreter listened intently to the Canadians and gave long–winded versions in Khmer. Chhorn's one–word replies sounded clipped and insufficient, but the interpretation seemed fuller and satisfactory. "What kind of employment do you plan to seek in Canada?"

"*Tday kaw ow.*" "She says she is able to sew."

"How come you want to come to Canada?" "Who is sponsoring you?" There was a disjointed commentary on the weather and then, "Good luck. Congratulations, you passed." In retrospect, the friends and neighbours who gathered to hear Prim or Chhorn tell and retell the event concluded that the private sponsorship had smoothed the way out for the long–staying Ims. As Chhorn saw it, the One Chouk called The Door had literally unlatched all manmade barriers before her.

It was June, 1989, when Chhorn and her brood began the five–and–a–half–hour bus–ride away from the border where she had spent the previous decade. Ahead lay unknown faces at the transit camp in the weeks or months required for medical quarantine and more paper processing. Behind, in time and space, lingered once–known, now–lost figures: siblings, *Mae*, *Ba*, ancestors, life's sources. Chhorn grieved.

Westward: The Name–to–Go

Living in Phanat Nikhom Transit and Processing Centre quickly gobbled up the five hundred *baht* Chhorn and Prim had saved in Khao I Dang. Money was a big worry. The charcoal ration was insufficient to last a week; they couldn't very well have their kids chew raw rice two

days out of seven. What cash they brought went for ready–made rice noodles, soft drinks or ice–cream in the market on days when Chhorn had no fuel to cook over. Prim wrote to Sao and Mom. His request for dollars would put the family even farther into debt with their sponsors, but, like countless others on his side of the ocean, Prim had not the slightest inkling of his creditors' monthly rents, utility bills, or insurance premiums, let alone income taxes and other payroll deductions.

Employment with the Catholic Organization for the Emergency Relief of Refugees provided alternative aid. COERR Sanitation hired Prim for its drainage–ditch cleaning, garbage–collecting crew. Chhorn had nothing much to do but wander through the market and scan the post office billboards for their name. She learned of a Catholic Father who carried cash gifts from North American relatives into the camp, but never made contact with him. Eventually, Im Prim showed up on a list of names outside the camp post office. A money order for two hundred American dollars was exchanged for four thousand *baht*.

One diversion for Chhorn was the class at the Canada School. For an hour a day, she joined a group of women who met with a volunteer with the Canadian Mennonite Central Committee and a translator. Slides provided a prompt for dialogue about the land to which all of them were headed. A projector beamed a fine, white porcelain toilet up on the wall. In Canada, one was actually expected to sit upon such things to relieve oneself. A formal discussion of bodily functions was almost as bereft of decorum as the idea of coming into contact with someone else's prior presence. The ladies giggled self–consciously. On the subject of cleanliness, Chhorn was intrigued by a contraption into which she could expect to dump dirty laundry, add powder, turn a switch and come back later to retrieve clean clothing. The incredible layers of clothing wrapped around children in winter settings were beyond belief. How hard it was just to keep her children modestly covered in Thailand! Would she ever be able to convince them to wear socks, let alone boots? Then there was a lesson about home heating.

Such a necessity had never crossed Chhorn's mind. First off, urban trees were not for household fires. Open fires were not to be built on apartment floors. Electricity would be available in every room. And it wasn't free. Indecipherable bills would be arriving in the mail. Chhorn had never had to pay somebody she never met for a commodity she could not see. A scene of a hand on a light switch was to remind the women, most of whom had never used such technology before, of the financial implications of "off" and "on". Much, much later, it occurred to Chhorn that Cultural Orientation classes had not included a segment on the power of turning off a television.

Prim's sessions touched more on employment issues, but he wasn't much interested; sitting in the dark under a pleasantly whirring fan was a sure–fire snooze inducer.

During the first week of October, 1989, the Ims' name and ID number were posted on the outbound list by the Intergovernmental Committee on Migration. After ten years of waiting for the *name–to–go*, Chhorn's last hours as an illegal alien went by in a blur. A next–door neighbour asked Chhorn to write from Canada; she suddenly realized she was going to be on the other side of certain expectations. At nightfall on the twelfth, her family began the six–hour wait in a weather-beaten building dubbed Lumpini, after the centre in Bangkok through which entire plane–loads of refugees had been processed in 1979–80 when the world had considered the plight of Khmer in Thailand urgent. About three in the morning, the departees regrouped on the tarmac at the bus shelter. Officious Thais rubbed sleep from their eyes and scanned reams of paperwork while the Cambodian men passed luggage up to the roof of the bus and secured it. A security check swept the undercarriage of the Mercedes chassis. At least one refugee had stowed away underneath one bus in an attempt to smuggle himself into Bangkok; he had been caught, beaten and tossed into the camp jail.

All around Chhorn, people were misty–eyed; some sobbed as they bade farewell to friends and relatives whom they would not see

for a long time, if ever again. There were no tears on Chhorn's cheeks. Her loved ones were all with her and, aside from Prim, were too young to grasp the significance of the moment. "*Mae*, where are we going?" Peng squirmed on the blue vinyl when those on the list were finally ensconced on their seats. "I don't want to go. I want to get ice cream. Let's get off." Getting off was not an option. For only the second time in his life, Chhorn's eight–year–old eldest had to sit in one place for more than two hours. It was tiresome, nursing seven–month–old Sokhom while placating Peng and keeping Sokha and Sokhea out of each other's hair. Thailand whizzed by; Isuzus, Toyotas and Nissans played tag along the highway. Nerves, noise and diesel fumes combined with nauseating consequences. At least she had a plastic bag at the ready when breakfast threw itself into reverse. Traffic density intensified and velocity ground to a gear–grinding lurch as the airport–bound bus arrived on Bangkok's expressways at the outset of another day–long jam. From overpasses, Chhorn could see rooftops in every direction. Clusters of high–rises towered over the cityscape like toddy palms over paddies. Thailand was big. How big was Canada?

Don Muang International Airport covered more square kilometres than Khao I Dang camp. The terminal itself was larger than villages Chhorn had known. The Ims and their fellow travelers gathered around ICM officials who began issuing labels and stickers for every box, bag, crate and kid. KD numbers identified what and who belonged to which head of household from Khao I Dang. Some of the fathers eventually disentangled themselves long enough to purchase drinks, snacks or take–out meals from various vendors. Chhorn didn't find food appealing. Everything was overwhelming.

By the time the group was called to clear security and begin the next phase of migration along the airport's interminable wings, Chhorn was shuffling along on auto–pilot. A carry–on slung over a shoulder, Sokhom in one arm and Sokha yanking on the other hand, Chhorn assumed her husband had the other two in tow. Wrong. A

barely comprehensible announcement over the public address system fortunately caught the attention of one of the ICM chaperones. A KD–stamped kid had been found. Would the parents please come to collect one Sokhea? "Count your children!" ICM ordered.

"Mine are here," Chhorn thought just before she caught sight of an official marching up with her four–year–old daughter. Instantly Chhorn's heart was in her mouth; to know was to fear. How oblivious she had been to the near catastrophe of losing a child in the City of Angels. But Sokhea was smiling as demurely as a sculpted dancing girl on Angkor Wat's stone walls. While her skinny little *upsara* skipped down the gangway to the waiting 747, Chhorn's pulse pounded in her ears. "Every available angel, O Lord, have them fly with us."

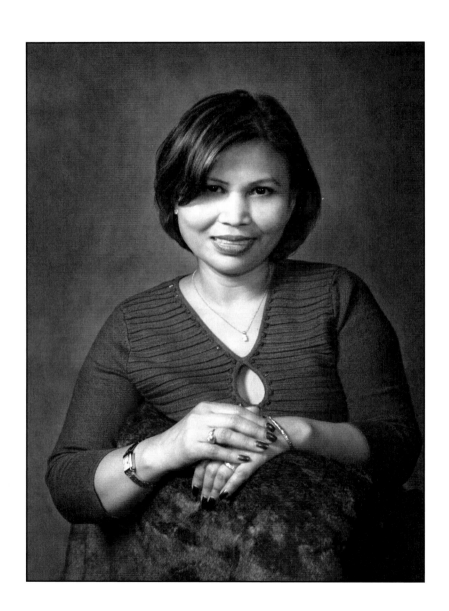

NARETH MOM

WEST, MEET EAST: PRELUDE TO POL POT

The slap–dapping of the waves lulled Nareth to sleep as she rocked in her grandmother's arms. The girl never questioned her *Look Yiey*'s love, but all other oaths of affection she had denied—and that vehemently, violently pushing parents and siblings away. Those teardrops, now dry upon her tiny, dark cheeks, had marred her vision but the distortion had not changed the facts. Coppery complexion, fine fly–away hair, a teensy excuse for a nose—all were assessed by her almond–shaped eyes and found wanting. There was no similarity. It was true. She was not one of them.

Keansvei village offered Nareth immediate sanctuary. The wide, wide waters of the Mekong separated her from the taunts of Toul Tom Boung district and of the trampled incense sticks at the base of the *bo* tree. Her grandmother's neighbourhood housed new friends who made no comparisons to Nareth's taller, paler, round–eyed, so–called sisters and brothers with their longer, more defined noses and thicker shocks of wavy, black hair. In these semi–rural suburbs of Phnom Penh, no one knew of the shattered porcelain urn, of the shrieks, of

Nareth's leaping tantrum or of how Elder Brother had restrained her by binding her to an interior teak column supporting the ceiling. No one knew except Grandmother, who spoke not a word of it. And the darkness that had welled up in this six–year–old soul on that cursed day ebbed ever so slightly.

A *bo* was no ordinary tree; every Buddhist child recognized the tree of knowledge. Enlightenment had come to the Indian Prince Siddhartha beneath the *bodhi* two–and–a–half millenia earlier. But the sacred banyan fig of Toul Tom Boung was exceptional; three adults could barely hold hands ringing the circumference of its trunk. The spirits who inhabited it were a well–fed lot. A succulent offering of re-cently roasted chicken sat upon a gnarled root erupting from the soil. Joss–sticks smoked constantly, wafting jasmine, resin and sandalwood scents into the leafy boughs above, along with supplications for heal-ing of a sick son or petitions that a wandering husband would return to his mother–chosen wife. Silent prayers for the just–exiled Prince stirred not a few lips and inaudible utterances cursed the conspirators of Lon Nol's coup–d'état. Resident devils with ears to hear didn't hear much to amuse them and Nareth, as other children, had been warned against estranging such spirits. But the *bo*'s shade was cool, and sam-pling solemnly proffered oblations was tempting. Perhaps, her mother speculated, a disgruntled demon had seized her little daughter's soul for kicking over one–too–many incense sticks. Such a scenario could have accounted for Nareth's implacable fury.

Anger had never been an acceptable attitude in the household of Cheui Ock. His commanding presence did not depend on displaying the five gold stripes on his olive fatigues. "Sir" was how his wife ad-dressed him, but to his five children, he was *Ba*. Even eldest sister Yanni, soon to accompany second–born brother Yanna to the cen-ter of the Francophile universe, called him Daddy. *Ba* was gentle—he seemed especially so to his fourth–born. Against Nareth, he raised neither hand nor voice.

Ba had been away on that fateful day. *Maq* was occupied as usual in her small gem–stone shop at the Toul Tom Boung market. The three servants were keeping an eye on the house and the children were permitted to play with neighbourhood friends. Nareth's playmates were children of a cousin of *Maq*'s, who had overheard and then confirmed their devastating words. "*Srey Oun*, younger sister," they asked. "Do you know where you come from?"

"Why, Tuol Tom Boung, of course!" Nareth replied.

"No. No. No," those second cousins countered. "You were found on a trash heap." As Nareth began to deny their claim, *Maq*'s cousin advised her to ask a mirror's opinion.

"You are so tiny. You are too black. You don't look like Yanni, Yanna, Yannet and Tin–Tin, do you?" The more Nareth's mouth protested, the more doubt gripped her heart. Sobbing, she ran home. The looking glass reflected everything the cousins had said. Her disbelief turned to despair and her despair enraged her. So this was why *Maq* had not breastfed her! This was why she had been put to sleep with a nurse or maid but not her mother on the mat beside her! All the security of well–defined family roles splintered like a bamboo hut under mortar fire. Little fists flailed. A finger snagged a crocheted doily. An imported Chinese vase smashed to the floorboards. The tiny terror had stormed around the house for an hour before Yanna returned from school. The eighteen–year–old pinned her arms to her side and trussed her to a post in the main room. Still thrashing about, Nareth wailed out of grief and into sleep.

The usual decorum of *Maq*'s house was pierced by fierce words in sharp voices. Through the arguing and yelling, Nareth felt Grandfather's anger. He erupted at *Maq*'s cousin, outraged at her insensitive inciting of disharmony. Unleashed from her bindings, the little girl resumed bucking about. She was, to be sure, possessed, people thought, whispered, even pronounced. Calm, now, in Grandmother's arms, sun–dappled waves of the river around her, Nareth left the house of tears and fears.

Over three–and–a–half years, she lived with Grandmother, first in Keansvei and then in Stung Mien Chey. There, in a village of paths pounded by hundreds of feet atop paddy dikes, Nareth met Chanvet. A more inquisitive and intrepid playmate Nareth had never had. It was Chanvet who reintroduced her to the spirit world.

Clinging to Phnom Penh's southwest hem like frayed lace, Stung Mien Chey nonetheless held holy ground. Long–gone papists had purchased a plot to bury the faithful, Khmer converts of French Catholic clerics. Like Cambodia's more monumental memorials to earthly empires and coming kingdoms in Siem Reap, this Catholic cemetery held riches Nareth had never dreamed of, nor would she ever have discovered, had it not been for Chanvet. The girls ventured into the graveyard hearts thumping against their ribs. Bumping into a ghost or two was a sure thing among headstones and tombs. Unlike the silent, symmetrical *stupas* scattered around temple grounds or the white-washed, brightly lettered grave markers sealing mounds in Confucian cemeteries, the stone crosses stood more or less at attention in rows and columns. How could Nareth be sure she wasn't treading on someone's bones or, Lord Buddha forbid, a skull?

What mysteries lay beneath their feet were suddenly eclipsed by visible treasures embedded in the headstones. Tens, no hundreds, of pearly beads encrusted some crosses. Like unscrupulous graverobbers who would lop off Buddha–busts by the hundreds at *Angkor Wat* to trade to soul–less collectors of art, Nareth and Chanvet yanked at the pearls, stuffing as many multi–coloured baubles into their pockets as possible before their spiritual sensibilities got the best of them. Dashing to the fence, the girls scrambled over it, panting prayers now, that the domain of the dead would not haunt them in the land of the living. They plunked themselves down under a shade tree and began stringing their booty into strands of jewels. Admiring glances from friends lifted the weight of ill–gotten gain from their consciences. Memories of that spine–tingling adrenalin rush lured them back to the cemetery

the next day. Four times the friends foiled the ghosts and giggled at their dare–devil pilfering. Finally, Nareth ventured in alone.

Pulling pearls from a cross, eyes on the prize, Nareth noted something, or someone, passing. Intent on indulging her earthly greed at her eternal peril, Nareth paid no attention until the person—now it was definitely a person, a person in white—floated by again going in the opposite direction. She lifted her head and noticed a small hut deeper in the cemetery. Overcome with curiosity, Nareth approached it then tried the door handle. The door swung open and inside, impaled on a crucifix, replete with gaudy blood stains, hung an anemic life–size body. Stunned, Nareth slammed the door shut and ran. She stopped short of the fence. Doubt surpassed fear. That man could not have been real. She hurried back, reopened the door and touched the figure. Nareth's fingers touched the dry, wounded side. She knocked her knuckles against it as she would to test a melon's ripeness. It was hollow. Clay maybe. Perhaps plaster. "He couldn't be dead," Nareth confessed later to Grandma, "because he had never been alive." *Yesu*, Grandma had heard quite contrarily, could not be dead because he was alive. The living dead sounded an awful lot like ghosts to Nareth; she would take on a crucified, plaster person over a living, moving foreign god any day.

Encountering things foreign enriched the familiar. As the image of that high–nosed, long–haired sarcophagus faded from Nareth's mind, her elder sister renewed her efforts to reunite the family under one roof. Yanni, tall and scholarly, Paris–purchased eyeglasses resting on her elegant nose, persuaded Nareth to smile. "See," she said, "our teeth are the same teeth. We are sisters." Nareth pursed her lips and pretended not to believe it. One day, though, knowing of Nareth's progress in school, *Maq* brought her birth certificate for her to read.

"See," she said, "our signatures, mine and your father's." Nareth narrowed her almond eyes, admiring the artistic script. *Maq* pointed out her daughter's names: Puong, her famous grandfather's name,

meaning a bouquet of blossoms; Sopong, meaning brilliant colours; and Nareth, a third and special name given by upper–class, urban Cambodians to beloved babies. Belief in Mother began to bloom. *Maq* arranged a visit to Calmette Hospital, the French facility where Nareth met a nurse who had assisted at her birth. It was time, *Maq* suggested, for Nareth to come home. Born on a Tuesday, Nareth's trip to Calmette took place on an ill–starred Wednesday. The *Ramayana*–based horoscope spoke of death and danger for *Maq*'s middle daughter; she must return to the family to whom she belonged.

West, Meet East: Pol Pot Time

Escaping was the farthest thing from Nareth's mind on that April 17 afternoon. The mass exodus from Phnom Penh seemed like a fantastic escapade in which everyone imaginable was engaged. Yanni and Yanna had barely been back from Paris for a week, to celebrate the New Year, when Toul Tom Boung was invaded, and emptied, by *Kmae Kahom*. "Why do you call them red, Mommy, they wear black?" the little ones queried. *Maq*, *Ba* and the older siblings walked together, consulting quietly, while Nareth and Tin–Tin skipped among them. The girls had never seen a city–wide parade before, let alone been in one. "Three days to sleep under the stars and to walk to where the sky meets the earth!"

The horizon was not exactly where they were heading; however, the deeper they went into Takeo Province, the greater were *Ba*'s hopes of reaching the border and crossing over into Viet Nam. *Ba* knew he was a marked man, being military and all, so he devised several strategies. The first had failed. *Kmae Kahom* had blocked passage southward along Route 2. The second made *Maq* cry but would prove prudent. *Maq* would later claim *Ba* had divorced her and that she, and the thus abandoned children, were destitute. Perhaps, fatherless, they might escape the fate *Ba* feared. Was fate smiling, or was that a smirk,

on the day the black–clad cadres announced that anyone with bomb disposal expertise was immediately needed back in the capital? *Ba*, pathologically honourable, identified himself and his family.

Bouncing along in the back of a truck, surrounded by her parents, brothers and sisters, Nareth scarcely noticed the surge in anxiety among the adults as the convoy of vehicles skirted Phnom Penh. Mortar–pocked Route 5 to Battambang could hardly be misconstrued as a detour to the capital's boulevards bordered by yellow, white and pink blossoms and aromatic magnolias. Northwest they rumbled toward Kompong Chhnang province; the trucks eventually halted in virgin jungle. Out! This was no Outward Bound personal challenge. This was for real. Shelter? Make your own. Food? Find your own. Time limit? Here, let me relieve you of your Rolex. Yanni's glasses went crunch beneath a heel before she and Yanna, along with other youth, were sent into the hills of Phnom Bat. The self–condemned officers had already been separated from their families. Where was *Ba*? Nareth's first wave of worry was for him. *Maq*, knowing, said nothing.

When *Maq* did speak, she lied. "Go on. Meet the other kids. Play with them." Three young women in black pants and blouses, carbines dangling from shoulder straps, hadn't rightly removed those thin-soled Chinese sandals when they marched into *Maq*'s hut minutes before. Without a greeting, skipping the honourifics that were the essence of Cambodian etiquette, one grabbed Nareth's arm.

"I've come to take your daughter." Nareth twisted out of her grasp and clung to *Maq*, a move that prompted all three cadres to seize limbs in the attempt to separate mother and child. That was when *Maq* lied. Her tongue, that was, not her eyes.

The *Kahom* pulled Nareth along, her resistance noted. It was September and the rains had made thick gumbo of the road. About a hundred eight–, nine–and ten–year–olds straggled, more or less together, carrying grain sacks or buckets of water according to command. After three days as a coolie, and three nights as a sponge under the leaky

thatch of a half–walled shelter, Nareth weighed the odds. She shivered at each animal howl, recalling the saliva–dripping jowls of cinema caricatures, man–eating, girl–gulping to be sure. On the other hand, the rude *mit bong,* or comrades, inspired a fear unlike any Nareth had known.

There was no moon when the nine–year–old spotted the *ang koal* stars. Plow's position assured her it was past midnight. Constellations Bull and Rooster were drifting across the inky sky as the kids' crew fell fast asleep. Even the two stationed at the entrance were slumped over, mouths agape, eyes sealed. Nareth knew enough about running away to steer clear of the high road. She tiptoed across the clearing and into an orange grove. Tiny green fruit dangled above her as she picked her way through thick grass festooned with feces. No toilets had been dug, and youngsters simply emptied their bowels wherever they happened to be. Nareth began to run, toes squishing in fetid muck, and her tummy squeamish. She paused to catch her breath beside a banana tree. Leaning back against the stalk, Nareth noticed the shape of a man in the gloom. "Don't catch me. Please. I only miss my Mom." The man, reclining on his side, said nothing in reply. "Perhaps he is running away too," Nareth thought and ventured closer. What was that dark splotch stretching from his left armpit down his side? It was damp. It was blood. Nareth peeled back the wilted banana leaves which had been strewn over the man, then lurched backward. His disemboweled body in front of her, Nareth began to crawl away. Her heart—had it stopped?—began to pound apace. On hands and knees she faltered. Another human silhouette, this one a woman sleeping the sleep of death, loomed up before her. Was she going in circles, only bumping into the same two bodies over and over, or were there countless corpses here in this orchard?

Eventually, Nareth reached a rice field which paralleled the road. The green grain was as high as her eyes as her feet sank into the undrained paddy. After she passed three small ponds she recognized as

landmarks of Bung Bai settlement, Nareth skirted the buildings and tripped through the trees behind *Maq's* place. Whispers unanswered, Nareth slunk to the doorway and crawled close to her mother. *Maq* thought it was little Tin–Tin. "Go back to sleep, it's not morning yet," she mumbled. Then Nareth's cold, damp hands encircled *Maq's* waist and jolted her to complete consciousness.

Mother had no comfort to give. "*Koun aut Maq!*" Motherless bastard! *Maq* shrieked with convincing ferocity as the *Kmae Kahom* burst into the hut. But she was yelling at her daughter, not at the strangers. "Go! Go! Never come back! Never let me see your face again!" Only the trickle of a tear on *Maq's* chin hinted that she hoped, by hurling coarse words in harsh tones, to distance her daughter from the infamy of her family. Nareth was too traumatized by the night's sights to translate *Maq's* antics into an act of love. Recoiling from the sting of rejection, she passively submitted to the pokes and prods of the rifle butt the children's overseer thrust into her backside.

"Three strikes and you're out!"

All the feisty stubbornness which Nareth had often exhibited outwardly, she now drew inward. She would need every ounce of tenacity to endure strike one. They bound her waist and ankles with two loops of metal chain to a tree trunk, her hands between the bark and her back. After forty–eight hours, someone responded to Nareth's whimpers for help, for a sip of water. They brought two mounds of ants, red and fiery. The clumps of twigs and leaves and soil and larvae and live insects broke open against her skin. One *Kahom* plugged Nareth's ears with fabric and tied another strip over her nose and mouth, then walked away. Scrambling over her body, the ants' jaws gnawed her arms, her legs, her head and her torso, squirting an acidic spray as they explored every crevice in her skin. Gagging, Nareth could not call out. She squeezed her swelling eyelids closed and swore an oath to silence. They would not muzzle her; she would shackle her voice. No sycophantic sniveling would be heard from her.

Almost as though they could read her mind, a test of Nareth's resolve began. The chains were undone and the girl was shoved to the earth, prostrate. "One hundred passes," someone called out. If anyone was counting, it was not Nareth, whose body jerked in spasms as the bicycle tires rolled up her spine and over her skull. The cyclist criss-crossed her stinging thighs and outstretched elbows, bruising her back and numbing her fingers. Grit ground into her lips, but Nareth bit her tongue and not the dust.

Strike two. Some months later, the overseeing of labour had fallen to several seven- and eight-year-olds who lorded it over the children's work group. A fifty-kilogram sack of cement powder had miraculously landed on the sandy slope of the canal, even though Nareth and her partner, who weighed less than their load, tumbled into the brack-ish water. Quite out of kilter, Nareth staggered up the embankment. When they had ordered her to lift the concrete mix the first time, she complied. She always said, "*Jaah*"—yes. When they sent her packing to the big boss, she went. All the kids on this crew were suspected of con-spiring against *Angka*. All of them were tainted by bad blood, coming from military parentage. Leaches of indiscriminate tastes didn't object to Nareth being enclosed with them in a tin tank, though. Four more hours up to her neck in bloodsucker-infested water seemed to satisfy both the lynchers and the leaches, the latter of which fell away swollen with plasma. The former left her alone.

Sometime in the second year of Nareth's isolation of soul, Yanna located the children's compound. Though the guard at the gate would not let him enter, and beat him about the head, Nareth's oldest brother called out to his little sister in a hollow voice. Then nineteen, Yanna's once-solid frame was shrunken and fragile. He, who had carried Nareth so high up on his shoulders that she could see beyond the sea of people evacuating the city that unforgettable April, shuffled off, stumbling under blows. His terse obituary of their elder sister pierced Nareth's heart. "Yanni is no longer with us." Neither would Yanna be.

Yannet, however, was wisely well out of reach of the Bung Bai district cadres. From the very first, he had volunteered for any task that would take him farther from the place where the military men and their families had been dumped in 1975. Unknown and passing himself off as an orphan, Yannet secured his survival and escaped abuse. Tiny Tin–Tin had been separated from *Maq,* too, and with considerable fuss, thus marking her as a trouble–maker.

Some troubles could be overcome. Some overcomers took pity on troubled kids. As Nareth entered her teens, she more intentionally learned from the old people, the peasants who hadn't been displaced and who harboured her no ill will. Racked by bouts of malaria, chilly or fevered, Nareth sought the advice of the elderly. "I am not going to die," she determined as she prowled around in the forest after a day's labour. The bark of a *sadao* plant she peeled and boiled to thick, bitter brew. Smoke from her fire, lit by stolen sparks from a cattle smudge, drew the ire of a Comrade, but seeing she was only making medicine and not cooking contraband, he let her alone. The concoction was utterly acerbic. To swallow it, Nareth unfolded a frayed card from her pocket. Focusing on the faded photo of a glass of iced coffee, she would sip the steaming liquid and fantasize that a cool glass beaded with condensation sat before her. The ice, the glass and the *café terrasse* where, oh so long ago, she had actually tasted such coffee, her tongue toying with frozen cubes, were all imagination, but the effects of the real drink were not. The malaria was beaten. This strike was in Nareth's favour.

In 1978, the Vietnamese struck back at Khmer Rouge incursions over their mutual border. Far to the west, the much–reduced crew of officers' children was shuffled about. Nareth joined a team of teenage laborers at Kahbal Moo. It was there, picking legumes, she heard big guns booming in the distance and felt an unfamiliar energy surge through her bones. "It's not long now," she assured herself, "someone will come." Nareth recognized that the local leadership were herd-

ing them westward, but resisted the logical movement away from the frontline. Camouflaging her intentions, she gleaned beans while heading deliberately toward a high road. Once hidden by a family driving a bullock cart, Nareth kept pace eastbound. The road led toward Battambang City, which had been taken by the Vietnamese. Nareth and her fellow travelers soon encountered several green–uniformed, metal–helmeted men. With the abandon of the newly liberated, Nareth ran up to the soldiers. "*Aukun! Aukun!*" She gratefully greeted them.

"*Cám ōn,*" a particularly pedantic trooper corrected her, exchanging Cambodian thanks for Vietnamese. Nareth attempted his language but her muddled mimicry sounded more like a reversed "*Ăn cōm*". Eat rice. A request for food was an altogether more common conversation starter between hungry Cambodians and the invading forces. Some soldiers pantomimed eating and passed out rice to the relieved peasants. They directed Nareth and the others several kilometres up the road. At a crossroads they would find many, many more of their compatriots.

A hundred or more milled around at the intersection on Route 5. Scrawny but belly distended by malnutrition, Nareth set about searching for anyone who knew anyone she knew. Where are you coming from? Where are you going? Rumours about caches of gold and fields of landmines stretched the truth about conditions both across the plains toward Phnom Penh and beyond the mountains to the Thai border. At one ludicrous account, Nareth grinned and a little face in the crowd lit up. "*Srey Pik!*" Tin–Tin recognized her surviving sister's smile and called out "Diamond Girl". Hearing a family nickname for Nareth roused Yannet and Mother. In the most spectacular reunion of their lives, the *Mom* family four clung together, incredulous at this encounter. Could coincidence alone account for this? *Maq* had kept tabs on Tin–Tin throughout the *Kmae Kahom* regime. Yannet had reconnoitered with those two immediately upon noting the Cambodian re-

treat. They knew *Ba*, Yanna and Yanni had perished; Nareth's end had been confirmed, too. *Maq*, however, dreamed of her middle daughter alive. For days the three of them had scanned the crowds traversing these crossroads, hoping against all odds to find their lost diamond.

United, *Maq* and her trio of teenagers set out for Battambang. A day's walk brought them to the suddenly burgeoning capital of Cambodia's westernmost province. *Maq*'s parents had once owned a house there, but it was occupied by squatters. Lacking the quantities of gold or gem–stones guides were extracting for safe–passage to oases of foodstuffs apparently sprouting on the Thai side of the western frontier, *Maq* turned her face to the rising sun. Scavenging well–picked-over paddies, rooting around gardens, filching fruit from unguarded orchards and pillaging looted grain bins, *Maq*, Yannet, Tin–Tin and Nareth trekked the two hundred ninety–three kilometres to Phnom Penh. When they entered Cambodia's royal city a month later, once frangipani–framed Pochentong Boulevard was strewn with the displaced and the dispossessed. They had come home to a citadel of widows and orphans.

East, Meet West: To a Second Country

She sat that night next to the husband her mother had approved for her. Nareth's mother was there, too, along with Tin–Tin and Yannet. The Phnom Penh twilight was comfortable, the wind warm. A couple of metres above the earth on *Maq*'s stilt–house porch, they gossiped and joked, dinner resting easily in their bellies. A satisfied stomach isn't necessarily a silent one; unbeknownst to his wife of six months, discontent rumbled through Sukonthia's.

"*Bong Srey, Maq*," Sukonthia addressed his mother–in–law deferentially, "the harassment hasn't stopped." He related the latest incident where Heng Samrin's men had given him grief over his Vietnamese identity. Ironically, Heng Samrin was the Khmer Rouge defector

whom the Vietnamese had installed as President of Cambodia in 1979. His port officials had slapped Sukonthia around and thrown him into the Kho Kong lock–up before. How could he prosper at business with the enforcers' fingers deep in his pockets? Nareth had not heard her husband's analysis of Cambodian politics before. She was, after all, the naïve, teenage bride whose knowledge of the world was negligible and whose opinion, therefore, was irrelevant if indeed it existed. *Maq*, however, was the older, wiser matriarch. Her endorsement was critical to Sukonthia's plan.

He began illusively. "I would like to go to Thailand."

Maq didn't show her hand. "Only Thailand?" she queried, her tone nonchalant. Sukonthia sketched out his strategy to reach America, Australia or Canada through the refugee resettlement system he had heard about, operating through United Nations' camps in Thailand.

When she spoke again, *Maq*'s voice had changed. It was excited, louder. "OH!!!!" She covered her mouth with her hands. This, this very idea had been her dream since the Vietnamese had invaded, driving the Khmer Rouge to Cambodia's western frontier in 1979. "Go, my son, go!" *Maq*'s exuberance brought tears to her eyes and Sukonthia, released from the stress of a potential confrontation, wept with her, for joy. Nareth did not join in.

Over the next weeks, Nareth continued attending the school established for young people whose formal education had ceased during Pol Pot's regime. She participated in practices and drills for *Défilé* Day; she had been selected to represent her class in the grand march past celebrating the ousting of the Khmer Rouge. Proudly sporting her uniform of blue skirt, tam and scarf worn with a white blouse, Nareth savoured the hours with nine girlfriends. On the eve of the parade, they joined others sleeping out under the stars in the schoolyard. The girls nibbled snacks and whispered secrets together late into the night. Under the cover of darkness, Nareth managed to giggle and tell titil-

lating tales along with her friends. Her deepest secret remained such. "I'll miss you. Oh, how I'll miss you," her heart cried out to her soul-mates, but her lips said nothing about her pending departure. *Maq* had strictly forbidden her to speak of it. And what was there to tell? She herself knew nothing but its inevitability.

Shortly after dawn, the marchers and flagbearers assembled around Phnom Penh's Independence Monument. Cheering crowds waved them on as they wound their way to the palace. Nareth's feet stayed in step along a route determined by some superior, but her imagination leapt unrestrained off the dusty streets and onto a sheer patina of ice. Her sturdy black loafers replaced by bright, white fig-ure skates with glistening blades, Nareth fancied herself twirling and swirling like American ice dancers she had once seen on the silver screen. Within weeks perhaps, she envisioned herself skiing through fresh powder at some alpine resort. There was no chill to her reverie; *Maq* and *Bong*, as she always addressed her husband, had conspirator-ially culled all references to danger from their conversation.

The scissors in *Maq*'s hand broke the spell. *Maq* and *Bong* decided Nareth needed to look as undesirable as possible during the escape. *Maq* didn't say that in so many words; she said a disguise was neces-sary. "I'm doing this because I love you." *Maq* sighed. Nareth resisted. She was convinced *Maq* deliberately cropped her hair like a boy's because she despised her. Love didn't push children away from their mothers. Had she survived Pol Pot time only to be banished from her home? As *Maq* snipped, Nareth's eyes scanned the room. Wedding gifts, a quirky hand–knitted bird from a chum, pictures of teachers, flowers, a photo of the nine fast friends in the surf at Kompong Som— none of these mementos could travel with her into the future. *Maq* had stitched several gold bracelets into the seams of the three blouses and three pairs of trousers packed into a colourful cloth bag, a gift from Sukonthia. *Maq* confiscated the lipstick, powder and eyebrow pencil Nareth slipped into the satchel; she safe–guarded on her own

body the travel permits her daughter would need to legally reach Koh Kong on Cambodia's western coast.

On the eve of the departure, feeling ugly and betrayed, Nareth stayed in the bedroom, and just as well, for a cousin and her husband dropped by, visiting so late that they spent the night. Nareth didn't dare show her altered self; she restlessly brooded over not being permitted to say good–bye to her surviving grandfather. And then, too soon, before dawn would give them away, *Maq* beckoned from below Nareth's window. Nareth shinnied down a tree. Tin–Tin tossed her the travel bag. Tiptoeing under the house and out the gate, Nareth followed *Maq* to the main road. Her mother roused a sleepy *cyclo* driver and uncharacteristically agreed to his ten *riel* fee without haggling. As the man pedaled the trishaw the five kilometres to a bus depot of sorts, they were silent except for *Maq*'s barefaced lie in answer to the driver's question about where they were going. The depot was really a glorified truck stop. A five–ton freight carrier belched diesel fumes as Nareth and *Maq* climbed up the mountain of rice sacks and furniture on which other passengers were sitting. For nine hours they lurched and bumped their way over roads of ill repute to the coast. There, *Maq* led Nareth to a quay where a contact of Sukonthia's had docked his boat. *Maq* gave the man a password to secure Nareth's passage and his protection of her. *Maq*'s arms reached around Nareth and drew her close. They couldn't afford a scene. "Go to meet your husband. The Lord bless you." Mother squeezed daughter. "Your father's spirit will be with you." Nareth stepped into the boat. *Maq*, turning quickly, vanished into the crowd.

The captain of the crowded scow dutifully looked out for Nareth, whose first sea voyage proved to be both wretched and remarkable. Seasickness plagued her that afternoon and though the skipper advised her to sit low in the boat and not look around, she stayed in the bow, catching the cool breeze. Under a full moon, the sea and sky merged horizonless and Nareth saw celestial faces among the stars.

The heavenly ones looked happy there. Maybe one day Nareth, too, would be happy again. Maybe, just maybe, she was fated to feel her mother's touch, to hear her brother and to see, once more, her sister.

The sun, a slender ribbon of yellow on the brim of the sea, unveiled the sleeping town of Koh Kong. Stiff passengers stirred, but Nareth heard only the voice of the South China Sea sloshing against the side of the ship. On shore, she saw Sukonthia, her destiny, waiting for her. As in a dream she disembarked, showed her travel permit to the soldiers on the pier and managed to mumble an acceptable reply to the officer curious about what her Phnom Penh accent was doing here just kilometres east of Cambodia's sieve–like western frontier. Halfway across a gangway to shore, Nareth stopped. "Where are you going?"

The soldier's simple question echoed through her mind. *Should I go on or should I turn around and get back on the boat to Phnom Penh?* There, suspended between land and sea, Nareth collided with fate. Was it hers to endure, or hers to choose?

Metres away, the man who had chosen her was calling. "Come! Come!" He thought she hadn't seen him. She had but she chose not to. *Go with your husband, if you love your children.* Those words, from the woman who had chosen her husband, rang in her ears. At that instant, it occurred to Nareth that she had missed her period. She caught Sukonthia's eye, passed the cordon around the dock and climbed the hill, with him.

Lying with him that night in an inkiness that heightened her sense of sound, Nareth listened to the soothing rhythm of the tide splashing the piers of the fisher's house that sheltered them. An irregular beat, wood on wood, rocked her. A boat, bought with gold igots, thudded against barnacled teak posts. Crossing the sea in this vessel, Nareth felt she would be dying and beginning another incarnation. She grieved for the family she loved and had left for a man she didn't. No one noticed the salt on her cheeks.

For a week, Sukonthia tinkered with the motor of the dory he had

acquired. The landlady took Nareth to the market where she heard Thai tones among the hawkers and shoppers. Koh Kong had been Siamese before the French extended the reach of their *mission civilisatrice* over this coastline in 1906. A pirated Chanel label in stark Latin lettering caught Nareth's eye. She happily parted with several *riel* to acquire a tube of luscious ruby–hued lipstick, an eyebrow pencil and a compact. All these Husband found wrapped in a sarong stuffed into her travel bag. He hurled them into the surf saying, "You'll have plenty of this later." Nareth flung her frustration back at him, but Sukonthia still didn't express his fear for her that other men, dangerous men refugees inevitably encounter, might find her desirable. Money and makeup gone, Nareth set about the one responsibility she was given in the escape scheme. She squatted at wide aluminum pans pretending to wash every stitch of clothing in the house. From a distance, fully loaded lines of laundry would deceive observers, deflecting suspicions that all the residents might have made a permanent departure in an obviously absent boat.

But they had. About two o'clock in the morning, when the waning moon lit little, Sukonthia, Nareth, six other adults including the landlady, and three kids slipped away from the shore. The men rowed along the beach, keeping the boat in the gloom of overhanging trees. Monkeys screeched at them and bobbed low over their heads from branches and boughs. Nareth detested these scratching, biting, thieving little mammals that congregated around some seaside temple sites. When she said as much, Sukonthia threatened to suture her mouth shut if she didn't stop adding to the cacophony which he prayed would not alert any authoritative ears. He ordered everyone to lie down in silence.

Within an hour, they passed beyond the bay and steered out into the open water where the men started the motor. Nareth stared out at the vastness of the Sea. She sensed how infinitesimally small she was. The Sea could easily capsize the scow. Great fish capable of bisecting

the boat in their jaws certainly lurked beneath the waves. Those creatures might even then be plotting to destroy and devour her. Her husband knew underwater beasts posed the least threat and tried to tell her so. Fear of some who sailed the surface was in his heart.

About dawn, someone spied a boat. Military? Pirates? Sukonthia decided to outrun it, though his lips said, "Don't worry, it's a partner." He twisted the lever to the highest point of acceleration and the engine sprang into top gear. Eleven pairs of eyes watched the "partner" and scanned the distant coastline.

Some of the men, including Sukonthia, had traveled this way before, hustling goods around the bandit–ridden border in an always lucrative import–export trade. All nine Khmer who called Koh Kong home spoke Thai, so when the fishing village of Klong Yai appeared they decided to land for drinks and food. Only Nareth felt foreign there. The others determined that turning themselves in to Thai authorities was best left for Trad, farther along the coast. Not quite steady on land legs, Nareth resettled herself into the boat as they nosed out over the waves now sparkling in the sun. It was easy to see and to be seen that morning.

One or two kilometres west of Klong Yai, the boat people noticed an elderly lady on the sandy shore. She held what appeared to be a baby and beckoned, calling out for them to give her a lift. This was a ruse, the Khmer concluded, and ignored the decoy. Within minutes, a motorcycle began keeping pace with them along the coast. A very visible long–barreled rifle was in the hands of a rider. Guiding the boat farther out from shore only to spot a sloop following them, Sukonthia aimed for a middle way, hoping to outrun the gunmen. Foreboding silenced the passengers. Nareth could hardly hear above the thudding of her heart, but Husband had a plan. They would get as far ahead of their pursuers as possible, ground their dory, grab what they could and scramble up the bluffs above the beach. Before the bow scraped the sand, Sukonthia was over the side of the boat into the surf. Nareth

felt limp as he grabbed her hand and they splashed to shore. A sharp shot of pain seared the sole of her foot but she kept going. Across the sand and, barefoot, finding footholds in the hillside, breathing dust and fear, Nareth clambered up the grade.

A flock of ducks waddled and squabbled over grain tossed to them by a demure Thai woman. Seeing eleven wide–eyed Cambodians crest the hill, chests heaving and perspiration seeping through their shirts, didn't faze her. "*Pood Thai dai–mai, ka?*" she inquired of the aliens with full etiquette. Speaking passable Thai, Sukonthia blurted out their tale of terror. The woman immediately tried to calm them. "You're safe here," she said, ushering them into her house, offering them food and telephoning her husband who, destiny determined, was a local administrator. Down in the surf, four men plundered the boat. In her haste, Nareth had abandoned one of their bags. Irreplaceable photographs, a toothpaste tube refilled with gold, a pure gold chain coated in alloys— almost all the portable wealth they would need to cut through bars of international bureaucracy was forfeited. What was lost Nareth knew; what she had risked it all for remained unknown.

Sweaty hair plastered to her head but injured foot cleaned and covered, Nareth and the others swayed with the movement of a large truck the duck lady's husband had sent up from the Klong Yai Police Station. All the adults were individually questioned there; only Nareth needed a translator. Husband had never given her a specific strategy for what would be the first of innumerable interviews, but Nareth's instinct was to tell all. "Why did you marry a Vietnamese?"

"I, er, my family loved him."

"Don't you understand that the Vietnamese are in Cambodia to overrun it?"

"I don't think so."

"Did any Cambodians attend your inter–racial marriage ceremony?"

"Yes."

No one was harangued or harassed at Klong Yai. No bribes were solicited. Once the talking was over, everyone was directed into the back of a military truck along with three well–armed soldiers. The administrator made it clear they were being taken to Khao Lanh, a special camp, forty–five minutes inland.

The truck trundled along, a solitary vehicle on a dry forest road. Impenetrable clouds of red dust rose up behind them. And then, in the middle of nowhere, the driver geared down and halted. The uniformed men ordered the Cambodians off the truck bed and into a small yard. Time to check everyone, someone said. One by one they were called into the house. The teenage daughter of their Koh Kong landlord stumbled out weeping but wordless. Nareth. In the first room a woman waited. She frisked Nareth with experienced hands. Running her fingers through Nareth's hair and over her scalp she felt the earrings *Maq* and *Bong* hadn't noticed. Adroitly pocketing them, she shoved Nareth into the next room filled, it seemed, by the man of the house. Rolls of flesh a decent man would have covered padded his paunch, but he was wearing only undershorts, which Nareth could see hid nothing, least of all his intentions. A hefty gold chain hung around his considerable neck; the five Buddhas in exquisitely carved ivory rested on his reddening chest. Nareth shook as he approached. Like the buttons popping off her tailored blouse, her dignity shattered. Fingering the seams of her brassiere, he muttered "Gold…gold." Trying to cover herself, she raised her hands in a plaintive *wai*. With ingenuity born of desperate shame, she pressed her thumbs together. "Husband. Wife. Married! Married!" She pleaded in Khmer not sure if he could comprehend. He loosened the sarong that slim–hipped Nareth had trouble cinching securely at the best of times. "No, no," Nareth begged. She pointed to her now bare midriff and pantomimed its expansion. "I'm pregnant!" Her heart's roar was just a whisper on parched lips. Perpetually groping fingers squeezed every conceivably concealed cache before the heel of his hand slammed into her belly.

Staggering backward, Nareth's knees buckled. Behind her, the Thai woman had been working over the garments the man had tossed her; they knew well the technique of sewing gold or gemstones into seams and hems. The woman handed Nareth a garish sarong and an outsized cotton shirt. She signaled for the quivering Cambodian to surrender her underclothes and pushed her out the door into the glaring afternoon sunlight.

Nareth's limbs were so shaky she couldn't stand. She crawled under the shade of a tree and collapsed. Anger seized her. She seethed with rage at Sukonthia. Words could not contain the fury of her hatred. He, he who had pledged to protect her, he had delivered her into the hands of that swine. Bitterness surged through her. Somehow, at some point, she returned to the back of the truck, the driver of which dutifully delivered all eleven re–dressed Cambodians to the destination Nareth had hours before anticipated with such hope.

Set between the Gulf of Thailand and the Cambodian frontier, three hundred thirty–some kilometres southeast of the Thai capital of Krungthep, Khao Larn was administered by the Thai Red Cross. Under the patronage of Her Majesty, the Queen of Thailand, special military representatives rotated as commander. A kindly Thai woman transcribed the atonal Khmer names into an indecipherable script. At Sukonthia's insistence, she recorded Viet Nam as his birthplace. The list, Nareth gathered, and accompanying documents, were required by the yoo–en–ehtch–see–ar, a previously unheard–of creature with a penchant for paper.

After this initial registration on January 18, 1985, the illegal aliens were assigned a place in the almost empty barrack–like shelters. In every long–house, on every wall, Cambodians who had earlier passed that way had inked, penciled or carved name upon name. Nareth wandered from wall to wall, scanning family and given names, birth dates, family trees, and any original addresses in Phnom Penh. Many postscripts added destinations deeper inland. Dong Ruk predominated.

Three days and one ration distribution later, the group was transported further to Kampot. Larger than Khao Larn but just as bereft of Cambodians, Kampot was quiet—too quiet for Nareth's comfort. Gentle people provided blankets, a mosquito net, and a quantity of rice and meat to each family. With polite speech and helpful gestures, Nareth was directed to gardens planted earlier by previous occupants. Vegetables grew there for the picking. The Thai administrators initiated a new round of interviews. An officer, bars on his uniformed shoulder, questioned Nareth. After the standard queries about name, parents' and siblings' names, birth date and place, he pointed to a doorway. "Go on, take what you like." Nareth was surrounded by stacks of canned food flats. She chose a handful of cellophane–wrapped sweets. The officer looked incredulous at her selection and offered tins of beef stew or fish. A new pair of plastic flip–flops felt very fine on her feet. Another Thai noticed the Cambodians had but one set of clothes, which the women washed at night when they wrapped themselves in their *kramas*.

"Where are your clothes?" He genuinely wanted to know. Nareth told all, much to Husband's angst. Many Cambodians gambled their futures on telling authorities what they thought the bigwigs wanted to hear, but there was Nareth babbling on and on about beach bandits and the hut of horror in the forest. The officer listened without offering comment, but Nareth watched his brow furrow and his eyes widen while he jotted down notes. Nareth felt vindicated by his acceptance of her account. Outside, Husband reprimanded her for such a "long story" but Nareth rebuffed him. She would speak her mind. No spit–and–polish uniform was going to cow her into sanitizing injustice.

No Khmer tongue in a *barang* body would either. This foreign woman's stature was remarkable; her fluency in Cambodian uncommon. *Yiey Sok Saw* scraped the metal folding chair across the uneven concrete floor as she settled her tall frame at the table. Nareth and Sukonthia stood before her in Khao I Dang. Khao I Dang, a four–to

five–hour drive north of Kampot involving countless security check-points, had held the largest concentration of displaced Cambodians in the world in the early 1980s. By 1985, the refugees included over 15,000 KDs who had been registered before 1982, over 4,000 house-holds possessing FC or family–card documents, and several thousand soon–to–be–registered Ration Card–holders. Thailand felt overbur-dened by the unending stream of peace and prosperity–seeking peas-ants who clambered at its borders. Compassion fatigue was the current contagion discussed by NGOs and their supporters in North America, Australia, New Zealand, northern Europe and Japan.

A mere eight kilometres from the mine–strewn border with Cam-bodia, the refuge–seekers seated themselves once the white–haired elder gestured her assent. Sukonthia responded with suitable hon-ourifics and deferential courtesy when *Yiey Sok Saw* brusquely began the interview asking, "Why do you come?" He had barely begun when the long–nose interjected rudely, "They don't need anybody anymore. They'll send all of you back. Tell me, do you want to return?"

Nareth was flabbergasted. "I had many problems getting here. Why would I go back?"

"There's a flight to Phnom Penh tomorrow. A comfortable and a safe seat."

"No," Nareth retorted. Her husband had received unofficial as-surances in Kampot that, due to his declared Vietnamese birthplace, resettlement options remained open to him that were almost sealed shut against Cambodians. The encounter with the first Khmer–speak-ing *barang* Nareth had ever heard concluded abruptly. A door closed behind them.

"Where do we go?" Nareth clamoured after Husband, who knew all too well what directives had been given in Thai. Unable to vent his own disappointment on the decision–makers, Sukonthia snapped at her. Intimidated, she retreated into imagined beatings by club–wield-ing guards. A door swung open. They were deposited among the filthi-

est, foulest collection of miserable humanity Nareth had ever smelled or seen. "I came for freedom," was the politically correct mantra of the migrating millions. Welcome to Khao I Dang jail.

Three tiers of bamboo bunks lined both sides of a narrow corridor. Cambodian men occupied the left bank, while women and kids were segregated to the right. Sleeping people were pressed together like fingers on a hand in a pattern of alternating heads and feet visible along the aisle. But how could anyone sleep? A couple of children with pus–oozing eyes sat naked, whining in their misery. Nareth found a spot near them. Her future loomed up before her. Was she to remain in this mess interminably? Would a child of her own womb first see the sun's dim rays through the mismatched slats in these walls? Her fingers found the Khao Larn candy she had hoarded in her pocket. Right palm extended decorously supported by her left, Nareth offered a bonbon to each teary baby. Their mother noticed. "*Aukun*," was all she offered then, while many covetous eyes were watching.

Nareth's thirst drew her off the platform and out into the jail yard. Through the fence, she watched legions of Cambodians sauntering, cycling, striding, trudging, strutting, ambling, plodding, sprinting. The whole world was moving, migrating, while her soul stagnated, chained to an imprisoned body. "How long will we be here?" she had asked *Bong*. Her asking unanswerable questions chipped away at his beleaguered authority.

"We'll be sent to Dong Ruk." Dong Ruk! Purveyors of false information said Dong Ruk was a border encampment on the wrong side of the border. Nareth's whinging exasperated Sukonthia, who yelled, ordering her to be quiet. How many arguments had they had since the first one over that compact in Koh Kong? Locked in her heart was extreme anxiety that she, too, had been discarded and no one would tell her the truth. This marriage, so pacific in Phnom Penh, had become a monsoon of swells and waves.

Nausea swept over Nareth as she rounded the corner of the jail-

house. The sole latrine, a pit in the earth surrounded by a shaky screen, reeked of leaking excrement. Maggots wormed their way out of the ocher clay. It was more than enough to constipate a diarrheatic.

On the far side of the compound stood a potable water tank, empty. The entire daily delivery of water had been distributed at eight that morning, therefore there was none to be had. Not even for big *baht* bills. The Thai currency *Maq* had given her and stashed inside the slit sole of her battered sandal was Nareth's secret. But no one offered any precious liquid in exchange. Swatting the ubiquitous mosquitoes, Nareth recalled a tableau she had seen at a Phnom Penh temple. Tiny people bent and broken, forming the lowest level of Mount Meru's multi–layered universe, languished in merciless torment. She was one of them. She was in hell.

Even in hell, fate intervened. There was room, at dusk, for her to stretch out on the bottom shelf of inmates. In the darkness, the mother of the candy–pleased kids uncorked her hidden water bottle and shared a cup with Nareth. Rain on the roof, rats rummaging through the thatch, men moaning, restless bodies turning, immeasurable hours stretched toward dawn. A crackling of a loudspeaker announced it was precisely eight o'clock in the Realm of His Majesty King Bhumibol Adulyajej. Within prison walls and all across the Land of the Free, the regal chords of the national anthem brought traffic, pedestrian and vehicular, to a standstill. And stand they did. Automatically, it seemed to puzzled Nareth, every woman, man and child in the jail rose to their feet. But no one knew the lyrics, let alone sang along:

Thailand embraces in its bosom all people of Thai blood.
Every inch of Thailand belongs to the Thai.
It has long maintained its sovereignty,
because the Thais have always been untied.
The Thai people are peace–loving, but they are no cowards at war.

They shall allow no one to rob them of their independence,
nor shall they suffer tyranny.
All Thais are ready to give up every drop of blood,
for the nation's safety, freedom and progress.

Solemnly at attention until the last strains of *Phleng Chat* faded away, the unembraced slouched back down onto their bunks. Only afterward did a little girl interpret the uncommon ritual for the uninformed newcomer.

For the first time in her life, Nareth began a day in jail. The eleven boat people from Koh Kong were oddities in Khao I Dang. Cambodians there had picked their way over minefields through the forests of the Dong Ruk Escarpment, some laid by Thai gatekeepers, some planted by Khmer Rouge–pursuing Vietnamese and some strewn by the *Kahom* themselves. Thirty–some kilometres north of Thailand's largest refugee holding centre, still within Prachinburi Province but outside the scope of the UNHCR, Dong Ruk's stateless residents fell under the purview of UNBRO, the United Nations Border Relief Organization. There, asylum–seekers could count on some relief, but not refuge. Within months, in the dry season, a renewed military offensive would obliterate Dong Ruk, but in early 1985, its jail appeared solid and its latrine passably sanitary to Nareth. What a sea change in expectations twenty–four hours as an illegal alien could produce! The six p.m. musical broadcast did not catch her off guard; she stood on cue.

At attention outwardly, Nareth's mind replayed the day's trip. The driver of the truck transporting them along the forested road north of Khao I Dang had been fixated by her husband's face. At his invitation they joined him in the cab. Sukonthia, he explained, bore a striking resemblance to his own younger, just deceased brother. Was he of Chinese ancestry? The driver's parents had migrated from China during the last generation's great influx to Thailand. He adamantly reaffirmed

the importance of Sukonthia's Vietnamese birth, regardless of his parents' Cambodian connections. Had Husband consistently given that information at his four previous encounters with Thai authorities and camp administrators? Sticking to one's story was vital, the Chinese–Thai said. He offered to verify statements Sukonthia and Nareth had given at Klong Yai, Khao Larn, Kampot and Khao I Dang. He urged them not to agree to settle outside Dong Ruk's jail among the general population of the camp's "displaced persons", none of whom were being screened for resettlement abroad. Their mentor gave them hope; Husband gave him half the gold he had concealed within the well–worn handle of the dented water bucket he had carried from Koh Kong.

The evening anthem ended. Nareth squatted by her cooking fire, thankful that the smudge drove mosquitoes away but less than grateful for the sack of pig feed she had received along with raw rice. She had put in several hours threshing rice, stepping on and off the shaft of the beam that rose and fell over its fulcrum into a concrete–lined hollow, crushing the husks and releasing the grain. Two hundred kilograms a day was Nareth's quota according to the one giving orders. Others from her boat had fed pigs belonging to the jail's Khmer keeper; the hogs gobbled up the same dried, ground fish the jailer pointed out when Nareth collected her rations. Her husband had been set to digging toilet pits. "Choose land," they were told day after day. "You can move out of the jail. You'll be allotted a place. You'll build a house." Nareth wasn't interested in a house, a place, a piece of land. Her daydreams of ice to skate on would have been satiated by ice in some pure drinking water. The smell and sound of pork slices sizzling in oil and soy sauce in the jailer's wok was too much for her voracious appetite to bear. A craving for sour dishes overpowered her fear of the warders; Nareth negotiated through the fence. She traded her rice ration for a serving of *num ban choke*. Hunched down behind the well, Nareth savoured the slender noodles bathed in sauce. On her second bite, a well–aimed kick struck her backside. Those precious, long white loops of noodles flew out of her hands

before the jailer's foot slammed against her spine a second time.

Two mornings later, she began to bleed. One of the older women from Koh Kong vigorously prodded and pushed on her belly. The discharge confirmed Nareth's first pregnancy was over. For this now–extinguished life she had crossed that bridge to her husband. Now there was no child, and to all her pains no purpose.

On her twenty–first day in Dong Ruk's jail, their benefactor unbelievably returned. No less incredible was the chilled, bottled water he brought. Nareth drank and drank and drank. Her throat couldn't get enough. Even her eyes, gummy with mucus, felt refreshed. Moreover the fragrant rice, fresh chicken and juicy sardines in flat brass tins with fat black letters—New Brunswick, Canada—amazed her. Succulent segments of mangosteen melted in her mouth. Two tablets telegraphed relief to her overcharged nervous system.

"The system," the Vietnamese land people scoffed, "doesn't see us. We're invisible. We've been here months—some six, some eleven, some eighteen. Not a single one of us has been registered as a refugee, much less been screened by a western embassy."

The kind–hearted UNBRO man had pulled some strings to get Nareth and Sukonthia out of jail and into the Vietnamese quarter of the border encampment. Husband's Khmer *Krom* accent was quickly recognized by the two dozen or so people who also hailed from *Bac Liu*, the Vietnamese territory west of the Mekong delta where his mother still lived among many ethnic Khmer. They badgered him for news, but did not believe his announcement that in three days he would be transferred out of UNBRO territory and into the domain the UNHCR. *Viet* skeptics notwithstanding, their contact had promised just that. Nareth clung to the Thai's promise, feeling doubly alien now as a Cambodian surrounded by Vietnamese voices.

At nine o'clock, the indicated time, Nareth stood watching the road. She was expecting it, so she was the first to see the blue–gray sedan purring along as the driver negotiated the potholed track. A tall

Thai, one who relished good food and drink by the looks of it, got out. He called out some unintelligible words and laughed. Then she heard her husband's name, and her name. With unwavering confidence, Nareth picked up the untouched bag of clothes their UNBRO intervener had brought her. She walked over to the car, opened a rear door and, enveloped in the chill of the air conditioner, climbed in. Sukonthia, meanwhile, approached the Thai, who examined some documents and then asked, "Where is your wife?"

"She's always first in the car." Husband's reply tickled the man, whose belly–laugh boomed out over the growing crowd of Vietnamese. Sukonthia tried to say goodbye to those he knew and handed out what meager household supplies he had. The incredulous landless wept. Calling out their despair, they swarmed the car. The Thai inched down the road. Nareth's last sight of *Dong Ruk* was through the rear window. She hadn't moved a muscle since she got into the car, but she turned as it eased through the gate. Behind her, hot tears of hopelessness coursed down cheeks of souls who had come too late, it seemed, for the west's time–limited compassion special.

Nareth slipped off her sandals and lay down on the plush seat. It had been over a decade since she had ridden in a private car. "We're not the same as escapees now, are we?" Sukonthia's shushing her could not burst the bubble of her bliss. Through the windows she watched vast trunks of the Thai forest flash by. She could hardly see the sky through the leafy canopy far above. In time, the rough road intersected the smooth surface of a macadam highway. Nareth sat up. Countless cars, motorcycles, Mercedes buses, trucks, military vehicles, huts, cottages and would–be mansions, bougainvillea, gardens, vegetable plots, farms and fields, Thais in broad, peaked hats shielding preciously pale faces from the scorching sun—her stomach reeled as her eyes tried to hold the images they were speeding by. Sukonthia explained her condition to the UN man, who handed her a pocket–sized vial of *Tiger Balm*. The pungent menthol fragrance filled her nostrils as she applied

a dab of ointment to each temple and massaged it in.

"Are you happy now?" Husband asked.

"Yes," she assured him, "I am happier today than the day I married you." At the translation of this exchange, the Thai roared again, his laughter filling the car. He informed Nareth through Sukonthia that they would be stopping at the next town. While the men continued their non-stop banter in Thai, Nareth rummaged through her small bag. She selected a sarong, still folded in its standard textile mill rectangle. Using it as a personal tent, Nareth modestly wriggled out of the stained cotton shirt and sarong she had been wearing for a month-and-a-half, and buttoned up a fresh blouse. She secured the new sarong around her waist and tried to smooth out the creases before the car came to a stop. The sounds, the smells, the sights and the tastes of the market drenched her senses. The freedoms of this day fed her fantasies as she drifted in and out of sleep during the afternoon on the road. Although she was far removed from the girl who had marched up Phnom Penh's Lenin Boulevard three months earlier, Nareth fancied America only weeks away.

The car topped a hill on a two-lane roadway banked by vast tracts of tapioca. A forest of corrugated tin roofs glinted in the afternoon sun; the high road cut a swath through the middle. Twinned barbed wire fences surrounded Phanat Nikhom Processing and Holding Centres. Guard towers loomed over the single-story buildings inside and at the gate, the Thai presented credentials to a soldier in camouflage, a semi-automatic rifle draped over his shoulder. The low-slung building where the car stopped housed the elusive *yoo-en-ehtch-see-ar,* which Nareth could read for the first time, the initials of the United Nations High Commission for Refugees having been transcribed into Khmer script on a multi-lingual sign.

Facing her sixth set of interviewers, Nareth approached them quite directly. She replied to the usual battery of questions, but was stumped when asked for *Maq*'s birthdate. Cambodians never celebrated any-

thing so individualistic and she had no idea what was expected of her. Nareth said just that, digressing to explain that if they asked her her own date of birth, she would have to think for five minutes just to re-member such an insignificant thing. Sukonthia pinched her and she abruptly stopped speaking. The rest of the exchange continued in Thai without the Khmer interpreter, but Nareth caught and counted fre-quent "okays". A photo of the two of them was taken, with Sukonthia holding a card stating CB130054. A copy of the print was attached to a broadsheet covered with typewritten Latin letters. With an authorita-tive thud, a large seal stamped and imbedded UNHCR onto the page. That stamp symbolized the certainty of resettlement to Nareth. With-out a clue as to what had transpired in that office, without so much as a word of explanation from Husband, she assumed some beneficent nation had chosen them.

Over the next three days, whenever Sukonthia left their assigned house, Nareth poured over the UN form. She couldn't read the English words, but remembered F–r–a–n–c–e from schooldays and, letter by letter, scanned fruitlessly for that arrangement of symbols. Laboriously retracing each character, she searched in vain for A–m–e–r–i–c–a. Nei-ther C–a–n–a–d–a nor A–u–s–t–r–a–l–i–a seemed to be typed any-where either. Frustrated at her inability to unlock the mystery of her destination, Nareth finally confronted her husband. "I've scrutinized every word on this form," she blurted when he returned. "What coun-try are we being put in?"

He laughed at her efforts. "You don't know anything, do you?" His derision matched her ebbing self–esteem. "We're not going anywhere, yet. Many interviews, with embassies, lie ahead."

"So this paper can't tell me where my future lies?"

"No. This paper certifies our right to stay in this camp. It is our only documentation that we are refugees." What else she might have been for the past six weeks wasn't at all clear to just–labelled Nareth, but then semantics are the purview of gatekeepers, not gatecrashers.

Not Yet West: Dreaming of a Third Country

What is it about the moon that makes the melancholy speak? That same wide-eyed, earless, celestial visage that had circumspectly contemplated Nareth's passage over the sea now discreetly peered over the eaves to the east. The quadrangle of twelve-by-four-metre buildings was empty after sunset. Nareth swung in a hammock; the rhythm carried her back to the Gulf of Thailand where she had known who she was. "I have run out of tears," she murmured. Nareth released her sorrows to that sole familiar face, whispering lest anyone hear her Khmer. "Oh Moon, please tell me. When will I be set free?" Another full phase had come and gone. So many faces had passed before her. Several had embittered. Some had distressed. A handful had even reminded Nareth that alternatives to misery existed.

For months now, Nareth had passed her evenings conversing with the moon or the stars and spent her days circumspectly listening. Only one of the units in building L121 was occupied—hers. The three other buildings facing this yard also housed refugees and they, like all the residents of Section C, were Vietnamese. Husband had warned her not to speak Khmer. By virtue of his birthplace, they had jumped the queue at the border and been allowed here at Phanat Nikhom, where most resident refugees were en transit to countries that had already accepted them. Talking her own language might mean a one-way trip back to the border. Nareth put off Khmer sarongs and blouses, but even in long, loose trousers and baby-doll tops she could not blend into the Vietnamese crowd. Reticent to approach others, Nareth was making no progress in language learning. Distinguishing the five tones of southern Vietnamese was a challenge, and the endless combinations and permutations of similarly sounding monosyllabic words constantly confused her. How many times had she blurted out *ung kuem*, "What are you doing?" when intending to say *cám ōn,* "thank you." Her interlocutors' amused laughter stung.

79

Worse than the unintelligible Vietnamese were haughty Khmer Krom. Ethnic Khmer, whose ancestors migrated south along the Mekong into what is now Viet Nam, the Krom spoke their own dialect, considered provincial in Phnom Penh but predominant among ethnic Cambodians in Section C. Among the Krom, Nareth's husband found Chanthoeun, one–time wife of his older brother, who had already re-settled in America with his second spouse. This former sister–in–law and her six–year–old daughter had accompanied her relatives on an escape by sea. The *ex* status didn't deter them from welcoming Husband into the fold. They insisted he take meals with them. In Nareth, however, Chanthoeun saw an all–purpose gofer, sous–chef and char-woman. With an unpillaged supply of gold, plus remittances from the west, this household eschewed the ration routine.

That first morning, Nareth followed Chanthoeun to the slipshod plywood and corrugated metal market slung along the fence between Vietnamese and Lao sections of the camp. Chanthoeun's manicured nails tapped on the Thai marketer's scale and pointed out vegetables or fruit for Nareth to stuff into her latticed plastic shopping baskets. From between her breasts, Chanthoeun withdrew a wad of *baht*. The grocers, butcher and sundries seller liked the color of her money; bra–padding was one of the less objectionable indignities suffered by King Bhumipol's royal likeness.

Nareth took offense early at Chanthoeun's manner. What right did she have to saunter on home leaving the flipping fish, papaya, lime, chilies and what–not bulging from the bags Nareth lugged alone? And grocery shopping proved only the beginning of Nareth's affront. Her food prep was deemed way under par. A scale or two were discov-ered on the tinfoil barb and crude curses spewed out of Chanthoe-un's mouth. Slandering Nareth's personal hygiene became a matter of course. Language, foul or not, was an issue. "Bring me the *takao*," Chanthoeun barked.

"*Takao*?" Nareth hadn't a clue what she was supposed to deliver.

"Where is it?"

"Are you blind? It's right behind you!" It wasn't that Nareth hadn't seen the five kitchen implements hanging on hooks at her back, but the Mekong delta patois stumped her. Which one was wanted? Fuming, Chantoeun stomped over, snatched the kettle, tsk–tsking condescension.

"If she wanted the *kasio*, why didn't she say so?" Nareth later lamented to Husband.

"If you don't understand, it's up to you to ask. Don't whine to me."

It was easy for her husband to brush off complaints; he had nothing to gripe about. Every noon and evening saw him sitting at the meal mat, long pinky nail peeling prawns, cracking crabs' legs, or relishing pan–poached pomfret sprinkled with julienned ginger and minced green onions. Some afternoons, Nareth hauled home beef, cashews, shallots, lemongrass, cilantro and chicken, which Chanthoeun had ordered in the morning. What burned Nareth most was being marginalized. By the time the nine family members crowded crosslegged around the spread, there was simply no place to sit. If they had had the modesty to fold their limbs under them, Khmer style, they could have accommodated her. So she took her meals from leftovers, brooding. From five in the morning until the sun set, Nareth was carrying, cooking or scrubbing for nothing. "Why should I work for such relations? We could get enough from our rations." Repressed frustration sometimes surfaced in whimpers, fits of tears, or acerbic outrage. Silence, for days, signalled Husband's response. His disciplined shunning of the desire to debate had been honed during the years he had spent as a monk in early adulthood. His stoic silence gouged, like slivers under fingernails.

And then they were gone. Nareth's nemesis got the *name–to–go* and with the flurry that five–day–notice, life–changing announcements inevitably bring, Chanthoeun and her extended family packed Nareth–scrubbed laundry and belongings, bid goodbye and vanished.

Promised letters and "back pay" for Nareth never materialized, not that she really expected them to. To believe others' words was to be naïve, a reputation Nareth was determined to overcome. Freedom from service bolstered her battered spirit. She didn't mind standing in the ration line for frozen fish that weighed more in ice than flesh. She had enough to eat and enough to do.

Hours and days of knitting stretched to weeks. She knit while the breakfast water boiled. She knit after Husband traipsed off to his two-hour–a–day English lessons. She knit during the mid–day siesta and she knit with Husband's *Essential English* propped against her knee. "WhatisyournameMynameisNareth," she exhaled entire exchanges without pausing, needles click clacking. Her jaw clenched at the memory of the Khmer Krom mocking her for not answering that question in their dialect.

"She's mad," they had scoffed. "She doesn't even know her own name." Losing a stitch, Nareth refocused and read the next dialogue. How are you? Or was that how old are you? English was downright difficult. As daylight faded, Nareth knit beneath the bug–mesmerizing street lamp. She knit until the curfew whistle. Then she went inside.

Home was a four–by–two–and–a–half–metre third of building L121. Like other long–stayers in the Vietnamese section, Husband had scavenged bamboo from which he tightly bound a wall between their space and the neighbours. Nareth had cooked a paste from sticky rice flour to glue threadbare blankets over the bamboo poles. A collection of paper, newsprint and aid agency office scrap was recycled into wallpaper, smoothed over the inner walls. Seven strips of cast–off lino—floral patterns, pseudo marble, stripes and geometric marvels—overlaid the concrete floor. A propable shutter improved air circulation. Chains and padlocks enabled residents to go away without leaving an open invitation to pilferers. In the corner opposite the doorway, more bamboo posts and slats became the family bed. Sometimes Nareth would sit and knit in the dark, waiting for her husband to come

home. An agency supplied needles and cotton or synthetic strands to spin into sweaters, cardigans, crew, V and turtlenecks. Finished goods were worth valuable *baht,* which Nareth exchanged on the black market for American dollars. She had thirty–five pinned to her panties before she heard about the affair.

Husband's affinity for languages was an invaluable asset in Phanat Nikhom. Beginner English and the passable Thai he had learned in his Koh Kong business ventures landed him a job in the restaurant run by a Thai couple next to the market. The proprietors spoke their language to refugee dishwashers and waiters. The waiters took orders in English and chatted up the international aid workers who took lunch in the camp, Monday to Friday. Five days a week, at seven in the morning and six at night, Husband flashed his prized pass at the Section C sentries. He wasn't the only one from the Vietnamese quarter who won this privilege by virtue of working for Mr. Tang. Tang paid three hundred *baht* per month for initiative and industry. He found it most often among the single Vietnamese men, defectors from the occupying army in Cambodia, some survivors of Khmer Rouge prisons but all who had endured incarceration in the Thai jail at Aranyaprathet. The restauranteur hired the occasional woman, too. Ouk was Khmer Krom. Young. Available. A blabber–mouth. According to her own confession, she was loved by a married man.

Wringing out scrubbed clothing in a flat plastic pan, Nareth heard a feminine voice asking in Khmer, "Are you Cambodian?" She continued twisting the last drops of water out of Husband's cotton shirt, though from the corner of her eye she spied twenty scarlet–lacquered toe–nails in plastic flipflops standing nearby. Another voice repeated the question, but Nareth still pretended she didn't understand, so great was her intent to not be identified as an undesirable Cambodian. The feet came closer. Nareth looked up. They belonged to two women: young, sisters and Chinese. She nodded. "We've seen you before. We thought the Vietnamese had hired you from across the fence

to do their laundry." The girls spoke Khmer with the Teochiu accent so common among the pre–war commercial barons of Phnom Penh. Their family, like Husband's, had evaded the Khmer Rouge regime by escaping over the eastern border to Viet Nam early in 1975. A decade later the east was heading west, as China's children were too quintessentially capitalist for the Socialist Republic of Viet Nam. Vietnamese in mannerism, the sisters bluntly affirmed Nareth's fears that speaking Khmer could jeopardize resettlement possibilities.

Although she might have been ecstatic at this first opportunity in weeks to communicate in her mother tongue to someone other than her disinterested husband, Nareth instead retreated into silence. She didn't want to hear the gossip, the latest buzz. Sources in and out of Section C dilly–dallied by the hour, wagging tongues and dishing scandal. They informed her about Ouk and Husband, their mutual affection and Ouk's apparent advantages over Nareth. A *miensrey*, a kept woman, offered a man certain distractions from the monotony of deferred hopes. From Nareth's vantage point, the future looked bleak, the past dim. Divorcing Husband soared high on her list of impossible priorities. Privately, she confronted him about his girlfriend. "Choose between us," Nareth charged. Husband didn't even deign to argue back. Come back he did, however, every night. While she waited, Nareth turned to her confidante, the moon, harbouring her eternal questions. "Who gave me life? Why is life unending suffering? You, out there, the real Master, show me a way out. Won't you lift me up? Please, don't put me down."

There was real risk in flaunting the curfew. For over three months, Nareth's husband had been pushing the envelope, crossing the threshold just before ten o'clock to keep out of serious trouble with the MOI. Officers of the Thai Ministry of the Interior enforced camp rules. They blew the whistle that announced the nightly limit on activity outside one's home, arrested refugees for misdemeanors ranging from being in the wrong house at the wrong time, or not being in any house at

all, to drunkenness or theft. That such crimes occurred was well attested to by the gaggle of jailbirds who straggled by each morning. Male and female, their shaved, bowed heads dipped and wobbled like bobble–head car pets as the criminals were exercised at sun–up, jogging humiliating laps along camp lanes. The penalty for a first offence, after the obligatory beating and twenty–four hours in solitary, was a month in detention. Putting up hundreds of thousands of illegal migrants over a decade had hardened Thailand's resolve to move them out or send them back.

In the mid 1980s, the powers that be set about closing Sikieu and Songkla camps, which had received thousands of boat people. A great push was on to move many through Phanat, off Thai soil and on to Bata'an in the Philippines, where the Americans could run their language and cultural orientation programs with less local interference. Following his relocation to Phanat, Anh Hong was assigned one of the other rooms in L121. A wiry, thirty–something man, he eagerly anticipated his fiancée's arrival in a forthcoming movement of Vietnamese. He couldn't cook, he told Husband, as he rolled out a mat and hung his mosquito net. Could he hire Nareth to prepare meals for him? He was prepared to hand over his rations to her in exchange and with money from his sponsor in Australia, they could add some condiments beyond the fundamental fish sauce. Husband gave his assent and, as was his custom, never appeared at mealtime.

That first day, Anh Hong handed Nareth a notebook. "*Ngay mai di cho.*" Tomorrow, go shopping. With the patience of a practiced pedagogue, Anh Hong dictated a list of vegetables Nareth should purchase. She transcribed his Vietnamese tones into Khmer characters and parroted them back until she gave an acceptable rendering. "*Bạn đang làm gì?*" was the requisite launch of bargaining banter. Anh Hong insisted Nareth memorize the going prices per kilo and offer only seven *baht*, for instance, when ten was demanded. The Vietnamese salespeople fronting for local Thai farmers would undoubtedly assume from her

stilted speech that she could be duped, so Anh Hong advised her to saunter away from any who wouldn't counteroffer. An air of nonchalance would invariably tip the scales in the shopper's favour. Using a thoroughly functional approach and rich in cultural resonance, "Essential Vietnamese" had begun.

One of Anh Hong's mannerisms baffled Nareth from the first. Whenever she set a bowl of *pho'*, a staple beef–based soup of noodles, onions, bean sprouts and various cuts of meat, before him, he would hunch over it silently before indulging. Did he assume she had poisoned it? Several times she bent down to peer up at his bowed face. His eyes were closed. What a queer custom.

Some time later, Nareth became ill. Anh Hong slopped through the mud to market to buy some medicine for her. He brought some food, too. "Be strong," he said. "God gave you life and power and a mind. Use them." He spoke very slowly. He insisted on taking her to the Filipina medic at the Section C clinic. Anh Hong had his own diagnosis of her moroseness. Quite diplomatically, he broached the subject of her appearance, suggesting she try to dress more tastefully. A touch of cosmetics couldn't hurt, could it? Nareth balked. Her stash of *baht* had gone almost untouched since she had come to Phanat Nikhom. She might need it for an emergency.

Without saying so directly, Anh Hong indicated he considered the state of Nareth's marriage an emergency. "Why did your husband love you at first? Why did he ask your mother for your hand?" Nareth drew on scant memories of pre–marriage encounters. "The first time we saw each other, I wasn't well–dressed and I certainly hadn't bothered with makeup," she answered somewhat defensively. "He came by the house on business with *Maq*. I had climbed the trunk of a tree and was picking fruit several metres above the garden. His attention interrupted my singing. I was wearing short pants and I hadn't done anything with my hair."

Anh Hong probed her recollections. "How long?"

"How long what?"

"How long was your hair?" Nareth gestured below her waistline.

Anh Hong nodded and pressed his index finger against his nose. "How long until you saw him again?"

"He came by my school the next day."

"And then?"

"The day after that, he approached my uncle, his friend, about arranging a match." "You ought to let your hair grow."

"I can't afford shampoo." Nareth wasn't following Anh Hong's counsel without some resistance. A plastic bottle of shampoo and one of conditioner showed up the following day along with advice from an elderly Vietnamese woman to stimulate hair growth by soaking one's head every evening. A slender lipstick tube twisted open between Nareth's rough fingers. Husband himself had denied her the privilege of owning any at the outset of their journey. If she prettied herself and he still had eyes only for his *miensrey,* then her shame would only be amplified. A husband had a duty to his wife. Promises had been made. Promises must be kept. He had said she would have plenty of cosmetics to replace those he had trashed in Koh Kong. Her lips massaged a scarlet streak into place.

Chi Pok, Anh Hong's lady friend, gave Nareth her first manicure. "You don't have to look like a refugee," she chided in her less than subtle way. She knew years in limbo took their toll on self–esteem. While barbed wire and gun–toting guards kept her physically within the bounds of mass migration management, a refugee's spirit withered directionless. Intruding into every waking moment and burrowing into dreams were shame and despair.

A Non–Governmental Organization offered postal services in Phanat Nikhom, making possible coded communication with family or friends the boat people had left behind in their homelands. However, having set off with high hopes, languishing in a holding centre for displaced persons was inadmissible. Saving face was requisite for

those who had expected to be walking on streets of gold within weeks of escaping unpopular people's republics. Absolutely no one had anticipated years of waiting on the whim of some distant quota–setting bureaucrat or on humanitarian gestures of post–American–War guilt before the International Committee on Migration could process their case. Rare letters home often included a photo of a refugee dressed to the nines standing beside the largest ghetto–blaster she or he could borrow, along with any other available trappings of material success. These pictures were the latest propaganda in the genre of justification. They mimicked the Polaroid prints of those who had already reached America, Australia, Canada or France. Women wobbling on unwieldy heels and men whose too short, dark suits revealed white sports socks leaned against vehicular props, muscle cars conveniently parked by unrelated owners. Everyone conspired to preserve pride. Allusions of wealth lured newcomers, while remittance–hungry relatives stoked fires of resentment with unrelenting requests for money, always American.

Just because one had nothing, having lost it all, or was nothing, being a Cambodian in the Vietnamese section of a Thai refugee camp, did not mean one had to look the part. Madison Avenue didn't hold the patent on pretense. A pirated copy of Stevie Wonder's *I Just Called To Say I Love You* crackled from a cassette player in the next building as Chi Pok shaped Nareth's cuticles. "What's the use? My husband couldn't care less about my looks."

"But that's where you're mistaken," the manicurist retorted. "You're worth all of his love. If he doesn't notice you, he'll soon see you turning other heads."

Maq had always asserted that aggression was unbecoming. Challenging the *miensrey* face to face, whether to trade insults or in a hair–pulling, nail–embedding row, would have impoverished Nareth. So while other first wives scrapped with their husbands' girls, Nareth bided her time. A friend of Husband's came apologizing to her for

having lent the key to his room for afternoon trysts. "It's not me who deserves the apology," Nareth replied. "Apologize to the had–woman. She's used goods now and still husbandless." Seething beneath an oh–so–Theravada veneer, Nareth plotted how to humiliate Husband, but when he came home she appeared completely calm. "It's me or the girl. If, as before, you remain silent, I will take that as love for Her. My mother entrusted me to you. Now I know only too well how trust-worthy you are."

Husband said not a word, but the next day he showed up five hours earlier than usual, in time to eat supper together. At dusk She ambled by, deliberately pacing slowly back and forth beyond the window. Husband slipped out. A friend followed them to the empty warehouse where Chinese kung–fu and Thai action flicks were shown nightly at five *baht* a viewing. Minutes before curfew, Husband returned to L121. "If you love her, just go." Nareth had nothing more to say.

"I will do," Husband said, "as I promised."

Two days later, as husband and wife sat eating their supper, the *miensrey* boldly appeared at the doorway. Nareth swept past her and out of the yard. Striding vigorously, she rounded several blocks in an attempt to vent her anger. A violet note fluttered in the gutter—five hundred *baht*. How propitious. Nareth stooped to pick it up; no one else was speed–walking along this alley. She pocketed the bill and retraced her steps to her home. The girl was tugging on Husband's sleeve. She stepped back when she saw Nareth and put her arm in front of her face. Whether to hide from shame or in defense, Nareth didn't know, nor did she care. "This man is MY husband. Out." The girl left. She never returned.

"You see, Nareth," Chi Pok and Anh Hong crowed. "See! Success for you!"

Without making a case of the dalliance, the Vietnamese couple invited Husband to join Nareth at their table. Nareth finally asked what Anh Hong was looking for when he bowed his head over each

meal. He couldn't take this food for granted, he explained. He paused in gratitude to the Creator. Nareth began to bow, too, though she kept her eyes open as Anh Hong prayed now in audible but often unintelligible Vietnamese. He told her she could pray in Khmer, that God understands every language. But formal Khmer prayers had a complex and exclusive vocabulary unlike everyday speech; Nareth had never been trained in Pali or in public liturgy. Wouldn't insufficient eloquence offend the Original One? Privately, however, Nareth began to petition Anh's God as she had previously invoked Moon. While Moon had good nights and bad nights, God, according to Anh Hong, was invisibly present always.

When Anh Hong and, soon after, Chi Pok got the *name-to-go*, Husband started to think and act like a real refugee. He became focused on following them out of temporary asylum in Thailand and on to permanent residence in a third country. His language skills soon made him an attractive applicant for a position of translator with the UNHCR. This part-time job offered the perk of a pass enabling him to move freely through the other sections of the camp. Payment in *baht* was still permitted, but Nareth did not ask for extra cash to supplement the rations from which she now made meals for two. Since the *miensrey* had moved on from Thailand, Husband returned home when he re-entered Section C about six p.m. at sundown. He had grown accustomed to the multiple-dish meals possible when people pooled their resources. One evening, a pot of rice and a simple dish of soup set him off. "This is no food at all!" he fumed.

About this time, a letter arrived from Washington State. Husband's older sister, Kim Tao, sent word of her family's resettlement in America, along with thirty dollars cash and intentions to sponsor her little brother and sister-in-law. Kim's missel also included the rather intrusive instructions to get on with making babies. It could cost thousands of dollars to deliver an infant in Seattle. Better to give birth in Thailand where there were no doctor's fees.

At least a little oblation was owed to Kim Tao, Nareth reasoned. A selection of produce from the main market might smooth relations with a cranky husband, too. So Nareth took twenty of her precious dollars and slipped through the barbed wire fence when the sentry wasn't looking. Wearing a sarong and walking through the Lao and Khmer sections of the camp, Nareth knew she looked like she belonged there. She found her way to the Transit Centre Market, a low-slung gallery of kiosks arranged in a maze of aisles. At the north end, facing the jail and adjacent to the canopied, concrete slab that served as the departure lounge for Bangkok's Don Muang airport, was a collection of tin tables and all manner of mismatched chairs and stools. Here VOLAGs, or volunteer agency personnel, UN staff, Thai administrators and refugees with *baht* could buy *cà phê sua đá*, Vietnamese iced coffee, sip smoothies or indulge in chili–fired omelettes among other delights. Like the marketers, the restauranteur was a local. In keeping with the prevailing wisdom, this business opportunity was his by virtue of being the highest bidder in a palm–greasing process curiously correspondent to the tendering of aid contracts. Tang had the highest paid help in Phanat; one was still Nareth's husband.

Nareth believed no one would notice if she stopped by the restaurant but *Anh* Jo just happened by. The ever–alert security boss recognized her out–of–place face and swaggered over, impenetrable aviator shades masking his eyes. On command, Husband handed over his legitimate pass. Jo pinched Nareth's cheek, then waved her away. Mrs. Tang called her over, sat her down and plunked a bowl of soup before her. Jo continued to play the enforcer with consummate cunning; his public would not have been his without it. He recalled Nareth before she could get one shaky spoonful to her lips. "To jail," he shouted over his shoulder, strolling across the street in complete confidence that Nareth, Husband and the restaurant operators would follow. They did.

Inside the concrete block building, Jo opened somewhat private negotiations. The walls had ears. Any sign of softness on his part would

ripple through the camp, resulting in further infractions of the rules. Jo had a reputation to keep. It wasn't for nothing the Interior Ministry had assigned him to Section C. Overseeing the Vietnamese was not run–of–the–mill law enforcement. Self–immolations and riots by refugee radicals reinforced the Thai take on their only real rivals in Southeast Asia. The boat people were outnumbered in the camps by the Lao and the Khmer. However, Thailand's northern neighbours were considered cousins. Not a few Thai transformed themselves into Laotians before resettlement gatekeepers caught on. Bad–*karma*–carrying Cambodians confirmed Thai superiority by their very existence. Acquiescence was not a highly visible Vietnamese trait; Thais considered them aggressive and arrogant. Jo's job was to keep them in their place.

"I'll let her go," Jo offered to Husband, nodding toward Nareth. "I won't even shave her head. You can take her punishment." Nareth fingered her then shoulder–length locks. She anticipated standard Thai penal practice—thirteen thwacks with a billy club, followed by thirty days of corvée strain and shame.

"I'm not responsible." Nareth gasped at Husband's refusal. Mrs. Tang's face registered dismay. Had her employee agreed to take the rap, she could have finagled a face–saving deal with MOI. Nareth felt her heart had fallen out. She sobbed. Kowtowing, she knelt before Jo. Bowing, sweating palms pressed together over her head in a submissive *wai*, Nareth poured out the tale of Kim Tao's letter, of filial obligation and of the twenty dollars. In her anxiety she reverted to Khmer. Jo yelled at her in Vietnamese, berating her for violating the pass laws. She waited to be struck but caught a wink instead.

Jo ordered Husband out and picked up an ominous pair of shears. "*Mai dai, krup.* But no, sir," Mr. Tang objected, elaborating his opinion.

"How much should I cut off?" Jo turned again to Nareth, who indicated a centimetre or so. "Ha! That wouldn't be punishment!" He banged a heavy pair of handcuffs on the desk. "How about a buzz cut!"

"Oh, no, noooo," Nareth wheedled solicitously. Was that a smile playing on Jo's lips? "Maybe I'm tired of this; I'll call in somebody else to cut your miserable hair." While Jo and the Tangs resumed their incomprehensible conversation, someone entered the room bearing three glasses of ice water. Nareth took what was offered. She couldn't guess what was passing between the Thais. Her memory replayed earlier encounters with Jo. On the day she and Husband had gone from *persona non grata* to stateless wards of the UN, Jo had toyed with the date stamp inking and pressing it on the back of their CB identity photo. She had thought he was going to tattoo 1985 onto her cheek. Roving around his Section C beat, Jo had occasionally stopped his motorcycle in their yard, blustering about, sending Nareth beyond the pale if he caught her in a sarong. Now, resuming a threatening tone, Jo warned Nareth of a month in his jail. After a lackey hacked off Nareth's hair, Jo gestured for once–again boy–look–alike Nareth to follow him. Outside, he mounted his motorbike, motioned for her to climb on behind and roared up the road. He pulled Nareth's arm around his waist. "Hang on! You want to die soon?" The Section C gate guards stepped back obligingly as their boss sped by. At the corner of houses L121 and L124, Jo let Nareth off. "Twenty dollars is hardly enough to risk your hair, your back and your face," was all he said.

Kim Tao remained true to her word and got the ball rolling in the convoluted family reunification process. What she hadn't thought of telling her little brother was that she had changed her family name while she had been working her own way through the refugee resettlement system. This discrepancy in information raised a red flag at the first interview where JVA , the Joint Voluntary Agency contracted to the US State Department to screen and process refugees, considered Husband and Nareth. Acquaintances had counseled the couple to stay true to the data imprinted on their UNHCR forms. "Name?"

"Mom, Nareth."

"Okay. Brothers?"

"One."

"Okay. Sisters?"

"One."

"Okay. Mother?"

"Loch Leap in Phnom Penh."

"Okay. Father?"

"Cheui Ock, deceased."

"Okay." Nareth believed okay meant her answers, spoken in Khmer then translated into English, were presumably satisfactory to the panel of pasty–faced people on the other side of the table. Nareth's very bones anticipated that the ecstasy of acceptance was at hand. She jiggled in her seat. Her happy body couldn't stay still.

The interviewers plied Husband with many, many more questions. These they asked directly in English or Thai so Nareth remained ignorant of the exchange. When they eventually concluded, Nareth could hardly contain herself. "We're going to America, aren't we? The judge said 'okay', I heard him myself."

Husband's face darkened. "No!" His sense of powerlessness erupted in anger. "No! We're staying here. There were a lot of mistakes." No further explanations were forthcoming. Nareth concluded Husband's English wasn't up to snuff. There was no doubt in her mind about the connotations of the countless okays she had heard. Her confidence crumbled the next day, though, when another UN translator confirmed Husband's summation. He explained what he knew of the Tao–Serng surname fiasco.

Were the heavens shut against them? Astrological portents seemed to oppose them. Kim Tao's next letter noted that whereas her darling baby brother had been born in the year of the Rat, Nareth had been born a Rabbit. An incongruous combination, doomed to be sure. Bad luck would dog them like a mosquito that made it through a mesh. The camp post office proved to be particularly inauspicious. That's where Nareth picked up the packet plastered with Ferdinand

Marcos' mug. Who did they know in *Bata'an*, a UNHCR centre in the Philippines? She didn't recognize the name above the return address. It looked Khmer, which was odd coming from the Philippines. Curiosity got the better of her. She slit open the well–stuffed envelope. Out tumbled a fistful of photos and a letter. It was written in Romanized Vietnamese characters, so she couldn't read it. The pictures said it all: the mistress and Nareth's husband striking intimate poses, romancing the camera as Nareth had never imagined he could do.

"You what?" Nareth's neighbours couldn't believe she had turned the entire packet over to her husband. She had toyed with the idea of destroying the evidence of his infidelity, but felt that sooner or later she would be found out. Better to take it on the chin now than to have worry gnaw a hole in her stomach.

"What gall!" Husband turned his back on Nareth and flipped through the prints. "You have thrust your hand into my mouth and pulled out my heart." Nareth remained silent at his self–pity. She knew she had done wrong by opening the packet. Husband shredded the pictures one by one. "That," he thundered, "is the first and the last time you open my mail."

"I'm sorry," Nareth squeaked, shaking now.

"Sorry?" A teacup sailed by her ear. She ducked. An unnatural silence outside told her the neighbours were eavesdropping. She wasn't going to give them a single word to repeat.

The full moon got an earful that evening, though. Nareth climbed up high on a water tank and gazed at the golden orb. Moon smiled and soothed her angst. Moonlight stroked her cheek. "Who made you so beautiful, Moon? Why wasn't I made like you? If I were like you, Moon, everybody would love me." She saw a tree in the moon that night. "Living in the shade of those boughs would be bliss," she imagined. But then, from somewhere deep within, came a radical thought. "Be happy with your life. You have eyes, ears, hands and feet. You move at will. Be happy with your life." Nareth crawled down off the tank and

slipped into the room she called home. Husband was stretched out on the bed. She lay down, too. There was nowhere else to go.

There was no way to deny it. Communal latrines didn't offer much privacy at the best of times, and every–morning puking was grist for the gossip mill. Knowing neighbours expected Nareth was pregnant before she did. At two months, she gave a urine sample in the Section C clinic and the medic confirmed the obvious. Nareth told Husband. He seemed distant, even disinterested. With a heavy heart, she wondered if a baby would be just another problem. "If you don't want babies, you must protect yourself." Nareth remembered the condom demo at the family planning centre. She got unsolicited advice from some Khmer Krom. Taking out a baby was a fairly routine procedure. They had traditional medicine, an alcohol–herbal concoction, to induce an abortion if she was interested. But she wasn't. What this family needed was someone with a sense of responsibility. That would be her role.

It was a Bollywood blockbuster. Bold outpourings of passion by the larger–than–life handsome hero, hapless heroine and inevitable villain flickered in subtitles on the whitewashed wall. Allusions to more erotic off–screen encounters afforded fine Hindu sensibilities sufficient stimuli for overheated imaginations. The movie manager most often screened Thai or Chinese films. Two days earlier, Nareth had met him in the market accompanied by an unfamiliar Thai, who invited her to join them for noodles. The stranger didn't want to take no for an answer and detained her, inquiring as to what kind of movies she preferred. She had answered "Indian," to which he answered via the translating ticket seller that she was welcome to watch for free. Nareth enjoyed the show, pure escapism that it was. Husband must have liked it, too. He had hugged her in the darkness and whispered favourite diminutives *Srey Pik* and *Pao* in her ear as they tripped home. Nareth heard him slosh the last of his shower bucket over his body as she waited for her turn in the old blanket and bamboo cubicle

shared by the quadrangle. She showered modestly, never completely removing her bath sarong, which she wrung out sopping wet after she had put on her pajamas. As she opened the padlock on the door, it slid out of her wet hand. Nareth bent down to grope for it in the darkness. Someone grabbed her from behind. A kiss on her neck. She squirmed. "No," she said, incredulous at Husband's uncharacteristic advance. As the man twisted her face toward his, the unfamiliar odour of alcohol caught her off guard. He tugged at her clothes and muffled her cry by pressing her mouth into his chest. Struggling against his grip, Nareth slipped. She shrieked. She kicked. The stranger fled faster than the crowd of neighbours, friends and Husband could scramble out of their rooms, around the corner and into the alley beside the wash-house. Nareth clung to Husband still shouting after her assailant. An MOI officer arrived. In the beam of a flashlight, they found a packet containing a small towel drenched in an aromatic chemical. Nareth passed the night in sleep–defying alertness. Her frame shook with spasms as she sat, hugging her knees in the darkness.

Word of the assault traveled quickly. In the morning, camp security personnel came by to investigate. MOI wouldn't confirm the suspicion that the towel had been laced with ether. Nareth gave a statement. Jo was piecing together facts from three separate incidents. Two months earlier, a teenager had disappeared from Section C; her distraught relatives insisted it was a kidnapping and not an ingenious escape strategy. More recently, another Vietnamese girl had been the victim of a nocturnal attack. She, taller and more muscular than most, had kickboxed her way out of a man's grasp. There seemed to be a link between late–night movies, unauthorized Thai visitors and shower–stall seizures. Within weeks of Nareth's nighttime trauma, a construction crew tore down the maze of wash rooms and installed more street lamps at irregular intervals along the lanes. Rather than showering under eave spouts, some refugees built bamboo and blue plastic–walled screens, which afforded some privacy but no lurking

in unlit recesses. Nareth didn't mind lugging buckets of bath water from the galvanized metal tank up the street. She adjusted, along with everyone else, to the less than jetblack darkness of the night now that an amber bulb glowed from dusk to dawn outside her window.

Fat five–*baht* coins clinked in Nareth's pocket. Movies were canned. For entertainment, Nareth roamed the small Section C market. A mountain of rosy rambutans mesmerized her. She imagined slitting the spiky red skin, slurping up the sweet juice and biting into the succulent, tangy flesh. Closing her eyes, she walked away, but looped back for a second and a third look. The fruit vendor, squatting on his haunches, broke her reverie. "How many?"

"Two." Nareth figured she could splurge.

"Two kilos. Anything else?" He gestured grandly at his wares.

"Oh, not two kilos. Just two fruit." Nareth was embarrassed at having to repeat her paltry request, but she couldn't pay for much.

"Only two!" Why did the seller speak so loudly? "Oh, just take them," he chuckled expansively and plunked two rambutans into her palm. Self–consciously grateful, Nareth scurried away. As sour rivulets of juice enlivened her taste buds, she resolved to talk to Husband about money. He was saving up Kim Tao's gifts and tips from the restaurant to start his own goldsmithing operation. They would need supplementary income to support a family. The baby within her had already developed a taste for mangos, mangosteens and other rich morsels. Perhaps she, too, could find gainful employment.

Getting one's foot in the door with an NGO was like infiltrating any organization. What mattered was who, not what, you knew. At least that's what Nareth's neighbour pronounced dogmatically. Luckily for her, he was in the good books of some Americans. To reconnoiter agency offices, Nareth would have needed a pass to the Transit Centre. An alternate strategy was to hang out at the *Tinh Lanh,* or Good News building. Some aid workers hung out with Vietnamese Protestants on Sundays. The Catholics and Adventists were liberal with their time,

too, but this neighbour was a Sunday morning liturgy–light man. A normal *Tinh Lanh* worship service was a curious event for Nareth. Of course, everything was in Vietnamese. The people squeezed their eyes shut and clasped their hands together as one fellow stood to speak in peculiarly melodious tones. Nareth had never been in a crowd where the entire population simultaneously appeared to be resisting hiccups. Oh, but they were breathing. Perhaps it was a weak bladder thing. Individuals ceased coming in or going out of the building during this exercise. At the end, everyone uttered a completely enigmatic "*ah men*" and came out of their trances. They studied a book annotated with large and small numbers. According to instructions from the speaker, everybody jumped from passage to passage, flipping from page to page. Nareth could follow Vietnamese numerals, but that was about all. There was one thing she couldn't help but notice. These people were so kind to each other and to her. Warm greetings and invitations to "Come back!" encouraged her to do so.

The next evening, a few faces peeked around Nareth's doorway. Their hands carried a bowl of *chè*. Nareth invited the visitors in and received the opaque agar gelatin. She didn't eat it that night, or even the next day. She couldn't recall the last time anybody had deliberately prepared something for her. It was pleasure enough just to see that jello sitting there, willing her to believe friendship was possible. The impossible happened soon after. Mark, Mike and Barb knocked at the door. Their American faces were familiar to Husband, but they had come to see Nareth.

Food for the Hungry International was where Mike and Barb worked. FHI operated ration distributions throughout the camp and also distributed charcoal braziers, mosquito nets and blankets to incoming refugees. These household wares were collected from Cambodians, Lowland Lao, Hmong, Mien and Vietnamese before they boarded the bus to Bangkok's International Airport. Barb's warehouse was a stone's throw from the Transit restaurant, which was where she

had met Husband. Smiling, he served her Khmer salad, tender strands of chicken on a bed of crisp lettuce and sprouts laced with cilantro, drizzled with lime and sprinkled with crunchy, crushed peanuts. Could she use a Cambodian worker? Yes, as a matter of fact, her blanket–washing supervisor just got the *name–to–go*. Barb followed Husband's directions to L121. Fortunately for Nareth, Mark spoke more than a smattering of Khmer.

In retrospect, the meeting was more a conversation than a job interview. The Americans asked the queerest questions. It seemed they assumed all Khmer to be Buddhist and couldn't get over the head scarf Nareth never removed. "Would you be available to work on Fridays?" Why not? She had no special obligations on the sixth day of the week. "Do you eat pork?" When she could afford it. "So you aren't Muslim?" Nareth laughed but didn't reveal why she wore the scarf, let alone take it off. Not for months. Not until the edge was off her jailhouse coiffeur. For the moment, Nareth grasped three salient certainties. Miss Barb came from a mysterious place called Arizona that produced incredibly polite people. MOI would process Barb's request for a pass permitting Nareth to cross into the Transit Centre. And she was, for the first time in her life, hired. She was wanted.

One Thursday, Barb brought the pink cardboard permit with instructions to begin work the next week at eight in the morning. When she left, Nareth stared at her miniature black and white face fixed under the plastic cover. She pinned the pass to her blouse and practiced how she would make her first legal exit past the khaki–clothed guards at the gate. Come Monday morning, anticipation and anxiety combined to set her heart pounding. As she walked toward the fence separating the Vietnamese from other ethnic groups, Nareth kept her gaze on the ground hoping no one would notice her. "Hey, you. Come over here." A guard called. She shuffled over to his booth, expecting to be swatted or worse. Her fears were unfounded. The Thai inspected the ID of anyone who didn't usually pass in and out of his post, includ-

ing NGO staff. "What are the rules?" He queried.

"Not sneaking anyone out with my pass and being back inside by five o'clock."

"Go." He waved her through.

After the eight a.m. anthem, a queue of refugees began to form at the door of the Food for the Hungry. Those favoured ones were within hours of leaving Asia forever and happily dumped dirty blankets, tangled mosquito nets and used cooking utensils in the warehouse. Nareth met Chandy and Kat, two single sisters, and three other Cambodian women. Miss Barb introduced Nareth as the new supervisor of the laundry detail, but Nareth didn't know how to give directions to the very people who were explaining the job to her. The six of them hauled mounds of smelly gray blankets to the concrete platform between FHI and Youth With A Mission's clothing distribution centre. They soaked the woolen covers in soapy water from a convenient faucet before stomping on them in the wide, shallow pans. What pleasure for hot, rough feet. The oldest woman shook her head. Nareth was pregnant. She ought not to jostle the baby by jumping and splashing—better to leave that to the girls. Nareth spent that day and many others just like it, wringing out sodden blankets, hanging them up on the line, turning them to dry evenly, snatching them inside just ahead of rainy season squalls and never complaining. Some of her co-workers grumbled about the ratty condition in which their compatriots returned the borrowed household wares. Nareth chided them. "If everyone washed their blankets before bringing them back, we wouldn't have a job."

Work meant much to Nareth. She noted each day's earnings in a tiny book, carefully inscribing the date and the figure. Every two weeks, Miss Barb distributed the pay permitted by MOI, ten *baht* per day. That was equal to one meal on Tang's menu. The first fortnight's stack of rusty-orange notes filled Nareth's pocket. She purchased an ice-cold bottle of *Vita*, a local cola, in celebration of her first-ever

wages. She cast her mind back over one year–and–a–half. Soft drinks at the *phsar thom thmei,* Phnom Penh's big New Market off Monivong Boulevard, had never tasted so good. Nareth patted her pocket. "My baby will have enough to drink grape soda on ice, too!"

The work permit allowed Nareth to mingle with her own people. When some invited her to the Khmer church, she accepted. The children's supplementary feeding centre run by COERR, the Catholic Office for Emergency Relief and Refugees, was empty at 7:00 a.m. on Sundays. A group of one hundred or so sat in a U on mats covering the concrete floor. Sam Sarin, a violinist and folk musician, directed the singing of familiar tunes with strange new words. A young man hand–beat the cadence on a traditional drum. Behind the musicians hung a royal blue sheet emblazoned with a blood–red cross where Nareth half expected to see a profile of *Angkor Wat.* Someone had traced and sewn Khmer characters in an elegant font on snow white cloth. Sarin read from a book and spoke at length, but afterward Nareth could recall nothing except the lyrics of some songs. "Do you know? Do you know? I died for you. Come to me. My yoke is not heavy." "Though no one walks with you, I am with you. Come, child, I'll lift you up." Words such as these were drawn from the middle of the book Sarin offered Nareth. A harpist, sometime hero, sometime fugitive, had penned those prayers, laments and praise long before Siddhartha had become Buddha. Could it be, Nareth asked herself, that the Lord isn't dead, that his spirit isn't within gold leaf plastered images in temples? Could it be, as the psalmist wrote, that God's eyes see, his ears hear?

The sentry didn't believe his eyes or Nareth's pleas. The woman didn't look nine months pregnant. She had been going through the gate at least twice a day on her work permit. She had even passed by yesterday. Uh–uh. This moaning and groaning must be a ruse. His fist bounced off her belly. It was firm but small. She wouldn't go away. Neither would her husband, whose further supplications persuaded the soldier to radio somewhere. While she waited for the truck that

never came, Nareth doubled up.

About four that morning, she passed blood. The contractions surged through her just as an older neighbour had predicted. Husband found the Section C medical clinic locked. Now the couple found themselves blocked from reaching the Out Patient Department in the Transit Centre by a guard with attitude that couldn't be more obstipated. This baby was moving whether the uniform agreed or not. Eventually, the Thai motioned Nareth through, but barred Husband from following. Nareth made it to the third fence post past the gate. She clung to it as muscles convulsed trying to displace the other within. The clinic was half a kilometre away and she got to it only because the sentry relented. Husband carried her. There, the night nurse got a truck, lifted Nareth into the back, waved Husband away, and bumped across the blacktopped road to the hospital in the Processing Centre.

Born to it, was how a doctor described Nareth's delivery. Giving birth had not seemed all that natural to her. Pacifying the little beggar wasn't instinctual either. A nurse helped Nareth wrap the wiry, bald baby—the tighter, the better—to relieve his vulnerability in this new vastness. Fear wasn't limited to babies. Mothers felt it too. At the first sight of meconium, Nareth thought David was dying. But he wasn't. His fist wrapped around her finger. She cuddled him and cooed a lullaby. He would be a musician like his namesake. One day, David would make music and she would sing. This was the primal power of a child, to loft groundless hope unfettered into the future.

Prospects for resettlement ebbed and flowed. Sam Sarin, the musician among the Khmer Christians, arranged a contact in Australia. It would be months before Nareth learned that avenue out was going nowhere. In the meantime, she decided to improve her eligibility by studying English. She exchanged babysitting services with another breastfeeding student. At the midmorning break, the other mom would bring David to Nareth to feed. In the afternoon, Nareth would watch two infants and carry the other baby to his mother. Once

the routine was established, it worked well. Getting started was the hard part. Nareth believed she wouldn't be able to understand the big-nosed, yellow-haired instructor. During the first class, Nareth felt far below the language level of the other beginners. The American teacher proved friendly, though, and concentrated on understanding word by word. Teachers changed and classmates did too over the year Nareth attended school. Outside of class she rarely heard and never spoke English.

Keeping house, including standing in ration and water queues, occupied most of Nareth's days. David wasn't getting enough milk, so he was eligible for supplements. When he could handle solids, the Mother and Child Health unit supplied an egg, banana and some sweet rice. Once a week, Nareth could collect a jar of sweetened fruit purée. David loved the taste, so it was easy to empty the jar under the watchful eye of the unit supervisors. Fattening up scrawny babies was their mandate and that included overseeing the actual eating. Mothers of more than one underfed child had been known to share infant supplements with older siblings, thus skewing the MCH success rate statistics. Hence eating under observation. Keeping an eye on kids extended to books. Nareth became a volunteer at the reading room. For an hour every afternoon she reshelved books, practicing the English alphabet on author's names or titles still visible on wellworn spines.

Bending low along the bookshelves eventually became impossible as Nareth's second pregnancy advanced. Then came the day she sensed the baby jockeying for release. She would need extra energy. Early that morning, Nareth headed for the market. She bought herself a cut of beef, water bullock flank really, some ginger root and fruit. After quickly cooking breakfast, Nareth showered. She packed strips of fabric from old sarongs, a pair of baby booties and mitts she had knit, and a change of clothes for herself. As Husband was at work, Nareth dropped off David with a Khmer woman. No explanations were necessary and, in any case, David was so *pnaieu kluan*, such a self-

possessed toddler, the neighbour kids all wanted to take turns lugging him around.

At the Transit Centre clinic, a Japanese physician was on duty. Dr. Alina was even shorter than Nareth, but her kindness was disproportionate to her size. Less than three hours after labor began, the doctor delivered a strong, wailing son. "Do you have a name for him?" Alina asked.

"Yes."

"Is it an English name?"

"Yes."

"Are you sure you want an English name?"

"I'm sure." Nareth had been reading the gospels. John impressed her. The Khmer version, Yohan, sounded German, someone said. So the hospital clerk anglicized it. "His name is John," Nareth told her husband when he came to meet their second son. She worried about rolling over the baby on the gurney–sized bed in the women's ward. She wondered, too, about David in someone else's care. On the fourth day, Nareth bathed and dressed her well–fed, second sleepy boy and walked home. David's little legs could not carry him fast enough when he saw his mother. His arms reached out to hug his first brother. "What yo'a name?" he asked in inflectionless English.

There were four names now to insert in the right slots, along with places and dates of birth. Beside John's name were the numerals fifteen, seven, eighty–seven. Try as she might to hold the tether on hope, Nareth succumbed to its upward pull. This baby would be the last she delivered as a refugee. Canada was calling. The forms were, in fact, just the beginning in another round of applications and interviews. There was a sponsor. A Canadian in camp had recommended the Serngs to a charitable firm in an unheard–of–city, Edmonton. YEG was the airport code on the ICM lists of names to go to Don Muang. Scanning these lists was a hobby for some refugees who would have been astounded to learn of the empires of paper built on legitimate traffic in people.

Filling out forms led to an appointment to see an officer of the embassy of Canada. CB130054—Nareth knew those Vietnamese letters and numerals well. The announcement of her ID number over the loudspeaker alerted her to the day and time when the Canadians would meet her face to face. Everybody had advice before an interview. She should wear good clothes. Nareth borrowed a white shirt and shoes to match her presentable pants. People said she should not hope for much. With Husband's sister and brother in America, there was no family reunification factor for Canada to consider. "Serng, Sukonthia. Mom, Nareth. Serng, David. Serng, John." Four persons in the fourth interview of the morning. Four, and again four. It had a deadly ring about it, for superstitious Cantonese speakers. The officer barely had time to get through preliminaries before John started squirming in Nareth's lap. She had answered questions about her name, her camp address, her sons' names and birthdates.

"How old is he?" John's restlessness had caught the Canadian's attention.

"Six months."

"Okay, you can go out and feed your baby." Nareth couldn't believe it. No "Where are you from?" He hadn't even asked all the questions she had practiced. A sense of failure washed over her. Nareth shifted John onto one arm and turned to take David's hand. The immigration officer was imprinting a long stamp on a document. Even upside down, Nareth could make out eight capital letters. The first was A.

"*Oun yeung choap haey.* We've been accepted already," Husband said in his controlled, understated tone. Ecstasy overpowered Nareth. She couldn't move.

"You may go," the Canadian repeated. Husband stayed ten minutes after the door closed behind Nareth's back.

"Too fast," the crowd outside muttered. "She must have failed."

"No! We passed!" Nareth found her voice. Neighbours and acquaintances joined Nareth, her husband and the boys in a celebratory

supper. Three years in Phanat Nikhom made them old–timers. Fantasies of a new life, of the other side of barbed wire, filled every head. They were dreamers, every one of them, and dreams have a habit of taking tangents.

It is said that no one dreams in Fahrenheit, Celsius or Kelvin, for that matter. There was a thermometer at the Canadian Orientation classroom. And a couple sent by the Mennonite Central Committee from Portage la Prairie, too. They knew about winter. They had lived through many. They talked about winter and showed pictures of it. Tena and Henry couldn't quite recreate it, though. Nareth and her classmates got a charge out of watching some hapless highnose putting on layer after layer of clothing only to go out into the brilliant sunshine. He must really have worked up a sweat plowing through sparkly white stuff that looked solid but into which he stepped up to his knees. Steam escaped from his mouth and nostrils as from a boiling kettle. Well–wrapped kids and adults on skates reminded Nareth of childhood reverie. Some people feared the months called winter, but Nareth figured it would be fine. Golden–leafed aspens and umbrella–sporting pedestrians were identified with autumn and spring. At images of summer, green parkland festooned with picnickers, the chosen cheered. Nareth's favourite pictures were four slides Henry had taken of the same scene at different seasons. "Is this the same place?" Henry would ask as he advanced or reversed the projector like an ophthalmologist flipping lenses.

"Oh no," Nareth had answered. If all places in Canada changed that much from month to month, it might be hard to recognize one's own home after an absence.

Finding home wasn't easy to begin with. The MCC office had a wall map of Canada. The colours and shapes intrigued Nareth, but meant nothing to people who had never used one before. Some of her classmates were sponsored by the government of Canada; they still didn't know where they would be sent. Most got the *name–to–go*

shortly after they had completed the orientation classes. The Serngs received notice to move, too, but not to the airport, just over the fence to the Khmer section of Phanat Nikhom.

Westward: The Name–to–Go

The monsoon season of 1988 was miserable. Water dribbled through the roof and trickled down the gray walls. Nareth learned to leave the charcoal brazier inside even when cooking. One thunderstorm had begun with a lightning strike to a pole outside her quadrangle. The post broke against her neighbour's tin roof. The impact and the rumble of thunder terrified Nareth. She scooped up John and David and huddled with them in the house. Outside, the rain pummeled her charcoal to dust. Those clouds must have collected half the Bay of Bengal. Drying clothes over the fire left them stiff and smoky. Nareth once went damp for a week. A rising water table shooed rodents out of their holes. Especially at night, the rats scampered around the buildings, crawling up on the sleeping platform and over inert bodies. Nareth had been bitten on the foot and she feared for her baby boys. Sleep was erratic. Stomachache plagued her, too. In such circumstances, everyone got irritable. Neighbour accused neighbour of trifles. To top it off, Nareth often dealt with the daily drudgery alone.

Husband was working as a translator for health care professionals, then. His work even took him to Bangkok to interpret for Khmer or Vietnamese hospitalized there. Surgical tours took up to three days, and the medical or ICM staff included their interpreter in restaurant meals and other frills. Generous aid employees topped up his wages, too. When Husband announced he would be going to Bangkok for a four–week stint, Nareth never suspected her husband's own health. It had been months since their own physical exams required by Canada Immigration. Her blood, urine, TB tests and lung xrays had not raised any red flags. Her family history—no leprosy, no asthma—gave no

cause for alarm. Nareth assumed her husband had been given a clean bill of health, too. Flashbacks to Ouk tortured Nareth as she packed all Husband's clothes and his razor in a small case. Maybe there was another girl. "Can you tell me when you'll be back?"

"You'll see me when I get here." Husband was being evasive but Nareth was misreading all the signals.

Two weeks into Husband's absence, Henry, teacher of Canadian Orientation, came by the house. "Hello Hungry." Nareth enjoyed Henry's easy banter; he never overlooked an opportunity to tease her about her mispronunciation of his name.

"Tena and I saw your husband at the hospital in Bangkok. He's doing okay. He looked pretty good."

"Could I send a letter with you?"

"No problem, as many as you want, my dear."

"A thousand?"

When she delivered the first letter to his office, Henry shook his head in mock protest. "I only carry English mail."

"It's Khmer on the inside, English on the outside!" Nareth quipped.

Inside the envelope that carried Husband's reply was the shocking news of the removal of a kidney. Henry hadn't mentioned surgery specifically to Nareth; he presumed husbands discuss such matters with their wives. Nareth hadn't guessed her spouse was a patient, not a translator, this time. Husband could not have been sure Henry had not told Nareth all, so he summarized the treatment and told his wife not to fret. But she did.

Worry locked its irascible roots on Nareth's thoughts. If her husband wasn't inexplicably absent, he appeared to be suddenly fragile. Who was to say what surprises a solo kidney had in store for the unsuspecting? In addition to the immediate health concerns, there was the matter of whether or not Canada received one–kidney heads of household.

His recuperation was progressing into its fourth month when Na-

reth next inquired with Henry. "What's going on with Canada?"

"You'll know soon," Henry replied. Nareth was tired of "soon" and "tomorrow". "Tomorrow never comes," the Vietnamese used to say.

"Exactly how long do we have to wait?"

"Maybe a year. Yeah. I'd say a year."

"Can't you go to the embassy and check about my name?"

"No. That's not my job. I'm just a little ol' CO teacher."

Looking back on that conversation, Nareth realized Henry knew more than he was saying. However, she suspected everyone knew more than they told her. What was "soon" about another year?

The nights were still hot in September and the daytime heat oppressive. Wise people limited movement in the sun. It was late afternoon. The loudspeaker crackled. "Serng, Sukonthia, CB 130054, report to the UNHCR. You have the *name-to-go* to Canada." The name to go. THE name to go. The NAME to go. The name TO GO. GO. Nareth jumped up. She dashed out. Halfway to the Intergovernmental Committee for Migration office, she realized she had left John and David alone at home. Jogging back, she hoisted John up on her hip, grabbed David's wrist and trotted again up the street. At the office, a Khmer translator intervened on Nareth's behalf. The departure would be the twelfth of September, 1989. Nareth scribbled down the details and ran over to Husband's boss. Would someone please call her husband? A colleague with pass privileges hopped on a bike and cycled over the highway. He returned doubling Husband, who wore the biggest grin in the world. He too had heard the news. Nareth couldn't stop running. It was almost time for aid agencies to leave camp for the day. She arrived breathless at MCC's office. "Hungry," she panted. "You told me only yesterday that I had to wait one year. But it's only six days! Six days!"

"Congratulations, old lady!" Now Nareth caught the twinkle in his eye. How could she have missed it the day before?

Back at home, Nareth toyed with the food in her bowl. She

couldn't eat what she had been cooking an hour earlier. David sensed something was up; he was so intuitive. What was Canada to a three-year-old? Nareth pulled out some postcards Henry had given her. "We're going to this city," she explained. There was a palatial sandstone structure in one photo. A fountain encircled with crimson and lemon-yellow petals sprayed jets into the air. A stream wound its way through an aerial shot. It was a river, the card said; with a name so long it could be Laotian. North Saskatchewan.

"Will we go to live there?" David wondered aloud.

"Oh, yes!"

"Is it good there?"

"It's one hundred times better than here."

"Oh," David chirped and slid off Nareth's lap. Play preoccupied him until dark. Nareth couldn't sleep. She wrote a note to send into Section C to inform her old friends. It didn't occur to her that the loudspeaker had blasted her announcement to everyone. For four-and-a-half years, Nareth had been hearing almost daily announcements of names. Each name represented an individual or a household whose wait to go west was over. For seventeen hundred mornings, Nareth had longed for this moment. Beautiful. There would never be another like it.

On the evening of September eleventh, neighbours and friends walked Nareth, Husband, David and John to the holding centre. They carried clothes and goldsmith tools in two cardboard bins, wrapped in azure plastic and secured in a net plastic twine. On each box a placard had been pasted: Serng, Sukonthia, CB 130054, Edmonton, Canada. None of the refugees in the centre could sleep, not that they weren't used to reeds between their bodies and the earth. Excitement flickered on every face. Babies and wee ones stirred at the novelty of it all. Adults anticipated—well, they didn't really know what to expect. Anxiety, ecstasy, aspirations, palpitations, faith and fear all swirled together beneath faces trained to mask emotion. Electric lights stared

down from the ceiling of the bus station. Women and children squatted. Men formed a chain passing everyone's entire collection of earthly goods, twenty–five kilos a ticket, across the tarmac, up the side of the bus and onto its roof rack. Nareth couldn't see her moon under the glare of the lights. She wasn't permitted to leave the line in search of some solitude. There could be no nocturnal soliloquy this last night in Thailand. "Get on."

The Mercedes engine turned over. Diesel–smelling smoke, roll call, slippery seats, laps full of drowsy babies—these smells, sounds and sights filled Nareth's senses. The bus chugged through the open gate. None of the guards there would ever again ask to see Nareth's pass. David pressed his nose against the window glass, unfamiliar substance that it was. The village of Gapo, Phanat Nikhom town, and Chonburi city twinkled in the night. Bangkok was bright. Even at four in the morning, cars, motorcycles, three–wheeled *tuk–tuk* taxis and trucks roared along the motorways. Under bridges and along thoroughfares, vendors were setting up stalls. Moto–trailers hauling cacophonous crates of chickens and ducks reminded Nareth of Phnom Penh. Everyone on Bangkok's streets walked unlabeled, free of a pass pinned to their shirts. A sense of emancipation overwhelmed Nareth; her family was being released into a wide, wide world.

Don Muang Airport was immense. Multiple levels muddled Nareth's mind. She steered clear of an animated staircase. David wanted to try the moving steps. "I've done it before!" he preposterously insisted. His dad guided him up the escalator, carrying John. Nareth climbed solid stairs. "Come again, Mom, I'll show you how," David offered at the top. What Nareth needed was not an escalator escapade, but some space and some silence, rare in a city which flogged everything.

A tall man, not Thai but speaking it, called the names to go to the gate. ICM–arranged passengers boarded before independent travelers. With two little kids, the Serngs went first. They were seated all in a row in the midsection of the plane. Glimpses of the runway, of

Bangkok and of clouds, thrilled flyers intrepid enough to look out the windows. "Mommy! Mommy! We're going up!" David was bouncing in his seat.

"Hush." Nareth planted her palm over her son's mouth. Nothing restrained his exuberance. After the jet reached its cruising altitude, a flight attendant came by. Husband translated for his son.

"Would you like to meet the pilot?"

"Yes. Yes, Daddy!"

Without reservation, he took the woman's hand and vanished up the aisle. It seemed an eternity to Nareth before David returned, just as drinks were being served. The attendant handed her little boy a plastic cup half full of ice cubes splashed with orange juice. Nareth steadied the tumbler as tangy sips of it trickled down to his tummy. "More?" Yes. More.

THE SENG SISTERS:
KIMSONN AND SIEM

WEST, MEET EAST: PRELUDE TO POL POT

"Come out, wherever you are, you sneaking, thieving, dirty, mud–caked, buffalo–dung–smelling little bandits!" Kimsonn and her older sister could see their neighbour's sturdy calves striding along the dike above the paddy where they wished themselves into invisibility. *Oom*, Elder Auntie, as the girls properly addressed her, carried on screeching invectives as her footsteps thudded purposefully toward their mother's house. Oh so cautiously, Kimsonn raised herself out of the rice paddy pond and peered through the stalks. She signaled to her sister and together, grasping a basket chockfull of slippery, palm–sized fish they had scooped up with deft little hands, they sloshed up the bank of earth that divided their neighbour's field from their father's.

Oom stood, one foot planted on the lowest rung of the steps up to *Maq*'s stilted house. *Maq*, nobody's whipping boy, looked askance at the accusations. "My daughters," she retorted unretractably, "are playing out back." The embodiment of condescension, *Maq* stared down,

garlic–dripping pestle in hand and baby Siem on hip. *Oom* squinted disbelief and turned, still muttering, her mud–splattered sarong twisted and rolled between her knees to tuck up *jong ka bun* style into her red waistband. The print of faded temple dancers fanned out like overcut jodhpurs, and exaggerated her duck–like waddle. Imitation was too tempting to resist.

"Kimsonn. Sien." *Maq* called; the girls came. Her glance scoured their paddy–drenched clothes and noted the basket with its still–squirming contents. "Look at you. What a mess you are. Out of those filthy rags. Take a shower. And leave the basket here."

Yiey, who wasn't really Kimsonn's grandma but who made a perfect one, lived the other way, up the road. One room in her house was stocked with the distractions of rural Cambodia: glossily packaged cigarettes sold sophistication to young men; betel leaves and lime paste supplies offered a buzz to post–menopausal matriarchs; biscuits and sweets and scrumptious soymilk ice cream tantalized more innocent palates. Most delectable was crème glacée served on slices of *nom pang*, a thirty centimetre baguette of French lineage. One ice cream sub could be Kimsonn's in exchange for three bottles. Like other kids in Klayung village, Kimsonn scavenged for whiskey and wine throwaways in ditches, and soy–sauce empties, chili jars and vinegar vials tossed out kitchen windows.

As an honourary granddaughter, Kimsonn could count on *Yiey* as a source of other essentials. Grandmother would let *Maq* know her scalp was on the itchy side and Kimsonn would be dispatched. For every white strand the girl plucked, *Yiey* rewarded her with another mini elastic band. These multi–coloured elastics were the primary game pieces in a popular pastime. Players launched their bands like surface–to–air missiles off the ground and over a line someone had drawn in the sand. Sand–etched checkerboards were designed by the players who challenged pebbles with twig bits. Another game of strategy entertained children and adults alike, but only at New Year.

Angkuang, big, brown seeds, which had burst their pods and floated downstream were collected along the river bank. Two teams of six set out to knock over a line or semi–circle of five nuts. The players hurled their own reserves in turn, trying to tip their billiard–ball–sized targets. When all *angkuang* were controlled by one team, the victors cradled two seeds in their fists and, clacking them castanet fashion, cracked them hard on the losers' kneecaps. Kimsonn's patella still smarted at the memory.

The sting of loss struck everyone sooner or later, but in 1971 Klayung village lost more than a game. Black–clad cadres of the *Kmae Kahom* came to town. Soon after, President Lon Nol's troops reasserted themselves and one villager, ill–advised on who really controlled the western province of Battambang, reappeared in guerilla custody. He had, they said, been on his way to the despicable Republican American lackeys to rat on them. Kimsonn saw the hole in his chest and the note pinned to his tattered shirt. "Don't do as he did."

More than half of Kimsonn's neighbours managed to evade soldiers of either stripe, leaving more than thirty houses empty and farms untended. Among the runaways was Tuon Sarun, Kimsonn's boy–next–door. Whoever was now next door was a matter of concern but not of conversation. The defense of silence Kimsonn had practiced once before came back to her. Earlier, in her preschool days, when Father had relocated the family from Kompong Som's port–city pressures to the relative self–sufficiency of the Battambang farm, playmates mocked her southern drawl. "Say 'rice'," they would taunt.

"*Saw*," the little belle would tell them and the northwesterners would snigger.

"*Sraw*," they chided, scoffing at her lazy diction, enunciating every letter and trilling the "r" for emphasis. But by age six, Kimsonn knew keeping her mouth shut was about more than avoiding pesky kids. Father's reputation for drafting blueprints and designing fine furniture made him suspect and subject to several interrogations. Kimsonn and

her siblings could not let slip one ill–considered word; even peering out past the shutters when a twig snapped after dusk was folly.

Risk–taking fell to *Maq*. One unforgettable morning, someone spotted several hundred Lon Nol soldiers heading toward Klayung. The Pol Pot men were massing beyond the village. *Maq* considered the prospects for her children if a firefight broke out; she calculated the outcome of house–to–house combat. Kimsonn saw *Maq* sling a yoke and two empty pails over her shoulders. She watched as her mother, with premeditated precision, sauntered down toward the river. Under the pretext of drawing water, *Maq* spoke to the *Kmae Kahom*. With great conviction, she implored the commander to move his men and prevent a civilian bloodbath. All this Kimsonn learned later, but those minutes, like hours, stretched as she squatted under the house, motionless as a mannequin and scarcely breathing more so. Eldest sister Soan, Sien, Kimsonn, little sister Siem and baby brother Cheuy ran to *Maq* when she turned in at the gate. Knocking over the decoy buckets, their feet sluiced with river sludge, Kimsonn squeezed *Maq*, perspiration plastering her blouse to her back, eyes welling with tears and triumph. Amid a most uncivil war, the childhood of Kimsonn and her younger sister Siem was not quite crushed.

Siem screamed. *Ba* held his trembling toddler close. "Come, spirits eight, nine, ten. To her body return her soul!" Thunder rumbled above the sugar palm grove. Charred, one once–towering trunk swayed, split seconds before by a bolt of lightning.

The bare–foot five–year–old had been flitting about under the tall trees, catching raindrops dripping from the great canopy of leaves overhead. It was the wet season. Cloudbursts and squalls blew inland from sea–spawned monsoons, drenching the Battambang hills and paddies. Siem's tin pan had tinkled with the first droplets splatting on its surface, amusing her. She danced about, shoeless, shirtless, fearless. There was no *rup preah,* Lucky Buddha, on the dainty gold strand around her neck. *Maq* had tied no *ambah* about her wrists, scoffing at

those who thought bracelets of looped white thread warded off evil. But evil had struck mighty close to home. *Ba's* arms sheltered Siem against his shoulder as he carried her up the steep flight of steps out of the rain. Below the warm, reddish–brown planks, planed smooth and polished, her bowl lay abandoned in the mud.

As the youngest, fairest daughter of the Seng family, Siem was *Ba's* treasure. Neighbours called her *koun barang*, foreign child, because of her uncommonly pale complexion and slightly longer nose. Father's friends or construction clients often scooped her up, kissing her *Kmae*–style, sniffing her cheek, their faces pressed against hers. Prickly whiskers perturbed Siem, who quickly learned to hide under a bed or dash out into the yard when these men came calling on *Ba*. Outside, she and her sisters and brother roamed *Maq's* one–and–a–half hectare farm, hiding and seeking among orange blossoms, in mango boughs, around papaya trunks and behind pineapple or banana stalks. Sometimes the kids caught freshwater crabs or small fish in paddy ponds and irrigation ditches. Occasionally *Yiey*, an elderly widow, borrowed Siem's company. For assuaging her loneliness, *Yiey* offered the pre–schooler a skirt or a pair of sandals. Pretty clothing bound the wearer to at least minimal decorum; Siem had more freedom clad only in short pants or underwear.

Freedom to move would prove much more important than the liberty to look pretty. Siem was meandering around the rows *Ba* was hoeing when a distant sound like thunder sent her scurrying close. Father scanned the sky, an impenetrable blanket of brilliant white clouds, but high, not a single cumulonimbus in sight. "Run! Run! Run!" *Ba* cried as loud and as long as his voice could carry the warning. Out of the horizon the planes came, streaking toward the village, screeching bombs and billows of smoke behind them. Siem tumbled into a ditch with her daddy. Reverberations of explosives impacting earth shuddered through her. Lon Nol's Republican air force aimed to flush out communists sequestered in the western hinterland. The

Kmae Kahom, however, were advancing inexorably across the provinces toward Phnom Penh.

WEST, MEET EAST: POL POT TIME

"Look here." Siem pointed out a beetle crawling across a leaf. She jiggled her baby brother strapped to her seven–year–old back. "Look at that!" she intoned in infant–soothing sounds. Distracting Pheap from his hungry tummy was a full–time task. With *Maq* working in the communal kitchen, *Ba* on a house construction crew, her three elder sisters and one brother sent off on youth or children's labour groups, caring for the six–month–old mouth fell to Siem. Pheap, whom Father had named "Peaceful" in an audacious display of optimism in October 1975, squawked and whimpered during the long hours between the two daily distributions of food. In the meantime the children lounged around the family's single room in a long house that sheltered the "new people" in Lawkabuang village or wandered along the fringes of the forest.

Siem found her duties decidedly uninteresting. At one point she left Pheap asleep at home and slipped away from the village to her brother's brigade of primary school–aged children. She demanded Cheuy change places with her. Siem joined his twenty or so workmates cutting down saplings to extend the size of vegetable plots. They were under the supervision of Nang, an incredibly short man, hardly taller than his charges. Nang also assigned the boys to catch fish and carry water while little girls in threesomes prepared rice soup with what vegetables they could gather. Wild fruit the children picked from untended trees.

At dusk, Nang sat in the doorway of the ratty dormitory telling fabulous folktales or spinning new yarns. His white hair glinted like a halo above a stooped frame. The melodious cadence of his voice transported Siem to a mysterious place where the spirits who animate hu-

mans migrated to beasts and birds. In one ongoing saga, a couple lived with a single child. The mother, by night a she–dog, had carried the baby of the human father and cared for it most tenderly.

Compassion called Siem back to the village where *Maq* was ill. Dehydrated by bouts of diarrhea, *Maq* was being sent by truck to Battambang City. Siem accompanied her to the wards of wasted bodies *Angka* euphemistically labeled a hospital. A subsequent trip up the Sangkor River yielded no better treatment. Back in Lawkabuang, daughter plied mother, then father, with well–boiled broths enriched by in–season vegetables from a patch *Ba* had cultivated in the bush. Health through stealth. Dysentery ebbed and toil returned.

All around her, Siem observed furtiveness flourishing whereas honesty disabled. And so she, too, pilfered and poached. One morning, she helped herself to one of *Maq*'s machetes, tied it in a towel and wrapped herself in a sarong before dog–paddling across a stream to an alluring sugar cane plot. The river was low, the current slow. While the eight–year–old was crouching deep in the crop, sawing several stalks as silently as possible, someone upstream equally uninterested in notifying others of his actions opened flow–regulating locks. By the time Siem scrambled down the bank with her bundle of sweet sticks, the river had risen. No one was on the home side drawing water. She tucked up her sarong and knotted the knife and cane inside her towel. Wading into the now rushing stream, Siem's feet slipped and her arms flailed still gripping the towel. It seemed she had swallowed half the Sangkor as she tumbled in its eddy, the sarong twisted around her ankles preventing her from kicking free. When she bobbed up in the shallows, the garment was gone but not her booty. Crying now and unclothed, Siem wandered up and down the far bank of the river. Eventually she spotted a man on the opposite side. "Help!"

He shouted back, "Walk upstream. Don't swim straight across. Float down. Don't try to carry anything." Siem took his advice and crossed successfully. She did not, however, succeed at evading *Maq*.

"Where have you been all day? With whom?" Her daughter's long absence had frightened her. Naked fear made one far too vulnerable, so characteristically *Maq* clothed hers in anger. Bowing before *Maq*'s sharp tongue, Siem confessed.

There were some sights and sounds Siem never spoke about. Such as those two terrified strangers trussed to papaya trees. Phobia–ridden cadres struck them. Doused them with water to revive them. Berated them. Accused them of spying. "Why have you come here? Will you inform others and destroy us?"

"Younger Uncle," Siem politely addressed a *Kmae Kahom*. "Why did you hit them?"

Mistaking frankness for the naïveté of a child, he replied that the men were enemies. Evil. Hmm. The trouble was nobody could define "evil", so anybody qualified. Everybody knew somebody who had or did or would. Afterward, the scene replayed itself over and over again in Siem's imagination, but the ropes around the trunks bound *Maq* and *Ba*.

Providentially, *Maq*'s renewed strength qualified her for assignment where raw silk was reeling off in filaments from vast vats of soaking cocoons. Although squeamish Siem resisted contact with the living larvae, unflappable *Maq* perspicaciously instructed her daughter in the ways of worms. They were a wonder. Women nurtured small, green silkworms, which daily, voraciously devoured bushels of leaves. Reaching full size, the worms nestled into crooks of twigs and stems. Their heads began to swing in figure–eights as they spun two delicate strands with sericin gum into the silk that encircled and eventually enclosed their bodies. These cocoons bobbed about in steaming basins of boiled water. Siem watched the women drawing out filaments with a slender rod tipped by tiny tongs. Releasing the silk from the melting gum, *Maq* and her co–workers wound the strands around a reel before they were twisted and boiled again, leaving the stronger threads shimmering gold.

Scooping up the shriveled insects, Siem learned to fry them. She licked the light coating of oil off her fingers as she chewed the crunchy pupa. Wiping her hands on her stained black trousers, Siem wondered what became of the bales of raw silk. Her clothes, now short on her limbs and tight in the shoulders, were thin and faded. She remembered when *Maq* had gathered the family's clothing, concocted an inky brew from vegetable matter, soaked shirts, sarongs and pants for hours and then immersed the textiles in a putrid mud. Once rinsed, the fabric retained a dark hue and, Siem recalled, a vile smell. Suddenly an acrid odour filled her nostrils. Heaven forbid! She had let a wok's worth of silk worms sauté somewhat beyond golden perfection. What penalty would follow such a breach of trust?

"You will report for a new assignment in two days." Kimsonn couldn't imagine what might be worse than how she had spent her eleventh year, but she didn't dare hope for anything better. Several months earlier, she and her older sisters had been separated from their parents for the first time in their lives. *Maq* had prepared personal mess kits and sent them off carrying a hammock and the clothes on their backs.

One day in the life of Seng daughter number three was much like the next and the next and the next. At the first bell, Kimsonn was to wake. At the second, she was to prepare. But what was there to prepare? She slept in her only clothes. She owned no comb, no toothpaste, no soap. At the third bell, rumpled and rat–breathed, she was to line up before the *mit bong*, the "equal" who was not. Her team trooped fifteen minutes through dewy grasses to the site they were clearing for vegetable crops. The *mit bong* envisioned rows of cucumbers, melons, corn and peanuts that reached the horizon; Kimsonn and her companions were to real-ize this dream. For tools, the kids had machetes. Kimsonn was toting several knives on her shoulder one morning when she slipped and one blade sliced her left wrist. Without a second thought, she tore a strip off the hem of her tattered clothing and another girl helped her tie the

improvised bandage. The received truth about such incidents was that the victim was at fault so blame rained down on Kimsonn's ears as blood seeped through the worn cotton and trickled over her fingers. She gingerly hoisted the unsheathed knives and tottered along to the worksite.

Hours of hacking down finger–thick saplings and tugging at roots ended when the noon bell rang. One comrade collected all the machetes before another spooned a tasteless gruel into the bowls the children carried with them. Aching back against a tree, enjoying the shade, Kimsonn licked her dish spotless before rinsing it in a canal and stashing it back in her kit. On a good day, there was time for a nap or more likely for rooting around in the forest to find wild yams. Kimsonn learned to identify edible grasses, mushrooms and unfamiliar fruits. Whatever the birds could eat, she would eat. Another bell rang to recall the scavengers for the afternoon shift, which stretched until an hour or so before sundown. The second meal was the same as the first, a little bit blander, a little bit worse. New moons or those waning or waxing might mean meetings in the evening hours. Under a bright full moon, the day's labours could last well into the night.

Kimsonn and her second–oldest sister Sien passed their last two nights at Tana Salaa in anxiety. Better the devil you know than the devil you don't. But even devils have off days when the evil they perpetrate doesn't pack such punch. The girls slept next in a staff ward of Bovul Hospital, in beds.

Bovul Hospital was actually a former high school in Battambang City, the classrooms of which were now crammed with patients cared for by the likes of twelve–year–old Kimsonn, whose medical studies amounted to a month of lectures and rounds under the tutelage of nurse–practitioners of questionable qualifications. Kimsonn was assigned to a team of five, all adults besides herself. Initially, the responsibility was heady stuff. Each medic admitted new patients, diagnosed symptoms and wrote a report. Basic literacy made keeping notes possible for Kimsonn, although she tried to pass herself off as a quick

study rather than relying on suspect prior schooling. On night shift, Kimsonn's group checked charts, gave injections or doled out tablets according to prescriptions written by their no–more–medically–aware daytime counterparts. Looking oh–so–official with a stethoscope around her neck and happy to help herself to permitted second–helpings at the staff canteen, Kimsonn pinched herself. Was this a dream?

Dreams die, as people do, and at Bovul Kimsonn saw more and more of death. Treating respiratory ailments with an injection of sugar water never quite had the desired effect. That yellow–eyed, jaundiced patient in one of six beds on a mixed ward shook uncontrollably as the team inserted a second–hand IV needle. Kimsonn spent an hour holding his arm as motionless as possible; there was no tape to secure the insert. He didn't make it through the night, and at shift–end Kimsonn and a co–worker trundled the corpse down to the first floor, out the door and over to the hospital cemetery. Next to the newest burial mound, they excavated a shallow pit, laid out the body and built up an earthen covering. The day of Kimsonn's first birth was the worst. She, who had never seen so much as a speck of menstrual discharge, who had never even heard that women bleed nevermind witnessing a delivery, left the scene numb and traumatized. Up on the hospital roof, Kimsonn stared at the setting sun, aching for home and crying over her spoiled innocence.

Over the next two years, the proportion of healthy, discharged patients plummeted. A crematorium of sorts was constructed to dispose of corpses the cemetery couldn't accommodate. Kimsonn gagged at the smell of the bodies, burned five or ten at a time. Her duties included clearing out the ashes and charred bones to bury in communal pits. The ranks of Bovul staff were not exempt from disease, either; the sturdy worked longer hours and covered for the absentees. Kimsonn suspected an inappropriate quantity of unidentified chemicals fed a series of horrific hallucinations she saw while being treated twice for fever. For five days, she lapsed in and out of consciousness. Her

pulse pounded in her skull, her skin afire, her mind unable to retrieve names for the blurry faces occasionally registered by her eyes. Muffled voices whispered death. Hands readied a bamboo coffin to carry a corpse—hers. In exitless dreams, Kimsonn wandered, lost along an embankment above a river.

"Go. Back." A giant of a man, the speaker was indubitably compelling. Kimsonn choked on sandalwood and aromatic resin, cloyingly close. The joss sticks smoked for her own almost extinguished spirit.

Not all the empty places in the staff dorm were caused by physical failings. Political purges also impacted the pseudo–clinicians who were Kimsonn's colleagues. Off duty, there were fewer and fewer hours to sleep and more and more meetings probing everyone's previous occupations and past associations. The stress stooped Kimsonn's posture and weakened her grip. Once, several stacked bedpans slipped from her hands dumping putrid contents all over her as she fell down a staircase. Outside, where high school students had once spiked volleyballs, a bulldozer was digging a massive trench.

Did *Ba* know something? A smuggled letter urged Kimsonn and her sister to make their way to his village by whatever means they could devise. Sien destroyed the note, too terrified to act on its advice. Kimsonn, however, convinced her destiny did not lie in a mass grave, made a deal with a boatman when she next took a bath in the Battambang River. Adrenalin pumping through her veins but heart heavy as she hugged her sister for what would be the last time, Kimsonn thumped down the hospital stairs and out to the first security checkpoint. The guards searched her empty satchel and apparently bought her story that she was going out to gather particularly potent herbs to stock the hospital pharmacy. A cursory check by a second set of soldiers didn't find anything sufficiently suspicious to stop a four-teen–year–old nurse supposedly collecting roots and leaves at three o'clock in the morning. The riverbank rendezvous went unremarked. Kimsonn's first escape was a success.

East, Meet West: To a Second Country

Rumours of gory, barbaric acts perpetrated by the "fire ants" of the east swirled around the quiet village of Jah'Kray. Word of mouth propagated ancient myths and generated gossip of mythic proportions. *Kmae Kahom* cadres battened down for battle and attempted to put a lid on the dissent that surfaced among those longsuffering pseudo–peasants who envisioned emancipation in a Vietnamese invasion. Violence went public.

Siem saw and heard a victim and spoke of him to *Maq*. His hands had been bound, his feet, too, as they beat him with a rod. He shrieked in pain as they struck his torso, limbs and head. The accusers berated him for being *ef–bee–eye*. "They said he was a spy, *Maq*." Siem had heard shrill shouts and screams and, with other surreptitious gawkers, witnessed the spectacle. Some must have known the victim but none acknowledged him. Silence overcame the accused, too, until he regained consciousness when sluiced with a bucket of water. The condemned man insisted on his innocence. His captors loosened his ankles and offered him a cigarette. They placed it between his lips and lit it, his own wrists still trussed behind his back.

"A meal is being prepared," one announced. "Let's go." The *Kmae Kahom* led the errantly optimistic defendant up the road and out of sight. A single rifle shot cracked the calm; Siem and the others scattered.

"Didn't they feel how they were hurting him, *Maq*? Couldn't they understand his pain?"

Maq's heart held her own pain. Even as many children, including Soan and Kimsonn were returning to the village, her second daughter had not and would not. The message from Battambang had said simply, "Sien is gone." The bearer confirmed he had seen her body. He did not speak of her soul, only her mind, which wandered when it could. Siem had hardly seen her second–oldest sister in three years. When she tried to remember her face, she recalled instead coming across a

clearing where a woman was caged in an oversized chicken coop. The prisoner kept undressing herself while a guard persisted in replacing her blouse and trousers. That cage was empty now. In fact, the entire community was evacuating.

Ba appropriated two cows and a cart. His wife, three daughters and two sons joined the melée of the suddenly ungoverned. The cart held some sacks of rice, a precious flint, an axe, several pails, a cooking pot, a few bowls and spoons, sleeping mats, blankets and Pheap when his toddler legs couldn't carry him anymore. They trundled to the southwest, away from the advancing army, *Ba* and other heads of households hoped. That night and irregularly afterward, Kimsonn heard the pupopoprrrrr of machine guns and distant whizzing shells. For days, Siem never saw a single soldier or any strangers. The Sengs and their companions passed through unpeopled settlements where water buffalo wandered, untethered, cantering away as anyone approached. Every evening without fail, *Ba* set up a camp site. If fate didn't begrudge them, the girls found fruit trees and fresh water nearby. Their parents built smokeless fires of bone–dry wood that boiled the next day's rice under the cover of night. The interminable walking irritated Siem. She was exhausted and irritable. She wanted to ride in the cart for a time, but her eldest sister pushed her off. Siem threatened to leave. She lagged behind, straggling along with another family.

A plume of dust rose up in the distance. All eyes eventually turned toward the verge beyond the rustling stalks of last season's harvest. A truck drew nearer. Siem could see bolts of cloth bundled into its box. A family crammed into the cab didn't acknowledge the retinue of cows and carts and parents and kids as they roared and rattled over the tableau of potholes that passed for a road. Siem envied their uncommon speed and style. However, when the migrants caught up with the transport sometime later, not a thread of the cargo remained. On the cracked earth beyond the empty truck, the driver and his passengers were laid out in macabre array from tallest to shortest, every

throat slit. "Where is Siem?" "Siem?" "Siem?" Siem heard distress in the voices of her family. Their earlier spat seemed inconsequential in the presence of so many dead.

Life and sustaining it weighed heavily on the adults as the caravan of a dozen families wound its way down into Pursat Province, seeking sources of rice and places of shelter. Quest unanswered, they turned north–northwest along the Cardomom Mountains. Guiding the bedraggled group was a man who climbed out of the gloom of the forest floor to pick a sun–kissed leaf far above. Whether from the view or from the pigmentation on the leaf, Kimsonn couldn't tell, but the scout determined their direction and everyone listlessly followed.

They wandered haphazardly into a pitched battle between guerrilla–again *Kmae Kahom* and not–quite–victorious Vietnamese forces. Fleeing a mortar shower that morning, Kimsonn lost the family, or they lost her, or everybody lost each other. She ran pell–mell into the jungle. When she huddled down in a hollow, lungs stretched beyond capacity, Kimsonn realized she was utterly alone. There was no fear like that of the lost in a forest infested with life, all foes. Death included. Breathing in check, Kimsonn started toward the artillery fire. Three men in green lay sprawled across her path. Beneath metal helmets, blanched faces seemed surprised at their own demise. So this was what Vietnamese looked like. The enemy was paler, finer boned, their epicanthic eyes narrower than hers. Coagulating blood drained the wounds of war their bodies bore. Some conscript's mother would weep not knowing her son's fate, but would wail more if she did know. But where was her mother? Kimsonn started through the ferns and fronds. The black–clothed *Kmae Kahom* had retreated behind the chaos of the splintered families who regrouped as night fell.

After almost three months on the move and a diet of dwindling rice stock boiled now with strips of cowhide, the group encamped in the dense forests blanketing hillsides and ravines between Prom Putoual and Thailand's Prachinburi Province. Siem's daydreams were

filled with food; her bowl never was. She had no thoughts for others' hunger or anguish, whereas her parents kept caring for their emaciated children. *Ba* cobbled together a shelter and even built a bed, a shelf of sorts, to keep them off the damp forest floor. As long as Kimsonn's strength held out, the fourteen–year–old joined the adults unearthing unlikely sources of food. In a most daring foray, five men and the girl followed a squad of guerillas through the jungle. After what seemed hours, the *Kmae Kahom* tensed and motioned for all to halt. In a clearing up ahead was a rectangular building, thickly thatched. One man, then another, was sent slithering across the dust on his belly. No guards. No guns. Everyone else dashed into the house, which sheltered sack upon sack upon sack of husked rice. Kimsonn cinched up the end of a spare sarong. She poured in almost more grain than she could carry and knotted the other end, too. The fathers and brothers with her overloaded their motley assortment of sacks and improvised carry–alls. Kimsonn squatted as someone settled her many kilos on her head and shoulders. She would need maximum balance to haul this treasure back through the forest. The soldiers, in the meantime, were stripping off their uniforms in exchange for civvies. They tossed unused cartridges into the trees and abandoned cool–barreled, emptied weapons. Before trekking off in the opposite direction, they pointed the six rice packers back toward their families.

"Where had all that rice come from? What was it doing in the jungle?" One of Kimsonn's neighbours speculated that the *Kmae Kahom* had stashed stores from good harvests far from the slaves they had made of Cambodians, but close to the Thai border in order to trade for Chinese arms.

Kimsonn should have slept better that night, her stomach satisfied, but her bowels rumbled. Ubiquitous ants made a supply line across her thin blanket, which *Ba* had padded with swatches of grass his machete had cleared. *Ba* himself didn't lie down, let alone sleep. He tended a small and smokeless fire and watched the shadows. Oc-

casionally, the sisters thought they heard the likes of tigers, but usually it was another's borborygmus toying with their imaginations. A stray centipede could bring on nightmares in which legions of arthropods marched over legs and arms and into ears and eyes and noses and mouths. Not that animal life was unhelpful. The children learned to observe the wildlife. What animals, birds and insects tucked into, famished people would try.

Water was another matter. Sometimes they resorted to scooping up liquid pooled in elephant footprints or by folding enormous jungle leaves into troughs, down which dew trickled into their mouths. Springs and streams were rare that season in the jungle. *Maq* sent Kimsonn to scout out supplies in murky ponds. Beside one such pool, Kimsonn stumbled over two Khmer casualties and looked up to see a pair of eyes observing her from the undergrowth. She averted her own, filled her pail and made a beeline for the old man she had shadowed to this source. Whether the dead were Red or their opponents, he could not tell her. Foreign mercenaries might have saved their bullets, though, for fractious Cambodian factions were staking turf along the Thai frontier, using wasted forest folk as human shields.

Regardless of the risks, the hungry teenager rooted about for *dom loang* or "candle root", which were nibbled raw or roasted or boiled, or *kahduech*. These potato–like tubers, some a half–metre in breadth, grew beneath the forest floor. "O *Preah!*" Kimsonn implored providence in divining the direction to dig. Under a dark brown skin, the firm, yellowish flesh had to be boiled, sliced, dried and cooked twice over before it was edible. Kimsonn had seen the too–starved impatiently devour poorly prepared *kahduech* only to suffer the consequences— surface capillaries burst and blood seeped through the pores.

Fever wracked Siem, Soan and their brother Cheuy. Around them, most of the dying slipped away without ceremony. *Ba* believed that if one of these three perished, the other two would recover. He and *Maq* set out one morning to scrounge the forest for edible plants

and potable water. Cheuy lay between his sisters. He had been moaning less since a skeletal neighbour, once a monk perhaps, paused to utter ancient *Pali* syllables by his ear. Siem saw his eyes flutter open. Her eight–year–old brother looked around, deliberately scanning his sisters' faces: hers, Soan's and Kimsonn's. He lay down again. And was gone.

Siem's delirium welled up as Cheuy's spirit eased out of his skin–and–bones body. Laughter, high–pitched and haunting, rose from her throat, her face frightfully jaundiced. Horrified, her older sisters reprimanded her, but Siem's sardonic cackle continued unabated. "You're cuckoo!" Soan and Kimsonn scolded.

"You're cuckoo!" Siem echoed in response. Hoping to restore soundness of mind when he returned from gathering roots and leaves, *Ba* determined to relocate the survivors. He wrapped his oldest boy in a makeshift shroud. Father and mother buried their son in a shallow grave. They had mourned four infants before the war engulfed their family, lost one daughter during the Pol Pot regime, and it looked inevitable that there were more tears to come.

The cart and cows had been cut loose. There was no path wide enough through the trunks and vines and undergrowth, and *Ba* didn't have the strength to cut a swath through the forest. The family followed a track others had tried to trace before them. Swollen corpses, some abandoned, some half–buried, half–dug up and gnawed by scavenging birds and beasts, enveloped the jungle with the ineradicable stench of rotting flesh. How she kept one foot moving in front of the other Siem didn't know, but when they reached a rough road she sank to the ground.

The stars twinkled up, way up above the tall, tall trees. As in a dream, a diesel jeep lurched to a halt in the gray dawn. Sturdy men in blackened boots and camouflage gear jumped out at intervals, dropping off bundles of shirts and shorts and bags of biscuits. Siem strained to reach a packet but someone larger and stronger wrestled it out of

her thin fingers. She whimpered and suddenly an even stronger hand thrust the package back into her lap; a soldier rattled away in Thai, berating the cookie *kamoy* and nodding at Siem. A daze of days mingled unordered and uncounted in her muddled, ten–year–old mind. Until she saw the buses, Siem didn't believe it. A convoy of twenty–some silvery, shiny Mercedes buses interspersed with white Isuzu pickups emblazoned with red crosses formed a queue at the edge of the meadow. Meaty–looking men, and women too, titian–haired and with noteworthy noses, stood head and shoulders above Thais who beckoned the forest people through amplified megaphones. "We have food. We have medicine. We offer you life, not death. Come." The Khmer *Serei* bloc would claim their Free Cambodia spokesmen had convinced the UNHCR and the ICRC, the International Committee of the Red Cross, to intervene, but *Ba* credited the divine.

"*Preah Vobedah*, the Master, has come," he murmured in amazement. He led his family, frail but achingly full of hope, down the hillside toward the coaches crawling now with converging Cambodians. Not everyone came. Some skeptics suspected a ruse. An ambush was all too likely.

At the foot of the mountain, *Ba* thrust Siem's hand into *Maq*'s. It had suddenly occurred to him he had dropped their only kettle back in the bush. No kettle, no clean water, no life. The logic of retrieving a battered pot seemed irrefutable at the time. As he panted up the hill, a tide of humanity swept his wife, son and daughters down toward the buses. They climbed inside a lead vehicle, past a bespectacled nun in an immaculate habit, who counted noses and kept the door. Once full, the engine roared to life and headlights blazed. Indescribably anxious at *Ba*'s absence, *Maq* rousted her brood out of their seats and clamoured for the door to be opened, letting them out, again, into the unruly crowd. Somehow out of that mayhem, mother, father and four children found each other and seats in another bus at the back of the convoy. Kimsonn, Siem and Soan, starvelings all, sank onto one

vinyl–covered bench, their parents and baby brother behind them. Rucksacks of rags and bowls and spoons rattled beneath their feet as the bus began to roll. Those wheels carried them not many kilometres but bore them over an invisible barrier into another nation, and more amazingly into asylum's grace.

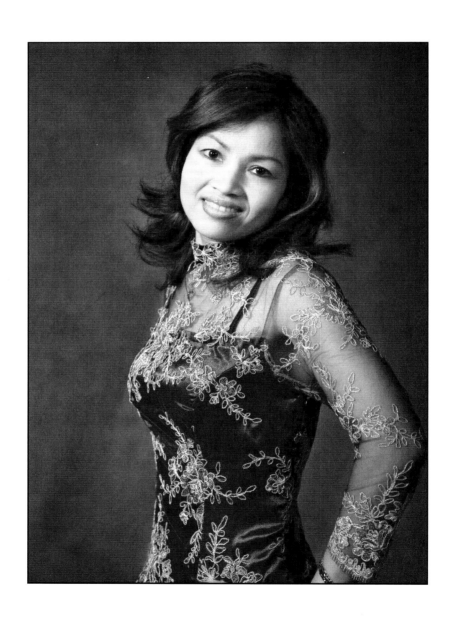

SIEM SENG

NOT YET WEST: DREAMING OF A THIRD COUNTRY

A sea of sapphire waved and fluttered in the breeze. At the back of the bus convoy, Siem pressed her nose against the glass, the better to see the expanse of plastic tents, blue and billowing. In her pocket, her fingers felt the fluted edge of the last biscuit the Thai soldier had handed her back in the forest. If she ate it now, what would she eat later? Sometimes, answers to a girl's questions came quickly. Siem's family was barely off the bus before they were into the queues for their own gleaming plastic sheet, a new, still-creased sarong and shirt, flip-flops and food.

The UN refugee camp called Sakeo bulged with the influx of scrawny Cambodians. The logistics of suddenly settling, covering, clothing and feeding thousands never crossed the mind of pre-teen Siem. She was soon indulging herself in the heretofore perilous pursuit of the lost arts. Siem had seen older people do it, their eyes pulling sounds out of symbols on fish tins, rice sacks and paper of any size or shape. Reading. Here was some magic she was going to acquire for herself.

There were twenty–five to thirty children crammed onto some benches, elbows resting on long trestle tables in a makeshift classroom. Scribblers open before them, and lead at the ready, the students copied diligently as the teachers scratched samples of the simplest of scripts on blackboards. Some of the instructors were just a jump ahead of their pupils; their own educations had been aborted by the Paris–schooled Khmer Marxists. The 1980s were not the 1950s. Sons of rural Cambodian fish hawkers, like the now infamous Pol Pot, weren't imbibing socialism along the Seine. Instead, in a string of tent settlements along Thailand's eastern frontier, daughters of the dispossessed were starting school at ten or twelve, or fifteen, or not at all. Siem knew an opportunity when she saw one. She seized it.

School days began at eight o'clock. Clutching her highly prized notebook and the family's only pencil, Siem stood at attention as the teacher entered. She read by rote the names of the thirty–three Khmer letters, copied them, rose to recite them, and took her turn at the chalkboard pointing to each symbol and leading the alphabetic chant. There were mathematical symbols, too, with lessons in adding and subtracting, and, most down to earth, health class. Personal hygiene inspections were a daily routine. Trim and tidy fingernails were a must. Instructors urged preventative measures. "Wear shoes when you walk or you'll get worms in your feet." "Wash your hands before you eat." And most indelicate, "Don't shit wherever you feel like it. Don't piss in the street. Use the latrines."

Sometimes, the teachers would show public health films on Saturday nights. They would stretch out a white sheet at one end of the muddy soccer field and project colourful cartoons featuring battalions of starchy nurses vaccinating battalions of Thai school kids. The live Khmer language voice–over too rarely diverged into theatrical improv.

Not communicating communicable diseases in cramped and unsanitary conditions proved unrealistic. Sooner or later, one got sick. When the fever first struck, Siem reminded *Maq* of a movie mono-

logue about staying home to prevent the spread of disease, but ended up in the hospital tent for over two weeks. There was more to being hospitalized than swabs and injections. Siem adored the nurses, who plied her with mangoes and played games to amuse their little patient. Could she toss a lime high enough to pick up an array of chopsticks before catching the fruit in free–fall? Sympathetic visitors brought her ration tins; Siem stashed cans of mussels and spicy dried fish under her sleeping mat for *Maq*.

In the hot, humid months of 1980, the powers–that–be relocated Sakeo lock, stock and barrel. The new site, being engineered with more forethought and less urgency than the original camp, was equipped with far superior sewerage and sanitation facilities. When the Sengs were transferred there, Siem saw at once that Sakeo II was cleaner. The unsullied setting prompted people to tidy up, too. Not that environmentalism was a trend. Khmer were wary of any isms.

Siem was still most intense about school. The first day was consumed in registration, in book and pencil distribution and in administrivia. Uniforms, albeit second–hand Thai school stock, but white blouses and blue skirts nonetheless, were the norm. Siem began to see that learning was a lot about form as well as function. There was a code of conduct to adhere to and consequences for the miscreant. First off, any adult entering the classroom had to be stood up for, greeted with a *wai* and an appropriate chorus of *"Chum reap sur"*. Students were seated after guests left or teachers gave permission. Wagging tongues were outlawed. How could one learn if one were talking? Superior peripheral vision became an asset. Even turning one's head to glance at a seatmate was grounds for disciplinary action. Forget *habeas corpus*. To be accused was to be convicted. To be convicted was to be made an example of, to stand, to extend one's hands palms up, to receive the stick.

Siem preferred to be an example of exemplary behavior. She wasn't above a little competition to win the monthly prizes of pencils or hard–bound notebooks festooned with cartoon characters

and cutesy quips in English, which she couldn't understand. Doing her homework at recess one day, Siem overheard two classmates dissecting her brown–nosing techniques. "You're jealous!" she spat. Pol, the bigger of the two, didn't let up. Her maligning tongue grated until Siem jumped up and, clenching two pencils in her fist, stabbed Pol's arm. Pol's cries reached the teacher, who examined the victim's punctured skin and demanded an explanation from both girls. After hearing them out, he thwacked all complicit hands and sent them off to the school's director. Indignant at this perceived miscarriage of justice, Siem determined that she would show no emotion even before a higher power. She restated her case and added that Pol's pain was not her fault. Facing down his self–righteous little charges, the principal put on his brinkmanship best and announced that they couldn't attend the class if they fought. Siem played her trump, a sycophantic sorry—utterly hollow. When would enforcers get it? An apology extracted is an apology concocted.

Some months later, Siem's public obsequiousness paid off. From each school, a girl and a boy were chosen to represent their section in a performance of traditional dance. Ten grade three students were selected across Sakeo, and Siem was one. After regular classes wrapped up, the chosen few began exercises. Finger flexibility was crucial for proper hand positions. Siem practiced bending her fingers backward, double–joints curving gracefully upward. Toes too arched upward off the floor as the children balanced on the balls of their feet or heels. Posture was important. Knees bent and backs arched; firm little bottoms thrust out. The dance instructors were women who, in their previous, pre–Pol Pot lives, had had some connections to court and *haute culture*. They knew the repertoire of the palace performers, the cadences of Angkor and the legends of Cambodia's Golden Era. Siem's troupe became *upsara,* temple girls, of ancient Angkor Thom. A poor man, the story said, lived at the great temple, sweeping the sacred stones. As he swept, the little dancing girls stood motionless on one leg, heads

balancing tall tiaras. When the cleaner lay down to sleep, the dancers came to life, moving slowly, fluidly, melodically to traditional tunes tapped out on *sko'ah,* drums, plucked on the *pun,* a harp, and *tro'ah,* a traditional stringed instrument, the belly of which is a carved coconut. When the sweeper awoke to recount his dream of fabulous women, the *upsara* froze. Like a living mannequin in glittering garments and painted face, Siem felt so self–conscious under the gaze of hundreds who came to applaud the graduates of the teacher training program and to enjoy the accompanying performances. She felt much more confident when a pay packet of over two hundred *baht* was put in her pocket.

The money didn't appease *Maq,* who, rather than praising her daughter's accomplishments, discouraged dancing. To Siem dance was an honourable path and, without her mother's approval, she snuck out to further lessons. Encouragement from the teachers kept the children coming, disciplining themselves and learning new parts. It took a month or so of daily practice to master the roles.

The *robumbatpaka,* first piece in any traditional dance programme, calls for five girls. The first enters balancing on her extended fingers a silver bowl brimming with flowers. Two pairs follow, bowing on one leg, turning and taking blossoms from the bowl, then tossing them into the air. Jasmine, bougainvillea or frangipani petals float down around the dancers. Siem had been learning the *robumkuatrawlao* for a couple of weeks before *Maq* found her out. When the *upsara* strike two polished coconut halves together, the girls raise their eyebrows coquettishly. No daughter of Soy Tak would ever be on stage making eyes at every ogling male. At thirteen, Siem's dancing days were over.

Those were bitter days. It didn't take much to set *Maq* off. Sometimes the anger was directed outward, such as when a heavy–set man shoved Siem out of the ration queue; *Maq* tore a strip off him in her daughter's defense. At other times, the family felt the lash of her

tongue. Soan, who at twenty–two should have been bossing around her own children, in turn vented her frustrations on her youngest sister. Siem took to avoiding home. She hung out with older, orphaned classmates who lived together in another longhouse. The girls owned an intriguing picture book. Siem puzzled over an image of a man with many animal figures in his heart. An evil snake, a lazy tortoise and a dangerous lion lived within him. There was another illustration of a different man. His heart was home to good and helpful creatures, including a beautiful bird. These pictures struck Siem as peculiar, downright weird. The traditions of the *tonsa,* or horoscope, ascribed animal characteristics to every Cambodian based on birth time and date. Who could exhibit several natures? What made one gracious, affable, irascible or peevish? Siem brought the book home, but *Maq* wouldn't have it in the house. Her mother's reaction made Siem all the more curious. What beast was brooding inside *Maq*?

When Siem returned the volume to her friends, they listened to her story and fed her. Over a meal, the girls sympathized with Siem's mother problems, but what did they know? Their mothers were dead or had disappeared. "Come along to church," they suggested, but that would really have set off the fireworks, Siem knew for sure. She had seen a holy book Christians were giving away in Sakeo I. Its onion-skin pages made excellent three–or four–ply cigarette rollers. The foreign god whose story Siem's neighbours smoked was called *Pra Yesu*, a name *Maq* despised. Long ago when she was young, she told Siem, a family in her village had abandoned the spirits of their ancestors for that French god. The family prospered, but wouldn't share a thing with the monks who came calling every morning. They had spoken ill of the saffron–robed *sangha*. More despicably, they had placed a picture of Gautama Buddha on the ground, stepped on his holiness, and promised health, wealth and happiness to any who would do as they did. It was inevitable that they should pay for such sacrilege. Their daughter, beautiful but unavailable to the local Buddhist suitors, for-

sook her family's faith to elope with a village boy, an adherent of the Middle Way and therefore a true Khmer.

Romance, far from vanishing in the despair churned up by thousands of displaced souls, flourished. Love was the ultimate hope, an intensely individual fantasy sprouting incongruously in a mass of uncertainty. Acting on it was, in Siem's experience, a male prerogative. Siem had caught Suen's eye. He was a new neighbour; his family had recently been relocated to Sakeo from Kampot camp. An eldest son and over twenty–five, he knew his responsibilities, and his rights. Siem's older sisters' singleness stymied any immediate intimacy, so Suen had to be satisfied with girl–watching the unsuspecting four-teen–year–old from afar. He swore to friends he would wait for his be-loved. Passion soon overcame patience, though, and Suen composed a letter of love designed to capture Siem's heart. The letter was to be couriered by his sister, who took it into her head to steer destiny. The paper she discarded fell into the hands of jealous peers, who read into the one–sided affair compromised decorum on the young lady's part. To make matters right, Suen would happen by just as *Ba* was fixing a shutter or mending the thatch. His helpfulness drew *Maq*'s attention. She anticipated a visit from Suen's parents and prepared for bride price negotiations, not for Siem but for Soan. They never came.

However, other matchmakers did. With Soan's marriage to Pat, it was one down and two to go, but Suan's restraint was not rewarded. In July 1982, fate intervened. The Seng family was one of many trans-ferred north to Khao I Dang Camp near Aranyaprathet, Thailand.

Among the tens of thousands of Khmer were some fine, fine young men. Nga, tall and handsome, was nicknamed "movie star" be-hind his back by the giggling girls who befriended his sister. Momm sat by Siem in English classes that *Ba* paid for, and although he was a protective older brother, Nga didn't lean in over the window sills to keep an eye on his sister. Momm's presence made it possible for Nga to speak directly to Siem. He had a plan for them. With relatives in Aus-

tralia, resettlement there was a good possibility. In order to present an acceptable bride price, Nga told Siem he would escape from the camp, find himself a well–paid position in the underground economy and return to open negotiations with *Maq*.

At about the time Nga quit following Siem to and from school, *Maq* received a letter from her brother, who had been resettled in California. Uncle wanted to broker a marriage between a green–card–holding Khmer and his niece. This news upped the ante for local boys. Imagine, already in America. Already walking the streets of gold. Already sending greenbacks back to currency–starved refugee relatives. Bilateral matrimonial negotiations eventually buckled, despite the best service of the Royal Thai Post.

Meanwhile, twenty–three year–old Savy Vonn convinced his mother that if she was determined to find him a wife, it would not be, as she proposed, Soy Tak's second daughter but her third, the delicate one with the very fair complexion. Rumour had it that the pretty looks weren't matched by pretty ways. Neighbours warned that Siem had a mean streak. "She's often angry, even rude with her mother, moaning about the meals." Savy's father suspected that pot–stirring busybodies had nothing better to do than meddle.

The gossip didn't deter Savy. "I like a feisty girl," he assured his parents. "I won't marry anyone else."

Although the prospective groom had had his say, and would stick to it, Siem had no idea her future was being decided. The first bargaining session with *Maq* got off to a good start. *Maq* had seen the young teacher passing the Sengs' house in Section 3 on his way to school. His demeanor, his gait and his features all indicated a trustworthy character. Obviously, Savy was not without rivals. *Maq*'s starting position was three thousand *baht*. The senior Vonn*s* balked. "This girl is too expensive!" Jie reported to her son. But he didn't agree. The mothers resumed haggling.

"Sister," Siem overheard an uncle tell her mother one day, "I heard

that Section 3 has one daughter that's too expensive." Uncle's uncharacteristically cryptic message set Siem thinking. Whose daughters were marriageable? Soan now had her own husband. Kimsonn was engaged. Who was fifteen, sixteen or seventeen and single in Section 3? I am. Me?

The too–expensive daughter was indeed Siem. Her future mother–in–law settled on two thousand *baht*. One hundred dollars Canadian equaled ten months' salary at NGO wages. However, if one had remitting relatives or rubies in reserve, such a *tlay tuk d'aw,* or bride–price, was manageable. The mothers set the date—December 13, 1983.

Extreme excitement seized Siem. A hundred guests received hand–delivered, type–written invitations. A rented tent extended from the eaves of the house out into the road to accommodate them. They were all coming to watch her. This was her day to shine. In the shadows of her mind, Siem began to wonder, would her husband be enchanting? Enchanted? In a flash of fear, it occurred to her that he might not love her. Maybe he already had a first wife. Quite possibly he would take a mistress. Marital bliss certainly wasn't obvious in Khao I Dang. Even happily married couples never flaunted affection. No self–respecting woman would let a man touch her in public. Why, spouses didn't even walk up a street side by side, let alone holding hands. What physical contact Siem had observed between wives and husbands was all abusive. She had seen neighbours riled by the discovery of another woman. Engulfed in the shame of having inadequate allure, they would launch a shrieking assault of foul language and flailing limbs. Kicking, spitting and hitting, battering sticks and black eyes were common.

On that December day, eyeliner accentuated the languid eyes which passed disinterestedly over Siem's face and figure. It was show time; Ra, the female–painting, male–preferring make–up artist, had arrived. Behind a curtain, his helpers got Siem out of her everyday clothes and into an elaborate, gold–flecked silk suit. The sleeveless

blouse hugged her snugly. Metres of red and gold were draped around her hips and thighs, then twisted between her calves into a tail that tucked up into a belt of gold at her back. *Ra* attached hair extensions to thicken her waistlength tresses and created a coiffure to rival the best bouffant. Tiny yellow petals and itty bitty plastic roses were affixed to the do. Faux gold armbands complemented the belt. The bride, everybody agreed, looked divine.

Three holy men came to bless the couple twice. Neither Friday night's sermon nor Saturday morning's message made much sense to Siem. The monks chanted in rich but unintelligible Pali tones. As they spoke, Siem sat still, palms together, fingertips resting on her scarlet lower lip. Liturgy concluded, the party seated the groom on a sarong–draped stool. Siem knelt before him as someone put a cigarette and lighter into her hands. She wondered what he looked like, this almost–husband of hers, but she couldn't bring herself to lift her eyes to his face. His hand brushed hers, helping to guide the cigarette between his lips. Siem noticed his black suit and tie, a white cloth spread over his knees and brilliant yellow socks. Grasping the lighter in both hands, she concentrated on the blue flame until the tobacco began to burn. She felt on fire. Someone took the lighter. Someone else settled the bride beside the groom on the dias.

Now was the time for *ambah saw*. Honoured guests, relatives and family intimates approached the couple to tie white or pink strings around their wrists. As the threads were knotted, money was placed in an ornate silver dish and advice was offered. "You must love each other forever." "You must be patient." Khmer voices mingled with Thai and American as Savy's workmates took their turns greeting the groom and winking at the bride. Siem couldn't understand their words or read their faces, which seemed outrageously smiley for such a solemn occasion.

Outside, borrowed tables had been set up under the canopy. Guests were consuming mountains of noodles bathed in coconut–

milk–enriched chicken curry, washed down with homebrewed rice wine. The wedding couple inched their way from table to table offering cigarettes, exhausting several lighters in the process, and *waiing* until Siem's fingers tingled from insufficient circulation. Guests pressed *baht* bills between their palms and thumbs. The foreigners were generous; at their table, Siem noted more purple fifties and red hundreds given to the girl with the silver bowl who collected the gifts on behalf of the bride. When all were greeted and fed, the party wound down. Friends stayed to clean up and dismantle the tent. *Ba* had divided the family sleeping room into two with woven screens. The smaller section, cordoned off, was for fifteen–year–old Siem and this husband of hers. A little privacy was in order; it was their wedding night.

Marriage yielded immediate consequences. Whereas previously Siem had had only her own dirty laundry to do, that very first morning she was expected to scrub for two. "If I'd known this," the newlywed muttered to herself, "I wouldn't have married." Her husband's small wardrobe couldn't stretch past a two–day delay, and like it or not, the duty was Siem's as Savy went off to work. *Maq,* too, had new demands of her. The onus for cooking for the entire household suddenly fell to Siem; *Maq* wouldn't let her make her own home before she could make an edible meal.

Then there was the matter of bearing responsibility for others' happiness. Suen, the Sakeo secret admirer, passed in the street with the longest of faces. As if she, not he, had made his fragile feelings precariously public. And at the soup stall in the market as Siem stood in line for a bowl for sick–at–home Savy, Nga appeared, seething with unrequited love. "One month I was gone," he bellowed as all heads turned, "and you marry another!" Siem's back stiffened. She bore her soup bowl home, brooding.

Siem and Savy had some serious decisions to make. Thailand's country–of–asylum courtesy was far from a permanent offer for the tens of thousands of Khmer, Lao and Vietnamese who washed over

shared borders or onto Thai beaches like a human tsunami following the earth–shaking "liberations" of April, 1975. *Maq* wanted to keep her brood intact, but Savy dared to differ. His new bosses at the International Committee on Migration organized documents and air travel for refugees screened in by the major players: the USA, Australia, France and Canada, as well as New Zealand, Japan, England and various northern European nations. Savy had his ear to the ground in one of the most informative offices in Khao I Dang. He knew only too well that Cambodians of a certain age from certain provinces were, by association, tainted as Khmer Rouge. Savy's youth, his urban education, his competence in English, and now his marital status made him imminently more acceptable to foreign embassy immigration officers than his in–laws. Waiting for an extended family mass migration might mean waiting in vain. Savy was convinced he and Siem should resettle first and then sponsor her parents. Siem figured they would go to America. Savy spoke of Canada. "Too cold," Siem sulked. She had seen chilling pictures of Cambodians awash in snow.

"They were outside and they didn't die." Savy struggled to convince his wife.

"I suppose we'll never eat real Cambodian food again." Siem spun excuses from every rumour she had ever heard, yet expected her husband to make an executive decision.

Expedited by friends at the Intergovernmental Committee for Migration, Savy's application to the Canadian embassy resulted in an interview in May, 1985. Siem heard her husband's name being broadcast over the camp loudspeakers in a list of many other hopeful applicants. A week later, the couple boarded a bus for the ride into Aranyaprathet. Siem peered at soldiers at checkpoints along the way. They sauntered out of roadside huts to raise or lower red and white barricade poles as the bus rumbled southward. Siem admired the orchards of papaya and mango they passed. She suspiciously scrutinized ethnic Khmer living freely in the Thai town.

One Canadian plus a translator welcomed Siem and Savy to the twenty–minute interview. The *barang* spoke softly and politely. His voice surprised Siem, who recalled that the American who had interviewed *Ba* two years earlier had barked out his battery of questions rather abruptly. This man turned to Siem. "Why do you want to go to Canada?" he inquired through the interpreter.

"I want to go because I like your country. It's a very nice country." Siem hoped that was the right answer.

"How do you know it's nice?" The Canadian pressed her.

"Friends have sent pictures. It is beautiful. They told us it's safe there."

"Yes."

"Yes." Siem and Savy received life–altering approval in a little, whitewashed room on a nameless street in a town on Thailand's eastern fringe. Disembarking back in Khao I Dang that afternoon, a deluge of "Pass?" "Fail?" queries crested over the bus. Siem forded the crowd with her seven–month belly.

"Pass," she said to *Maq, Ba,* Pheap and Pheak, suddenly realizing that her first–born might not meet his grandparents or uncles for years, if ever. Nor the aunties. Although Soan, Kimsonn and their husbands were being processed for resettlement too, Siem and Savy were the first to be accepted. The first to leave. Within two weeks they would be transferred to the Transit Camp closer to Bangkok.

Nothing occupied Siem's mind but the inevitable separation. Her brothers were still so young. Would they remember her? Her parents were getting older. Would they manage without her? How could a daughter do her duty long distance? There were no parties, no celebrations, to mark this significant step out of alien–ness, only goodbyes, endless goodbyes, it seemed. And then tears, unstoppable all the way from Khao I Dang to Phanat Nikhom. Her only present family then was Savy, the father of this baby within. Thoughts of little ones brought her last sight of Pheak to mind. Born in the border camp, was

this precious baby brother to pass his entire boyhood behind barbed wire? Such speculations set off another bout of sniffles, which Savy, compassionate as always, attempted to soothe. Comfort didn't come easily.

Westward: The Name–to–Go

L–16. European letters and figures stenciled onto graying wallboards directed Siem, Savy and the other new arrivals to assigned quarters in the Transit Camp. Phanat Nikhom was much smaller than Khao I Dang; in 1985, there were far fewer than the maximum 25,000 residents. It didn't take long to locate the building that would be home. Three households shared the thirty–square–metre structure. There were no interior walls, so the Cambodians hung makeshift curtains from rafters, creating three rooms, each with a door and a window opposite. Savy didn't want pregnant Siem sleeping on the concrete floor, and within a week scrounged up bamboo and scrap materials to build a bed. Other housekeeping necessities, such as a cooking pot, were borrowed from a depot stocked by Food for the Hungry. The newcomers collected these supplies upon arrival in the camp and would return them prior to departure. By 1985, the centralized kitchens and pre–made–meal–dispensing of the emergency era of Thailand's refugee crisis had devolved into greater individual responsibility.

Siem felt lucky to have good neighbours. Even the couple with three children next door to the left, and the family with five beyond the curtain to the right, kept their kids in line. There wasn't much squabbling and nights were quiet.

Siem was having increasing difficulty sleeping, though. After sunset around seven, there wasn't much to do in the dark but go to bed. Like clockwork, Siem's bladder would wake her about eleven. She would roll over, find her flip–flops and shuffle across the yard formed by four houses to the communal latrine. Inside the little cubicle of

corrugated metal, Siem's system wouldn't cooperate and she would go back to bed for another restless night. *Maq* had advised Siem that before the baby's birth she would feel the need to visit a toilet, and so this nocturnal ritual inevitably led to wondering if delivery was imminent. It was during such a toilet trip in July that Siem's water broke. An elderly neighbour lady overheard the kerfuffle and announced that the baby was on his way. A blanket and bamboo rod stretcher was offered, but Siem did not want to be carried all jiggly and vulnerable in others' arms. Under her own steam, she set off at a fast clip for the camp gate. The soldiers on night duty helped her into a truck but held Savy and their neighbours back.

It was a lonely three–minute ride across the secondary road to the Catholic relief agency hospital in "Chonburi", the name Cambodians gave to the Processing Centre of Phanat Nikhom. Contractions were intermittent but the three Cambodian nurses, one man and two women, equally without personal experience in birthing, crowded around. The women, both single, seemed to have little understanding of pregnancy and even less of bedside manner. "*Bong Srey*," one commiserated as Siem moaned, "I wouldn't want to have a baby."

"*Jaah*," Siem answered. "This is agony. I don't want babies. I hate babies." Siem knew next to nothing about childbirth. She would need to push. Pain was the inevitable lot of women. Before they had been separated, *Maq* had explained that much.

The nurses wiped her face with warm, wet cloths. When Siem said she was going to die of hunger, they brought her some rice soup. As her abdominal muscles thickened and shortened, the nurses would stand on either side of her and press their hands down her belly. A doctor, a Thai woman, appeared after about an hour, along with an American physician. He was the one who performed the episiotomy, which eased Siem's son's *chhlong tonlé*, his crossing of the sea. The boy looked very long when the doctor held him up to Siem, who thought, "Oh Baby, I hurt so bad, it's infuriating." The nurses cleaned

and wrapped up the infant while the doctors completed the operation. *Maq*'s warning hadn't prepared Siem for the pain as she was stitched up and as the surgery healed. A night of contractions, a month of recovery, days of dizziness.

When Siem woke to the world, it was about six in the morning. She was lying in a ward with fifteen other women. The baby was tucked in beside her. A new nurse stepped up and said Savy was waiting outside. He hadn't slept the night of July 10 and, as early as was acceptable, had awakened someone authorized to issue him a pass with which the guards would permit him to cross the highway to the hospital. It occurred to Siem that she didn't know of any other Cambodian who possessed such a pass. Savy's document said he could stay even past the eight o'clock curfew. Indeed, he stayed the night, sleeping at a friend's house. In her woozy, postpartum state, Siem pondered her husband's power. Every visitor commented on how lucky she was—a healthy son and such a good husband. People brought or sent meals to the hospital during the two weeks Siem stayed there. They came oo–ing and aw–ing at the infant with that intensity only babies bask in, as they credited particular body parts to his mother, his father, or a grandparent. When Siem first looked into her son's face, she saw her full lips and Savy's shapely head. Naming their son was up to Savy, who liked a suggestion from a cousin and chose Sytha.

When she got over the first few days of disequilibrium and some scary falls, Siem realized Sytha had nothing to wear. "Honey," she said, "You need to buy some clothes," and sent Savy off to the camp market. Although there were Cambodians who dressed their little sons in whatever was available, including girls' wear, Siem was miffed at the frilly outfit Savy brought back. What little infant clothing she had stored in her boxes was rather feminine; like other Cambodian mothers, Siem felt a first–born daughter was a blessing because she would soon help around the house or with subsequent siblings. Even such preparation as Siem had made was tempting fate, others had cautioned.

It seemed a preparatory state of mind was as ill–advised as material readiness. Siem had received no pre–natal training and now got no lessons in baby or self care. She should breastfeed, she was told, but not how or why. Learning by doing worked for some, but listening or looking to learn would have helped Siem.

On the July day when Savy got an NGO driver to bring Siem back across the road to the Transit Centre, L–16 was full of neighbours and friends. Some brought gifts for Sytha and everyone offered best wishes. Over and over again, Siem heard people speaking about her. "Siem is SO lucky," they said, watching Savy tuck Siem and Sytha up in a blanket as the sun went down. The crowd didn't thin until long past the curfew and many were back the next morning. How could happiness be experienced alone? To enjoy was to be joined in joy.

One almost perpetually happy place was the Canada School, a house converted into a classroom and office for the Mennonite Central Committee, which recruited and supported Canadian staff. During cultural orientation, Siem watched slides of store scenes with delight. Bartering gave her a bit of a buzz in any situation, but those vast, indoor markets were something else. The volunteer teachers showed stoves and other appliances to the students in Siem's class. A translator tried to explain how to open gas burners or turn on electric ovens to women who had always squatted over three stones to cook. It was all rather fantastic.

While Siem was taking flights of fancy through carpeted apartments, Savy's Aussie bosses at COERR were trying to convince him to transfer his resettlement destination to Australia. They were very well–meaning, but once Siem received a letter from her sister, Kimsonn, announcing she had been accepted by Canada too, there was no changing of minds. The sisters would be together again.

With two–month–old Sytha on her hip, Siem stood waiting at the Phanat Nikhom bus shelter. It was a large concrete pad lined on two sides by cement pillars supporting a high metal roof. The roof kept

the rain off refugees waiting interminably on airport departure days or for arrivals from border or seaside camps as they listened to the official welcome–harangue. Siem scanned the Khao I Dang buses for Kimsonn, her husband Sarun and Nara, cousin to Sytha. The reunited sisters clung to each other, happiness coursing down their cheeks and dripping off their chins.

One morning not long after Siem helped Kimsonn settle into her quarters, Savy sat on their stoop scraping soot from a pot with a cleaver as the Thai national anthem was being played over a loudspeaker. A Vietnamese, an enforcer for the Ministry of the Interior, came into the quadrangle and spotted Savy. "What gall!" he berated Siem's husband. Accusing him of not standing in honour of King Bhumibol, the Vietnamese hauled Savy off to jail. Phanat's jail was a low–slung set of buildings fenced and guarded in the center of the camp. MOI, which managed refugees under the titular administration of the UNHCR, was responsible for law and order. Among 18,000 illegal aliens with no exposure to the rule of law, there were some who followed orders, some who were seen to do so, and others who were not. There were also a number who saw some benefit in reporting what they had seen.

Siem stood outside the lockup all morning, wondering what was happening inside. Although she had never crossed that threshold, it was a given that correction was corporal. Various unlicensed practitioners used psychological methods, too.

When Savy emerged, he not had lost his thick, wavy shock of hair to the usual shaving. A whip–equipped guard herded Savy and some Laotian guys along a ditch, which they cleaned, picking litter and pulling out stalks of grass. Siem couldn't help sobbing at the humiliation of her husband. "If that Thai soldier strikes Savy," she thought, "he might as well hit me and Sytha." Siem stepped closer. Savy noticed her and told her to go home.

"It's too hot for the baby," he said. Friends called Siem to come away, but she stood and watched. She learned the Vietnamese stooge

had accused Savy of wanting to kill him. She fumed at the memory of her husband, charcoal–covered hands behind his back, being led away. That Vietnamese did not know whom he was dealing with. When the Thai jailers questioned Savy, he didn't need a Khmer interpreter, but answered respectfully in the language of the land. Furthermore, his *farang* advocates came in handy; Savy's Australian boss showed up at MOI's office pleading his case. After five hours, sufficient time had lapsed so as to maintain face for the Thais. Savy was released, Siem relieved.

Freedom can be a frightful thing. In November 1985, fear loomed large. It took the shape of a piece of paper, stapled to the ICM bulletin board. The departure date was to be the thirteenth. Typewritten letters spelled "Vonn Savy…YEG." The *name–to–go*. Out of the jail, but in a camp. Soon to be out of the camp, but in the air. Then quickly out of the air, but into winter. There were two other Cambodian families' names posted there in black on white with YEG to the right. Diep Sophon was a solid man with a self–controlled wife, Ly Pho, and three daughters. Run, the wife of the second, Prum Saroeun, a reticent fellow, had a sister and brother–in–law already resettled in this place they called *Emmondon*. Some other friends had gone to *Hammordon* last week. *Emmondon, Hammordon*—with variations in Khmer provincial accents, they assumed they would all be neighbours within days. In reality, Hamilton was almost three thousand kilometres away from their Alberta destination.

Preparations were minimal. There were house wares to return to Food for the Hungry. Some free clothing was distributed by Youth With A Mission. Siem bought a new cotton sarong in the market. She decided against wearing it to travel, though, and put it into one of two big cardboard boxes. She paid another refugee fifteen *baht* to waterproof these in blue plastic secured by pink plastic string knotted into netting. Thoughts of departure set off tears often during those last days. Siem really had no idea what she was going to; her mind was full

of what, who, she was leaving. On the twelfth, Siem, Savy and Sytha ate a last supper with Kimsonn's family. That night, ten to fifteen households slept together on the floor of a large hall, their water–proofed boxes labeled Vancouver, Saskatoon, Calgary, Winnipeg, and Edmonton in big, bold black letters.

At daybreak, the last refugee camp Siem has ever seen was lost from sight. The bus rolled through the hamlet of Gapo. Around mounds of hay, water buffalo stood, moist muzzles raised to the rising sun. The bus rumbled through the town of Phanat Nikhom. Along a lane, silent monks padded barefoot, bowls tucked under an elbow. The bus roared past the provincial capital of Chonburi, out of the shadow of Monkey Mountain, bright waters of the gulf glinting to the west. About her, the vistas of Asia became a blur. The present paled before tomorrow's terrible unknown. "Oh *Maq*, *Ba*," Siem petitioned the spirits of her parents some two hundred kilometres to the east. Help me." For so they had. That woman and that man who had given her life, had guided her into a place of asylum. Now she was leaving, going on to a place they had only dreamed of, the third country.

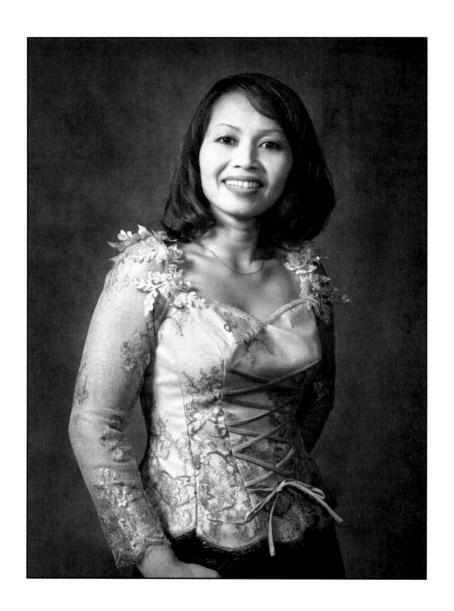

NOT YET WEST: DREAMING OF A THIRD COUNTRY

Curiosity overcame exhaustion. Although she could hardly keep her chin from flopping to her chest, Kimsonn stared in wonder at the woman on her left, then tipped her head to gaze at the man on her right. They had slipped their thick and hairy arms around her bony back and held her by the elbows, helping her totter unsteadily off the bus and through the field, already churned by thousands of feet into a potage of puréed clay. His nose rose like a mountain ridge above a bristly moustache. Hers, aquiline, mesmerized Kimsonn as the woman smiled and emitted unintelligible though unquestionably gentle tones.

The buses disgorged their miserable cargo, people of all ages invariably malnourished and ill, in hundreds of cases within hours of irreversible collapse. The skies were dripping pathos, adding to the mire with inevitable cloudbursts. Though the clouds were gray, the field, newly clear–cut by bulldozers still snorting on its fringes, seemed to Kimsonn gloriously bright and airy after months in the forest. Looping around pre–dug latrines and sewage ditches, a sea of

skinny souls were erecting tents with blue plastic sheets and bamboo poles. Kimsonn's parents were allotted a place, two metres by one-and-a-half; the six of them could all lie down at once if they wished, in the mud. Kimsonn squatted outside the flap of a door watching several people approach pushing a wheelbarrow of cylindrical tins and another of rice. They measured a cupful of rice per person and handed out several cans at each shelter. *Ba* got six. Following the example of those before them, he punched a ring of holes around one end with his knife and pried off the lid. Fish. Imagine that! Kimsonn had had fresh fish before or none at all. How on earth had those people managed to catch and cram so much seafood into tiny tins? *Maq*, meanwhile, found three stones, arranged a hearth and set the rice boiling. Salted! This was heaven.

Even after sunset, light blazed from fluorescent tubes strung up the street beside the hospital tent. That was a ten-minute walk away from Kimsonn's shelter, but she could see shadows shimmering within it. The next day, Red Cross personnel continued their tarp-by-tarp assessment. A Khmer-speaking Thai translated *Ba*'s replies as a "long-nose" jotted down vital statistics and took a brief family history. In the distance, people queued up at the hospital according to directions broadcast over a loudspeaker. When Kimsonn's turn came, she shuffled inside. Tall, short, fat, skinny; blue eyes, green, brown, black, round, almond, slim slits; curly, kinky, poker-straight hair coloured improbably yellow, all shades of brown and red, fake for sure, and skins of every hue, too.

There were Japanese and Filipinas among South Asian, Arabic, Afro-American and aid-workers of European descent. One of them took Kimsonn's temperature, dispensed some capsules and kept her under observation for a time. That second night, Kimsonn couldn't sleep. Her heart pondered deep questions. Why had these people come here to help her? Why spend so much on practically lifeless paupers? Where had they come from? Maybe *Ba* was right. Perhaps *Siemetrei*,

Lord Buddha's prophesied Lord of Love, had intervened.

Within days, Kimsonn felt strong enough to take her turn collecting the family's rations. Entrusted with the valuable yellow card issued by the census–takers, she made her way up the line that snaked around a large truck. At the head of the queue, someone examined her card and impressed a red stamp on her inner forearm. On other days, in other weeks, the ink would be blue or black. Three hollowed coconut shells full of rice were measured into her basket and a fairly fresh fish, packed in ice, was chipped out of a block and passed to her. Frozen slivers melted on Kimsonn's fingers. Too cool. Like the blast of arctic air from the refrigeration unit that served as the morgue. The hospital fascinated Kimsonn. How she yearned to work there now that, against all odds, her health was returning, while floods, fever and other diseases rampaged through the encampment. This was the reality of Sakeo, housing within days of opening in October 1979, nearly 30,000 illegal immigrants, aliens, refugees.

Conditions eased over the weeks. Construction began on long houses—five three–by–two–metre rooms for five families. Able crews framed a building, then the assigned families set about thatching and siding the structure. Kimsonn watched her elders before trying her hand at weaving elephant grass into thick, rainproof panels. They had a roof over their heads in two days' time.

The Cambodians received assistance in organizing a primary school, craftworks and recreation. At fourteen, Kimsonn was deemed too old for basic literacy classes. She started loitering around the windows of an NGO office where teenage girls were turning out bouquets of vividly coloured cloth flowers. "Come on in!"

"Me?"

"You."

"With pleasure." Kimsonn spent about three hours every morning among her newfound friends. Some lived with a parent, siblings or perhaps both. Others were orphaned but had been taken in

by foster families. Under the care of a Cambodian translator and an American, Judy, the dozen or so girls wove baskets, mastered knitting and even made cookies together. Their activities began with the students queuing at the door and filing in past the women. The girls pressed their palms together in a polite *wai* and greeted the honoured instructor with a proper "*Cheum rep sur, Look Kruu*". Soon the Cambodians were chattering away or sometimes singing folksongs. Judy tried in vain to transmit some basic knowledge of English. The girls invariably burst into giggles if singled out for conversation. Kimsonn loved the soft up, up, down, up, down irregular rhythms of this foreign language; it was much smoother than the rapidfire staccato of mono-syllabic Chinese or Vietnamese. She enjoyed listening to the sounds that trickled over the tongue like a babbling brook when Judy tried to teach some baking vocabulary. Enchanted by her blue eyes, her definitive nose and her entirely unauthoritarian tone, Kimsonn joined the others in blatantly rating the foreigner's looks and gestures even in her presence. Judy was none the wiser, though, because the circumspect interpreter preferred to expand her own English competence rather than thoroughly translate gossiping girls.

This rather eclectic exposure to English continued during the mid–day heat when a friend of *Maq*'s, a high school graduate no less, regularly read to a roomful of dozing adults and snoozing kids. Kimsonn invariably rejoined her parents to be entertained by the antics and misadventures of *Aboulkesen*, a Cambodian folktale character. Bou Roeum's expressive voice carried Kimsonn into this antihero's world. His lively interpretations made the miserly character out to be such an ass. Kimsonn couldn't imagine having all that wealth squirreled away but not parting with the few pence necessary to replace his decrepit shoes, in one of many adventures.

Owning neither shoes nor sous, Kimsonn endeavoured to acquire both. Her handiwork—baby booties, mitts, caps and sweaters—initially cost her nothing in capital outlay; the classroom supplies kept

her in stock. Kimsonn's even–handed, perfectly purled outfits pleased many eyes. She could collect about eight *baht* a piece and needled away late in the evening to cash in on the demand. Kimsonn knew better than to ask her parents for money they didn't possess, but happened to be in the right place at the right time to benefit by another authority's largess. In an inordinate display of organization, the camp administration distributed school uniforms to a battalion of ragged Cambodians in advance of the arrival of a most honourable visitor—an American First Lady. For a week, Kimsonn simply admired the permanent pressed white blouse with its left breast pocket and the knee–length pleated navy skirt. On the day of the event, she and countless others emerged in their newfound finery, flitting about like butterflies free of their chrysalides. "They're coming. They're coming!" Row upon row, diminuative first–graders in the front, on up to sprouting adolescents, Cambodian children lined both sides of the road from Sakeo's gate to the office of the Camp Commander. The first of five black sedans turned in. In every tiny hand, the red, white, blue, white and red bands of Thailand's regal standard waved excitedly. Tinted windows masked the dignitaries. Spontaneously cheering, Kimsonn strained to see past the host of serious soldiers who lined the route. It was almost beyond belief that the great would honour the likes of her with their presence. All too soon the entourage swept past them once again, away from the children, out of the camp but not out of mind.

Much later on, another visitation provoked a lot of thought and even more talk among Kimsonn's friends and family. A stage had been assembled; everyone suspected someone was coming, but as usual no one who knew told anyone who didn't. And Kimsonn was one who didn't. She didn't know whether to gawk or hide her face in surrogate shame when the Japanese youth descended from their air–conditioned bus. Both boys and girls were clad only in sleeveless shirts and form–fitting sports shorts, a combination which amounted to underwear in Kimsonn's estimation. Impoverished she and her companions may

have been, but no one could accuse them of immodesty. Unaware of the stir they were creating, the Japanese bounded up on the platform. After an appropriately convoluted welcome, the troop engaged in heretofore unimaginable gymnastic fortitude. To a toe–tapping beat, lithe young bodies flipped and flexed before a rapt audience. Though hardly sensuous, male–female holds evoked gasps and giggles of sheer embarrassment. Kimsonn had never seen her parents, nor any other couple for that matter, touch. The absence of public affection was not merely a matter of decorum. Displaying desire was antithetical to the Middle Way, the Buddhist way. All in all, it was the most erotic after-noon Sakeo was ever to witness. What the refugees had seen or heard about set tongues wagging for weeks.

Scuttlebutt had it that a major move was underway. In fact, as the Supreme Command of the Thai military and the international aid com-munity got a handle on the crisis along the Thai–Cambodian border, the chaos of 1979–80 was becoming a managed medley. The world's shortlived attention–span thrust Thailand into a self–defensive stance. A plethora of policies evolved: voluntary repatriation, resettlement, local settlement, relocation, and humane deterrence, all designed to reduce both the number of illegals in the country and the countless who came to consider Thailand their conduit to Gold Mountain, that mythical epicenter of prosperity whose waves of remittances had been washing back over East Asia for generations.

Sakeo residents were moved en masse in July 1980. They remem-bered their first refuge, erected in the emergency, now rickety and un-sanitary, as Sakeo *tee–moui*, number one, and called the new camp Sakeo *tee–pee*, number two. Without a tidal wave of wasted humanity crashing its gates, Thailand was able to provide a planned and better policed sanctuary for the displaced Cambodians. Kimsonn was down-right astounded at the concrete pad floors poured for houses, clinics, schools and offices. Solid walls, corrugated sheet metal roofs and even some access to electricity made this place up–scale. The refugees ar-

rived in well–coordinated stages. Trucks ferried designated families and their belongings about thirty minutes from the original camp.

There were new procedures to adapt to. Rations, for instance, were distributed once every two weeks. At an assembly of household heads, *Maq* and *Ba* learned each group leader would report to the Thai Red Cross to verify the mouths per family. On a prearranged day, at a specified time, one designate would present her family's ID papers in order to pick up rice, fish or chicken, vegetables and sundry supplies. A quantity of rice was counted out; there was always more than enough for fourteen days. Bok choy and other greens were eliminated once the camp garden plots began to produce onions, chives, chilis and more. Keeping ten palm–sized fish fresh was impossible of course. Some *Maq* would coat with salt, pepper and sugar before steaming. Others she scaled and rubbed with spices and citrus juices, covered with cheese cloth and hung to dry in the sun. Cooking oil, salt, soy and fish sauce were guarded in bottles refilled once a month.

In all this effort, *Maq* called on her daughters to help. Kimsonn returned from her mornings in school not at all happy to do housework. Her elder sister excelled in tailor training and soon became a teacher of others. In the evenings, Kimsonn cut and handstitched holes or sewed buttons on double–layered blouses which Soan made to order for women who managed to buy fabric on the black market. Business boomed as the Cambodian New Year approached. Everyone who could would wear new clothes on the thirteenth and fourteenth of April. The sisters sat up all night, sewing by oil lamp light, to finish off long–sleeved blouses, flowery lace over synthetic bodices buttoned above the clavicle in vivid fuchsia, lemon, aquamarine or tangerine.

Saffron–robed monks were highly visible at the New Year. They made their daily circuits shortly after dawn, pausing at doorways to receive merit–making meals in their bowls. "Offer some," *Maq* would say, thrusting an aromatic curry toward Kimsonn. But without exception Kimsonn would refuse. These monks were young, perhaps her

age. Why bow to such as these? She hoarded honour for her elders. Certainly she held none for the horny, hairless ones she had seen eyeing, even ogling, round–bottomed girls sashaying past in sarongs Calvin Klein could not have wrapped tighter.

"I don't have time," Kimsonn would say to *Maq* who dismissed the gossip—monks disrobing when darkness fell, to rendezvous with coy creatures of the night.

Kimsonn was decidedly cynical when it came to religious rituals. She never knew what to say when incense was lit. No common prayers had been taught her; she understood not a single word of the priestly chants performed in Pali. That Prakrit link to India and Ceylon's mystic isle meant nothing at all. The *taybada* spirits to whom *Maq* uttered all manner of requests had no hold on Kimsonn's heart. During the war, she remembered her parents kneeling to life's essence, smoking sandalwood sticks shaken between their palms. They prayed for peace. But bombs fell. In the forest, wretched and starving, they petitioned for provision. Yet brother Cheuy perished. Angels were entirely immaterial to Kimsonn.

In April, altars to the divine, incarnate in earth or sky, or to ancestors, adorned the entrances to almost every house. Joss–sticks burned before offerings of fruit, colas and scented rice. *Maq* prepared tangy salads and savory noodles which she donated at the temple. Kimsonn tagged along and joined traditional New Year games. There were rounds of *angkuang*, an archetypal Pac–man she remembered from pre–Pol Pot times, in which two teams aimed to eliminate each other vicariously by blasting their stash of seedpods from the tree of the same name. Five on five tug–of–war required the conquered to reward the victors with candy or balloons. Circles of *drop–the–krama* expanded or shrunk as participants morphed into spectators or vice versa. Youngsters from the school of dance wowed the crowds with a fluidity of form unparalleled. The audience stood long into the night, mesmerized by the dancers, charmed by musicians and lost in the drama on-

stage. Dazzling fireworks brought the enchanted evening to a close.

At other times, looking for some diversion, Kimsonn wandered around the fish farm. The fish were feeding, surfacing, wolfing down a meal tossed out by a man making rounds along the banks of the reservoir. On a billboard Kimsonn once noticed a sign announcing upcoming registration for a weaving project. Some old ladies welcomed her as she entered the workshop. She could begin the next afternoon.

The looms were arranged in two lines, five on each side of the long hall. Under the tutelage of the grandmas, three girls teamed up to thread each *kai tabahng*. They looped skeins of coloured cotton lengthwise into a popular plaid pattern. A repeating warp of five black strands, two yellow, three green, five red, and two white was prepared for a crosswise woof of the same hues. Kimsonn worked the metre-wide loom, pulling the shuttle in her left hand and raising and lowering a harness with her right. Once she and her teenage co-workers got the hang of it, they loved weaving. From a set of skeins, they produced about ten *kramas*, which were cut and hemmed as a batch. Amid the bup-bupping of the shuttle, the girls talked and joked together. Kimsonn would have stayed all day, but had access to the machines for only two-and-a-half hours each afternoon. At the end of the month, she received her wages. One hundred and twenty *baht*, six American dollars. The first pay day, Kimsonn set aside sixty for her mother and wandered down to the market. She fingered sarongs and watched a silversmith shape a chunky bracelet, intricately embossed. Kimsonn parted with only a couple of coins. The salty shrimp chips tantalized her tongue, but Kimsonn intended a better investment.

Rith was a genuinely ingenious entrepreneur. An agency staffer by day, he wired his house and offered electrically-lit evening English classes. For fifteen *baht* a month, Kimsonn could study every weeknight. Initially she shared a well-used edition of *Essential English*. Beginners borrowed or bought green and white Book One. Orange-tinted Book Two covered more advanced material. The text was

stock-in-trade for language learners across Southeast Asia. When she purchased her own copy, Kimsonn could continue memorizing at home the dialogues Rith decoded in class. His literacy lessons began with a student inscribing the Latin letters on a chalkboard. Rith would appoint someone to stand to name each character. Everyone seated on the floor would follow and mimic "ehye, beeye, seeye" and so on. Identifying the alphabet was one thing. Stringing consonants and vowels together was another. Kimsonn and her classmates read and reread Mr. Presley's patter. "Wah ee youa nayem?" "My nayem ee Kimsonn." Rith's grammar-translation techniques filled the margins of Kimsonn's copy with Khmer notes. "I am going…you are going… he is going…she is going…it is going…we are going…they are going." Rith was going to America. His name was on a list that counted. Within half a year, he got the *name-to-go*.

Kimsonn had heard of *Amerique* and of France, of course. The former looked absolutely fabulous in glossy photos friends received from cousins or acquaintances who had met resettlement requirements. The latter retained its allure for Cambodians who rarely cursed their former colonizers for schooling the Red Khmer in community-crushing communism. The United Nations High Commission for Refugees had been processing applications and funneling applicants through sponsorship, health and security screening since the Khmer Rouge regime had lost control. Was it collective guilt that spurred the G-7 and aspirants to throw billions of dollars at the sorry millions who had survived the genocide they had once denied?

Already disclaimers barred the way to the west. No relatives resettled? Ineligible for family reunification programs. No professional skills? Refused on economic grounds. No speak English? Rejected. Dejected. *Ba* couldn't speak a word of English, even though he had once acquired some French. *Maq* didn't read or write Khmer, let alone a foreign language. Kimsonn fantasized she had an elder sibling in Australia or maybe Canada. "Go to Canada. Go around the world."

The twangy tune wangled its way into Kimsonn's memory; a neigh-bour replayed his single audio track incessantly. But equally persistent was a sense of absolute hopelessness. Her parents had brought them to Thailand in utter desperation, knowing nothing of the massive mi-gration schemes. They had come for food empty–handed. Without an opportunist's eye or a smuggler's stash of rubies from the gem–rich ground of Pailin province, Kimsonn's parents would never qualify for a third country. Like father, like Sonn.

Among the more imaginative of Kimsonn's neighbours in Sakeo were those who bought and sold birthrights. Some well–connected to the west traded their *name–to–go* for a price. Through family–reunifi-cation sponsorships, Cambodians were interviewed and accepted by western embassies. Incredulously to Kimsonn, there were those who chose to sell their identity and its valuable kinship. Shysters and huck-sters collaborated to shuffle "uncles", "sisters", "mothers" and "hus-bands" of convenience to America and its allies in the place of blood relatives who made a killing in gold and gems and Jackson–or Grant–faced greenbacks. A dollar was a dollar. A Cambodian was a Cam-bodian. Maybe they all looked the same to visa officers who handled hundreds of claims. Kimsonn didn't know anyone who got caught in one of these concocted relationships. But then she didn't know anyone of consequence at all. At fifteen, the future looked very bleak.

Kimsonn looked mighty fine to Reth though. The young man with a thick mop of wavy, black hair couldn't escort an unchaperoned girl according to Sakeo's traditional strictures on the separation of the sexes. So he came calling. Reth dropped in daily, chatting with *Ba* or *Maq* while Kimsonn sat demurely, legs tucked to one side, toes hidden beneath her sarong hem. She made considerable progress on her knit-ting during those visits. Intense concentration on needles and yarn left little opportunity for conversation. What would a young lady say to a man she didn't know? The attention to Kimsonn did not please *Maq*. Soan, the elder by seven years, was still single. It wouldn't do

to have surviving daughter number two married off before her first-born. *Maq* said as much to Reth's emissary, dispatching him into that netherworld of humiliation peculiar to unrequited lovers.

Maq was easily provoked that autumn of 1981. She complained of abdominal ills but the standard remedies for stomach or bowel troubles brought no relief. Against Mother's protestations that she was too old, a midwife came prodding and poking. She pronounced there was no pregnancy and prescribed heat treatment: resting a wrapped, roasted rock on the belly. But a baby there was and his movements, familiar after eleven earlier deliveries, proved to *Maq* she wasn't yet of a certain age. Expecting a new sibling excited little Pheap and his much older sisters. In contrast to adults often overburdened with anxiety for the future or collectively depressed about their present powerlessness, carefree kids inspired hope. Where population planners saw worst case scenarios for child rearing, babies regenerated motivation to make the world a better place. For the sake of their posterity alone, refugees coped. Confucian duty ran deep. *Maq* presented *Ba* with a son, her first and last child born in a hospital. Kimsonn first saw her new brother there. *Ba* invested great faith in this wee one; he named him Pheak, "place of safety and security".

Suddenly it was a sure thing. The sanctuary the Seng*s* had found in Sakeo II was closed by decree. Fear of forced repatriation spread like wildfire along the border. Involuntary relocations had drawn criticism from the international community, which had accepted nearly 200,000 Cambodians. But an equal or higher number still remained on Thailand's eastern frontier. What was to become of those unwanted ones now in their third year on Thai soil? Uncertainty about tomorrow coupled with profound grief. Sakeo II had given Kimsonn a sense of permanence and of purpose. She had prided herself in having a job and in contributing to her family. Rumor had it the Sakeo population would be relocated to the biggest camp of all. But big wasn't better. Khao I Dang's buildings wouldn't match Sakeo's metal–roofed long

houses. Apparently there were no electrical lines from which to si-phon watts to energize fans or incandescent light bulbs. As the Thai military transports rumbled into camp, Kimsonn stoically found a place to stand. There was no joy in the journey. The destination was everything and, as in everything, it was predestined. When the trucks transporting Sakeo residents rolled to a stop north of the Thai town of Aranyaprathet, Khao I Dang engulfed Kimsonn.

The camp, whose population had peaked in 1980, was divided into sections constructed around central administrative and medical buildings. Each section contained its own office, water station and usually a primary school. A section was divided into two or three blocks. Every block included sixty groups. Each group held up to one hundred refugees. These refugees were housed in four–family units built of bamboo and thatch. The toilets were lined pit latrines. They stunk. Kimsonn was disgusted by the facilities, filthy compared to Sakeo's. Rust–coloured laterite dust clung to the belongings the family had brought with them, now in an unhappy heap on the dirt floor of House 3, Block A, Section 6. Kimsonn sighed.

Sleeping on the floor was not *Ba*'s idea of home. He and other heads of households learned from their group leader about stores of building materials. *Ba* devised natural lighting for the five–by–four–metre room by cutting a window in the long east wall and constructed a shutter, too. He built a bamboo platform, several centimetres off the floor against the south wall shared with the neighbours. It extended one–and–a–half metres into the room and served as the family bed; Pheap, Baby Pheak, *Ba*, *Maq*, Siem, Kimsonn and Soan each had a place along its breadth. Renovations also included a *bantuop som ngat*. Some parents excavated holes in the dirt floors masked by mats or kept an extra clay water urn for secreting their daughters; *Ba* built a false wall along the inner west wall shared with another family. There was standing room only in the foot–wide squeeze space, which was their hiding place. *Maq* was taking no chances. She had three virgin

daughters to deliver untouched to eventually approved suitors. *Maq* mistrusted the Thai soldiers who patrolled Khao I Dang; she feared the Khmer bandits whose nocturnal rounds robbed countless refugees of valuables and uncounted women of value.

Gunfire commonly punctuated the cacophony of camp. Not all vice slunk around at night. Supplementing survival rations motivated some of the smugglers; the lure of wealth in a revived market economy enticed others to risk life and limb slipping under, over or through porous barbed wire. Dried shrimp, sugar, cigarettes, ice cream, salt or *Singha* beer waited outside the jurisdiction of the UNHCR, where shrewd locals were quite delighted that *karma* had fated them to exchange such cheap sundries for rubies, gold or unspoiled girls or boys.

In Khao I Dang, anything could be had for a price. Accruing a medium of exchange was the challenge. During her first week there, Kimsonn purposefully set out job hunting. She asked at the soap factory, stopped by the aquaculture project and inquired about sewing. Kimsonn's certificate from the NGO in Sakeo opened the door here. Having a job meant being paid in kind, according to Thai Ministry of the Interior regulations. Noodles, sarongs, chickens, shirts or toiletries were listed at the sewing office. Machine operators could choose what they wanted at month's end in exchange for their labor. Kimsonn and her sister also began knitting at home. *Maq* sold baby booties for ten to twenty *baht* a pair. Cash came in handy. Classes cost and could generate money. *Ba* began teaching Khmer language lessons to children, teenagers and adults, but although Kimsonn had only rudimentary literacy, she didn't take advantage of free lessons. She couldn't foresee a need to read or write Khmer in Australia or America.

Kimsonn's confidence that a third country was in her destiny did not dim. The ICRC and the UNHCR urged KD number holders to apply to western embassies. *Ba*'s lack of English threw the family on the good graces of friends, who assisted in filing applications with the French, the Americans and the Australians. Canada was too cold,

Kimsonn's parents thought, but she had seen photos from a faraway place her neighbours called *Mont Royal*. Their sister had resettled there. She stood, swathed in thick clothing, knee–deep in what looked like heaps of raw cotton. *Neige*, they called it. There were snowless pictures, too. The young lady stood near shiny automobiles, in front of brick row houses with exterior staircases spiraling to upper stories or against tree trunks beneath leafy boughs. Images such as these fueled Kimsonn's fantasies. Little did she know that a photo of her was activating other imaginations.

About a month after the Sengs had established themselves in Block A, Kimsonn's cousin was married. *Ba* attended the festivities and came home with gossip from the groom, who was related to Tuon family, their long–ago neighbours in *Klayung* village. The groom's nephew was at Kampot, another border camp. Sarun, the newlywed uncle had confided in *Ba*, was an eligible bachelor himself and wouldn't *Ba* send a picture of his second daughter? This last insight Kimsonn's parents kept to themselves. *Ba* did pay an entrepreneurial camera owner to photograph members of the family. One black and white print, of Kimsonn and her younger sister Siem, was sealed in an envelope and, hand to hand, traveled out of Khao I Dang to Kampot. The girls stood solemnly outside the fence of the fish farm reservoir. Dark sarongs brushed the tops of their dusty flip–flops and modest, buttoned–up blouses didn't reveal much form. Kimsonn hadn't cut her hair in three years and it hung down her back, parted in the middle, two bobby pins pressing it down on her temples. She looked skinny and ugly, Sarun would one day tease, but in the meantime that girl would become the subject of intense negotiations.

During the 1982 dry season, the Tuons too were transferred into Khao I Dang. Shortly thereafter, Sarun's mother came calling. *Maq* directed Kimsonn to prepare a meal for the guest, who didn't get down to business until the eighteen–year–old had served the older women and disappeared out the door. Sarun, now a husky twenty–year–old,

also stopped by House 3 when Kimsonn wasn't home. Her parents and sisters gossiped about the young man, who juggled jobs translating English language forms for other Khmer and teaching at a preschool. They were impressed he was so occupied when "going around"—literally meandering around and around the camp's streets seemed to be the most pressing pursuit of many refugees. It was along one such road where Kimsonn was ambling arm in arm with two girlfriends that Sarun first approached her. "Where are you going?" Unrecognized by Kimsonn, Sarun appeared to be just another audacious male. "And who are you?" she wondered but didn't dare to ask, looking away. Later, in the company of his cousin, Sarun dropped by the Seng house. After the niceties of offering water to the visitors, Kimsonn found an excuse to leave. Nice young ladies didn't banter with big boys.

But others talked. "He's SO handsome," Kimsonn's friends tittered.

"He's so right," *Maq* felt. She called Kimsonn in to sit with *Ba* and other elders. "We'll hold the engagement ceremony tomorrow. What do you think of him?" Kimsonn whispered that maybe he was okay. Although Mother had said it was up to her, the course of events seemed to have a life of their own. Not that this appeared odd to Kimsonn; didn't fate dole out one's lot?

An *ajah*, a Buddhist lay preacher, officiated at the engagement. His knowledge of this rite of passage brought a rich sense of tradition and propriety into the house. Although not a member of the *sangha*, the *ajah* was a learned man. He had Kimsonn's parents record the names and birthdates of their daughter and prospective son–in–law. A caster of horoscopes determined dissonance or harmony in birth signs, foretelling everything from finances to fertility. That Friday afternoon, as people filled the Sengs' room, the astrologer saw a happy union with a baby eight months following the marriage. The fiancé arrived in procession, his retinue of family and friends bearing symbolic gifts of fruit, clothing and rings. Although the families couldn't afford the whole roast pig which ought to have accompanied the betrothal,

there was plenty to feast on. The *ajah* spoke of rules governing appropriate relations between the young couple; the engagement was to be for six months. It would not be fitting for Kimsonn and Sarun to meet unchaperoned during that period.

Social life for the fiancée varied slightly from that of a single girl. For fear of theft, the Sengs never left House 3 unattended, so Kimsonn would invite girlfriends in or join them if they were on duty at their homes. They passed hours crocheting, knitting and chit–chatting until curfew was almost upon them. A crackle of the camp PA system meant it was eight o'clock, time to be at one's registered address. Twelve hours later, as Cambodians reappeared on the streets, Kimsonn often found herself sweeping out the dirt floor and the earth before the door. Again the loudspeakers would begin to hum, and as the national anthem began to play not a soul stirred. All over the kingdom of Thailand, His Majesty King Bhumibol was honoured by motionless, silent subjects.

Lack of movement also described the resettlement plans of the Seng family. Fully a year after *Ba* had submitted a baffling application to the American Embassy, a letter arrived advising him to scan the bulletin boards in Section 6 for his name. The date and time of an interview would also be broadcast over the public address system. Kimsonn was ecstatic. Watching buoyant interviewees board buses bound for appointments in Aranyaprathet, and analyzing expressions as they returned, was a popular spectator sport in Khao I Dang. Now it was her turn. On the appointed day, the seven Seng*s* dressed in their best were seated around a table facing an American official and a translator. Only *Ba* would answer the questions. "What did you come here for? Why do you want to live in our country?" Kimsonn admired *Ba* at his obsequious best.

"It goes without saying that we desire to settle in America because your land, sir, is so very, very nice." Telling the interviewer what he wanted to hear became ever more perplexing. What did he want

to hear? There were further inquiries about Pol Pot time, about the family's experiences and, most bluntly: so many had died, why had THEY not perished? While the translator encouraged *Ba* to talk at length, the final question cut a rut in Kimsonn's mind, treading over and over like a bullock on a threshing floor. Why had she lived? The answer to that question was as elusive as a positive response from the Ambassador's staff.

Ephemeral ties to America were undone, in any case, by marriage, which required Kimsonn to be re–registered with Sarun under a new KD number. The new photograph and new UNHCR documents signaled a life's path separate from her parents more distinctly than the marriage ceremonies of January 29, 1984. Traditionally, there would have been three days and two nights of celebration, but in camp two days and one night would do.

Mats were spread on the floor and out into the street. Behind a curtain, the bride was dressed, undressed and redressed successively in five *krama pehchiung* outfits. The billowing silk trousers, sleeveless blouses and sashes came in bold orange–gold, purples, red, gold and finally royal blue. Accessorized with anklets, armbands, bangles, necklaces and earrings, the entire costume was owned, altered and rented by a Khmer who styled Kimsonn's hair and topped the pile of tresses with a tiara. He touched up her makeup, too, just before each hourly entrance. While his bride was on the other side of the draperies, Sarun sat on the floor before the *ajah*'s array of fruit and candles. A large, curved sword representing protection lay before his knees. Sarun's feet, cramped under his body, grew bloodlessly numb, and as he could not politely reposition himself, a friend seated behind him massaged his toes. The first three times Kimsonn reappeared and settled herself at his side, Sarun would hear the *ajah* begin another half–hour sermon on loving one's partner for a lifetime, receiving guidance of the Buddha and respecting one's in–laws. Following the third address, he waited until his bride disappeared behind the veil and took an oppor-

tunity to stretch his legs outside. Kimsonn, meanwhile, submitted to yet another costume change. She felt weak, almost ill and bombarded by instructions from a myriad of experts on what to do and how to do it. The fourth speech was delivered by two Khmer monks in incomprehensible Pali, loquacity constrained by the late morning hour, for the religious could not eat after midday. Before noon, the groom and bride plied the celibates with the best of the dishes, happy to loosen arms and hands from respectful *wais*, and legs and feet from polite, foot–covering, concealing positions. When the monks departed, everyone inside and out indulged in the platters of *look lak* salad: thin slices of beef and tomatoes on layers of lettuce, and cauldrons of curry served over figure–eight loops of rice noodles.

Maq's women friends and neighbours who had pitched in to wash, chop, mince, dice, slice, boil and serve Thursday's feast were soon at it again, cutting up other ingredients for Friday's. They advised Kimsonn to lie down to rest, but sleep wouldn't come. Through the bamboo walls she could hear their voices rising in mock argument over whether the purple blouse had been plum or puce, falling to inaudible whispers as someone confessed some wedding night *faux pas* followed by shrieks of laughter by empathisers. Not a one had been prepared for sex, nor were they illuminating their unwed daughters. While Kimsonn waited and wondered, Sarun and his friends were hauling tables and chairs from Sarun's preschool. They set up seating for one hundred or so guests under a canopy stretching from *Ba's* eaves out into the street.

On Friday, invited guests crowded in as a band played electric guitars powered through an eclectic array of extension cords. An amplified drum kit provided the beat to traditional tunes. Kimsonn and Sarun, in all their finery, were seated atop a table where they were visible to all. Another young couple, recently married, were costumed as *taybada*. These angels danced around the dais, carrying a mirror, comb, a pair of scissors and some perfume. They pretended to cut

the couple's hair and performed other mimes for good fortune. While others dined, the bride and groom only nibbled at the plates set before them. As curfew approached, people squished into the house to watch the couple stiffly lounge on the family bed. A banana was pressed into Kimsonn's open palm. Knowing what was expected of her, she peeled the fruit and attempted to feed it to Sarun, who wasn't at all helpful. Next, someone handed Kimsonn a cigarette and butane lighter. Fingers quivering, she placed the cigarette between Sarun's laughing lips and tried to light it. There was whiskey on his breath from the innumerable toasts and his face was flushed. With both hands grasping the lighter, Kimsonn steadied and held the flame until the tobacco began to burn. There were more antics with other fruit before the partiers cleared out.

Before night fell, *Ba* hung a curtain creating a somewhat private space for the newlyweds at one end of the family sleeping platform. Sonn's little brothers and her parents would take their usual places on her right. On her left, empty since Soan had married several months earlier, was not the wall but a man, a husband.

Before the first month was out, the section leader found a vacated room for Kimsonn and Sarun. "Having our own house," Kimsonn thought, "is freedom." She could go around as she pleased. She could eat when she felt like eating. She napped at will. She asked no one's permission to visit friends. She hung out at the market. Cooking for two was quick compared to six. Sarun had *baht* to burn from his various jobs and didn't mind spending. They would go out for breakfast, saucy bowlfuls of noodles someone else had prepared. Recollecting her stolen childhood and her parents' strictness, Kimsonn told Sarun she had never had such fun.

There were householder responsibilities, of course. Sarun would line up for their water ration about seven every morning. From a tank, the section leader would fill two ten–litre metal pails, which Sarun slung from a yoke and carted home for drinking, cooking, washing

and bathing. In dry season, bucket showers were pretty precious for Cambodians, whose personal cleanliness was a matter of pride. When the rains came, a good downpour brought out all manner of people shampooing and soaping up under skies on a perpetual rinse cycle. Kimsonn supplemented collected rations by dealing with black marketers for fresh fruit and vegetables. Like *Maq*, she built a stove of three large stones anchored in a corner of the dirt floor. Not encumbered by kids, Kimsonn kept her job as a sewing machine operator and still had time to take regular walk–abouts. Sunset was invariably a social time. It was dark by half–past–six in January and by seven in July. Under a full moon, Kimsonn and Sarun sat on their stoop listening to old people telling tales. Cigarettes glowed and bobbed in the deepening twilight as listeners chuckled or snorted in response to the stories. It was possible then to escape the limbo of statelessness; warm night breezes blew tomorrow's worries away.

As always, some soul higher up the hierarchy of earthly existence was charting a course that would determine Kimsonn's next steps. In 1984, the karmic coordinator was Sarun's boss at the UNHCR. *Khun* Rattana was a forty–year–old Thai. Kimsonn recognized his predestined power, obvious in his lighter skin, college education and authority over the Khmer staff, female and male, both those younger and those older than himself. Demystification of international refugee resettlement was one of Rattana's contributions to Sarun, whose rural roots, want of formal education and lack of relatives in France made his chances with the French slim. Likewise the Americans. Canada, however, had a humanitarian reputation to keep and was accepting an annual quota of refugees worldwide. Neither Sarun or Kimsonn wanted to be separated from their parents and siblings, but Rattana persuaded them to apply while a door was open to them. "You can sponsor your parents once you resettle," he urged them and wrote a letter on their behalf to the UNHCR. Forms arrived, were filled out and sent in. Sooner than expected, Kimsonn heard her name among a

list being broadcast by the camp administration. "Come tomorrow at eight o'clock." So she did.

In the morning, Kimsonn and Sarun joined the line outside the High Commission office. Neither had dressed up for the event; if selectors overlooked spit and polish while looking for attitude and adaptability, then they would play the part. The chill of the air–conditioned bus put a damper on the excitement felt by the thirty families during the drive to the Thai border town of Aranyaprathet. Kimsonn's thoughts kept returning to her mother–in–law's tear streaked cheeks and *Maq*'s stoic expression as she had waved from the bus window a half–hour earlier. This daytrip didn't even qualify as a farewell, and yet what an evocative departure it was.

"*Sawatdee!*" "*Sawatdee–ka!*" With enthusiastic greetings, Thai vendors crowded around the bus as the Khmer descended. This would have been an opportune time to trade, but Kimsonn waited in the shade, watching and wondering when she and her husband would be called through the closed doorway. They were third. On the other side of the door was a table. Two tall men, whose remarkable noses Kimsonn strove not to stare at, welcomed them. The Canadians carried out the interview in English. They first peppered them with the now–familiar queries: How old are you? What did you do before April 17, 1975? What did you do during the time of Pol Pot? Tell me what you know of Pol Pot. Why did the Khmer Rouge kill? Tell me about your education. After about twenty minutes, the second, a Security Officer, took over, probing for details which might identify the young couple as Reds. He also checked out Sarun's command of English with instructions to "Stand up. Turn around. Tell me what you see around you."

Sarun said, "On my left hand is a big road. A big truck is running on the road." Kimsonn, who was not questioned, wouldn't have been able to spontaneously string English words into sentences. She was bouncing one–month–old Nara on her knee, watching the first interviewer scribbling, circling and shuffling forms.

"When you go to Canada," he finally announced, "you'll have to send some money to me for this." Kimsonn noticed a twinkle in his eye.

"He's joking," the translator added unnecessarily as the Canadian placed one document in front of her to sign and passed it to her husband. Very seriously, he advised Sarun that by signing he was committing himself to repay the Government of Canada for the $4,000 travel loan, which would cover two airfares. The sum seemed a fortune but Sarun signed. Better indebted with unalienable rights in the true north than an illegal alien in "the land of the free"—Thailand's motto.

Hope suspended reason for many on the camp–bound bus that afternoon. Although no one revealed whether they had signed a sheaf of papers, there was a very buoyant atmosphere. Several Khmer vowed to shave their heads if the interview results went their way and one man zealously did so that very evening. His chagrin was unbearable a few weeks later when the *name–to–go* document was posted outside the Khao I Dang office. Only one head of household was listed. Tuon, Sarun.

That had been the eighteenth of July, 1985. On the twenty–fifth, this world would pass away. Kimsonn wept. She sat with *Maq*, who moaned unendingly, "I will never see you again." She held Mother close, embracing the body which had born her. Harmony in the universe hinged on responsible adherence to prescribed roles. Dutifully, Kimsonn repeated unfounded promises to sponsor her parents and brothers as soon as she landed in Canada. At night, sleeplessness struck but between echoes of her mother's lament, Kimsonn felt a fortuitous beat in her heart of hearts. For over five years, she had seen so many others off—including her younger sister—clambering aboard buses, all earthly possessions bundled in a cardboard box, all heavenly prospects in their eyes. How many times had she fought the thought that all would go but she would not, forever dispossessed, discarded? To be chosen was to ride a rollercoaster of ecstasy and misery.

Westward: The Name–to–Go

Kimsonn rinsed her face a final time. She settled Nara on her hip and followed her husband out of what was no longer their house. Parents and brothers, in–laws and friends, neighbours and hangers–on, a tearful retinue trailed behind Sarun, who balanced a single box of clothing on his shoulder. An opal and chrome Mercedes bus had opened its door and was swallowing a load of Cambodians one by one. Those on board lowered the upper window panes to entwine fingers with loved ones not quite as palatable to western compassion. Suffering with her family had defined Kimsonn's twenty years; now she suffered because she would be without them. Out the gate of Khao I Dang, the bus rumbled. Arms waved dusty and sweaty long after *Ba* and *Maq* and Pheap and Pheak had become tiny figures in the distance. Sarun's wristwatch read ten o'clock.

"It's three," Kimsonn heard Sarun saying as she felt the bus gear down. Kimsonn had dozed off despite her best efforts to drink in the sights and sounds of Thailand while the refugee transport wound its way westward to Chonburi province. Phanat Nikhom Refugee Transit and Processing Centre straddled the road. Kimsonn could see a couple of uniformed men lounging in a bamboo hut outside the barbed wire barrier. They waved the driver past to a concrete platform where the bus disgorged its carsick passengers. Phanat Nikhom, then housing 12,000 Khmer, Lao and Vietnamese during their months of medical screening, was tiny in comparison to Khao I Dang. Built on a slight rise in an agricultural plain, Phanat offered neither vistas nor mountains such as those along the border. The tallest things Kimsonn could see were the guard towers. For all her fantasies about being free, she was still fenced in.

Kimsonn had walls, a roof and a floor, too—no door, though. House K56, like all the others, was a concrete pad enclosed on three sides by asbestos sheeting topped by a gable roof of corrugated metal.

The fourth wall was of bamboo slats; three doorways opened up on a quadrangle formed by four houses. K56 had no interior walls, so the three Khmer families assigned there simply stashed the sleeping mats and cooking pots they were loaned against the graffiti pocked wall panels.

K56 was a fifteen–minute walk from the MOI and UNHCR offices at the heart of the camp, but it was around a corner from a market run by local Thais during the daylight hours and used as a movie theatre in the evenings. Thai melodrama and epic kung–fu flicks out of Hong Kong were voiced–over live by a Khmer with a handheld microphone and a 70 dB amplifier. At five *baht* a show, movies became regular fare after Sarun began working for Save the Children. The NGOs in Phanat were still permitted to pay cash to their refugee employees, a great leap forward from the officially cashless society in Khao I Dang.

A couple of afternoons a week, Kimsonn sat in on a class with about twenty Khmer women and one man. The man was a translator for cultural orientation classes provided by the Mennonite Central Committee of Canada. Kimsonn marveled at the instructor's slides. She wasn't sure she could believe Henry. Why would people climb high up a cold mountain to careen down it on skinny strips of wood? And the stores. So bright they could have been lit by the sun; shiny, spotless floors; endless rows of shelved boxes, bags, packets and produce but no proprietors perched on or near the wares. Wouldn't shoppers pillage the unguarded merchandise? How could a few women manning stations with strangely moving surfaces settle accounts for the cartfuls of cargo presented by buyers who couldn't bargain?

Food was one thing some refugees in Phanat were stocking up on. Rumours of third–country insufficiencies in stock items such as rice abounded, along with myths of marvelous proportions. Canada, for example, was apparently so cold people stayed in their houses for six months of the year until it was safe for sorties to humongous markets called malls. Incredulity saved Kimsonn from succumbing to every tall

tale circulating around the camp. In December, after her sister Siem sent the first letter from a place called Edmonton, Kimsonn pshawed authoritatively at fear mongers.

There was plenty of time to spin yarns and weave gossipy webs in Phanat. Kimsonn was passing a typical afternoon sitting in a hammock she had slung between two trees in their quadrangle, swinging Nara, when she caught the name Tuon Sarun on a very garbled announcement over the PA system. Kimsonn scooped up her toddler and headed over to the Save the Children Khmer kindergarten where Sarun was working. It was true. They were to report to the ARC medical clinic. There was only one explanation for this appointment; their names were on that all–important list for imminent departure.

It was that hope which sustained Kimsonn through the most personally demeaning experience of her refugee years. Inside the Out Patient Department, Kimsonn was shown into an exam room occupied by a Thai woman and an American man. A nurse and a doctor, Kimsonn presumed, although no introductions were made and no Khmer was spoken. Through gestures, Kimsonn was instructed to remove her clothing. Having never before done so with anyone watching, she was stunned. Her face burned with shame as she lay exposed on the examining table. The medics examined skin for unknown signs and symptoms, and took blood and urine samples. Pointing to her clothing, the woman gestured that Kimsonn should dress and leave, which she did. Kimsonn passed through the waiting room, eyes downcast, overwhelmed by the feeling of having been violated. She suspected everyone witnessed her shame although they, in fact, were about to be just as humiliated as she had been.

On the afternoon of January 28, 1986, Kimsonn and Sarun laced up the last of their three boxes. Wrapped in periwinkle plastic secured by a mesh of pink plastic cord, the containers held cheap cotton clothing from the Phanat market, some Melmac dishes purchased with money sent by Siem and some gift sarongs. Sarun inserted big placards

behind the netting. TUON, SARUN, they read. WINNIPEG, CAN-
ADA. If fate smiled, Kimsonn believed she would be loosening the
strings in Siem's company within forty–eight hours. Canada was Can-
ada. Winnipeg and Edmonton were parallel avenues for all she knew.
As his parents packed up their refugee lives, little Nara grew cranky.
A persistent cough shook his chest. Kimsonn felt his forehead was
feverish. She had Sarun take the toddler to his friend at the OPD, who
diagnosed pneumonia. Pneumonia! Was their ticket to freedom to be
cancelled because of a rheumy baby? The doctor doled out ampicillin
in time for the family to present itself at the overnight holding centre.

There was no sleep for Kimsonn, that last night in Asia. A ware-
house was sealed and guarded to prevent imposters from sneaking in
on false papers or feuds being settled before oceans separated enemies.
The hall was hot and home to many mosquitoes, all thirsty. Because he
was able to provide basic translation, Sarun had been named respon-
sible for accompanying anyone who became ill to the OPD that night.
There were many complaints. Not a single soul on tomorrow's depar-
ture list had an iota of experience comparable to the physical, emo-
tional and spiritual seas she was about to cross. The concrete floor was
uneven under a thin straw mat. Snoring, whimpering, insects hum-
ming, buzzing, a couple arguing, coughing, wheezing, sneezing, some-
one peeing into a tin can. Rocking Nara, Kimsonn longed for morning.

Even before first light, the centre was astir. Under tent–like sarongs,
women modestly changed into clean clothing. They dressed their chil-
dren and shuffled out into the gray dawn. Kids in stiff little denims
and shirts sporting packing creases watched daddies hoist innumer-
able sky–blue boxes up to the roof racks on four buses. Grannies in
worn flip–flops, batik sarongs and traditional blouses squatted on the
tarmac beside young women in form–fitting local jeans masquerading
as *Levis* but mislabeled *Lives*. Four–inch heels on black strap sandals
pinched toes not too tired not to care about looks. Looking over the
rabble was "The Black Man", a dark–complexioned Thai employed by

the Ministry of the Interior to keep the Khmer and Lao sections in line. His rotund compatriot from the Intergovernmental Committee for Migration took up his post near the door of the first bus with a trio of translators hovering like backup vocalists at his side. Sarun was one. Kimsonn watched him circumvent last-minute crises. When all the outbound aliens had been settled into their seats, Kimsonn and Sarun took their places just inside a door. No sooner had they sat down than the stress and sleeplessness caught up with Sarun. Vomit dribbled down the exterior of the bus; at least he had had the presence of mind to stick his head out the window. Someone handed him a handful of meds, anti-nausea tablets nobody had but everybody needed. Before the drug could have reached his bloodstream, the buses revved their engines and eased over the ruts in the road through the gate Kimsonn had entered exactly six months earlier. The placebo effect of the tablets was going to make for a pleasant, pukeless trip to Krungthep, as Thais called their capital.

Hurtling along the highway before the inevitable bottlenecks of Bangkok, the convoy of buses carried heavy-hearted Kimsonn out of the dawn and into the smog. Don Muang International Airport, like everything in the Thai capital, looked large to Kimsonn. Huge hunger pangs hit her there where the price of rice, by the bowl, was an outrageous 30 *baht*. Sarun obligingly parted with the last of his Thai bills; if the airline didn't serve rice, it would be at least twenty-four hours before they could eat properly again. It was this fear of foodlessness and not of flying that consumed Kimsonn. Seated next to a window at the rear of the filled-to-capacity economy section, she scanned the ever diminishing roads, rooftops and river as the jet banked and rose above Bangkok. She pressed her cheek against the Plexiglas, surveying the crazy-quilt pattern of chartreuse to emerald paddies far below. A cluster of toddy palms. A column of smoke. "Where is my *Maq*?" the question burst Kimsonn's calm and trickled, salty, over her cheek.

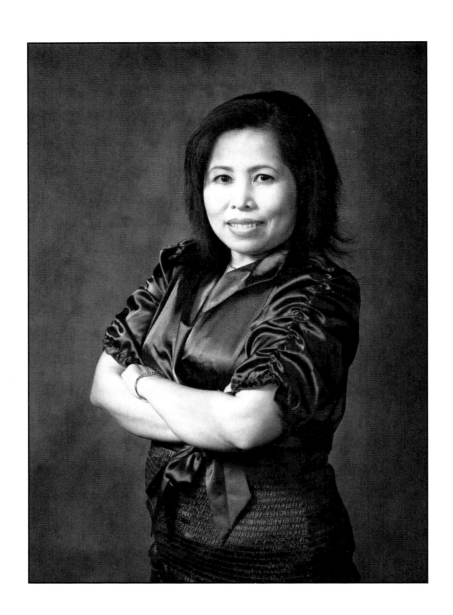

Chantha Kong

(Sisowath Karadath Chanrada)

West, Meet East: Prelude to Pol Pot

Set back one hundred metres from the high road that traversed the village of Kean Klayung, Grandmother's chocolate–coloured house of treated teak was swathed in the foliage of towering coconut palms, guava and longan orchards and bordered by a banana grove. Srey, as Grandmother and Mother called Chantha, their little bundle of courage and curiosity, had been born under the moon in the year of the tiger. "You 'crossed the sea' on a Thursday," Grandma reminded her time and time again. "you shall become an honest and a gentle lady."

Certainly Grandma saw signs and portents in almost every aspect of daily life; all this sagesse she unselfishly shared as Srey passed her pre–school years in Grandmother's care. *Maq* had entrusted her beloved only child to her own mother as family obligations in the palace kept her across the *Tonlé Sap* tributary in Phnom Penh. *Ba*, also in public service, lavished love on the daughter for whom he had waited fifteen years. How often they retold the tale of *Maq*'s pilgrimage to a

shrine, where for seven days and seven nights *Maq* implored *Yeajay* and *Yeajop*, fecund boddhisatvic symbols, for fertility. When Mother had dreamed of a lotus bracelet floating in scented water in a silver chalice, Srey was conceived.

Honesty and gentleness may have been written in the stars, but their imprint on a little life required the discipline of a human hand. Under Grandmother's direction, Srey learned to peel segments of a coconut's outer husk, remove the nut intact and stitch the strips back together with palm string. They carved sparrow–sized windows and doorways, stringing the bird houses from boughs and eaves about the property. Srey delighted in the colourful macaws, expected good luck upon sighting magpies and prided herself on providing for the black–capped sparrows whose caged cousins city-folk purchased and released at Wat Phnom to acquire karma of merit.

Caring for pretty songbirds was not a characteristic easily trans-ferable to more prickly primates. In conflict, too, Grandmother saw teachable moments. Most memorable was that morning down by the Chreuy Chung Va ferry, where passengers milled about waiting to cross over to the capital city. Srey and an older cousin were scam-pering among them when someone shoved the girl; she stumbled. Ire up, she turned to see a despised Vietnamese boy. "*Yoo–un*, fire–ant," she spit out the condescending slur.

"Come away," Cousin called unconvincingly.

"*Moan som–lah*, chicken!" Srey cursed his cowardice and set out to extract revenge. But the boy was bigger and faster; he slipped onto the ferry as it pulled away from the shoreline. Steaming, Srey squatted down. She would wait.

At dusk, the final ferry docked and Srey spotted her nemesis on deck. With premeditated precision, she gripped a length of firewood and, motionless, listened for his footsteps, roadside signage eclipsing her shadow but revealing his advance. "Uuuuhhhh…" Srey's victim exhaled his pain and crumpled to the ground, unconscious. The girl

stepped closer and executed another blow, this one drawing blood.

"Blow for blow!" the Vietnamese mother later shrieked to the police officer who was under no obligation to defend, let alone deliver retribution for, a disenfranchised foreigner. Srey's grandfather drew on his mediation experience as a community leader and argued against settling the score with violence. At his suggestion, the constable locked up the school–girl in a holding cell. A previous occupant escaped by suicide, someone announced, and the battered boy's mother cackled. The voices of the adults retreated to an office, where Grandmother began to negotiate blame and compensation. Yes, Grandmother agreed with the aggrieved woman, Srey was a spoiled child. Surely the priority now was on medical care for the boy. Had the Vietnamese been seen by a doctor? What was the fee? What medicines were required? Would the mother be forfeiting earnings to pursue justice and nurse her child? Grandmother assumed all damages regardless of this woman's inconsequential social standing. What love was this, Srey asked herself for the first time, that intervened for the oppressed outsider all the while securing the release of her indefensible granddaughter? Why had cousin avoided a fight while she had chosen combat? The price of peace–preserved paled before the cost of reconciliation.

Like waves crashing on the coast of Kampot Province, a distant din roared and rose. "Careful, Chantha," counseled Grandmother, calling out Srey's public name, "Stay close to the house." Srey needed no reminders. In spite of the thick heat that brooded over the Mekong plain prior to the New Year rains, the girl shivered. *Ba*'s chauffeur was burying the Mercedes under heaps of hay, stacking straw around the car he had parked by the fruit trees, face flushed and fingers quivering as he stuffed silage around the government plate. Out on the high road the rabble came closer. Beef butchers, fishmongers, day laborers, rural school teachers, noodle sellers, ice vendors, weavers, migrant sowers of rice and diggers of dikes, bribe–lacking mothers of conscripted

boys, and debtor fathers of sold–to–brothel daughters, infiltrated by liberation theologians now marching somewhat to the left of the Buddha's moderate Middle Way along with, some said, not a few Khmer Rouge, these chanted and sang and shouted and accused. Over their heads were banners proclaiming, "We want freedom!" or "We work for Sihanouk!" The just–ousted prince's picture bobbed up and down in stride. It was March, 1970. The demonstration was in response to a coup, which had toppled Sihanouk while he was in Moscow and turned the Kingdom into a Republic led by former Prime Minister General Lon Nol. In their hands the crowd brandished bats, knives, machetes and scythes. Some dispersed from the mob on the macadam road enjoining locals to remove the Lon Nol standard from the almost obligatory household flagpole. They entreated everyone to hoist a white flag, even if it were a swatch of cloth or a piece of clothing. "Who is with Sihanouk? Join us!" they cried, megaphones amplifying their slogans across fields of beans, squash, tomatoes and jicama. Bus horns and bicycle bells added to the hubbub behind the protesters, over whom hovered a great cloud of dust. And in front of them a contingent of Republican soldiers advanced from the opposite direction.

"Put down your weapons. We shall shoot!" The volley of government–sanctioned verbiage met its mark without casualties.

"We shall not put down our arms. We shall kill your leader." Peasants and poor folks afflicted by skyrocketing inflation and grieving children lost in a war that was hardly civil retorted fearlessly. "If we die today, we'll live again tomorrow. We are not afraid." Who were they trying to convince? Grandmother ordered everyone out of the house and into the bomb shelter under the banana grove. Grandpa, Auntie, Father, his driver, Cousin, Grandmother and Srey huddled in the root cellar excavated some months earlier. A child could stand there but the adults hunched over, squatting on the damp earth, grateful for Grandpa's forethought. Through the doorway camouflaged by shallow–rooted vegetables, muffled sounds of the mayhem outside could

be heard. Through the air vents, bamboo pipes inserted into old termite tunnels, conflict echoed. Gunshots. Screams.

The rumble of running feet vibrated above the shelter. A groan of agony twisted Srey's heart. The safe six heard cries for help and stumbled out, blinking in the sun's glare. Demonstrators, now deserting in horror, fanned out across the neighbourhood away from the carnage on the road. Srey got to him first, a man whose flight of fear blinded him to the screen of bamboo slats and stakes that shaded Grandma's carrot patch from the scorching sun. A sliver had pierced but not dislodged the eye ball. Blood streamed down his cheek and trickled over the fingers he held to his head. "I can help you," Srey assured the stranger, and bracing one hand on his skull, extracted the stick with the other. Like water the blood flowed, so she tore a strip off the man's shirt and stuffed it against the wound. "*Ba*, come help!" she called. Father examined Srey's patient and sent his driver for first aid supplies. "But, *Ba*," Srey started, then hesitated, unable to speak such intimate words to a male, moreover the very one whose intercourse had created her. "Grandmother told me a traditional remedy," Srey began again, "we need pubic hair." These last words were whispered in a servant's ear. "Cut some now," Srey urged. "it will absorb the blood and speed clotting."

"Mine or the patient's?" Driver queried, incredulous and not a little stunned by a prepubscent girl speaking of private antatomical parts she didn't possess and therefore must mean the male equivalent, which she couldn't respectfully speak aloud. In the end he snipped off some armpit mat, which they secured over the gash to staunch the flow. Although the retort of gunfire still sounded five hundred metres away, Grandmother was dishing out rice for fugitives while others mopped up the injured. Srey's escapee regained his equilibrium sufficiently to feel the rumble in his stomach over the throbbing in his temple, and after several mouthfuls, like the others, ran off into the growing gloom.

Along the highway, soldiers carried away their fallen comrades. Even the most grossly wounded managed to remove themselves from that evil stretch of tar, while collectors of civilian corpses retrieved the silenced ones. But were they silent? Who dared to tread among the dead whose spirits, severed from their bodies, no Pali blessing enabled now to rest in peace.

Terror lurked in Kean Klayung for months after that bitter March day; *proleung kmout*, spirits of the helpless, brooded at the site of the slaughter as luminous red, airborn phantoms. Grandfather himself, once returning from his bus route past midnight, entreated his cousin Pheak to meet him so he would not need to pass that way alone. That starless night as he came up the road, Grandfather heard ghostly voices, "Help! Help!" "My wife! My child!" "I'm thirsty!" Cousin Pheak dared not leave the porch, but answered Grandfather's call for company with advice to moon the spirits, loudly slap his posterior and head for home posthaste. At daybreak, Grandfather's encounter with the netherworld fueled conversations over coffee, fritters and steamed pork dumplings. Srey stopped laughing at Cousin's description of pantless Grandpa when she noted his silence. The previous night, Srey had seen no lights and had heard but one voice. "Where are you? Where are you?" The plaintive tones of Grandfather's quivering falsetto reverberated in Srey's memory. "Where are you? Where are you now?"

West, Meet East: Pol Pot Time

Juliet and Romeo, two French–speaking Italians in an English plot on a Cambodian cinema screen, loved and died before Chantha's eyes, there in Phnom Penh just before the Buddhist New Year 2519. Cinema–going itself was an act of Shakespearean proportions, as artillery thudded to the southwest around Pochentong Airport and unknown dangers lurked in the inky–black recesses of the darkened theatre.

Kidnappers and men of ill–repute preyed upon unaccompanied children, sources said, and Chantha believed them, snuggling deeper into the plush seat. *Maq* must have believed them too, as she had chosen several other adults to chaperone the dozen or so nieces and nephews she treated to a day in the palace district. Outside, under a brilliant April sky, ablutions of best wishes and good luck flowed in the traditional water–tossing ritual and the super–soaked kids arrived back at Grandmother's well-fêted. Against the evening twilight, flares and mortars whistled and glowed. Distant machine–gun fire reminded Chantha of the rat–ta–tat–tat of the cinema's popcorn maker.

At the second sunrise of the year, *Maq* crossed over the Sap River to collect gifts to distribute that evening. Above the river, great flocks of black birds fluttered in the opposite direction, passing over Grandmother's house. "They are an omen," *Yiey* said. *Maq* hadn't returned by sunset when everyone went to bed—everyone but Grandmother, who sat up late, listening. She heard Chantha, past midnight, tiptoeing over.

"*Yiey*, come with me to the privy," the girl whispered.

"No." Grandmother was strangely reticent about going outside. She insisted Chantha use a new spittoon as a chamber pot, and for a time they argued in barely audible undertones until Chantha tripped back to her bed and, behind a closed door, tinkled self–consciously in the shiny brass and lacquer vessel designed for betel chewing grannies.

Before the third dawn, Chantha rose again. Her ducks were clucking unusually early. "What are you gap–gapping about before sunrise?" she inquired of them as she gathered their eggs. "Are you hungry? I couldn't sleep with all the racket you were making." In the darkness, a figure the ducks could sense but Chantha couldn't see started toward her. A man in black wore a *krama*, the trademark Khmer Rouge checkered scarf, at his neck and carried a carbine. He must have expected to startle the thirteen–year–old, for when she saw him he was signaling "shhh".

"What are you doing, little girl?"

Chantha replied to his guilelessness with the equally innocuous answer, "Collecting eggs," although she had to bite her tongue to stop herself from demanding the stranger explain his presence in her garden.

"Srey?" Grandmother called Chantha's nickname from the house. "Come back to sleep."

"Don't be scared," the man whispered. "You'll be all right." And he let her scurry up the steps and into the house.

Inside, the pretense of sleep could be heard in everyone's irregular breathing. As red tinted the eastern sky, Grandfather, Grandmother, Auntie, Cousin and Chantha splashed water on their faces and got their first look at real, live *Kmae Kahom*. About two dozen men and boys emerged from under the house and among the fruit trees. Grandmother did what she always did; she shared food with the militia, eating together being a most significant social act of good faith.

While the adults prepared the meal, a teenager approached Chantha. He looked very small, particularly so beside his automatic rifle. He spoke softly, "What's your name? Srey? When I see you, I miss my sister..." "This group," he went on, when his comrades were out of earshot, "is called Red Khmer."

"Why?"

"Because we have left home, we never think about our far–away families and we have committed to give our blood for our cause. We will take over all Cambodia...the Red Khmer have no family, no fathers, no mothers, no sisters, no brothers, no lovers. But I really like you, *Srey Oun*. Younger Sister, you are most charming."

"No family? Really? No relationships?" Naïve Chantha missed his coquetry completely, shocked at a world without Confucian parameters.

"Our guide is *Angka*, I myself am Saveun," the youth hastened to introduce himself as Grandfather moved closer.

"*Angka*?" Chantha had never heard this word before.

"The leadership," the boy continued. "*Angka* determines the rules. For example, in our team, if one does wrong, he is punished by being set an extremely arduous task. If he cannot complete it, he is killed."

Chantha was horrified. "Why don't you run away?"

"There isn't even the slimmest of chances of escape. In 1973, during my student days, my parents desperately devised a plan for me to avoid the military draft. While Republican officials respected my novice status at a local *wat*, the Red Khmer conscripted me."

Grandfather's loitering had caught the attention of Saveun's leader. Grandfather answered his call and as he turned his back, Saveun reached out and touched Chantha's hip–length locks. She pulled back, misreading the caress as a tease. "*Angka* has ruled against such lovely hair. Let me cut it carefully, before another hacks it off in a hurry."

"NO!"

"Everyone follows the rules, Srey."

"Cut it," Grandmother spoke from over Chantha's shoulder. She, who had, as long as Chantha could remember, shaved her head in the vanity free fashion of the religious, understood *Angka*'s edict better than this granddaughter still innocent of her own allure. Saveun pulled a pair of scissors out of his pocket. He snipped straight across, above the ribbon with which Chantha had bound her glossy, thick waves. With tears in her eyes, she collected the strands.

"I'm doing this because I love you." He said *srawlang*, parental love. "If you are my lovely girl, don't cry. Be strong. Wherever you go, remember me. I will carry your likeness in my heart always. Will you remember me?"

"Do you imagine I could ever forget? In all of my life no one has ever, ever even tried to trim my hair and you, you've cut it away with one swoop of your scissors!"

"So you hate me then?" Saveun was serious. "Look here," he said. For an instant their eyes locked, but Chantha could not fathom the intensity of the boy's gaze. "Hmm, the left side is a bit longer than the

right." With the air of a salon stylist, Saveun pulled two strands together along the girl's neck. He snipped slowly, tilting Chantha's head with his free hand and blowing away the trimmings. Bending close to her ear, Saveun whispered, "Don't ever tell the Red Khmer the truth of your family's origins. Never reveal your parents' occupations. Under no circumstances admit links to the palace or Lon Nol government. Lie and live." Saveun stood back, brushed his hands and turned to Cousin. "You're next," he said, and silently mowed Vonn's curls to a brush cut in double time.

Over the next few days, Grandfather plotted survival. He was under no illusions about communists, despite the etiquette of that initial encounter. Chantha understood *Maq* would never come home to Kean Klayung again. Although residents of the rural community were not evacuated without notice, but given the choice to stay or to go, Grandfather rightly perceived security in anonymity. He procured a river canoe and loaded it with rice, pickled fish, salt, his wife, one daughter, a nephew and two grandkids. They left behind their house, their home, their identity. They deliberately discarded Sisowath family photos. If eighteenth-century French revolutionaries had severed noble heads from bodies, whom would their Cambodian emulators dispatch? The family cached gold, let loose Chantha's chickens and ducks, and slipped away without an "*au revoir*" to all-knowing neighbours.

The downstream voyage found the six sailors among the flotsam and jetsam of the nation. Every conceivable form of watercraft plied Indochina's longest river. Steamboats, tugs, rowboats, barges bursting with passengers to nowhere, a scow ferrying a caged boar, crown jewels bobbing with every wave, freighters listing halfloaded, sampans drifting, fishing trawlers nets dragging, Chantha sailed toward the South China Sea among a flotilla of the dispossessed. Towering above the ten-metre sandy embankments, kapok trees cast pods into the silty water where bare-naked boys still splashed unabashedly. Kandal Province to starboard, Prey Veng to port, Chantha imagined the world

from the vantage point of a Mekong catfish. The river had always been an obstacle to cross to and from Phnom Penh but now, leaning over the bow so the spray cooled her face, the mighty current seemed the best place on earth, a highway of hope.

Ro Ka Kaong had been Grandmother's birthplace; distant relatives offered a very decrepit lean–to for the first night's shelter. Dilapidated sufficed while the family constructed a most unostentatious two–room thatched hut. Thus began a year of field trips unlike any Cambodian secondary student had ever seen.

Chantha had been destined for *Lycée Providence* as she completed class six at the local primary school and entered class seven. Year Zero, as the Khmer Rouge decreed in their Democratic Kampuchea, supplanted the academic stream with a distinctly vocational curriculum. Chantha was on a steep learning curve to convince the *Kmae Kahom* she was the peasant kid she claimed to be. Fortunately, the youth team leader was no match for Grandmother's wit. *Yiey* had more than a few tricks up her sleeve.

Rice planting week, Grandmother roused Chantha early. She set up a mock paddy with mounds of river mud and bunches of grass. *Yiey* demonstrated how to grasp the base of the green stem just above the roots. Chantha practiced until she held it properly, thumb pointing straight down. Spearing the muck with the roots and her thumb supporting the stock, the girl withdrew her thumb and swept her index finger in semi–circular strokes covering the transplanted base. Sowing corn required a special stance and confident strokes. Grandmother modeled the tasks of knotting a rope every forty to forty–five centimetres according to a bamboo measuring rod, of pacing out each seed trough and of planting. Chantha had the procedure down pat before her toes ever touched a corn field. Left foot forward, she thrust the pointed stake into the soil with her right arm; without a glance her left hand fingered four or five seeds, no more, no less, from the satchel slung around her neck and dropped them into the shallow hole. Her

right foot slid up, pushing just enough soil over the seeds before tamping it down.

The all–purpose *krama* was another foil against *Kmae Kahom* criticism. Chantha copied Grandmother's innovation of looping each end of the scarf to create two deep pockets. She hung the *krama* around her neck so her free left hand could dip into one and then the other, scooping up soaked corn seeds. By alternating sides, Chantha kept the pouches balanced as she strode along the rows. *Yiey* taught Chantha how to drape a *krama* over her hair and twist the two ends like pigtails until she could wrap them around her head and knot them at the nape of her neck. This snug style ensured greater warmth during the pre–dawn chill, and changing it to form a peak over her face when the sun was high convinced the overseer this child had rural roots. "Where did you learn to harvest corn so efficiently?" one asked at the end of the first season.

"From my grandmother," Chantha answered truthfully for the first and the last time.

"Where did you live?"

"In Ro Ka Kaong."

"How many years have you been a farmer?"

"Since I was seven."

"And did you go to school?"

"For part of two years; we were very poor."

"Yes, many Cambodians were poor, but now no one is poor. We are all the same."

But they were not all the same. Grandfather felt the noose of recognition tightening around his neck. Remaining unknown was his code of survival, so when, as the rains of 1976 swept in from the sea, the *Kmae Kahom* asked for volunteers to relocate in the service of *Angka*, Grandfather raised his hand.

That year the journey was upriver on a barge bulging with five hundred non–swimmers. Chantha peered intently into the night as

the boat slipped past the silent capital city. A gleam of gold filigree atop *Wat Ounalom* shone in the starlight, but head–high elephant grass hid the ferry landing and had overgrown Phnom Penh's royal boat launch. At Ra Ro Mee, the landlubbers transshipped to a train, by which they traveled northwest toward Pursat Province. Chantha's high sense of adventure had not dimmed throughout the preceding months of change and challenge, but here at the village of Kahbal Tnout, Saveun's warnings began to be realized.

Families still intact from Ro Ka Kaong were separated according to work detail. Chantha, though small for fourteen, was assigned to the youth team. Having one hundred kids as room–mates soon lost any attraction. That first night, whimpers and sobs echoed through the long hall. One order to sleep was given. "Sleep now or be killed." Terrified but testy, Chantha wondered to herself whether anyone had ever issued such an edict to the ubiquitous bedbugs.

All Chantha's role playing as a professional peasant had paid off in Ro Ka Kaong, but here there were no pats on the head or praise for work well done. Blisters popped on little palms hoeing hard in the dry season soil as cohesive as concrete. *Angka* decreed a canal had to be dug, ten kilometres or more, village to village. *Angka* dictated food stocks had to be preserved—one tablespoon of rice in a watery broth twice a day would suffice for rations. *Angka* determined that a full moon called for round–the–clock rice harvesting; on the threshing floor, scrawny kids led a water buffalo worthy of Pharaoh's nightmare round and round the mill. *Angka* decided the threshing crew could each receive a bowl full of sweet rice laced with palm tree sugar; *Angka* didn't provide the traditional coconut milk but no one complained.

Complaining was the exclusive purview of *Angka*. Criticism sessions were conducted as the need arose; then everyone criticized on command. By 1977, the consequences of criticism and of hunger had taken their toll. Only fifty kids sat in the circle around Chinda on the morning after Chantha had counseled her to live with a growling

stomach rather than die with a full one.

Lying beside her on the dormitory floor, Chinda had taken the necessary precautions of waiting until the others were asleep and of speaking in hushed tones. "I know they have more pickled fish in the kitchen. I saw it. Come with me. We'll die of hunger otherwise."

"But that'd be stealing…*Yiey* said stealing is wrong."

"Are you crazy?"

"You're the crazy one. Sneaking into the kitchen isn't like slipping a bean or two under your shirt while picking. Someone will be waiting for you." Quibbling resolved nothing, so Chantha turned her back toward Chinda, who poked her protruding spine before tripping away toward destiny.

In the light of day, Chantha could see Chinda had made it into the kitchen and a fish or two had found its way into her stomach. "This girl," the *Kmae Kahom* spat out the words with disgust, "this girl wants to live by stealing the food that belongs to us all. Should we keep her or let her go?" The mouths of the skinny–bodied children remained empty. "Shall we keep her or kill her?"

"Kill," the assembly mumbled. A cadre cinched a rope around Chinda's neck, tightening a plastic sheet draped over her head. Chinda writhed and clawed. And fell limp. The noose was loosened and water thrown over the face of the accused. More questions. More accusations. More condemnations.

"Help me! MOMMY!" Chinda's last, strangled words rang on and on in Chantha's ears like a gong that could not be silenced. Silent Chinda was now, but not one witness gasped when she finally suffocated, nor even shed a tear. Crying was an infraction of *Angka*'s orders.

Angka could not hear the voices conversing in children's heads, however. Sometimes Chantha appealed to God. "*Preah*, please help me. I don't want to die. I want to see my Mom." She also sent supplications to angels called *taybada*. "Just give me enough food to eat, day by day." In dreams, the deities answered. An ethereal woman entered

Chantha's vision, wide eyes smiling and palms open.

"You're hungry."

"Yes, I want to eat."

"I can give you as much as you want." Two huge, circular plat-ters appeared, one to the left and the other to the right of the woman. Bowls of steaming noodles swathed in oyster sauce, whole fried fish sprinkled with shallots and cilantro, scented rice, delectable desserts of sweet corn in coconut—the aromas filled Chantha's nostrils, the sights consumed her. The woman handed the girl a clear glass of pure water. "Drink this water and you will never become thirsty again. With this food, you won't become hungry. Whenever you are really, really hun-gry, speak this word: *angheesatoopangbopahbopangsagawonteh* and at night, in your dreams, you will be fed." The vision vanished but the fragrance of the feast lingered. From time to time, Chantha would ut-ter the angel's incantation, which may have accounted for the fact that in 1978, she was one among seven originals still tilling the soil at Kah-bal Tnout.

East, Meet West: To a Second Country

"*Viet mao.*" "*Viet mao teh?*" "*Jaah, Viet mao.*" The Viets are coming. Coming? Coming. Like queues of ants scavenging an enormous car-cass, incessant whispers of invasion from the east ate away at the awe of *Angka*. The remnants of Chantha's youth crew were swallowed by a hundred or so adults and kids trooping toward the Tonlé Sap under armed *Kmae Kahom* cadres. From Kahbal Tnout to the great lake, the forced marchers tramped along forest paths. If heaven were sincerely sympathetic, Chantha considered, it might have withheld its tears, but rain pelted the raggedy riffraff, whose fears of tigers and elephants kept them moving for seven days and seven nights.

Monsoon–gorged streams gushed into the lake, pushing the waterline wider and wider around its shallow basin. But not high

enough to wash away the dozen dead whose corpses seemed asleep on the moist banks. "Don't look, children," a pistol–toting guard admonished. "Just collect the fish." Even though his new, car–tire–rubber sandals sank inelegantly into the wet sand, he exuded authority. His sheen–free, never–patched trousers and shirt didn't flap about a too–thin body. His cheeks lacked the concavity that characterized every one of his charges. Chantha's eyes turned away from his plump voice. Drying fish littered the shoreline. For a fleeting moment, she wondered whether the fisher folk had died from overeating. Her fingers fumbled at first, uncoiling a vine and threading it through a slit in sun–dried gillsother hands had caught and spread, hands that had no more use for fish. Each vine was looped onto a yoke. Each yoke was settled across a set of shoulders. Each set of shoulders was turned away from the lake but not back into the jungle.

The Vietnamese were in the forest now, they were told. The Vietnamese were not to be trifled with, barked a *Kahom* who unslung his rifle and narrowed his eyes menacingly. "Should you see any Vietnamese, run. Run. They will slit the veins of your legs and leave your life's blood oozing out of you. We, on the other hand, are here to protect you…" Chantha spat in disbelief. It was invisible spittle, mind you, and the inaudible splat sounded only in her imagination, but it assured her she was still capable of independent thought. How would they recognize a Vietnamese? Someone was explaining. Skin tone would be different, lighter. Hair would always be straight. Eyes would be very closed–looking, more Chinese–like. How could skin, hair or eyelids be adversarial? Nobody could explain.

A huge, unflooded plain spread out before the group. Not a tree poked above the undulating grass that stretched to the horizon. That first dark night of sleeping out in the open, Chantha curled up among some other teenagers. Through the inkiness, she heard snatches of a conversation. A young couple, Pot and Eang, discussed ways to elude the *Kahom*. As Chantha feigned sleep, the wife whispered that they

ought to take the parentless children with them. The urgency of escape became clearer as the moon rose on subsequent evenings. Against the sliver of light, Chantha saw silhouetted cadres rouse sleepers, shuffle them over a hill and return alone.

That week, a gray–haired man began to camp near the teenagers. His newer clothing and fuller frame raised suspicions. At dusk, separated from other clusters of fish coolies, he revealed to the youth that he was seeking his son. He claimed to have had contact with Vietnamese soldiers who, contrary to local propaganda, would welcome and help them. One young woman questioned why anyone of them should believe him. In silent response, the man unwrapped a package. Pure, well–processed rice unlike any Chantha had seen in three years lay on the cloth before them—tinned food too, ham, chicken, vegetables, fruit. This fare was standard issue behind the Vietnamese lines, the man disclosed. Why stay here among Khmer who kill their own?

There was immediate acceptance of his offer to lead the young people to the Vietnamese. All possessions were to be left behind, with grass rolled up inside their sleeping sheets as decoys for *Kmae Ka-hom* surveillance. A kettle, a blanket and some underclothes were all Chantha had in the world. Against orders, she tied the pot and lid around her waist, knotted everything else together and rose up as the man, acting out a death squad commander, prodded the eleven children toward a thicket. Anyone observing the empty–handed shadows heading away from the yokes, and fish, and other sleepers, would have lain low to avoid being volunteered for a one–way trip. Two toddlers were hip–slung or piggy–backed by the older youth. Without age–sensitive caution, their teenage porters blatantly threatened death if they cried. They promised total tongue and tummy satisfaction in return for silence.

The crescent moon slid beneath a shroud of clouds as the fugitives reached the bush. Deeper in the darkness, moans, groans and curses rustled among the leaves. "Go to hell!" gasped a voice, not

specifying which of the eighteen levels of the Buddhist netherworld its assassin should go to. "You kill me today, another will kill you to-morrow," cried the proactively vengeful victim. The old man hurried the children along, skirting the trees. Grass gave way to mud. In loose formation, the group waded into a pond. Leeches lurked. Spiky stalks broken near the swamp's floor pierced feet too firmly planted. Sway-ing and steadying herself, Chantha's kettle lid clanged against the pot.

"You endanger yourself and all of us!"

"Sorry, Uncle, I'll throw away the lid.'" On she trudged, coverless cooking pot quietly beating a bruise into her hip. Beyond the pond, a denser forest lay. Legend had it that none had entered there and left alive. Into the gloom they went. The next afternoon, they halted at the far fringes of the woods, where they waited for nightfall. The old man wanted no one to spot them roaming across the countryside.

The fields they crossed after sunset held more watermelons and squashes than the group could carry. Squatting among rows of ripe melons, the children split open the fruit and crammed its sweet flesh into their mouths, rivulets of juice cascading down chins and drip-ping off elbows. Everyone filled arms and hustled on to an abandoned village where bamboo huts and wooden stilt houses stood empty of inhabitants but full of provisions. *Om,* "Uncle" as they addressed him, had the children eat their fill while hiding among head–high grass. He didn't allow them to enter the homes, but led them to a barn thick with duck and chicken odours. All the birds being gone, *Om* hoped no one, not even provision–scavenging *Kmae Kahom* would investigate the shed. Nonetheless, he directed the children to burrow in the hay to sleep, to cover themselves completely. Chantha settled in, drawing a huge, black duck net over her. Sleep didn't come easily for bodies and brains on high alert, and fortuitously so. Soled footsteps—several, maybe a dozen—approached. Chantha held her breath.

Low voices, men, soldiers likely as they had shoes, muttered in Khmer. "No chicken." Someone stumbled on the edge of the duck net.

Chantha's heart pounded in her ears. Imminent death stalked her. "No ducks, either." "Maybe people, though." Under some straw, the two toddlers slept the inaudible sleep of the unaware. "No, there's nothing. Let's go to the cook house." Voices and footsteps faded. Death passed over.

At dawn, the absence of the dangerous ones was confirmed. *Om* and his straggling band were about to resume walking when someone sensed movement other than their own. Vietnamese. The invaders appeared to be on friendly terms with a crowd of Cambodian hangers-on. *Om's* guidance had been true. As Chantha and the other youth stepped out of their hiding places, their tattered black clothing immediately identified them as newcomers. "Where are you from? What do you have with you? Weapons? Grenades? Guns?" Intelligence-hungry operatives questioned the children. A sun-browned, straight-haired, slim-eyed soldier scrutinized Chantha's face as the translator interpreted his questions.

"What did you do?"

"I was a member of a kids' crew."

"What did the *Kmae Kahom* have you do?"

"We were making fertilizer."

"Did they give you weapons?"

"No."

"Do you know where any weapons are buried?"

"No."

"Do you know where any *Kmae Kahom* are?"

"Yes, we heard some last night."

Eventually, the Vietnamese troops pressed on in pursuit of their fellow communists. As for the Cambodians just behind the front lines, some turned toward Pursat's Cardomom Mountains; rumors of freedom in the land of the Thai swirled like dust in dry season.

Many, Chantha among them, wanted to go home. She longed to find her mother and her father. A highway, Route 5, beckoned. Mor-

tar–marked macadam blistered bare feet. Swollen soles stumbled on. Rising before the sun to cook enough rice to eat throughout the day, Chantha arrived in Kompong Chhnang City after walking fourteen days. Along the way, some villagers met migrants with buckets of clean water and offers of shelter under stilt houses, but others shooed them away. Great throngs gathered on the river bank in Kompong Chhnang, waiting for boats plying the Mekong in either direction. Warehouses packed with rice were pillaged, and Chantha, like others, bartered grain for harder–to–get goods or passage to Phnom Penh. Rice as a medium of exchange had limited value as supplies suddenly abounded. Gold was the currency of choice.

And gold there was. Chantha herself had succeeded in stashing a pair of earrings in the strap of the satchel that had held her blanket for three years. These last links with her childhood paid the way for her to return to the capital city. The rain, the exhaustion of walking, the diet of rice and little else, and insufficient clean water had taken their toll. A fever immobilized Chantha when she disembarked at Chreuy Chung Va on the far bank of the Tonlé Sap River from Phnom Penh. Chantha's traveling companions, Pot and Eang, waited for her and on her, graciously gathering herbal remedies and wisely forcing a slimy, bitter concoction down her throat. The couple led Eang's younger siblings and Chantha along once–familiar paths through various villages, including Kean Klayung where Chantha paused among the coconut groves under which she had first faced a *Kmae Kahom* back in 1975. Although there was no trace of the solid stilt house, Chantha could almost hear Grandma's voice, "KKKKrrrr" chiding the chickens for the greedy gobbling. Almost. Chantha saw no signs of anything or anyone who might make this space home, and though a salty trickle ran over her cheek, she shook off the melancholy before anyone else could notice. Three years of severely stifled emotions would take much longer to work through.

Eang and her siblings were determined to reach their childhood

home, which lay downstream near the banks of the Mekong. Along the way, some settled people took pity on the skin–and–bones brigade. They offered fruit and prepared food. One road–side seller of *num kruah* even handed Chantha one of her wares for free. The egg–white pancake sprinkled with coconut and onion flakes was hot out of its baking mold. Was there anything so delectable in all the universe?

Each encounter with loud–hawking, colourful–sarong–wearing traders made Chantha more aware of her utter shabbiness. Her threadbare cotton blouse still modestly covered her elbows and collarbones, but the black trousers hung an embarrassing ten centimetres above her ankles. The sandals she had carved out of motorcycle tires flip–flopped indecorously every step of the way.

Eang's entourage arrived at her family home. Empty—neither parent had returned from the great displacement; the house hadn't been occupied by squatters either, so the four siblings, Eang's husband, and Chantha set up camp. Providing for themselves had meant scavenging but now, with a place, it was possible to plan. Pot began fishing early that first morning on the river. Chantha took on the duty of trading his excess catch for salt, fish sauce and other basics. Quick sales were the only sales as the mid–morning sun dehydrated the palm–sized *try rial;* putrefaction put off everyone exercising the recently reacquired privilege of choosing what not to eat.

Not two weeks later, Chantha was wandering farther along the road than usual when a woman stopped her. Rather than the usual "*Tlay ponmaan*?" which initiated the habitual haggling over price, the woman peered intently at Chantha. "What's your name? What village are you from?"

"Srey." Chantha gave her nickname and pointed upstream toward Eang's house.

"Who is your mother? Your father?"

"Chantoo and Vong."

"I am Yaum, your mother's second cousin." Yaum's chin quivered

as she began to sob and clutched Chantha close. Unused to public displays of affection, Chantha waited stiffly until Yaum composed herself. After Auntie Yaum sorted out the details of Chantha's housemates, she shared her own. She had five children, no husband, a big house though empty, and a generous heart. "Come. Live with us. Although it's little, we'll share what we have. And don't worry about the fish. I'll pay Eang for it." The fish! Chantha had completely forgotten about the now very fragrant bucket swarming with flies in the blazing sunshine. Just as unceremoniously as it had begun, Chantha's attachment to Eang's household ended.

Two days later, after eating pigfeed–quality corn mixed with rice, Chantha was immobilized by wretched gastrointestinal pain. She was passing blood, but Yaum had no meds and no means to get any. Praying through tears, Yaum called on the highest god to help and to heal. She assigned her eight–year–old to attend Chantha, serving a concoction of young guava leaves steeped in water as the others continued to glean what they could in the local corn harvest. Chantha felt she was nothing but a burden on her cousin–aunt, who had more than enough mouths to feed. When she staggered to her feet, Yaum was again convulsed by a spasm of weeping. "Stay still, stubborn girl. Rest until you are well."

1980 crawled along like a paralyzed millipede. Occasionally a missing person would return to the district, prompting an explosion of repressed emotion in Chantha. What had become of Mother? Grandmother? Grandfather? The aunts? Father? Curiosity overwhelmed Chantha's sense of loyalty to Yaum in the sixth month. She had heard a dear family friend lived about three kilometres away in *Yiey's* ancestral village. Yaum agreed Chantha could pay a visit. It was only an hour's walk, but the variance in lifestyle was vast. Toun, at 59, was considered a fairly old woman, but with a grown son to support her and no youngsters to raise, she had more than sufficient rice. "Would you like to stay with me?"

Chantha hesitated. "Well, I am with another auntie." After Toun got Chantha talking about conditions at Yaum's, she filled several sacks with foodstuffs. Toun accompanied Chantha back to Yaum's home where she set down the provisions and took Yaum aside. The women walked out of earshot, where they negotiated Chantha's next move. Yaum then took Chantha out along a paddy dike for a final tête–à–tête.

"You are always welcome here. If there's any abuse at Toun's, come back." And so, taking nothing more than memories, Chantha retraced the track to Ro Ka Kaong to yet another house that wasn't home.

Toun had more than rice to offer the seventeen–year–old. She had reached womanhood during the French protectorate, endured the Japanese occupation, prospered under Sihanouk's reign, evaded the American bombing and survived the subsequent genocide. In so many ways, Toun reminded Chantha of Grandmother. Not a day went by without Toun presenting her with an opportunity to expand her understanding of time–honoured traditions. There was the garden, of course. Learning by doing, Chantha copied Toun sowing tobacco and nurturing corn. They fabricated trellises for climbing beans and con-structed a composter. Being lithe and limber, Chantha's first task was to excavate a pit, more than a metre deep and more than two in diam-eter. Under a hot, hot sun, Toun showed Chantha how to layer bul-lock manure or fish entrails, ant–hill soil, stalks of harvested grain and vegetables, all buried under some of the original earth. For variation, cabbage leaves were added. These, Toun advised, would decompose into a stronger fertilizer best suited for next year's tobacco.

Dried cow dung they burned along with branches of coconut palms; snail shells blanched in the heat. The shells were crushed to make the white quicklime paste smeared on betel vine leaves. Older women wrapped boiled and dried pieces of betel palm seeds in the limey leaves, then tucked a chew in their jaws to ruminate, suck and spit bloody–red saliva. A betel buzz was sedative. Toun and her peers

had chewed betel for years. On their wedding nights, the groom had been presented with a packet of cigarettes. The bride customarily received pre–packaged betel. Chewing had been beneficial to family relationships, wizened widows said. A wife who chewed was less excitable, less likely to be stimulated by men other than her husband, to say nothing of any Don Juan's reaction to the scarlet spittle dribbling at times from pursed vermilion lips guarding blackened teeth. Betel had a bitter bite to it, a bit like orange rind and altogether unattractive. Her first chew made Chantha almost instantly sleepy. She watched betel juice stain Toun's mouth and rubbed her own lips together. If it weren't for the terrible taste, betel might have been a poor girl's substitute for lipstick.

And lipstick some women wore again. The local market with neighbourhood vendors and itinerant traders resumed its focal point in the community. Being in the market gave Chantha a wider window on the world. She kept her eye open for any relatives, locating another "auntie" but none of her immediate family. Chantha met many strangers too, including men, with whom she maintained a cool, business-like demeanor. True, years of deprivation had pushed back puberty and her child's body was only beginning to catch up to her analytical adult outlook. One aspect of that attitude was a deep–rooted dislike of perpetrators of violence. In every execution Chantha had witnessed, the *coup de grâce* had been delivered by a man. Coy winks and too hearty laughter at their own jokes made market rakes all the more repugnant. Who knew what grim and grisly past lurked behind a flashy smile and witty repartee? Toun's son, older and married, seemed harmless, though. If Sry met Chantha on the road home, he would load her purchases on his bicycle and push it along, chatting as innocuously as any girl. These encounters didn't appear quite as virtuous to Sry's wife, who read infidelity into her husband's friendliness. Rude remarks fueled neighbourhood gossip as everybody told anybody about somebody whom nobody would confront.

Yaum re–appeared to persuade Chantha to move on before irreparable harm was done. She had consulted Toun and the third "auntie", Muech. It was the right thing to do. To mitigate Madame Sry's loss of face, to maintain Toun's neighbourly equilibrium, and to avoid further assault on Chantha's virginal honour, the good life was going to be abandoned. Auntie Muech was a farmer. In their most convincing tones, everyone said Chantha would have plenty to eat in her home. Food. Once again, decision–making came down to who could put rice in a girl's belly.

Muech came over for a day. Chantha crossed the Mekong with her that evening. The river severed social links and profitable prospects. "A girl should stay home, cook and keep house." Muech made her approach to child rearing clear from the outset. Her pedantry carried up to the bow of the boat where Chantha sat wondering what fate awaited over the waters. She followed this auntie up the bank in the twilight. A couple of trees and a string of simple houses surrounded by dry stalks of harvested rice formed a village. "We rise early to prepare breakfast for field workers," were Muech's last words to Chantha that night, but in the morning a softer side was overheard murmuring, "How this age likes to sleep."

Not that sleep was possible. The village headman owned a radio, which he amplified through a conical contraption. Elders reveled in break–of–day broadcasts of Khmer opera. Legends of Ramayanic proportions replete with giants, maharanees, and magical monkeys played and replayed in whiny, melodic tones. A heart–breaking serial of a family decimated in Pol Pot time followed. This story reduced Chantha to tears. Unable to console her new charge, Muech marched over to the headman's house. "Turn off this tragedy. My niece is crying herself to death." The melodramatic moment was made all the more memorable by the headman's acquiescence. He agreed to turn the dial, but wanted to meet this woebegone girl. Before he entered Muth's house, auntie wrapped a *krama* around Chantha's head, covering her

hair and part of her face. Later Muech explained the traditional head covering she enforced. The scarf, she reasoned, prevented men from seeing an alluring face. It also shielded that face from the sun, keeping it unblemished and attractive. While Chantha didn't see much point in beauty behind bars, she had no quarrel with Muech's maxim that young girls didn't mix with men. Chantha was not to talk to, touch or be touched by one. Fair enough, Chantha concurred, silently reliving a rare memory of men publicly touching a female—the traumatic morning the *Kahom* had manhandled Chinda, strangling her for foraging.

It was a man, however, who next diverted destiny from the humdrum of daily housekeeping. A peddler, an old man, sold bullock yokes and swapped stories, bearing good news and bad throughout Kandal province. Hearing this trader's description of Muech's new-found niece, a man left his second wife and four children to see for himself. Chantha was out in the fields when *Ba* arrived. Muech recognized him and invited him in. He was napping when Chantha returned. "Who is he?" she wondered about the wrinkly-faced, older, thinner, wavier-haired-than-remembered-father she had last seen five years previously. When he awoke, *Ba* didn't recognize his almost grown-up daughter either. "My father was tall. Now he seems to be short," Chantha observed.

Ba smiled and turned toward her. "Do you remember anything distinctive about your father?"

"Yes. A mark on his forehead, just below his hairline. A scar on his leg." *Ba* obliged, pulling back curls untouched by the pomade he used to use. He pointed to his thigh. Sure enough, his body bore the marks, but still Chantha was uncertain. "Do you know my mother's name?" she asked.

"That," *Ba* said, "is something everyone in the village would know. It's not a very astute line of questioning. Daughter, remember 'barrette." A trigger fired along a long-silent synapse. "*Barrette*" was the first French word Father had taught her.

"*Papa, fermez la pipe!*" The silly little retort still slipped easily off her tongue.

"*J'ai une poupée,*" *Ba* began to sing, "*Je ne sais pas son nom.*"

"*Papa,*" Chantha whispered, "it IS you." They wept. At nineteen, Chantha was too old for *Ba* to embrace; he patted her head, bodies properly apart.

Ba stayed three days. Although in the mid–1960s he had divorced *Maq,* who had born him only a single girl–child during eight years of marriage, *Ba* had remained on courteous terms with his in–laws. His visits, the sweets and surprises Chantha invariably found in his pockets, and the mystique of the Sisowath name endeared father to daughter, however Vong had parented only by proxy and it appeared that pattern was to continue. Chantha's step–mother had her own priorities, so Chantha remained with Muech.

Shortly after *Ba's* departure, it occurred to Chantha that Muech had more than pure altruism motivating her hospitality. One potential suitor's mother was entertained specifically to dissuade that family from pursuing a match. "Chantha is not yet a woman." That was true. "She cannot cook." That was false. The tall man's mother wanted to question the prospective daughter–in–law herself. Chantha contradicted Muech on cooking. In response to "Would she marry?" Chantha declared—as much for Muech's consideration as for the matchmaking mother's—that she was waiting to find both her mother and her father before taking such a step. As for not having achieved womanhood, no married woman discussed such matters with a girl.

Severe blood loss meant certain death, Chantha remembered Grandma saying. And so it was with absolute horror Chantha discovered she was bleeding one evening at a temple–yard opera. "What is happening?" she whispered to Muech's grown daughter, who shushed her up once she realized Chantha's condition.

"Say nothing, say nothing," she ordered through clenched teeth. "Don't move," she reprimanded when Chantha suggested they go

home. "No one must hear. No one must see. No one must know." Surrounded by boy cousins who provided the requisite security for girls out after dark, Chantha's confidante slipped her *krama* off and around Chantha's hips. "We'll rise when they all rise. Then drape this around your buttocks to hide any stains." Shivering and afraid, Chantha sat through the rest of the drama unaware of any but her own.

At the end of the play, the audience rose to their feet, rubbing numb ankles and toes, straightening sarongs and, in Chantha's case, rewrapping a scarf as an outer skirt around her hips. Second Cousin seemed ecstatic over Chantha's distress. Back at the house she prepared a special dessert. "Girls all get it. I do. Don't let anyone see. Go. Clean yourself. Shower." Tearing up an old sarong to fold into a pad, Cousin burst out with the news when Muech entered the kitchen. "Chantha's ready to marry!" Marriage was most definitely not what Chantha had in mind. Auntie's scheme to betroth Chantha to her son ignited desperation to escape the household. She sent word to *Ba,* who arrived with assurances he had never dreamed his daughter would wed an uneducated farmer. Without *Ba*'s blessing, Muech's purpose in providing for Chantha evaporated. It was time to meet Step Mama.

Sarin had weathered the *Kmae Kahom* storm in her home village of Kaw Dach just beyond Phnom Penh, on the other side of the confluence of the Mekong and the Bassac Rivers. Her ancestral property produced abundant mango and tobacco yields, which she had resumed transporting across the country. She imported refined sugar, MSG and textiles to retail in the reviving capital. Chantha joined *Ba* caring for cucumber and corn crops. It seemed to Chantha her father still considered her his dainty little darling of happy, long ago days. They shared no adult conversation as they worked in the fields, but when Chantha twisted her knee slipping on a rickety flight of stairs *Ba* treated her like a preschooler. He softened a paste into a plaster and massaged her muscles. "Don't fuss over her," was all Stepmother said, but Chantha sensed jealousy. Tension in the household eased with

Stepmother's absences but heightened with each successive incident. Chantha believed even rhetorical questions deserved an answer, while Stepmother considered Chantha's explanations nothing but cheek. She found fault even in her step daughter's successes; Chantha resented credit withheld where due. She refused to go along with Stepmother's arranging a match to a prosperous neighbour.

"I'm waiting for my mother," did nothing to soothe Second Wife's pique. Overhearing the ensuing argument between Stepmother and *Ba*, Chantha concluded she would have to leave for her father's sake.

Ba's sister, an ascetic whose shelter was a one–room cottage in a forest, offered a sanctuary for thought. When Chantha paused in re-telling her dilemma, Auntie nodded. "I know a nun, in the city, at Wat Lanka. She's concerned about her daughters living with their father, a surgeon. His second wife is a tailor, busy with her business, none too mindful of the second–hand children. They need a nanny." Goodbyes might have thwarted the plan, so Chantha said none.

Phnom Penh at the end of rainy season, 1980, was hardly the overcrowded, risky business capital of New Year, 1975. Frangipani again flowered fragrantly along a boulevard now called Russie. The pro–Vietnamese government, like other historical revisionists, had such a fetish with labels. Perhaps they really believed they could alter the past by erasing references to its heroes. Renamed roads perpetu-ally referred to as a.k.a.'s led exactly where they always had. The New Market, its water–stained yellow dome rising above buyers and sell-ers, was back in business. The train station, silent rails rusting away to nowhere, stood guard over a plaza strewn with litter. Elephant grass displaced pedestrians along the riverfront esplanade and camouflaged squatters' hovels. For a week, Chantha stayed with the nuns, follow-ing them around the *wat*, cooking and hauling water for them. Auntie returned to Kaw Dach when Chantha's situation had been arranged.

Songtan, twelve, and Tup, ten, were Chantha's charges. She also cleaned house and prepped for family meals. Neither Saru nor his new

wife would part with gold to pay a house girl, but Ly did initiate Chantha in the intricacies of operating her treadle machine. Moreover, the mysteries of measuring a client and cutting the cloth were revealed over the weeks that followed. Chantha's first customers were soldiers of the Vietnamese occupying army. They paid six *dong* per pair of shorts. Chantha snipped and stitched, sewing seams rapidly whenever Ly took a break from the machine. She saved all of her earnings, which at a hundred *dong* she exchanged for gold, and sent it all to *Ba*.

Chantha had accumulated a second ounce of Cambodia's preferred currency when Saru and Ly invited her to a secretive family gathering. An unfamiliar man with an unmistakable western Cambodian accent delivered news from Saru's step–daughter. That young woman had smuggled herself over the Thai border. The stranger was prepared to guide the family past the checkpoints of the Vietnamese occupying army and around *Kmae Kahom* guerrilla bases on the western frontier, while evading Thai forces who were trying to close the sieve–like border. He would enable them to join thousands of Cambodians who had sought sustenance and security in Thailand since 1978. For the first time in her life, Chantha heard the name Khao I Dang, a refugee camp whose population then made it the second largest Khmer settlement in the world. Only two prospects loomed out of the future that night: return to Kaw Dach, or join this journey into the unknown. The going guide price was between two and three ounces a head. Chantha had one. She offered all and the guide, pitying her perhaps, cut a deal.

Being a savvy strategist, the guide sent Saru's two daughters and their birth–mother, the nun, on ahead. New Year was the cover for the adults' cross–country trek. Cambodians had customarily traveled to ancestral villages for the festivities, and 1981 marked the resumption of many traditions. The April rains had yet to fall so the roads, though eroded by a decade of war and weather, were passable. In Phnom Penh, the family boarded the best in public transportation—a

spot atop a truckload of rice sacks. *Kramas* wrapped around the head and over mouth and nose filtered out some of the dust that billowed up from ruts that could rattle a loose tooth right out of one's jaw. The bone–jarring journey ended after dusk at Psaa Dam Dong, a market in Battambang City. Chantha followed Ly, Saru, two nephews, a niece and the guide into a nearby house. A meal and a mat were part of the package price.

In the morning, three motorcyclists picked up the passengers. Off–road now, they scooted along cow paths and bumped over paddy trails. On the road to anywhere, it wasn't quite a "que sera sera" experience, but then Chantha lacked unflappable confidence in providence. If her nineteen years had taught Chantha anything at all, it was that destiny unfolded as it would. An individual, no more than a grain of sand, could not divert the breeze that blew it.

Another safe house sheltered them the second night. City clothes were exchanged for country wear and rural transportation. At dawn, the group was already bumping through guerrilla territory close to the frontier. A Khmer patrol called to halt them. The guide gave his best answers, appearing convincingly nonchalant. One bandolier–laced soldier stopped Chantha and the two–wheeled ox cart she was driving. "Married?"

"*Jaah.*" As coached, Chantha indicated the guide was her husband and hoped the maternity shirt she wore looked plausible. "I'm pregnant," she lied.

"Too young. You're much too young for him." Chantha felt his gaze but didn't meet it. Decorously downcast, her eyes couldn't give her away. "Divorce him," the guerrilla continued.

"I became his wife at a cadre's whim," Chantha breathed like the star of one of Muech's radio soaps, "but, now...I love him." Getting nowhere, the soldiers waved the seven on up the track toward Chum Roeum Tmay.

This border camp was one of many controlled by splinter groups

of Khmer resisting the Vietnamese occupiers. Massive international relief efforts along the Thai–Cambodian frontier, now into their third year, included survival ration distribution to women and children inside Kampuchea. Chum Roeum Tmay was one of the delivery points. A Tmay bigwig, introduced to Chantha as Doctor, was their guide's contact. On the floor of Doctor's house that night, Chantha couldn't sleep. Her perilous circumstances were suddenly clear. There would be no food without a registered ration card and no card without a male head of household signing on for compulsory service with the controlling faction of "freedom–fighters". Going back was not an option; getting into Thailand dangerous. Mines were strewn all over the border. Feeling like a pebble in someone else's hopscotch game, Chantha wondered when she would be thrown and where she would land. Destiny be damned. She had not come here to die.

Hanging out hand–washed family laundry the next morning, Chantha bumped into one of Doctor's bodyguards. He wore a square of black fabric tucked into the breast pocket of his shirt. "Who is he mourning?" Chantha wondered, following the strong, silent soldier with her eyes as he hauled water buckets up to Doctor's compound. An unfamiliar feeling washed over her. Throughout the morning, Chantha overheard snippets of Saru plotting the next step with the guide. She noticed some Europeans in the camp speaking French with Doctor. Someone said Khao I Dang housed over 100,000 Khmer. Collecting the sun–dried clothing, Chantha couldn't find her hanky. Perhaps the wind had blown away the white embroidered cloth with her proper name in dainty black letters.

"Don't worry about a handkerchief, Srey," Ly advised. But passing through Doctor's kitchen, Chantha spotted it on a sleeping mat. Without a second thought she retrieved her handiwork.

"Have you seen MY hanky?" the soldier from the morning accosted Chantha as she stepped outside.

"YOUR hanky? It's mine. I made it myself."

"But it says 'Chantha', and your family calls you Srey."

"That's only my nickname. My real name is Chantha."

"It's beautiful. I love it. Won't you give it to me?"

"Would that make you happy?" Chantha glanced up from his black *kantook,* or mourning cloth, and caught a twinkle in his eye. Whether or not he was happy, Chantha couldn't control this strange pleasure that bubbled out into a giggle. Suddenly she was speaking with a man and enjoying it. Quite.

Chum Roeum Tmay wasn't all that bad, the soldier was saying when Chantha returned to earth. Crossing no–man's land from here to Khao I Dang meant risking life and limb. Brutes of the Thai army corps ravished any female who fell ill–fated into their clutches. Rape. A prospect worse than death. "You may keep the hanky. I must go with the family. If I die, I die. Remember me."

"Remember my love," were the young man's last words to Chantha a few mornings later. Under a three o'clock sliver of a moon, he bid the family the best of luck as they set out on the last leg into their future. "So you won't stay, even if I feed you," he had pouted. Not for quite some time did Chantha fathom the deeper passion beneath those words, and then it was too late. She never received a response to the message she sent back to the frontier from the other side, if in fact it reached the unappreciated suitor.

If, in fact, she reached Thailand. Midnight shadows hid loitering militia who stepped out just as the guide passed. Flashes of steel, blades and butts, hard against clammy flesh, secured silence from Saru's "family". "*Mea'h.*" Gold, the mercenaries demanded.

"What you got, little boy?" One addressed Chantha whose current disguise in tattered trousers, shirt and twist–tied *krama* over just–butchered hair passed muster. "No gold, no mother, no father, I'm just tagging along," Chantha spun another yarn.

"Do the others have gold?"

"Couldn't say, they don't show me nothing."

"Where're you going?"

"Khao I Dang."

"Why?"

"To find my mom and my dad." A hand clamped around Chantha's bony shoulder. Expecting a shake–down, Chantha tensed as one of the soldiers dragged her away from the group.

"If they learn you're a girl, they'll rape you." Why the warning? Pity. Why hang with such brutes? Self–protection.

"Hey!" the commander called across the clearing. "Finished inspecting the boy? Any valuables?"

"Only his dink." A round of guffaws. "And stinky! This squirt never showers." More laughter. The inexplicably forbearing bandit shoved Chantha unharmed back toward the others, all robbed. The five hundred Thai *baht* rolled in the scarf around her skull remained out of sight but on her mind.

Chum Roeum Tmay was barely behind the five fugitives when Chantha stumbled on her first corpse. The fields and forests through which Guide led them that night had been the end of the road for other émigrés. Chantha's path plunged over or around such obstacles. Just before sunrise, a ditch appeared before her. Full of water and bordered by dense, long grass—Saru's group sank into the thickness. A palm pressed flat against lips signaled silence. Someone was singing. Unintelligible. Thai. Boots hit the sentry track within kicking distance. Whorls of dust. Grit in Chantha's teeth. Tongue too dry to lick her lips. Bladder never so eager to burst. In the sanctuary of her mind, Chantha plead her case with One at Mount Meru's summit. The footsteps faded. Guide scrambled up over the dike and wrangled wire barbs apart. "Your turn," he motioned to Chantha. In.

NOT YET WEST: DREAMING OF A THIRD COUNTRY

Chantha was the first of the five to squirm between the first row of nasty spiked wires Guide pulled apart. One by one, they weaseled their way through the camp's perimeter fences, huddled near the Khao I Dang reservoir and inched over to the nightwatchmen's hut. Guide had greased their passage. As the sun rose, the watchmen turned their backs while the illegals rerobed. Someone tossed Chantha a sarong and a loose, long–sleeved, old–lady blouse. They put a basket of water-cress onto her head and closed her hand around the fist of a tiny tot, a child prop.

The walk to the safehouse was an interminable half–kilometre. Chantha had no idea where she was going. She had heard the Khmer camp police arrested illegals on sight. Once jailed, an appropriate bribe might ensure leniency, dispensation to remain a scavenger beneath the scumheap of the world. Insufficient funds meant being turfed out quick and sure. Chantha tried to be inconspicuous, but as she passed row upon row of bamboo shelters, women called out. "Are you sell-ing?" "How much for the watercress?"

"No." The truth seemed too abrupt. A lie massaged the sharp edges of her fear. "This bundle was ordered earlier. I'm just delivering it." Uh–huh. The delivery, which was in fact Chantha herself, success-fully reached a nondescript house in Section 3.

The house was home to Saru's step–daughter. She, her husband and two children shared their five–by–three–metre one–room house with the newcomers until Guide pulled strings to assign Saru his own unit. Guide was a ten–house block leader. The entire camp, Chantha learned, was administered in sections and blocks. Housing, rations, paid work and privileges were all funneled down through the hier-archy. Considerations were siphoned up. By virtue of his connections and skills, Saru soon found work in the camp hospital. International Aid medics slipped him quality rice and slabs of beef; without a UN-

HCR registration card, no one could access the rations officially–sanctioned refugees collected twice a week. The pay–in–kind staved off the hunger that growled in Chantha's gut. What *baht* she had carried with her was soon used up. The household traded for cheap red corn and rice bran, chicken–feed really, and foul–smelling, yellowed fish.

Within three weeks of their arrival in Thailand, Ly and Chantha were plotting an escape minus the men. Back in Phnom Penh, they had been free to come and go. They had made a decent living by tailoring. They had slept on full stomachs every night. The women talked themselves to tears. Saru couldn't help but notice their unraveling emotions. "Calm yourselves. Being hungry for the moment is nothing compared to being legless forever. Think of the mines. How would you avoid them? Besides, there's nothing left in Phnom Penh." He had a point. Their house near Wat Lanka would have been claimed by squatters. Even if they could scrape together enough to buy a sewing machine, Ly's advancing pregnancy would work against her. Who but a whore would come from the border in such a state? Social ostracism was hardly the foundation for a solid client base.

Chantha and Ly sweated out the hot season. Along with the regular rains of July and August came an opportunity to register with the UNHCR. Saru handled the matter. As Head of Household, he enrolled himself, his wife, their relatives, and Chantha as his niece. In exchange, he received a stiff, white card, which he swathed in crinkly, protective plastic. Presenting the card made the family unit eligible for ration distributions. This significant advance in security and provision did not last long for Chantha. Ly's relatives, already resettled in Australia, whose letters had kick–started this escapade, filed sponsorship documents for Ly, her husband and her kin. They knew nothing of Chantha, who afterall was no blood relation at all.

The trouble with lies is that once you let one loose it spawns promiscuously. It looked like her foster family was going to leave her behind. Chantha wasn't prepared for abandonment. On the advice of a

friend, she approached the Red Banner Society, a Khmer charity with a mandate for orphan and widow care. She lodged a formal complaint against her "family". Her declaration stated that they treated her as a slave. Truth twisted into sympathy–inciting stories. She had done all the laundry. "Don't mention that the nephews hauled the water," her friend coached. Or that Ly couldn't squat and scrub around her third–trimester tummy. And cooking, it too had fallen upon Chantha's young shoulders. She didn't care to explain that her culinary services had been offered, not demanded. Utterly disingenuous, Chantha's report haunted her all the more after Saru confessed to the accusations. Perhaps he was playing along, easing his so–called niece under some other protective wing when he saw the end to his own influence looming. Chantha never found out for sure. She simply couldn't face the man who had sheltered her from family–wrenching antagonism, who had, without compensation, included her in a well–executed escape plan, and who had provided patronage in a place where the fatherless were particularly vulnerable.

Red Banner approved Chantha's separation from her paper family. Chanteen, a refugee staffer, invited her to move in with his family until other housing arrangements could be made. Chanteen was an ethnic Lao married to Teng and an impending first–time father when Chantha met him. He took seriously his responsibilities to link unaccompanied minors and young adults to resettlement opportunities. During her first uncomfortable weeks in an unfamiliar household, Chanteen signed Chantha up and paid for English lessons. Classes got her out from under Teng's pregnant crankiness and into the entrepreneurial swirl of Khao I Dang's language elite.

By 1982, the intercontinental mass migration of Southeast Asians was well under way. Embassies were picking and choosing according to their own demographic designs. Mechanisms for screening out or allowing in churned through thousands of applications. Linguistic competence kept many gates. Cambodians who had successfully

masked secondary or higher education during the Pol Pot regime launched private schools. Unlike the aid agencies, which paid in kind as required by the Thai, Khmer teaching English or French expected and got cash. No *baht*, no books. The system favoured well–to–do and well–connected youth. No one over forty went to school. It was inconceivable to the Confucist mindset that an elder could learn anything from a teacher younger than himself. So teen to thirty–something–year–olds with already–overseas, money–sending relatives filled makeshift classrooms as well as receiving priority placement on embassy interview lists.

For thirty *baht*, Chantha enrolled in three sessions a week. The first lesson was complimentary. Teacher wanted to assess the fifteen students crowded around the rows of tables and benches crammed into the three–by–four–metre classroom, which took up half of his house. Four one–hour classes served sixty students every afternoon between one and five o'clock. Chantha found a seat near Keng and Yin, two other young ladies. Teacher began with a recitation of the English alphabet, which he assigned students to print on a chalkboard mounted on the wall. He introduced a little ditty sung to a folk tune to help them memorize the twenty–six letters. Chantha recognized the characters from French lessons seven years earlier, but was chagrined at Teacher's constant corrections. *Eh*, not *ah*. *Bee*, not *bay*. *See*, not *say*. Nevertheless, Chantha's seatmates looked on in awe as she confidently recalled even enigmatic guidelines such as "I before E except after C."

Afterward, they pestered her about her background. "You must have been rich to have studied French."

"And you," Chantha queried, "didn't your primary school have a French teacher?" Yin and Keng giggled to cover their embarrassment. They had never attended school.

In class, the students experienced a return to *ancien regime* etiquette. They rose to their feet to greet Teacher appropriately. "Good afternoon, Sir," they chorused. He replied, "Good afternoon, Class."

The hour passed too quickly. Teacher was humourous, never boring. He talked non–stop and gave numerous examples. Although Oxford's *Essential English* Book 1 was *de rigueur,* most of the students could not afford a copy. Teacher chalked up Mr. Presley's dialogues, which students copied verbatim; Chantha liked copying. Writing helped her remember. Her notebook filled up with vocabulary lists: carrot, bean, beet and rutabaga in multiples with the requisite final–s plus s–less but certainly not singular rice, corn, soy sauce and salt. It seemed to Chantha that French had been much easier to master. Now she kept confusing *ananas* and bananas. Nevertheless, Chanteen was pleased with her progress. Not so Teng. She pocketed the *baht* Chanteen intended for Teacher's second monthly fee. A row ensued. In Lao, Chanteen chewed out his wife. Couldn't Teng see how investing in Chantha's language skills now would pay off if she resettled with them in America? Her income added to the family pot would make a lot of their dreams come true a lot faster. Teng had other visions. Through jealous eyes, she saw her husband spending unnecessarily on a cute, young thing. If he was so sold on education, why not send a real relative to school?

Chantha vowed to the moon she would continue learning English even if formal classes weren't an option. She would, one day, speak fluently to Teng's face without owing her, or anyone else, a single *satang.* The next afternoon, Chantha told Teacher she was dropping out. Under the circumstances, he privately offered free tuition. It wasn't every session he had the pleasure of instructing motivated, literate students. But this was an offer Chantha couldn't accept. Teacher's wife, like Teng, was expecting. The last thing Chantha needed now was another encounter with a wife whose center of gravity needed serious realignment. Instead, she borrowed the notes classmate Keng copied every afternoon and spent the evenings rewriting them. Even this initiative irked Teng. "You see," she muttered to her husband, "how the oil is wasted, how the wick is whittled away." Teng never confronted

Chantha face to face, but Chantha took the hint. She engineered situations that provided secondary light—bright fires under boiling water or dancing flames on incense. For part of every month, her friend the moon shone his favours, too.

Keeping out of Teng's way, Chantha registered for programs operated by the Japanese, Catholic Relief Services and World Concern. A baking project was administered by a can–do Chinese woman. With minimal resources, she initiated her charges in the mysteries of yeast as they prepared shorter, pointier Khmer copies of the French baguette. *Nom pang* to die for rose on her table and baked in the clay oven outside. The crew mixed and kneaded and rolled and twisted to points the ends of foot–long loaves. Loaf after loaf of crusty, chewy bread emerged from the oven, aromatic gold. Rolls spread with freshly grated coconut, and sprinkled with sugar or crushed peanuts were another accomplishment.

Chantha would never forget the day they deep–fried donuts shaped like stogies instead of inner tubes. The young ladies were cutting and shaping fritters while a few boys built up the fire and set the oil to boil. In jest, one tossed chunks of ice into the cauldron. As the teacher dropped in the first dough, a cube popped up and out. BOOM! Oil splattered. The instructor was burned. The class erupted in accusations. "You, you, you…chopstick!" Chantha railed at the skinny iceman. "What would happen if I threw you in?" The girls moved toward him, menacing. Fortunately, things didn't get out of hand.

Not all classes were so hands–on. The two–hour sewing course Chantha registered in with World Concern had twenty–two students on twelve machines. Women actually fought over access. Elbowing one's way to the head of the queue worked for some. Gift–giving, a time–honoured tradition, secured an instructor's intervention in one's favour. Once one's foot was on the treadle, it was all too easy to set aside project pieces and send the motorized needle hurtling up and down seams that took forever by hand. The garments the girls were

officially producing: blouses, baby clothes, shirts, trousers, bibs and hankies, were distributed in the camp or sold to the Thai. The young seamstresses gained skills and speed as well as one article of clothing each month. Chantha mastered button–holes and hand sewn hems while sitting on the floor mats. Like many of the others, Chantha was no novice at putting clothes together. What she longed to learn was pattern blocking and cutting. She passed many hours analyzing the teacher's deft movements and measurements without hearing a word of instruction. Knowledge was power. By jealously guarding her sewing secrets, the instructor rendered her students dependent and herself indispensable.

Consignment was a formal arrangement. A giver rarely resigned herself to the past perfectly; she never relinquished her say–so. Every dispensation had strings attached. Every present accepted became a debt. Whether she liked it or not, each relationship enmeshed Chantha deeper and deeper in the gridlock of obligation that defined camp culture. The parsimonious were rated lower than a latrine flea according to the ones in the owe—a Khao I Dang combo of Emily Post and Standard and Poors.

There was that incident in the knitting project. Chantha's nimble knit and purls had caught the attention of the supervisor. Nai slipped some skeins of ivory yarn to her prize student. Chantha would have the honour of producing a lovely baby sweater which Nai might, in turn, present to someone who had earlier favoured her or whose future favours Nai hoped to secure. Less privileged knitters had to settle for ugly, gloomy colours. White was in short supply, so Nai made a special request of the Khmer program director. Nul turned her down. It was his prerogative. Giving, not giving, or forgiving was at his superior discretion. He figured Nai was up to something. "Selling special products for personal profit, are we?" Nai snapped. So she lost it—face, that was. Nul sat out Nai's tirade, betting the Japanese coordinator would back him up. Their agency sold camp–knit sweaters to

fund the refugee programs. To be an accessory to squirreling away the best products for personal gain would shift the hierarchy. Reciprocity with her boss in shambles, Nai pulled in a favour someone else owed her. The next day, a market–brand white skein dropped in Chantha's lap, enough to complete the contentious sweater some innocent infant would eventually wear, entirely ignorant of its controversial creation.

Although Chantha found means of staying out of Teng's way, she never earned her way into her good graces. Once too often, she overheard Chanteen's wife haranguing her husband over housing the homeless under their roof. Chantha went directly to the Red Banner. At nineteen, she was too old to qualify for parentless' protection, but there was a space in the dormitory for unaccompanied young ladies. Under the supervision of a middle–aged married woman, seven eighteen to twenty–year–olds shared a house in Section 9. This quarter of the camp was closer to the center and freer of the dust and noise along the border route. A sorority of sorts established itself. The young women took turns carrying water while others cleaned or cooked superior meals they could concoct from pooled rations. Most of Chantha's housemates had jobs, although a couple attended Khmer, English or skills–training classes. Chantha completed a Japanese sponsored childcare program and, armed with her certificate, was hired at the Section 9 Preschool.

Full and varied daily experiences were recounted around the supper circle. The friends realized they were better off than most peers placed in foster families. At greater liberty than girls living with real relatives, they reveled in freedom from having to please elders. Particularly on weekends, Chantha and the others took advantage of opportunities to sleep in. Waking up, one by one, whispers grew to giggles and inevitably dousing the deepest sleeper with a bowlful of water. There was no use protesting too much. Sooner or later everyone got a dunking. In front of the house, in an empty lot, they put up a netless basketball hoop. Other games, remembered from abbreviated

girlhoods, entertained them. A favourite was a version of hide and seek. "It", blindfolded and spun into dizziness, stumbled and groped her way toward voices calling "Come here", "This way", or "Chantha!"

In preparation for the Cambodian New Year, 1983, the Catholic Relief Service gave t-shirts to the residents of the Young Adult Houses. Chantha was none too pleased to sport bold blue letters on canary yellow announcing herself as "Motherless and Fatherless". After the obligatory photo for the charity's donors in Bangkok, Brussels or St. Boniface, she vowed never to be caught dead in it. April 13, 14 and 15 turned out to be marvelous in spite of the pitiful labels. The dawn of BE 2527 found Chantha and her housemates fêting the New Year with family-less boys and young men from another dorm. Supervision by house parents permitted single males and females to mingle within the customary controls. Sitting around a feast to which everyone contributed from his or her savings wore down barriers to banter between the sexes. There was safety in numbers; private *tête-à-têtes* were suspect, touching taboo.

Flirtation flourished under restraint. Chantha's roommate, Koan, had an admirer who found opportunities to be invited for a real meal from time to time. Several months later, Koan's young man arranged to bring along a buddy. Oun, at 20, lived independently and spent hours perfecting barefoot football moves when not working for CARE, a private international organization engaged in relief and development projects. Chantha was aware of none of this. The scrawny guy, skin darkened by the sun and unkempt hair hanging almost to his shoulders, evoked pity if anything as the group ate together. Chantha might have been frightened of him except for the gentle voice Oun never directed at her. Not that she had anything to say to an unfamiliar man. Polite and unaffected was how Chantha saw herself, but Oun saw more. Although not as much as he wanted. A fortune teller had seen more of Oun's future wife. "She is fair-skinned and petite, with wavy hair and a small scar on her chin."

Oun couldn't devise any propitious plan to get himself close enough to Chantha's chin to verify if she was the one. Some feats were for a woman to accomplish. Oun's one-time foster mother obliged. She just happened to bump into Chantha on the street. The ruse was un-original. "Let's see your face, honey. Oh, there's something black." Her fingers reached out, thumb rubbing an invisible speck from Chantha's chin. Her eyes spied what she was looking for. "I found your wife," she crowed upon reporting to Oun.

Chantha's house mother wasn't nearly as gleeful when the former foster mother approached, set to initiate pre-nuptial negotiations. She disapproved of a match. "Forward, unpolished," was how she described the would-be suitor to Chantha, who was left entirely unsure of how to respond. For a time, further developments appeared impossible, but fate intervened. House Mother's sponsors in Australia came through on long-awaited paperwork, and she was transferred to the Transit Camp a couple hundred kilometres away. Even from a distance, she attempted to guide her charges' lives. A letter arrived for Chantha, a rare but severe missive, warning her against such a marriage. It came, however, too late. The new House Mother had an entirely different opinion of Oun. She encouraged Chantha to consider him.

"Do you love him?" she probed.

"Love him? I don't know him," Chantha answered honestly. She couldn't recall a single conversation with Oun, only the mild, mellow tones of his voice.

Would a husband protect her? Would marriage bring an end to the almost nightly flights from the dorm to the temple when bandits infiltrated the camp for gold, guns and girls? She was tired of running to the *wat*. The nuns, noisy beyond belief, chanted until midnight. Before dawn they were at it again, in not-quite-unison tones that roused even the sun. Chantha longed for a full night's sleep. It didn't cross her mind that a husband might have other desires in the darkness. She did wonder, after a lifetime prohibition on male-female friendship, what

people would think of her if she spent the night alone with a man. "You're old enough to be with a man." House Mother's matter of fact advice reassured Chantha that, at twenty–one, age and a few formalities rendered respectable behavior that otherwise branded a woman as loose. Of course, there were the rituals, public proclamations and celebrations that sanctioned unseen intimacy, that legitimized making love even where there was none.

At the Red Banner, House Mother and Chantha registered her consent. The bans of marriage were published three weeks before the ceremony; the society deemed this sufficient time for contenders to come forward. Supporters—dorm–mates, co–workers, former foster families and all the elders of the neighbourhood—rallied around. To wed was to bow to the will and the ways of generations who had gone before.

On the thirteenth of March, 1984, Chantha woke very, very early. An esthetician, a frightfully cheery morning–person, arrived to do the bride's make–up and style her hair. "Where have you been hiding, girl? If I'd caught sight of a gem like you, I'd have arranged a marriage with my nephew! Oi yoi! I guess it's too late now!"

Before sunrise, elders came to guide Chantha and Oun in unintelligible *Prakrit* prayers. After a change of clothes, a *sangha* squad settled in. These Buddhist monks intoned honourable but incomprehensible blessings while the bride and groom knelt side by side. Chantha concentrated on counting the laths on the dais beneath the monks. She willed herself to feel the fibres of the mat under her numb knees and feet. She pressed her palms and counted carpal, metacarpal and phalange junctions silently, interminably. And still her thoughts strayed to the energy emanating from the almost unknown man kneeling precariously close by.

Outside, neighbours were setting up tables and chairs borrowed from some aid agency office. Others were cooking cauldrons of chickens donated by friends. Mounds of rice and noodles were steaming.

An ensemble of traditional musicians took up positions in the shade, tuned and plunged into their repertoire of folk tunes and ballads. Eventually, an elder addressed the couple in Khmer. "You, husband and wife, be together, be honest, be faithful. Love each other until death." Following this simple benediction, friends and elders crowded in to signify their wishes for good fortune and fertility by tying innumerable *ambah*, white threads, around the couple's wrists and dropping *baht* notes into the silver bowl the couple carried from guest to guest during the feast. Tippling toasts at each table, Chantha felt the glow of rice wine on her cheeks. After the dance, guests lingered until Oun left for his house.

An hour before sunset, House Mother and the elders walked Chantha out of the dorm and along the dusty lanes to Section 1. The bride was a bit out of sorts; according to custom, a new husband moved in with his wife's family until they could get their own house. Chantha hadn't any thought to the inappropriateness of spending the wedding night in the single girls' dormitory. Or that this groom already had his own place. But talk about being in a snit. Oun's chickens had escaped the coop and run away during the festivities. He had spent the past hour tracking and stalking several. His wedding wear was in disarray and his hair disheveled. Chantha felt as put out as Oun looked.

"Come in," the gray–haired ones beckoned. They came. "Sit down, face to face," they said, patting the bamboo platform inside Oun's darkening room. They sat. "Peel this," the elders directed, handing a banana to Chantha. "Feed him." She did, awkwardly. "Call him *Bong*, Husband, ask him if the banana is sweet," they instructed.

"*Bong*, is the banana sweet?" Chantha repeated gingerly.

"Tell her it is," they prompted Oun.

"It is sweet," he said, a smile playing at the corner of his banana–scented mouth.

"It is sweet," one crony cackled, giving a second banana to Oun and restarting the antiphonal address. Chantha had never liked ba-

nanas. This one was as bland as any and pastier than most.

"It is sweet," she said on cue. Next, bowls of spirit rice were served with incense. Surrounded by nodding, clucking, peering old folks, Chantha and Oun ate together. The sun had long set. Curfew had come. The elders got up to go. "I'll come with you," Chantha whispered to House Mother.

"No." The long–ago–married put on the sandals they had left at the stoop and disappeared into the night.

Oun lay down in the dark, humming a Thai pop tune. "Never turn your back on your husband in bed." Sage advice of wise old women had drenched Chantha's ears for days. Now, in this most awkward of nights, she had to figure out how to follow it. She eased herself down on the mat–strewn bamboo slats. She curled up on her right side facing Oun more than an arm's length away. He rolled onto his right. Chantha wondered if his back toward her was as sure an omen as hers toward him. She got up and crawled around her husband, settling down so they would be facing each other, again at a distance. It wasn't long before Oun shifted once more, sending Chantha scuttling back to where she had been. On the third roll, the third movement, the husband shape in the darkness spoke to Chantha. "Are you frightened?"

"Please don't move. We must sleep face to face—if not, our marriage is doomed to fail." This superstition Oun found ludicrous, his newly–wed wife's naïveté boundless.

At first light, Chantha was up, rummaging through the sole cabinet next to the clay–covered stand on which two firepots stood. Though she was quite clueless as to nocturnal obligations, she had a fairly firm grasp of daytime duties. Breakfast. The room was dim inside shuttered windows and a closed door. She rattled the chain. Husband awoke. "Want to go back to the singles' dorm?"

Chantha wiped a tear and stifled a sniffle. "Where's the rice? The salt? The water?" Oun tightened a sarong around his waist and climbed off the platform. In the far corner, he opened a rat–proof plastic pail to

show her the unpolished brown rice. His stash of salt was camouflaged among some sacks. There was no in–house water jar, just one big urn outside. During their first, quiet, conjugal meal, Chantha fidgeted under her husband's attentiveness, unable to swallow. She could sense his eyes roaming over her face and form, but didn't dare look directly at him. Instead she examined the room, mentally collecting the clutter, removing the screen that kept all sunlight from the sleeping platform and rearranging the boxes, folding table and two chairs. "Eh, *Bong*, may I organize your house?"

"My house? It's your house, too."

Domesticity wasn't much of a substitute for romance, but it did get the couple talking. Oun rounded up a deep plastic pan and a quarter–oil–drum basin. Chantha collected every stitch of clothing and fabric in the house. Outside, she began a triathlon of scrubbing, wringing and drying that took well into the afternoon. On the sunny side of the house, Oun set up a frame of bamboo stakes on which Chantha hung shirts, shorts, sarongs and underclothing. Sheets, pillow cases and towels, too, fluttered on the racks.

The first apparent advantage of marriage was an iron, which Oun had acquired earlier but rarely used. A metal lid slid back, making room for burning coals. Care had to be taken or an ember could fall through small air vents, damaging fabric. Chantha watched Oun's strong hands demonstrate how to fill it. He swung the iron back and forth until the coals glowed red. Then he settled down into the hammock he had slung from one doorpost to the center rafter. Chantha wished he would go out and leave her alone. Instead, Oun hung around all day attempting conversation. Chantha felt like a tiny bird trapped in the cage of a huge one. What was there to say to a man who seemed content to watch one breathe? Chantha spread a towel and a *krama* on the platform, selected a sun–dried shirt, positioned a protective press–cloth and ironed away. It was almost too dark behind the woven grass screen to see if her efforts were accomplishing much. She sighed.

"What would you like? Want me to go get something to eat at the market?"

"I don't need food, I need light.'" If a husband was in the mood to be helpful, a wife had to have a suggestion. Oun thought the vertical grass mats improved the privacy of the sleeping area, but it was Chantha's opinion that closing the shutters and door at night was seclusion enough. She said so. Proposing to one's husband was not as formidable as she had imagined.

On the second morning, a buddy of Oun's showed up. Together, the men detached half of the panels dividing the room. Behind the remaining screen, Chantha stacked a couple of sturdy cardboard boxes, into which she sorted and stored clean laundry. She prepared a meal for the guys. A tin of tuna packed into tomato sauce, fried tofu with bean sprouts, salad and hot and sour soup filled the tiny table. There were only two chairs. These, Chantha thought, Oun and his friend would fill, giving her a perfect excuse not to eat with them. The friend, single himself, seemed shy in the new wife's presence, although upon seeing the spread he exclaimed, "Wow! So many dishes! Your wife is quite the cook!"

Oun turned a bucket upside down and made a seat for himself. "Eat with us, *Srey–Oun*, Girlchild," he said. "You're not some servant who eats leftovers later."

"Is that your wife's name?" the friend asked, evidently unused to public terms of endearment.

"Don't ask too much, just eat," Oun advised. The sound of the men slurping, burping, chewing and smacking their lips made Chantha all the more homesick for the girls' dormitory. Mealtimes had been full of chitchat, laughter and even songs.

When she went outside to fill fingerbowls, Chantha overheard their guest. "Where did you find a wife? How did you meet her? What do you know about her family?" Oun still knew very little about Chantha. Not even her original name. She was separated from her father.

She had never relocated her mother after the Vietnamese ousted Pol Pot. There were no siblings. She had been Phnom Penh bred, that was obvious. Well, to some. Oun's rustic friend may not have known what to look for. He would have drunk the bowlful of salted water Chantha placed on the table if Oun hadn't stopped him. Village boys weren't accustomed to washing their hands after, or before, meals.

Simple proprieties, whether in serving food or in speech, set city people apart from peasants. Who was this wife of his? Oun often wondered during those first weeks together. If he came home late for supper, he always found a generous helping arranged on a plate, protected from the flies by an upside down bowl. No one had ever done that for him before. He was used to eating out of a cooking pot.

Letting the last diner scrape the bottom of the barrel had not been acceptable in Grandmother's house and it wasn't in Chantha's. Remembering Grandma guided Chantha, from household chores to choice of words. "*Nam bai*. Come. Rice," she would invite her husband to the table. "*Ang cheun pisaa bai*," she reserved for worthy elders. "*Hoap bai*," rough and rural to Chantha's ears, quickly faded from Oun's vocabulary. Learning wasn't a one way street in marriage.

Staff and students of the Section 9 Nursery School welcomed their co–worker back a week after the wedding. The first morning, Chantha showed up promptly at seven. The teasing started as soon as she signed in. "Wow! Look who's on time even though she's married!"

"Morning, my little early bird," the director baited. "Not too long now and you'll be too lazy to get out of bed." "Not too tired?" "Getting enough sleep?" "Don't work so hard, you're doing double duty at home now." Everyone used to joke around, but now it seemed they were picking on her. Chantha wondered if they disliked her. She determined to ignore the jibes and act cheerful. "Ooohhh! Aaahhh! Take a look at that happy face." "Big smile this morning!" "Uh–huh!"

Chantha was delighted when the parents began arriving to drop off their two to seven–year–olds for class. The familiar hugs of the

fifteen preschoolers in Chantha's class were a great relief from the smug, over–the–top staff. Six and seven–year–old alphabet enthusiasts chanted first and second series consonants with glee. Small hands formed animals from modeling clay while they sang a Khmer version of "Old MacDonald had a farm". After completing their artwork, the kids filed out into the fenced yard to burn off some energy. Flexible little bodies stretched, performed jumping jacks, and touched head–shoulders–knees–and–toes in reps beyond counting. A snack followed. The children chomped on thick, nutrient–crammed biscuits and sucked on milk cubes. The afternoon class proceeded much the same. Once the kids went home, the teachers prepared lessons and materials for the next day.

A colleague handed around some sweets. "Hey, small teacher," another called out to Chantha. "You won't be eating the same stuff as us for long," he predicted. "I bet you'll soon be into sour in a big way." The winks and nods signaled who was in the know. And who wasn't. As the last of the staff to marry, Chantha felt excluded by euphemism and innuendo from the echelons of the experienced. She couldn't come right out and ask for an explanation. This wasn't the society of Jesus, in which the less erudite could question the master. Chantha's eleven older co–workers maintained status by knowing more. Or at least posturing so. All the other women would say was they expected a shift in Chantha's dietary preferences. What. Not why.

Within a month, their predictions came true. When Chantha pulled out her lunches, everyone knew she was pregnant—everyone but her. Slivered guava, pickled gooseberries, green mangoes, unripe bananas dipped in fish sauce. Hmmm. Veiled comments and evasive responses compounded ignorance. Finally, Chantha went to see her former house mother. The last time she had lost her appetite, Mother had poured her a glass of spiced wine. While she waited in the kitchen, Chantha uncorked a bottle and served herself a swig. Mother listened to the symptoms. Had Chantha missed a period? Yes, but undernour-

ished she had never been regular. "You may be pregnant. No alcohol. No more skipping rope with the preschool kids. No jumping." What not. Not how. Not why.

The cycle of not knowing was perpetuated with the next generation. At school the next day, the kids called Teacher to take a turn as they turned the rope. "Not today. My legs hurt," Chantha replied.

"Yeh, right," Mr. Know–It–All chimed in from across the playground. As her belly expanded, the other instructors laid off teasing. More cautionary tones and questions were raised. When did she plan to get off her feet and relax? The kids, however, exercised their uninhibited curiosity. Patting her tummy, they related her shape to their own experiences.

"Do you have worms?"

"Yes. I have a big worm."

"Big?"

"Yes."

"Is it moving?" some asked, feeling third–trimester thrusts and kicks. "Oh!" they squealed, "it's crawling!"

At eight–and–a–half months, that was about all Chantha felt like doing. "Hello. Goodbye. See you tomorrow." Shrill little voices trilled in triune salute as the youngsters left on her last day. Chantha had given up badgering them to distinguish between an English greeting, a formal and an informal leave–taking. "Goodbye."

"Hey! *Bong–Srey!*" Oun rapped on the midwife's door. Half an hour earlier, Chantha had woken with an urgent need to visit the privy. It was pitch–black as she groped her way off the sleeping platform and shuffled to the doorway. "Is the baby coming?" Her husband's premonitions were usually more accurate than her own interpretations of unfamiliar physical signs. Chantha recalled Grandmother saying she herself had almost been born in the loo; Mother had delivered her so fast. "Just stay here." Oun was on his feet, dressed and out the door, running. The midnight commotion had goaded next–door neighbour

busybodies out of bed. In Oun's absence, they argued about which midwife was more professional. One hurried off to call for a second opinion. Both were happy to help.

Husband was shooed out. A lamp was lit. The midwives held Chantha's hands as she paced the room. They asked detailed questions before explaining what was happening. "Keep your pain a secret. No theatrics. Think happy thoughts. Imagine a beautiful garden. Butterflies. Fly with them among the blossoms." Each contraction startled those butterflies out of sight, but Chantha kept her mouth shut.

"It won't be long," one encouraged. "Push like you're constipated, but not continually, only when you feel the surge."

"Let's take a look," the other said from time to time. As they assessed if her cervix was fully dilated, Chantha wished more than ever that she could fly away. She had never touched her own body the way these two strangers were unabashedly poking and prodding it.

"I want to walk." Chantha got up again to waddle back and forth across the platform. Her feet ached. Her legs trembled.

"When you feel shaky, lie down." She did. One momentous effort and a big–for–a–baby head crowned and came. Slippery shoulders, belly, bottom, heels and toes were barely out when Boy howled.

"Thank God!" one midwife exclaimed. The other scooped up the baby, nestling him in clean but well–worn sarongs. She unwrapped a packet of razor blades and cut the cord, wiped Boy off and handed him to Chantha. Such a red face peered out at the world, mouth wide and sucking, enormous eyes rapidly roving around the room.

"You're lucky," the midwives agreed as they gathered bloodied sheets and tidied up. "Only three hours of labour." "Only!" Chantha had thought it an eternity. The women cleaned Boy's mouth. "He's hungry," they laughed. They demonstrated how to breastfeed and how to clean his knotted cord which, they explained, would wither and fall off.

At first, Chantha sensed no connection to the infant; exhaustion dominated all other feelings. However, as she nursed him, his tiny

hand reached up, stroking her, not quite seizing a finger or a lock of hair. Baby's touch birthed rapture. As he lay beside her, his cries said this little guy needed her so much. His life was bound to hers. "What a wonder, half you and half me," Chantha murmured to Oun.

"Oh, no," he replied. "This one is one hundred percent me. You were simply carrying him. He's all me."

"Get real. This boy's a fifty–fifty cooperative production. You were alone a long time before we came together. I never saw you single-handedly produce a son. However, if that's the way you feel about it, next time he whimpers for milk, the kid's all yours."

"He's mine! He's mine!" the ecstatic dad boasted. "But I'm letting you care for him." Care, compassion, devotion and delight blended together. This mouth that gaped, grinned for new–*Maq* Chantha. Those fingers that stretched, reached for *Maq* alone. This was love. Uncalculated, unconditional, unaffected. It sluiced over the lip of the mother–baby reservoir and trickled into marriage.

It startled her when she first realized how she felt about the father of her son; Chantha loved Oun Tes. Tes was the only name Pia and Khon were sure about when they arrived at the Out Patient Department to register Boy's birth. Chantha's two friends had offered to take the wee one in, as Chantha's legs weren't able to carry her the kilometre or so to the international medics at the Khao I Dang hospital. Faced with a blank form, the women wondered what they might write in the box labeled "given names". Dara, they decided, perhaps for the starry host that welcomed him into the world. Roth, they wrote. What realm would be his in the future? The names pleased Chantha when her friends presented the birth certificate. After they left, she revealed to Oun her own birth name: Sisowath Karadath Chanrada. Sisowath linked Chantha's father to a former Queen Mother. This son of theirs was more a prince than Oun had ever suspected. He had been very open about his family. Born in a village in Kompong Speu province, Oun's sisters and surviving brother were destined to eke out

a living from the land. The closest they had come to royalty was a framed photo of Prince Norodom Sihanouk, which their father had hung highest on his wall.

The forty days of being treated like a queen, all bed rest and humour–balancing fare, were somewhat abbreviated in Chantha's case. While Oun was very helpful, not just boiling water but even scrubbing laundry, there was no substitute for female relatives. Chantha was overwhelmed by the desire to hear her mother's voice and have her massage her inactive limbs. Then, suddenly, Chantha had no choice but to get moving. The Tes family, along with other Section 1 residents, was relocated within Khao I Dang away from the mountain.

Further north around the unwieldy UNBRO encampments, the Vietnamese dry season offensive was battering refugee settlements along the border. Construction crews sunk concrete ballast, secured posts and strung barbed wire to enclose an area of Khao I Dang called Bang Poo. Newcomers from the bombarded camps were housed within. These Cambodians who lacked UN accreditation were candidates for repatriation rather than resettlement, and as such were restricted from contact with certified refugees. Back in Section 9, Chantha and Oun found their newly–assigned shelter much smaller than their first home and incomplete. Until Oun finished the roof, Chantha cuddled one-month–old Roth under a plastic tarp. At least it wasn't rainy season.

Two weeks after the move, "Take cover!" meant more than crouch under polyethylene. Chantha had heard the retort of shotgun fire before she got the warning. In fact, she had seen the thugs coming down the wooded, westward mountain at dusk. Their shouts and shots into the air cut short Oun's shower. Chantha snatched Roth out of the hammock and bolted for the hospital. Its solid walls were a familiar refuge for Cambodians, whose shacks around the circumference of the camp exposed them to marauding militia. The gunmen were also Cambodian. They preyed upon the captives of the international aid community corralled between the Dong Ruk hills and a war–zone. This foray

was particularly audacious, as it had been launched from the Thai–ward side of the camp before nightfall. Fear churned in Chantha's gut. She rocked Roth until her skinny arms ached. His calm, tiny tummy rising and falling in unperturbed rest astounded her.

Sickened was how she felt the next morning. Walking back toward their house in the gray dawn, Chantha and Oun stepped around a couple of pools of blood–soaked sand. Two of the bandits had been slain here. The inquisitive ferreted for details around a truck, tires shot out and body bullet–pocked. Rumor had it a Thai officer had been ambushed. His corpse had been removed with more dignity than those of the guerrillas. This incident sparked a running battle. Night after night, Chantha and Oun sought sanctuary at the hospital or in the homes of friends at the center of the camp.

Unqualified security was not something Oun expected in Khao I Dang. It was, however, what he and Chantha wanted for their son. Without consulting his wife, Oun completed an application for immigration under the humanitarian relief program of the government of Canada. He told Chantha Canada was looking for young people— strong, young people, who would work and repay Canadians for the expenses of resettlement. Canada. Chantha knew no one there. She had received letters from acquaintants who had successfully maneuvered through the screening process of *Amerique* or *Australie*. Everything there was big. Big cars. Big roads. Big stores. Big people.

In America, no one built fires on their kitchen floors. Women stood to cook on raised gas burners. Food cooked on gas didn't taste as good as over a charcoal grill. Chantha had laughed when she read that. Her *Maq* had purchased a propane hotplate in the early seventies, but used it only to boil water. Maybe she would have to accept convenience in lieu of quality, too. One thing she knew for sure, it would be a mighty fine day when she wiped the last smoke–smarting tears from her cheeks. In her mind's eye, Chantha saw city houses, multi–story buildings and markets as she remembered Phnom Penh. She imagined

Roth speaking English effortlessly. Massaging his tiny hands, Chantha pictured that, in Canada, they would never be calloused from manual labor. Perhaps they would suture surgical incisions, present evidence in court or hold the reins of a prosperous business. All Chantha's visions were as ethereal as smoke.

Ten men squatted in the shade, sharing a cigarette. Their long-faced women and children batted flies beneath the bougainvillea. "If you get sent to the guy on the left, you're done for. Toast. If they steer you to the lady on the right, you've got a ghost of a chance." Chantha's fellow travelers had come out of Khao I Dang by bus that morning. Canadian embassy officials had seen about a dozen families before *Tes* was called. Most had been rejected and were more than ready to recount how the tables had been stacked against them, over and over. As Chantha and Oun entered the office, someone directed them toward a gruff-looking, chubby fellow, on the left.

"Hi, howar ya?" His voice belied his reputation.

"I am fine. How are you?" Chantha could hardly believe the greeting slipped so smoothly off her tongue. Oun, the embassy translator and the officer all paused. They looked at her. The Canadian recovered before the Cambodians. Perhaps he had previously met a woman who spoke first.

"Is it a boy or a girl?" The diplomat now enunciated slowly and carefully, tipping his head toward Roth.

"A boy." Chantha ventured a smile.

"How old is he?"

"Four months."

"What colour is his hair?"

"Brown."

"His eyes?"

"Brown, too." Chantha was pleased with herself, although she wasn't entirely sure where colour ranked on the immigration point system. The officer continued in a casual vein before shifting to the nitty-gritty.

"Are you sure you want to come to Canada?"

"Yes."

"What work can you do?"

"I was a preschool teacher. I can sew."

"Good. Are you willing to work in Canada?"

"Yes."

"Will you pay back the transportation loan?"

"Yes." Chantha peered at the man's hand scribbling notes, checking boxes and circling words on the documents between them. It was impossible for her to decipher the upside down characters. The topic changed.

"How long have you been married?"

"One year and a half."

"Do you want more children?"

"Not yet. I need more money."

With a chortle, the interviewer turned to Oun. There were more questions about his work in the camp, his level of education in Cambodia and what he had studied since he had made it into Thailand. All the while, the translator sat silent. "You speak well," the official concluded. He nicked a couple x's onto the forms and handed his pen for Oun and Chantha to sign. "Those are for the airfare loans. Congratulations. Enjoy your flight to Canada." He sat back. Chantha and Oun looked at each other. Their eyes sang.

"You passed! How?" Outside, the rejected ones wondered aloud. Chantha didn't say anything. Making more babies than headway with English or French, the less–likely–to–succeed were never the embassies' first picks. Heaven had smiled on her, though, and Chantha grinned back.

It was a covert grin. Guarding one's heart was a survivor's number one rule. During the two months of waiting for transfer to the Transit Camp, Chantha spoke to no one of the impending move. Providentially, none of the other interviewees that day in May lived in her

section. "I don't know if I'm accepted," was her reply to the curious. Word of acceptance spread among unscrupulous neighbours could spark rumors of non–existent sponsors remitting funds. Even imaginary riches had been known to lure the robber within an apparently sociable section–mate.

In preparation for the move, Chantha washed clothes and packed them and a few kitchen utensils into a cardboard box Oun picked up at CARE. At this point, Chantha let her next–door neighbour in on her secret. Were there any pots, blankets or pillows she might want among the house wares? Goodbyes among her charges from the Young Adult House moved Chantha's former House Mother to tears. Masking emotions was too much to ask of the young women once their self–confident guiding star broke down. Well–wishers dropped by the house. "Remember me" had so many implications.

Recollections of Khao I Dang rippled through Chantha's mind, splashing into the rush of adrenalin. Fear lurked in anticipation's shadow. No one she had known to leave Khao I Dang for the west had ever returned. It was said busloads of refugees had driven out of camps into oblivion. A couple of buses stood ready to swallow Chantha, Oun and Roth along with the hundred–plus Cambodians over whom others were weeping for joy. Upon boarding, Chantha waited and watched. Faces, farewells, roll–calls, lowered bus window panels, hands held, released in reticence, waving and waving and waving.

WESTWARD: THE NAME–TO–GO

Across Prachinburi Province, Chachoeungsao and Chonburi, the buses rolled past farms. Small stilt houses in the lee of immense trees reminded Chantha of her homeland. Fresh air rushed in the open windows and ruffled Roth's hair as Chantha held him, nose to glass, entranced by a new world. Nursing, dozing or gazing, her son traveled well. Chantha sniffed his cheek affectionately.

247

Shortly after noon, they turned off the tarmac at a sentry hut. On either side of the secondary highway, Chantha could see barbed wire fences and tin–roofed buildings within. On July 21, 1985, the Khmer section of Phanat Nikhom was chock full. Slips of paper with Roman letters and Arabic numerals were thrust into the grasping hands of household heads. L–21. Oun loped ahead of the crowd to scout out the assigned housing. While he energetically whisked out a prize corner–third of the shell of a building, Chantha collected their single box and waited. By the time Oun returned to the bus depot, hoisted their belongings on his shoulder and led his wife and son back to house twenty–one in the Lao section, his cleaned corner had squatters. Three families had L–21 addresses. Three doorways opened into the undivided space. The desired eastern end, cooler perhaps in the afternoon, and just swept by Oun, was occupied by a couple with two kids. On the far side, a limper argued for that door. Its low sill was more manageable for him. "Let's quit squabbling and be friends." Chantha figured if she had to live cheek by jowl with these people for several weeks or months, it would be best to begin on a peaceful note.

The pursuit of peace was a foreign concept to most occupants of Chantha's quadrangle. Ten families filled the four buildings opening onto an earthen courtyard. As required, they set about selecting a headman whose unenviable duties included collecting rations for his quad and equitably dividing them. Each adult wrote the name of her or his choice on a scrap of paper, rolled it and placed it in a dish. The votes were read aloud. Tha was the overwhelming choice. His wife looked forward to garnering the food allotments of the moneyed among her neighbours. Refugees with spare *baht* usually preferred to buy ready–made dishes or superior produce in the market.

There were two distributions of perishable items per week. Monday was chicken day. Tha, his wife and kids would queue up at Food for the Hungry and haul home the quad's quota of poultry. Much squawking ensued from the spectators as Tha butchered the birds,

sorting out portions of approximately one hundred grams per person. Chantha would not have wanted Tha's job for all the world. One fellow routinely rearranged which cuts went where. In the end, Tha always offered to exchange his family's measure with that of any unsatisfied customer; this set his wife flapping. Surely there had to be some payback for all the harassment Tha had to endure.

Haggling went on even over relatively abundant rice. Official documents claimed each adult received three–and–a–half kilograms, and children two each week. The sacks Tha lugged from the warehouse may well have held the calculated quantity; however, divvying up grain without a scale took bombastic rhetoric over the top. Nitpicking neighbours gave a play–by–play colour commentary on each scoop of Tha's tin can into the rice. Perception was everything. Dipping more or less aggressively set off a chorus of victims decrying favouritism and oppression. It wasn't Tha's fault the Dobermans belonging to the UNHCR's director received more meat per day than refugees got in a week.

Chantha agreed some rationed items were inadequate. Five hundred grams of vegetables and Friday's can of sardines, an egg or two hundred fifty grams of fish (including ice) weren't putting flesh on anybody's bones. Moreover, charcoal allowances were an affront. One–and–three–quarter kilos were never enough to prepare seven days' meals. Chantha insisted on properly boiling water before drinking it or making Roth's rice gruel. She wasn't taking chances with worms perniciously lurking in the untreated litres Oun collected daily from water tanks maintained by COERR, Catholic Office for Emergency Relief and Refugees. Damp coals didn't burn, and the crumbly lumps often disintegrated into useless dust before Chantha could build a fire. The market sold charcoal, but five *baht*–worth wasn't enough to bring water to a boil, let alone fry a meal of vegetables and fish. Doubling the money would buy a serving of sweet and sour pork on a bed of rice at the rustic Transit canteen. Why bother cooking if you had a resettled

relative remitting dollars?

Without a cash flow, Chantha quickly used up the savings she had made in Khao I Dang. During her first pregnancy, the revolting smell of soya beans had turned profitable when she mixed her uneatable legumes with excess rice and sold a coffee–can quantity for a *baht*. Four tins equaled a kilo, and five kilos could be bartered for a sarong. *Baht* bills in a plastic sheath fit into thief–proof caches: hollowed bamboo bed posts, buried under household garbage or inside barfed–on baby pillows. Roth was growing and always hungry. It seemed Chantha could never keep him satisfied. Once solids suited him, Roth got the best of Chantha's bowl, too. Making money became a priority for his parents.

Oun found employment with an agency that paid him the maximum ten *baht* a day. The equivalent of two to three dollars a week eased Chantha's concern about food. Over time, they improved their living quarters. A bamboo bed abandoned by an acquaintance leaving for Australia was much more comfortable for Chantha and Roth than a mat on the floor. Oun got himself a hammock. A collection of cotton strips stitched into curtains separated them from the sights, if not the sounds, of their housemates.

During the day, Oun was away from the chatter and clatter, delivering medicines to Out Patient Department patients. Almost every evening, he had tales to tell about patients who zoned out during his translations of the detailed procedures for taking prescriptions. Cambodians expected take–out tablets or a packet of pills with every visit to the OPD, but following directions was not their strong suit. Oun estimated that a significant percentage of pharmaceuticals were thrown out; patients simply didn't believe capsules could cure them. Supervised distribution of anti–TB doses prevented dumping of those meds, which, if discarded or misdirected, could delay or reverse the resettlement process. Still, the traditional medicine centre did a booming herbal business among hypochondriacs and other skeptics. Oun

had daily arguments over the generally accepted notion that western chemicals were far too potent for smaller, eastern bodies. Virility was another touchy subject; innumerable prophylactic devices landed in Phanat's refuse bins.

Chantha wondered if her own efforts at adding to the family's coffers got any farther. When Roth napped, Chantha crocheted fast and furiously, churning out lacy pillow cases and vests in vivid fuchsia, lemon or tangelo shades. The entrepreneur in her sought out an L.A.-bound refugee trustworthy enough to carry these wares to sell in the burgeoning southern California Cambodian community. Chantha banked on fifteen to twenty dollars a piece. COD apparently meant nothing to the first courier. With a second, Chantha invested a couple silk sarongs and a valuable Khmer/English dictionary. Again the rate of return was disastrous. Ever hopeful, Chantha completed a fine pillow case during a month of naps and risked sending it with Pheap, who swore she would sell it or keep it until Chantha joined her in Canada. Pheap's destination was Winnipeg, Chantha's Lethbridge, but having hardly traveled farther than they could walk, the women expected to be in the same vicinity.

Chantha had lots to learn about Canada. The Canada School ran classes twice a week for an hour and a half or two. Mouen Tiv translated for an ex–pat teacher Chantha never got to know well. The lessons provided Chantha with plenty of fodder for evening conversations with her husband, who chose to work rather than attend CO, or cultural orientation, yet another among countless camp acronyms and abbreviations. Meaningless nicknames stuck where formal, politically correct labels were lost on uncomprehending clientele. If there was one thing Chantha's classmates knew not to mistake, it was the colour of money. Canadian bills, like Thai denominations, came in various hues: orange, green, red, brown, and violet. Dollars were uniformly sized, however, so distinguishing Laurier, Macdonald or Mackenzie King in the dark wouldn't be quite as easy as counting fifty or five–

hundred *baht* notes. Being unfamiliar with the currency was sure to lure con artists in the markets of Thailand; the Cambodian women studiously turned over the teacher's coin collection and fingered the paper. In Canada, they intended to hit the shop floors running. Slides of supermarket scenes astounded Chantha. Blonde or brunette shoppers pushed wheeled carts over polished tiles. Were there no brown people there? Interminable aisles of efficiently stocked shelves, higher than she could reach, stood undefended. Where were the proprietors? Weren't they worried about theft? There didn't seem to be anyone keeping a wary eye on the customers. Wow! Say "self serve" in a camp and you'd be cleaned out before you could finish the offer. A woman in white operated a machine that combined conveyor belt, scale, typewriter and cashbox at the far end of the cavernous store. She probably never noticed shoplifters right under her nose, she was so preoccupied with typing prices and swathing wares in plastic.

Canadians seemed obsessed with packaging. Slides showed fashions for formal occasions such as job interviews, and seasonal wear, which Chantha found ghastly. Stuffed into thick garments, children looked outlandish as they rolled down white slopes. She vowed no child of hers would hurtle down icy hillsides shaped like tempura shrimp encased in puffy batter. Imagine meeting cross–country skiers with flushed, drunken–hued faces exhaling smoke like chimneys on some isolated forest path. And the skaters! No tights or tutus. Just well–insulated silhouettes balancing on silver blades as the sun set behind a frozen pond. Didn't Canada ever rest? There wasn't a single slide of Canadians at ease, just sitting around, watching, and waiting for nothing in particular.

Maybe her baby already understood his Canadian destiny. Roth rarely relaxed. Chantha planned her morning marketing with him in mind. Opening hour at seven was prime time. Phanat's *talat* carried many more goods than Khao I Dang's market, where recycled rations got traded for inedibles. Here Chantha found *chee*, vine leaves for fla-

vouring broths or broiling pomfret. Bittermelons at one kiosk, gold at another, flasks of face cream, vials of nail polish, yarn, and needles were all for sale. More often than not, Chantha would purchase a bagful of bouillon to add to rice noodles for breakfast. Before the eight o'clock national anthem, she and her squirmy son would be back home where they could move with impunity. It was not a good thing to be caught chasing an agile toddler along the market's slippery passages when Thailand's Hymn to Glory blared out from loudspeakers positioned around the camp. Chantha had no intention of being thrown in the clink over an eleven–month–old who didn't appreciate the rigours of standing at attention.

The market held other dangers. One mid–morning, Chantha, Roth on her hip, recognized a man from Khao I Dang. Panah had been an unregistered latecomer and therefore was ineligible for emigration to a third country. Thailand granted such illegals asylum only until repatriation processes could be ironed out. "What a surprise to see you here!" Chantha's curiosity overcame propriety. "How did you make it?" The man was tantalizingly circumspect. Shrewdly directed dollars. A Thai conduit. Pending French visa. Chantha suspected he had purchased an alias from someone else's dossier. Flexible identities didn't sit well with Chantha. Panah said he had heard Chantha had divorced Oun. No. He would like to drop in to visit her. No. She was married. So? It shouldn't have been necessary for Chantha to remind him that married women didn't receive male guests. Rules, it seemed, were made to be broken.

A couple of evenings later, the man showed up at Chantha's neighbour's place with a guitar. Through the curtain, she learned he was a night watchman at an Adventist agency office—hence the access to the instrument. As the men tuned the strings and strummed chords to familiar folk tunes, Oun went out to join them in the quad. The sight of Chantha's husband caught Panah off guard. Suddenly there seemed to be too many mosquitoes for him to play in the courtyard.

Neither Oun nor the gimp–legged neighbour knew anything of Chan-tha's earlier encounter with the guitarist, and insisted on continuing the impromptu concert. The neighbour didn't want to go inside. His kids were supposed to be sleeping and, in any case, it was cooler out-side. Someone lit a DDT–laced Baygon coil, whose smudge drove off the whining, winged, back–up vocals. There was one tune the trio just couldn't get. "Is Roth sleeping?" Oun called out to Chantha.

"Yes."

"Help us with this melody." Chantha stood inside the doorway and hummed as loud as she could. "We can't hear you, come out, come out." With downcast eyes, Chantha quavered through the torturous adagio.

There were no subsequent music classes in the quad, but Panah loitered around the bazaar making marketing an obstacle course around chance encounters. Chantha avoided shopping by convin-cing Oun to purchase foodstuffs across the highway in the Processing Centre where he then worked. They were cheaper there, apparently. Restricting her own movements was the price a woman had to pay to keep her honour intact. Men made and kept their reputations by entirely different standards. Chantha remembered Nee, a nice young man who had been interested in her back in her single days. Along a road in Khao I Dang, Nee had appeared riding a bicycle strategically borrowed for just such a chance meeting with Chantha. Spurred by the achievement of this coincidental crossing of paths, Nee enjoined her to sit side–saddle while he cycled her home. "People will gossip."

Chantha's blunt refusal deterred Nee not a wit. "People always talk. Who cares?"

"But I'm the girl. They'll talk about ME! I care." By doing the honourable thing and walking away from an unsanctioned advance, Chantha preserved her self–respect. Nee, spurned, lost face. There was a gulf between women and men. A smile of recognition, the simplest act of kindness, and non–negotiable expectations came into play.

There was no denying Chantha's second pregnancy. Morning sickness arrived with a vengeance that December. Oun was much more stoic about the situation than his wife. Advice to be careful, to avoid falls, to take care of herself and above all not to worry about their by–then longer–than–usual stay in *Phanat* were his daily off–to–work words. There had been a second battery of tuberculosis screenings for Oun. He worked among TB patients. Had a spot on his lung delayed their departure? Lacking any formal explanation, Chantha's imagination went into overdrive. Perhaps her husband's American boss valued his translation services so highly that he had deviously worked out a deal with the United Nations to shuffle their file downward any time it approached the top of the heap. No matter that the documents were actually in the hands of the Canadian embassy in Bangkok and medical forms shuttled to Singapore or Ottawa and back. Money was the ultimate adjuster. If it could accelerate the migration process of some, stalling a departure was feasible.

Part of Chantha's daily routine involved scanning lists of names. At the post office, hand–scrawled registers in no apparent order were tacked to a bulletin board, layer upon layer. Scanty paper trails tracked who knew somebody. Outside the office of the Intergovernmental Committee on Migration, more pages rustled in the breeze. Somewhere within, an air–conditioner coddled a computer into spewing out tables of names, last and first, airport codes and dates. Under the sun, Chantha squinted at the glaring white lists. Day after day her conclusion was the same. No *name–to–go*.

It was about noon one sticky April day when a staticky PA announcement startled Chantha. Like an Eastern Orthodox cantor, the man at the mic chanted Tes Oun in triplicate. "Report to ICM." It never occurred to Chantha that she might report to ICM and have someone official locate her husband over in the Processing Centre. Instead, she convinced a neighbour to lend her the pink laminated pass, which would permit her to cross the highway, and taped a black and

white visa photo of herself over the other woman's face. The lunchtime crowd of privileged pass holders easily absorbed Chantha as they approached the guard at the Transit gate. Once she had located Oun, they retraced her steps and presented themselves to the appropriate authorities. In the flurry of activity, Chantha hadn't considered what lay ahead.

The first stop that afternoon was at the OPD. Sweaty from dashing about in the humidity of a mango–rain tease, Chantha steeled herself for the "visit". About a week before a scheduled international flight, everybody with the *name–to–go* was summoned for a cursory but degrading physical examination. Nobody in camp was bothered by the common sight of buck–naked toddlers, but now never–nude adults cringed. Not even spouses exposed themselves to each other in the light of day. Canadians must be very uncouth indeed. Why did they demand such a parade of flesh? Explanations of skin inspections didn't wash. "Be strong. They won't eat you," someone admonished Chantha as she approached the door. Inside the examination room, a male doctor and a female nurse sat writing up charts.

"Remove your clothes." "Stand tall." "Raise your arms." "Turn around in a circle." "Get dressed." A form was stamped and Chantha returned to the waiting room. Unseen faces looked up questioningly. The seen left as quickly as possible, some in tears. A few, who had actually passed out from the trauma of baring all, were fanned back into consciousness. Being processed for transport left an indelible impression on anyone with a modicum of modesty. Bureaucratic procedures never factored in feelings.

Marketers, however, capitalized on an affective response. The queen–sized comforter, strewn with peach blossoms, was precisely what Chantha wanted. Not a moment too soon, a personal money order for twenty–five American dollars fell out of an envelope from a friend now in the United States. Five hundred *baht* covered the cost of the quilt. The next day, Chantha was back at the market. There wasn't

much she wanted to buy. Just looking at the merchandise distracted her from thinking too much about the unimaginable journey before her. Too much distraction was a bad thing. Roth was so quick with his fingers and fists.

While Chantha bargained for a better deal on a string of sausages, her one–year–old got a grip on a one–kilo bundle of the stuff. He yanked it off the stand as Chantha turned to go. Several steps down the way she felt something thwacking her backside. Roth's toothless grin was not reassuring. His handful of dried meat could land her in hot water. Chantha knew she ought to return the sausage but bet the vendor would accuse her of theft. She couldn't afford a major misunderstanding. The middle way seemed to be to slip the loops into her bag with the little bit she had really paid for and to get out of the market as inconspicuously as possible. The sausage, a basket of sticky rice, and a flask of water filled a tote bag Chantha was preparing for the flight. Sealed in its plastic carrying case, Chantha placed her new winter–proof blanket inside one of two cardboard boxes along with garments, shoes, knives and her circular mahogany cutting board. The packing was almost complete when she realized the shoes would be more helpful on her feet and a few changes of baby clothes would be best in the carry–on luggage.

On the evening of April 5th, 1986, neighbours heaved the cases onto their shoulders and cuddled Roth as they accompanied Chantha and Oun on their last walk through the camp. From the evening curfew until the doors of the Lumpini holding tank were unlocked in the pre–dawn darkness, the whining of cranky kids and muttering of uncomfortable elders filled Chantha's ears. Eventually, the roar of the bus and the gentle rocking as it rolled toward the sea and northward to Bangkok lulled many over–tired travelers to sleep. Chantha woke to visions of tall towers. This couldn't be Canada yet. The sun rose over Thailand's sprawling capital; the din of traffic, heavy diesel fumes and city grit settled on the bus–load.

In spite of the cavernous halls of the airport, Chantha was determined to wash while a washroom was at hand. A lavatory sink was large enough to bathe Roth so he was cool and refreshed. Outside the women's restroom, Chantha waited for her husband. She hadn't paid attention on the way from the spot where they had stowed their baggage. Eventually Oun came around to guide her back to the group. Some refugees sat on their valises. Others filled scarce and uncomfortable airport seating. Everyone unpacked stores of food. There was some wisdom common among refugees. One was to keep wealth portable. Another was to carry food and water in the eventuality of scarcity. Chantha rolled a ball of glutinous rice in her clean hand and popped it into her mouth. The accompanying sausage seemed tastier now, far from trouble. Some more seasoned travelers passed the refugees, eyeing their ICM placards and holding their noses at the aroma of *pra–hok,* pickled fish paste. For the first time, Chantha wondered if the smelly condiment might offend her future Canadian neighbours. The future consumed her thoughts. Would it be cold in April in Alberta? She believed the government was going to provide for her family for twelve months, but how would they find a place to live? Would she find work transplanting rice? The seedlings were just being set in Thailand. Maybe a factory would hire her? Sitting for long stretches was feasible now, but in a couple of months her pregnancy would make operating a sewing machine unbearable.

Row L, at the window, was where Chantha was assigned to pass the trans–Pacific journey. Oun bounced the baby on his lap as Chantha belted herself in. Roth became adamant about looking out the window as the jet taxied into position. Fear sucked Chantha's mouth dry; earth–gazing wasn't for her. There was no looking back, either. She couldn't change the past. Full–throttle engines hurtled the plane down the runway. Chantha felt the inevitable coming at her, fast and furiously. It pinned her to her seat. The future. It was more liable to change her than she was to alter it.

Sareen (Soureun) So Bou

West, Meet East: Prelude to Pol Pot

"You belong to me, my daughter, my dear, dear daughter," Soureun's step–father cooed, cradling with delight the newborn tightly swathed by the midwife in strips of a used sarong. Oh, how Soureun longed to hear those words spoken expressly for her own ears, but the eleven–year–old bit her lip and blinked back tears. Would Puk renege on this fatherly pledge to her infant half–sister? Step–father had banished Soureun from her widowed mother's house when he became Yeun's second husband.

Puk's disdain for daughters had been common knowledge around the village of Baidamram. Sporting machismo as cockily as he wore his monarchist military uniform, in bandit and rebel beset Battambang Province, Step–father had beseeched the Buddha for a son. He had gone so far as to publicly offer childless neighbours his unborn issue should she turn out to be female. There was then, in Cambodia, honour in one's word and the humility of breaking it was not easily born. But *Mae* bore Puk a girl.

As Mother lay unbathed on the bamboo slat bed, literally roast-

ing over the burning brazier below, Soureun was called back to her father's farm along one of the streams that flowed into the Tonlé Sap. Post–natal practices required Mother to rest for forty days. To rebuild the loss of warm humours, which had flowed out of her body during childbirth, Mother avoided obviously cool influences such as full–body showers, sponge–bathing instead in water steaming with boiled lemongrass and lime leaves. At the midwives' insistence, she eliminated from her diet cool fruits such as lock–jaw–inducing watermelon. Copious quantities of gingerroot and black pepper festooned her food, purifying her womb of unclean blood and clarifying her skin. Eleven–year–old Soureun attended *Mae,* tended the house and tentatively dared to love little Saron, whose presence seemed so temporal.

What is it about babies, their own babies, which bewitches big, blustering men and breaks their resolve? Soureun alone overheard Puk's murmurs to her new–born half–sister. Her heart, dispossessed of all hoped–for happinesses, ached easily. At seven years of age, Soureun had witnessed as three days of fever, diarrhea and vomiting snuffed out her birth father's life. At eight, this step–father married her mother but cast Soureun adrift. At nine, Grandmother sent her to Auntie, whose poverty of pocket counted Soureun's school fees a burden and whose poverty of soul calculated that hugging a niece might deprive one of her own five children. Now, Soureun could scarcely believe her ears. Step–father was sobbing. He summoned her help, affirming for the first time Soureun's worth. Together they made a pact to secure Saron's place in the family; Soureun, not Puk, with uncharacteristic intransigence, would present the news to the childless couple eagerly anticipating adoption. "I shall not give up my sister. I want my sister." Soureun pressed her palms and fingers together and raised them from her chest til her thumbs brushed her lips. The words echoed back from her *wai*–cupped hands as she practiced her part. Salvaging Step–father's public honour and saving baby Saron from her own fate, Soureun sampled success. And it was sweet.

In time, Mother recalled Soureun from Grandmother's to mind her toddler step–sister. Midwives reappeared and then Savannara arrived, a boisterous boy whose birth thrilled everyone. They nicknamed him Chhuch, meaning tickle; he made Soureun laugh. Step–father also made Soureun giggle, but apprehensively, for he considered that, closing in on puberty, she was more than marriageable. Watching Chhuch roll over onto his tummy for the first time, Soureun wondered what negotiations Puk would enter into. Commanding a platoon of thirty men and with contacts throughout the district, Step–father's standing might attract suitors outside her mother's circle.

Indeed, in 1972, to be outstanding in Battambang was to attract attention, most of it undesirable. Soureun was the last to get the news. The body, they said, was already being prepared at the temple. She would never see him again. Sealed in a coffin of planed boards with a woven bamboo bottom, the battered corpse, quick to bloat in the 38°C heat, would be set upon the fiery pyre. Auntie said it had been a *Kmae Kahom* ambush. Puk and one of his men had been targetted on a routine patrol through a wooded area. Shot at close range, the motorbike beneath them flipped and slid over the tarmac. There it was, the blood stain on the pavement, the very place where Step–father's life seeped from his lips and streamed from his wounds. Speeding past it toward the temple, didn't the hired driver know, or did he know too well, as Soureun did, that Puk's poor soul, divorced from his body in violence, lingered here on the highway?

WEST, MEET EAST: POL POT TIME

"We don't like colour." The royal we he could not have meant, though this chromatically challenged *Kmae Kahom* had just announced once–king–turned–prince Norodom Sihanouk was coming. All hundred–house headmen, the ten-house group leaders, along with entrepreneurs of any sort, a doctor and a politician had been invited to

travel by car to kowtow to the former monarch. "Prayers would be offered." Indeed.

That had been the first congress of the comrades in the village of Put. Soureun squatted on her haunches, swatting mosquitoes away from four–month–old Sareang, who suckled contentedly, oblivious to the pedantic, pistol–toting talker. The *Kahom* packed a PM Chinese–made automatic rifle as well, while his two teenage retainers sported grenades clipped to their black shirts. "Black," he reiterated, "was best." Blot out bourgeois prints. Eliminate middle–class stripes. Weed out floral designs and other urban expressions of individual vanity. Among the other new rules were a prohibition of jewelry and an obligatory collection of any military–issue clothing or arms.

Over the next few hours, Soureun sorted through her meager wardrobe, wondering what was so offensive about the modest, long–sleeved, button–up blouses and made–in–the–kingdom sarongs. Her mother collected Soureun's husband's army uniform and claimed it had belonged to Puk, already dead several years. *Mae* herself carried several pairs of Chhoeun's olive–coloured trousers to the barracks formerly occupied by soldiers loyal to President Lon Nol. She also managed to divest the household of the bayonet clip her son–in–law had carried as life assurance when he had gone into hiding two months earlier. Soureun ripped identifying loops and buttons off three fairly new shirts. Presciently uncertain how long it would be before her husband would be able to buy another, she determined to disguise their military origins. Along with her mother's clothes, Soureun submerged her husband's and her own in an inky vat bubbling over the coals that Chhoeun had built in *Mae*'s farmyard. Like her neighbours, Soureun was conforming to the *Kmae Kahom* diktat to eradicate coloured clothing. It went without saying that the means to this end were up to the people. Some villagers trod their garments into the mud, squeezing out vivid hues with somewhat less than anti–esthetic vigor. They stripped off tree bark, boiling it into a not quite colour–fast dye. Three times,

Soureun repeated the process and wrung out the darkening textiles. The tint held best to her fingernails, she observed. Vanity of vanities, some manicure.

Sareang whimpered. Soureun put the baby to her breast and fanned the coals. Sareang. Mother–in–law had chosen this name for her first grandchild born in the dying days of the old regime. There had been a wealthy Chinese woman in the neighbourhood, and Dam Choum believed such an auspicious name would garner any name-sake a propitious future. The birth itself had not boded well.

Chhoeun called a midwife when Soureun's contractions had begun. But Soureun, pathologically bashful for an already pregnant sixteen–year–old, pushed away the prodding hands of the *Yiey Mop*, or Wise Woman, and refused her prying eyes a look at the body no one had ever examined in the light of day. Exasperated, the woman left and Chhoeun, more anxious than his wife, rowed across the Songkhai River to fetch another midwife, whose wise fingers sensed what her blind eyes could not. The father-to-be prodded the scow through the January shallows and hoisted the elderly *Yiey Mop* into a hammock, which he and another man ported to *Mae*'s three–room house. In the intervening hour, Soureun's labour had become intense, and alone, on a sleeping mat, she had delivered her daughter. Some minutes later, the midwife found the placenta still intact on the floor beside the ex-hausted mother. Expertly severing the cord and cleaning the infant, the *Yiey Mop* massaged Soureun, tugged at her breasts to initiate the flow of milk and presented her with her child, tucked into an all–pur-pose *krama*, a woven cloth often wrapped around the head or neck. "I saw you and I loved you," Soureun murmured to still–under–four–kilogram Sareang, "and your father loved you instantly. He was so ec-static he could not sit still. His hands fashioned this basket for you. He wove these bamboo blades with love."

Soureun had never known a father's love, and she was determined her daughter would. The *Kmae Kahom* was, however, redefining family

relationships. In Bang Snao, Sla Kram, and Kum Wat Khor—all the villages in which Soureun and Chhoeun would settle, and from which they would be uprooted over the next three years—Chhoeun, as other men his age, lived apart in mobile labour crews. Soureun blessed the unknown God that Sareang was but an infant, for children over five slept and worked apart from their parents, too. As a nursing mother, Soureun was assigned local paddies to plant or harvest. Her own privations seemed small beside the suffering of others, but through her loved ones she vicariously faced death several times.

Chhoeun, the village headman informed the *Kmae Kahom*, had served the enemy of the people, that pathetic palindrome of a president, Lon Nol. Almost as an after thought, the elder had credited Chhoeun with being, at best, a deserter from the defeated republican army. In a census, both Soureun and Chhoeun had listed their occupations as farmer, but eventually he fell under suspicion. To exonerate himself, Chhoeun chopped more bamboo more efficiently, transplanted more rice more adeptly and scrambled up palm trees unaided. Like a contestant in some absurd iron man match, Chhoeun outdid other suspected dissenters. Soureun sighed an unspeakable sigh when her husband shinnied down a gnarly trunk, tapped a coconut and offered a drink to his grudging judges.

Disbelief died hard, though, and critics dredged up the family's past yet again when Mother–in–law approached her own village henchmen to ask permission for her son to relocate there—a son, in Cambodia's communal consciousness, being responsible for the care of his mother. The request to the village of Put stirred controversy; surely Soureun's husband was plotting to run away. The evening the appeal arrived, one leader strode into Soureun's hut unannounced to call Chhoeun away on a special assignment. Without violence, the two men cycled out of sight. "O *Preah*," Soureun pleaded to an invisible Lord, "Preserve my husband." She hadn't seen the firing squad that had taken out Lon Nol's lackeys earlier that April. But she'd heard.

Now, she couldn't see the farm house where Chhoeun was incarcerated. She couldn't hear the thud of the club on the skull of an orange thief. She couldn't read the mind of Chhoeun's interrogator or anticipate that her name might save him.

"Your wife's name?"

"Soureun."

"Your mother–in–law's name?"

"Yeun."

"And her mother's name?"

"Pom."

"Pom?" Quieter then, "Pom, of Put, originally from Kampong Thom?"

"Yes." Soureun would never know the mind of this man, but some recollection of long–ago neighbourly kindness ignited mercy. Under the cover of darkness, a faintly squeaking bicycle interrupted Soureun's insomnia. Her man, and not his ghost, came home; one prayer had been answered.

Soureun's husband first returned from the dead a month into the new year. *Angka*, literally the Organization of the *Khmer Kahom,* emulating the Jacobins, had decreed Year Zero. By Buddhist reckoning, it was the year of the Rabbit. According to the zodiac, Soureun's husband, having been born a Tiger, faced mortal danger on the first day of the week, but the second predestined success. Hitching up *Mae's* bullock pair to a wobbly, two–wheeled cart, Chhoeun and Soureun loaded her mother, half–brother, step–sister and daughter atop a pile of portable possessions and abandoned *Mae's* ancestral village of Put.

A day's journey through fields, around irrigation canals and drainage dikes brought them to Bang Snao, where Soureun's father had bequeathed *Mae* a one hectare property. The hamlet, home to about twenty families, long passed over by both the weekly circuit market and resident merchants, promised an obscurity sufficient to survival. Soureun's paternal grandmother's house still stood empty in mid–

1975, as controlled, coerced and covert migrants crisscrossed Cambodia. Soureun's blood ties to Bang Snao classified her family as "old people". Peasant labor, neither unfamiliar nor onerous, was Soureun's lot. Her daily tasks were to draw water, haul it from the well to now-communal vegetable plots and hydrate the tobacco. Once harvested and cured, the broad–leafed luxury crop curtailed otherwise insatiable appetites and its foul smoke foiled equally famished mosquitoes. Women took to the weed which had previously been primarily a male pleasure. Husbands were often too far away to have anything to say about their wives' habits in any case. Soureun's man was sent south of the village along with known secondary–school students. A three-day journey away was a massive canal construction site, from which Chhoeun tottered back three weeks later, his calves swollen with scarlet boils. He complained to his wife that there had been no potable water. *Seechu*, a sour, white, sugar–looking powder was dispensed as treatment for the skin inflammations, which subsided, signaling to local *Kahom* that the patient was fit for another tour of duty. Separations, during which her man toiled at back–breaking labour on grand water diversion schemes, interspersed with bouts of illness marked the months at Bang Snao.

It was clear to Soureun that the customary schemes to recast one's karma weren't working anymore. Say, in the old days, you had purchased a cow with a queerly coloured hoof. Subsequently, your family quarreled more than usual. Without a doubt, the unusual foot would have been the cause. You would have sold the cow at any price in order to restore harmony at home. Now dissonance rippled through every relationship in Soureun's world, but there were no decisions she had the power to undo.

Someone else with a will and a way reassigned Soureun's husband to a cutters' crew, harvesting head–high grasses for thatch, but these men, too, had restricted access to their families. Later, Chhoeun became a palm toddy cropper, but it wasn't empathetic acrophobia that

kept Soureun awake at night. She feared for him, not that his sinewy thighs wouldn't bind him to the towering tree trunks, but that his military past would be bared by some treacherous slip of the tongue. Soureun guarded her loved ones behind a wall of silence. Monosyllabic discourse became second nature. The unvoiced conversations in her head confirmed her fears; "they" wanted to kill him.

Soureun's mother–in–law shared her anxieties. During the third dry season under the *Kmae Kahom,* she nursed her son through another malady. The fifty–two–year–old widow renewed her insistence that he relocate to her village at Sla Kram. *Mae* intervened back at Bang Snao, twisting the arm of an old friend, a *Kmae Kahom* sympathizer, who persuaded the local cadres to permit the young couple and their toddler to resettle along the banks of a brown, brown Battambang river. There Soureun joined crews of women nurturing rice seedlings, transplanting translucent, emerald stalks and tender roots into murky paddies and eventually harvesting the crop. As the grains swelled, so did Soureun's belly, not miscarrying what she had conceived before Chhoeun, deemed healthy, was sent out on bamboo detail in the Cardomom Mountains of neighbouring Pursat province. Beneath his feet, beds of blood–red rubies lay unsuspected, while in his veins unimagined parasites, courtesy of anopheles mosquitoes, set off the cyclical fever and chills of malaria. For the umpteenth time, Soureun welcomed back her languishing man. Little Sareang sighed at the state of her daddy. "*Mae,*" she advised, "Pick the special leaf. Crush it with your pestle. Soak it in water. Wrap it on Daddy's head under a towel." Soureun dismissed the precocious little know–it–all. What did a three–year–old in an anti–social socialist state know about public health? Sareang, however, had spent most of the preceding months in the care of her grandmother. By 1978 the surviving elderly were the chief repositories of traditional knowledge, medicinal and otherwise. When Chhoeun's fever didn't break, Dam Choum sought out a *Kruu,* a learned one.

"Pick some *sleka trung* leaves," the elder directed. "Crush and moisten them. Plaster the poultice on his head and torso. Wrap him in a towel." Soureun gazed, amazed, at her little one. How had she known?

Soureun's pregnancy did not excuse her from work. Her hands moved more slowly than most, but she completed her quotas. Often, she arrived late to the communal noon and evening meals, but something was always set aside for her. Asking for a second bowlful of meatless rice broth, Soureun would savour it, satisfying her hunger with vegetables. From her husband, Soureun knew not every comrade–leader distributed food so evenhandedly, let alone compensated for the special circumstances.

One unforgettable dawn, Soureun received personal attention from an unfamiliar cadre. The *Kmae Kahom* brought permission to trek from Sla Kram to Svei Prakiep, where her mother had relocated. In a most unusual manner, Soureun was advised that *Mae* had fallen in a field very early that morning. Perhaps she had been tired from the lengthy re–education speeches the night before. Certainly she had not been feeling well. Mother–in–law set out with Soureun immediately. They tramped the entire morning and into the afternoon. From a distance, a telltale column of smoke spoke of death, though cremation rites were rare in those years. Soureun's legs could not carry her fast enough, and by the time she approached the pyre, only a charred corpse smoldered amid the ashes. "Oh *Mae*," Soureun wept, "I'm sorry, Mother. I'm sorry; I could not look after you." Saron, the younger sister Soureun had not seen for months, had also been summoned. Orphaned now at ten and nineteen, the sisters listened as *Mae*'s co–workers described her last moments. Falling suddenly. Carried to the village. Lacking a pulse. First–aid administered. Earlobes pulled. Achilles tendon bitten. Muscles massaged. Arms and legs stretched taunt and tugged. No response. One heart still. Two broken.

East, Meet West: To a Second Country

Scythes, blades sharpened on stones, sliced through ripened rice stalks. Soureun's handheld sickle hadn't felt heavier than usual when she'd waddled out into the drained paddy before dawn, though her feet had. Then the contractions began. With a stoicism born of experience, Soureun retraced her steps to the village. Kuangnow "crossed the sea" without a midwife and without mishap. Without a calendar or clock, the infant's actual birth time and date would never be known. Casting a horoscope would prove chaotic; *Yiey*, as Soureun addressed her mother–in–law, and her old cronies tsk–tsked about the likelihood of a star–crossed marriage. Soureun, on the other hand, pondered the mysterious incarnation of eternal spirit in an oh–so–vulnerable baby body. In whom had Kuangnow's soul previously resided? What past determined this present? Had previous merit or malevolence cast her into Cambodia's killing fields? It seemed only some inexpiable karma could account for such a fate. One couldn't direct one's destiny, could one?

Kuangnow could barely hold her head erect when some villagers in Sla Kram and neighbouring Kum Wat Khaur did take matters into their own hands. Or did they? Rumors of a Vietnamese invasion were running thick and fast. Chafing at *Kmae Kahom* strictures, not a few men voiced vengeful thoughts. Lest the dead—by murder, malnourishment or malady extinguished—be forgotten, the avengers rounded up their oppressors. The captured cadres were bound as a crowd contemplated retribution. There was no consensus. Among the fledgling rebels, none had ever had sufficient social standing to issue orders. Not that anyone was predisposed to obey. As for the villagers at large, it had been three–and–a–half years since individuals had overtly exercised any initiative whatsoever. They dithered away precious time even as an informant alerted district authorities, who swooped in, barrels blazing. Bullets weren't exactly a renewable resource by 1978, but spent cartridges littered the dusty earth that day. Corpses, swollen

in the heat, lay in curdled blood. Every male in Sla Kram suddenly had a price on his head. Soureun's husband had bolted from the village at first sight of a dust wake swirling up the gritty road. He warned her of approaching trucks and of impending death. He swam the river immediately; she and the girls were to follow as soon as possible. And off he had run into the morning.

Hours later, Soureun picked her path down the silty river bank. Baby pressed against her wildly pounding heart, Sareang stumbling alongside and a rolled up hammock holding the children's clothing, Soureun spied a teenager poling a punt among the elephant grass in the shallows. Her throat was too parched to call out, but he had already seen her and was adeptly guiding his craft to the shoreline. There seemed little to say. The boatswain settled Sareang in the bow, helped Soureun aboard amidships and headed for the far bank. There, he hoisted the toddler onto his shoulders, grabbed Soureun's bundle and found a way up the steep, six–metre embankment. At the top, he set down the girl along with all her family's earthly goods, and slipped back down to the water. Soureun gathered her wits and then began walking along a footpath. In the shade of a *bo* tree, nestled in the grass sprouting from the paddy dike at its roots, Chhoeun squatted, dozing. Soureun reported what she had seen and heard before abandoning their home. The *Kmae Kahom* had issued a district–wide edict to execute any men who fled from Sla Kram. Avoiding roads and worn paths, the couple aimed for Puom Oh Salau village, where they hoped a cousin of Chhoeun's would receive them. He did. In fact, the group leader in his longhouse turned a blind eye to their presence. Perhaps he had his own axe to grind with *Angka*, possibly he retained a measure of human kindness, or maybe he astutely read the winds of change.

Within weeks, Vietnamese battalions had taken Battambang City. Centuries–old antipathy notwithstanding, Khmer flocked toward the invaders. Soureun followed her husband who followed his cousin who

followed his uncle who followed…conformity being altogether less cumbersome than having to make up one's own mind. They found the provincial capital quiet, roads in disrepair and buildings cracked or crumbling. Collapsing infrastructure mirrored social anarchy. During the ensuing months, Soureun, Chhoeun and their tiny daughters scavenged for food, gleaning rice grains from abandoned fields, trading rice for meat with squatters who had slaughtered a cow. They looted salt stocks and dried fish from unguarded warehouses, moving from Battambang to Puom Kadal village to Tmal Koul, where they reunited with Chhoeun's mother, brother, sister–in–law and kids. Unclaimed acreage soaked up the mango rains that March, but they had no water buffalo or plow to turn over the clods to plant a crop. Years of fear that life would be taken turned to anxiety that life–giving sustenance would trickle away.

Soureun began hearing of Chum Roeum Tmay, an encampment surrounded by soldiers from the Thai kingdom to the west. Help awaited all who entered there. Europeans, Britons and Americans, the ultimate *Angka*, were organizing distribution of foodstuffs and medicines, of potable water and nit–annihilating soap. As she picked cooties from her four–year–old's scalp, Soureun noticed Sareang's fever was rising. Everyone was speckled with red blotches. Kuangnow grew listless. A self–styled medic, itinerant like the rest of them, was making the rounds in Tmal Koul. He offered the ill a lifesaving injection, some serum straight from Red Cross stock at Chum Roeum, he said, in return for an appropriate sum. The only medium of exchange was gold. Soureun presented the only valuable she had kept hidden for four years, an eighteen–karat necklace. She held Sareang immobile while an antidote flowed from an experienced hypodermic needle into a miniscule vein. An anguished Soureun cuddled Kuangnow. A single piece of jewelry couldn't cover a second shot.

Without ceremony, Soureun wrapped her baby's empty little body in cloth and handed it to her husband. He climbed a hill alone, dug

a grave alone and buried their eight–month–old alone. There was no reason to remain in such an ill–fated place. Many people were walking west. Chhoeun and Soureun would go, too. Sareang was recovering from the rubella. *Yiey* was up to the journey. Her younger son's family would stay behind, his mother–in–law being too ill to trek to Thailand. Shoeless, clothed in the black silence of well–worn cotton, twenty or so people padded out of Tmal Koul on an evening in November. They walked at night, afraid of being turned back by Vietnamese soldiers still battling *Kmae Kahom*. The Reds, whose political hue blended with their Vietnamese foes, were being armed by various sympathizers whose own unresolved issues with Viet Nam coloured their relations with the genocidal Pol Pot clique. Up to that time, Soureun had never heard of Saloth Sar, though his *nom de guerre* would soon define the era. She only knew one wrong move might mean an end to a foot, or a leg, or a life. Smugglers' trails flowed with fearful, hungry people who followed survival instincts away from the souls of their ancestors. How could *Mae*'s spirit, or Puk's, or Father's, guide Soureun as destiny carried her farther and farther from home? On the third tense night, Soureun's group left fields behind for dense forest. Felled trees occasionally barred the way, warning of mines. Soureun's sore feet stumbled on after her husband, who carried their remaining daughter. From time to time they heard gunfire. Everyone would fall to the jungle floor or crawl single–file until it seemed safe to stand upright.

Some time after midnight, the refuge seekers came across a clearing. Someone at the head of the line guessed this was an abandoned campsite. Through the trees, a distant hum of talking and Khmer tunes grew louder. Were they approaching Chum Roeum Tmay? Suddenly, Chhoeun tripped and tumbled into the tall grass on the edge of the forest. Soureun and *Yiey* turned back from the group, who continued toward the voices. "I'm too tired," he mumbled. "I can't walk. I'm too dizzy." Too dizzy! And just when they were within reach of heaven–on–earth! Soureun set her sleepy daughter in the grass and began to

massage and pinch her husband's skin.

She felt her hopes disappearing down the trail with their fellow fugitives when "*CHHOP*! STOP!" resounded over the whir of insects. Up ahead everyone halted. A gunshot echoed. One man buckled over. A bullet to the thigh. Peering through her shield of grass, Soureun saw several bandits surround the Tmal Koul travelers. Threats induced her companions to hand over valuables. A gold chain eased from inside a sleeve seam. Some gemstones—rubies or sapphires, who could tell in the dark—emptied out of a waistband. The bandits fired no more shots, and left their victims to bind up the wounded man. Soureun could sense Chhoeun sitting up behind her. His breathing was fast and deep. What twist of fate had knocked him flat just before the ambush? The couple scooped up their daughter, motioned to mother–in–law and cautiously rejoined the others. A few men lifted the injured one and, with great trepidation now, the cluster continued in the direction of the Khmer voices.

The source was an encampment of the Khmer *Serei*. The Free Khmer, who had long struggled against the French and then Prince Sihanouk, were regrouping along the Thai border. An officer spoke to the newcomers and designated Soureun's husband as group leader. He issued Chhoeun a twenty–kilogram sack of rice with orders to distribute it among his charges. It was clear the food and the fire and the permission to sleep on a spot of guarded ground were in exchange for imminent military service by the men. Lying together in the dark, Soureun heard Chhoeun whispering with his mother. He rolled over and continued the muted conversation with her. He had seen more than enough of soldiering under Lon Nol. What bitter irony that their search for orderly access to the necessities of life had ended in the necessity to be under orders.

Before dawn, *Yiey* was up and away from the others. About mid–morning she was back, bristling with indignation and sputtering curses. She had taken it into her head to trade a long–hidden ring for Thai

baht. The prospective buyer had taken his time sizing up the item and then ran away faster than she could pursue. Like a peeved pullet, she fumed and fretted. Soureun was more upset over Chhoeun's impending conscription than *Yiey*'s ranting about compensation. The men were to join training exercises and formation drills, when suddenly shells started whistling into the camp. In the mayhem, the Bou foursome bolted. That night, they slept on the forest floor at a site called Nong Chan. An estimated one thousand families sheltered there under the trees. This encampment, too, turned out to be controlled by the Khmer *Serei*. A quartermaster of sorts provided fish sauce and dried fish in addition to a ration of rice for the family. Over several weeks, rumours of mass relocation swirled around Nong Chan.

For the first time in her life, Soureun overheard the name Khao I Dang. Her husband squatted on his haunches, listening intently to a dignified–looking Khmer. Chhoeun had recognized the former pilot from the Battambang air force base where he had been stationed in the early 1970s. The pilot spoke in hushed tones of a vast tent city staffed by international organizations. An immense and towering tank dispensed water. Convoys of trucks delivered food. Buses would soon come to take the displaced of Nong Chan farther into Thailand, near the town of Aranyaprathet. From there, people were being resettled in peaceful lands. His own brother had been accepted by the French. Others were going to America or Australia. Despite the pilot's confidence, Soureun disbelieved. She had heard stories about bus trips in Thailand. Those one–way mountaintop tours climaxed by Khmer being toppled off cliffs to their deaths. On the other hand, infantry–seeking Khmer *Serei* were urging men not to go to Khao I Dang. Perhaps…

Trucks came, not buses. Diesel–belching, rut–jumping trucks. It was now or never. Soureun's fear rose up her throat. What to do? How could she choose in one split second a course that would determine her future and that of generations to come? Why, she had never decided whom to marry, or even how long to wear her hair, let alone

made a decision of such magnitude. Then she saw him, a *barang*. A pale–skinned, high–nosed foreigner. He was helping Khmer over the tailgate of a truck. If he were here, the first European she had seen in years, she would trust the pilot's promises. Soureun and her family squeezed onto the flat bed of a military vehicle.

Standing on a lurching lorry for an hour made Soureun's knees wobble. She craned her neck for a first glimpse of Khao I Dang. A sea of plastic tents stretched back from the single–lane road toward the mountain. Someone pointed out the hospital. If only Kuangnow could have…if only *Mae*…

The human cargo surged forward and tumbled out as the truck ground to a halt at Section Four. United Nations High Commission for Refugees' logistical machinery geared up. Tent tarps, rice, fish sauce, vegetables, a slab of pork, a pan, some blankets and some coal. Soureun, Chhoeun and *Yiey* collected their portions with Sareang tagging behind. There was an assigned place to construct their tent. There were officials and a translator, who came by to register each one. Names, places and dates, many of which could not be clearly recalled, accurately transcribed into the English alphabet or in any way verified, were entered onto enigmatic forms. A black and white photo sealed the Bou family in celluloid, Chhoeun holding a placard stating KD 009741. As of December 2, 1979, it was official. Soureun was no longer an illegal Cambodian feeding on Thailand's eastern flank. She was a displaced person recognized by the Geneva Convention. At the whim of the transcriptionist, she was no longer Soureun. She was Sareen, a counted, certified, statisticized refugee.

Not Yet West: Dreaming of a Third Country

On an unforgettable day, in the seventh month in the first year of her exile, Sareen looked up as four shadows filled the door–shaped patch of sunlight on her floor. One of the four women properly extended

her right arm, supporting it at the elbow with her left hand, and bent her knees slightly so as to be shorter than the lady of the house. She offered Sareen a leaflet. "*Pra Yesu* will help you," one announced. "*Yesu* can save you." "*Yesu* died on a cross for you." Of all the lies Sareen had heard, and those were by no means few, this sudden pronouncement seemed most preposterous. Could the dead deliver the living? Father's spirit had provided no protection during her childhood, despite desperate prayers. If *Mae*'s ghost did wander the earth, she brooded about Svei Prakiep, where the breath of life had left her. And this *Yesu* was a *barang* lord, likely a *français* or perhaps an *angkrit*, suspect to be sure. What influence could a foreigner, bodhisattva or not, have half–way around the world from the site of his execution?

"I don't need this paper," she replied, refusing even to touch the tract. "Go out."

When Chhoeun returned home that day, Sareen said nothing of the visitors. However, she broached the subject with an aunt, who, to Sareen's astonishment, defended the foreign god and urged her niece to take her own copy of the same leaflet. "I've heard enough. I don't want it." Back at home, Chhoeun's interest in auntie's news led Sareen to let loose a torrent of incredulity.

"Don't believe. He died. He can't help." Nevertheless, after two days of reflection, her husband announced he had decided to go to the church. "No," Sareen protested uncharacteristically. "You are mad."

"It's okay to be crazy," countered Chhoeun in his familiar teasing tone. But a couple of hours later, when he came home, he was silent. The following week, he went back to the bamboo and thatch structure in the shadow of Khao I Dang mountain. Tucked under his arm was a book, pale blue with a still stiff spine and red–trimmed pages. This, he explained to his wife, was *Prae Kompee,* The Sacred Word. A Buddhist layman such as himself had never held holy writ, let alone possessed a personal copy.

"Just what do they do in that church?" Sareen wanted to know.

Chhoeun's new knowledge provided an opportunity to pontificate. "They stand up or kneel. They close their eyes. They pray without liturgy and without *took*—the three smoking incense sticks pressed between the palms when beseeching ancestors or buddhas. They speak ordinary Khmer, not ancient Pali, but I still didn't understand much. They have One God; I'd say they are an Islamic sect." This last observation left Sareen all the more perplexed. The Cham, a much–maligned Muslim minority in Cambodia, had always riled her husband; it didn't take much to spark his diatribes against their un–Cambodian nonconformity. Now he was joining them weekly. Sareen had to admit she was curious about these monotheists who had so altered Chhoeun's perceptions. Yet she felt such revulsion for this *Yesu* that when she went to temple, she would not let her eyes light upon the church. The way to the Buddhist *wat* most unfortunately led directly past that offensive site, but Sareen could turn her chin over her shoulder and fix her gaze on the mountain rising to the west. Eyes being the window of the soul, she would safeguard her sights.

Out of sight, tucked in a tin away from nibbling rodents, the blue book sat baiting Sareen. Time stood still at the border. Some people, such as her husband, would while away the hours arguing about the past, about Pol Pot time, about Lon Nol's republic and Sihanouk's kingdom. The speculative nattered about the future. Rising before the sun and reposing when it set, Sareen's days were occupied by fire-making, water–boiling, rice–steaming, dish–washing, ration–receiving, stain–scrubbing and more of the same. Her only surviving child was old enough to amuse herself with neighbour kids; her mother–in–law found more enthusiastic interlocuteurs among other sixty–somethings. Sareen wasn't much for chitchat. Interludes of solitude begged for stimulation.

The Book beckoned. Years had passed since she had held any text. Its unflexed binding crackled with newness. Her fingers stroked the fine pages, tracing streams of symbols, of unseparated words colliding

breathlessly into seamless sentences. One had to read such thoughts aloud to make print talk. It was possible to sound out syllables without comprehending, but meaning was what Sareen was looking for. The first page almost strangled the undertaking. Her eyes scanned left to right, from border to border, lurching over an odd vertical space that split the text in two. The purpose of this division wasn't at all apparent. Perhaps there had been a malfunction with the press. Maybe that's why the Book had been given for free. Sure enough, a column of emptiness ran down each page. Sareen lost her train of thought every time she bumped into the middle or the beginning of a row of letters.

A couple of doors down lived a lady who also had the Book. Sareen's curiosity overcame her characteristic insularity. She approached her neighbour. Was her copy a dud? No. The gap bisected each page into two columns. Sareen should read the first column as if it were a long, skinny page before starting at the top of the second. Odd, but effective.

She pored over the Book perhaps five or six hours a day until she had read it from cover to cover. Three convictions came to Sareen. First, though the very name had set her teeth on edge the first time she heard it, she shouldn't loathe *Yesu*. Second, praying to her *kahnsang* and to her *preah parot* Buddha were contrary to the Book. The *kahnsang* was a thirty–centimetre square of white cotton, imprinted with fortuitous symbols. Like the tattoos Lon Nol's soldiers had etched on torso, neck and limbs, the fabric was believed to shield its bearer from harm, even death. Sareen's *preah parot* was of cool black, finger–polished stone. The length of a digit, it had survived the *Kmae Kahom* in hems and in holes. Finally, the Book condemned contempt. Aloof and apart, Sareen despised almost everyone. If she had had an opinion of you at all, it would have been disdain. Authorities were unworthy of honour, performers of notice, snivelers of concern.

How did one respond to a book? Never before had a book spoken to her. She talked back. Nicely. Appeasing the word–god became her

first priority. Sareen started to sense death lurking in consequence to her own actions, whereas previously it had always threatened through others' evils. "Forgive me. Forgive me," she breathed over and over, the spirit of the word having sprung off the pages in her lap, through her eyes and into her soul.

"Chhoeun," she asked her husband without speaking directly of her spiritual turmoil, "does the church need more people?"

"It's very full," he replied. Such a disquieting response sent Sareen off to her Book-possessing neighbours. The husband was home. "Is there any room in the church?"

"Sure. Tomorrow, meet my wife early in the morning. You can walk with her." An entire day of waiting! And a night! What if God the Lord struck her dead in the meantime? Sareen hardly slept. She was at Tai's door at dawn. Unaware of Sareen's soul-deep angst, Tai puttered about, showering, bathing her kids, cooking and tidying up. Eternity couldn't be so long. Finally, the two women set out along the street. They found the church filling up fast; there was space to sit on floor mats among hundreds of worshipers. Sareen experienced that soul-rattling solitude, being alone in a crowd. Everyone else seemed to know what to do. No one initiated conversation with her. The rather strange morning ended with an offer of prayer by the preacher. Holy men praying for the unwashed had been entirely appropriate in Cambodia, so as the crowd jostled to the exits, Sareen moved against the stream to the front of the hall. What felt foreign was the touch of the *Kruu*, the physical link to an intercessor more righteous than she was. Whereas a monk defiled himself by even unintentional contact with a woman, this cleric stood shoulder to shoulder with each of the three prayer-seekers and spoke aloud, in the vernacular, to the One Who Hears about forgiveness of seen and unseen sins. The three repeated the Teacher's words in unrehearsed antiphony.

Sareen attributed the end of her insomnia to that prayer. She continued reading the Book at home while her husband was out sifting

through the world's ills with his loquacious buddies. Sometimes Sareen sat with Tai to read. She invited Sareen to a group of ten who met in her home twice a week. The entire group read the Book together. Sareen learned to decipher headers—tongue–twisting names of scribes and cities mostly—and superscripted numerals. The Book became a talisman of sorts. It was the most potent of her set, although she didn't carry it with her everywhere. The Holy Word was given honour by storing it in the highest place in her house. Her Buddha and *kahnsang* no longer traveled with her in the drawstring bag Sareen used to tuck into her waistband. She ceased praying to them, figuring some concession must be made to keep the God of the Book disposed toward her. For the same reason, Sareen opted not to go to the *wat*. She missed the familiar rituals: scented joss sticks, individuals kneeling at altars in private petition, and monks chanting sonorous mysteries. Months of wavering went by as Sareen tried to walk both the Narrow Way of Jesus and Siddhartha's Middle Way. Try as she might, she couldn't shake off desire. Above all, she longed for certainty.

Sareen hoped her family was leaving the border bandits behind that morning in July, 1980. She had heard the reassuring flag of *angka kakabaal kahom*, a red cross on a white field, flew above Sakeo, too. To go or not to go? A change of camps might mean increased security and improved resettlement odds. Chhoeun decided his family would join the busloads leaving Khao I Dang. Half a day later, farther from the porous international boundary, Sareen was assessing her space in the stilted long house to which five families were assigned. All in all, the move seemed to have been a good one. The camp was quiet. New blankets, mosquito nets, a cooking pot, and even some clothing were distributed to the relocated. The houses were solid, not flimsy, foundationless bamboo. Concrete cisterns stood in each block; Sareen noticed tankers trucking in water every day. A makeshift temple stood just a stone's throw away. Sareen turned away collectors for the merit–making building fund drive. Money, money, money. Prince Siddhar-

tha had given up his; why were his followers so hungry for more of it? Sareen decided to buck the tide and look for a church. She found Chan Hom. Hom was no rice–Christian converted through his stomach under the illusion a baptismal certificate softened western immigration officers' hearts. He had pastored in Cambodia long before anyone had heard of the Khmer Rouge. His parents had turned to the Cross during the Japanese War.

In Sakeo, the current generation of soldiers harangued anyone so un–Khmer as to forsake the Eight–fold Path of the Middle Way. When stalwarts like Hom suspended big Sunday gatherings in a food–distribution warehouse and reorganized Christian compatriots into smaller house churches to avert antagonism, Sareen's fears muscled their way into action. She had heard soldiers were raging against converts to Christianity. She wasn't prepared to be beaten for carrying a Bible. Sareen thought of the baby just beginning to kick within her. One boot to the belly and a life would be gone. She couldn't risk another loss. Sareen wrapped the blue book in plastic and buried it in the garden plot in front of her house. At night, she dug it up, repackaged a songbook with the scripture, placed a bayonet–shield plank over both and tamped down the earth. Some soldiers thrust wicked–looking blades into the ground during security surveillance. A thorough search could yield untold treasures; the earth itself had become the vault of the refugees. It occurred to Sareen that if she associated "garden" with "hiding place", then the soldiers might too. She convinced her husband to conduct yet another nocturnal excavation. Although Chhoeun retrieved the Book and stashed it in the roof, he was of quite another mind about Sareen's anxieties. For one thing, she worried altogether too much. For another, the God of the Book was probably perturbed by the *kahnsang*–wrapped Buddha still in her possession. In his opinion, Sareen ought to toss the amulets.

Her husband's iconoclasm frightened Sareen almost as much as the enforcers of Buddhism. Her New Testament, pages swelling in the

trickling rain, nestled in the roof. Safe. Her good luck charms again accompanied her to Christian gatherings under her sarong. Hidden. In a home where twenty Cambodians had gathered for singing and scripture readings, now just three met. They closed the door and prayed, whispering. Out of sound and sight. Safe.

The wave of opposition to un–Khmer activity ebbed, and Sareen brought her holy book back into the house. Two months of monsoon moisture had undone the binder's glue. Craters, moguls and water–stained ripples had formed on the loose pages. Broken and battered, the state of the gospels appalled Sareen; she was overwhelmed by the belief that the speaker of those words had saved her life. The least she could have done was to cherish them. Suddenly, Sareen determined to bury the Buddhist symbols. She announced her plan to her husband, saying she had no further cause to trust Buddha. He had saved her from nothing. She would pitch them into the pits where people peed at night. Through thin longhouse walls, a neighbour overheard. Such defiance of the spirits was sure to bring a blight upon them all. The man insisted Sareen not desecrate their neighbourhood. He argued, begged, cajoled, berated, threatened, cussed and lost. His wrath descended upon Sareen's obstinacy as silence. His entire household refused to speak to the now–despicable Bou family.

As the Buddhist charms sank into the rank refuse, the need to publicly identify with *Yesu* became crystal–clear to Sareen. She would have to approach camp authorities to register her apostasy from the religion of the majority. Making the transition from unspoken to disclosed minority was not for the fickle. Pastor Hom's sermon at the reservoir after the baptism seemed to be an initiation into an apprenticeship in perseverance. A cool, dry wind blew over the shivering converts. Under cloudy November skies, Sareen stood on the bank in soaking wet clothing, as did the pastor, who preached on and on. Hom warned of temptation to come. Water dripped down Sareen's goose–bumped legs and pooled around her ankles. Mud oozed like henna

paste between her toes. Stand firm or you don't stand at all.

Sareen's footsteps were very sure one morning four months later. Four years had passed since she had carried a baby to term, and, for the first time, a hospital, a familiar Khmer midwife and a foreign physician were within reach. It was March 4, 1982. Sareen walked to the camp clinic accompanied by her husband and a friend. With the blessing of the doctor and the prayer of the midwife, Sareen bore down through an intense labor. Perhaps she had expected God to ease the pain, but the contractions were sharper and longer than when, alone, she had delivered both her living daughter and the lost one. There was a difference in these pangs; the one "crossing the sea" was a son. Her water broke, and by sundown a three–and–a–half–kilo baby boy was charming his father. Sareen ached. Her husband and mother–in–law's voices were hammering in her head. Chhoeun was bidding for John, an English name that sounded similar to his own with the bonus of rich meaning. "A gift of God" seemed appropriate. Mother–in–law was more concerned with where this kid was going than where he was from. "Good fortune wherever you go" was her motion. Samnang it was.

Little Sam and Sareen stayed in the ward for three days. Wraps for the infant, a well–built bed to share, and mosquito repellent were provided by the medical agency. The family brought food and attention. Seven–year–old Sareang loved to cuddle her little brother, but she was too tiny herself to carry or help care for him. Like the neighbour children, Sareang spent her days outdoors, whatever the weather. The youngsters, unschooled and unrestrained, were oblivious to life–altering processes emanating from Geneva and vetted through the Thai High Command.

While Sareen was weaning Sam, steps were taken to close the camp called Sakeo. In 1983, her family was aware of three routes out. The first had been taken by most of their neighbours. Of the five families who had originally shared the long house, one had been resettled in France and three were accepted by the Americans.

Unbeknownst to the Bous, Sareen's much younger half–brother, Chhuch, was living in Boston, one of many Cambodian orphans scooped up in the initial campaign of compassion. Cheeung, Chhoeun's sister–in–law, and her two children were settling into life in Texas. Chhoeun didn't know then whether Cheeung was dead or alive. Unconnected and therefore unable to be sponsored, Sareen and Chhoeun felt the doorway west was blocked. The second destination was Nong Chan, the border camp where the Bous had first found refuge.

The final option was to return to Khao I Dang. By 1983, that camp housed tens of thousands of Cambodians just inside Thailand. Sareen had been there. There was nothing appealing about going back. Just the thought of bumping into some familiar face filled her with shame. To be returned was to be labeled: loser. The unwanted were susceptible to all manner of schemes. Revoking marriage vows, rewiring family trees, agreeing to drug–running deals, retailing sex, recanting one's creed. No one asked if the end justified the means. That was a given.

It was degrading enough to be discarded by third countries whose agents rode away from the sweaty frontier in air–conditioned comfort. But what Sareen found particularly humiliating was to be told she was unwanted by God. The very woman who had assisted at Sam's birth, praising *Yesu* for Sareen's healthy son, turned back to the temple. A sponsor in France materialized. From her position of assumed authority, the woman lectured Sareen on the folly of her faith. *Yesu* may have gone away to prepare a place for her, but he sure as heck hadn't notified the appropriate embassy. Sareen's prayful passivity and watchful waiting for deliverance smacked of quiescence. Didn't she remember the poverty and danger at the border?

In France, Sareen wondered, did no one want? Did no one die? Tai's driven other–worldliness seemed a little skewed. Listening to her, you would have thought France was nirvana on earth. Swapping the third world for a third country was an unadulterated desire. Didn't Buddha teach that with such an appetite, suffering was inevitable?

Sareen's audacity stunned Tai. It wasn't every day a fringe–element–peasant talked back to an educated, moral–majority authority. And Tai had only been trying to help, as usual; she turned away. From that moment until her westward bus pulled out of Sakeo, Tai's eyes never again acknowledged Sareen. The Bou family went east.

Hidden beneath Khao I Dang's dusty roads lay a labyrinth. While aliens with KD identity numbers lived legitimately on the surface of the camp, other west–seeking Cambodians concealed themselves in tunnels. Sareen had been back about a year when the Red Cross broached the misery of the infiltrators with the Thai. Soldiers had been deporting any paperless Khmer they caught, so their presence was documented. In 1984, the first amnesty occured with FC regis-tration cards processed for those who came forward. The procedure would be repeated in 1985, in the RC roll; and in 1986 with the final TD tabulation. By then, remaining KD card holders were the least–likely–to–be–resettled residue of the 1979–80 wave of humanity that had inundated Thailand's eastern provinces. When the 1984 registra-tion was launched, Sareen and her family were already oldtimers. They had spent half a decade under the auspices of the UNHCR. People like them were not first–draft picks, although they had had a crack at US Immigration in 1983. The interview had not gone well. Sareen blamed herself. She must have answered wrong. Answering right meant say-ing what the interlocutor wanted to hear. Sareen was confounded as to what she was supposed to say. "No, we can't take you." She was convinced her own mouth had condemned her to yet more months, maybe years, inside patrolled, barbed wire fences.

In the meantime, Sareen's husband occupied himself working at the camp post office. The babble of remittance–happy refugees spilled over into gifts of fruit or even *baht*. Extra food was always appreciat-ed. Little Sam qualified for supplements: additional rice, oranges and bread, at the Mother and Child Health centre. Health was a big deal for Sareen. In the crowded conditions, where sanitation was lacking, her

children caught every flu or fever buzzing around. The camp hospital was a regular destination. Khmer staff under foreign medics handled anything from sutures to malaria. Almost every treatment came with western meds. No capsule, no cure. There was quite a niche for pain-killers in Khao I Dang; the most common ailment was *kit chhraen*, thinking to excess. Sareen thought too much about departures. Her faith wavered. It seemed her husband abandoned the Way entirely.

Going, going, gone. Week by week, the buses carried Cambodians away. Sareen would bounce baby Chamnan on her hip as she stood in the shade watching the biggest draw in camp: the crowd of leavers and grievers at the bus stall. The only thing Sareen left was her house. For weeks, during a particularly thievish spell, she would prepare the evening meal by four in the afternoon, feed the children, roll up mats, blankets and clothes and trudge over to the hospital. Hundreds of people spent the dark hours camped out within the circle of electric light that held bandits at bay.

Whole swathes of Section 21 were empty at night. A few aluminum cooking utensils and rice stores were all that remained in unguarded houses perilously close to the perimeter fence. Well, that was all anyone could see, but the invisible ones brooded. One day, an eight–year–old tumbled into a well. Not long after, his lifeless body had been hauled up the shaft but his spirit eluded the living.

Rain pelted down nonstop. Sam was sick. Sareen decided to risk a night in her own house. Perhaps the thunder would deter robbers. What would they want with an old lady, three kids and a pregnant woman? Sam's fever rose with the moon. Sareen panicked. The hospital was a ten–minute walk away across several sections. A mini–clinic was just two blocks away. However, between her home and the clinic lay that cursed well. It was long past curfew. The only legitimate reason to be out on the streets was to be headed to the hospital, flashlight on high beam. Sareen did not own a flashlight. She pressed her palm to Sam's burning cheeks, then hoisted his body against one shoulder.

Holding her umbrella over her son with her other hand, Sareen began running. "God help me," was her mantra as she sloshed through the dark. Flashes of lightning lit the road around her. She shrank between two houses. No bandit bullets flew.

Sareen pressed on, arriving soaked to the skin at the clinic where she startled the Khmer night crew dozing in their hammocks. Reading Sam's thermometer, one radioed the main hospital. They undressed the toddler, laid him down under a fan and administered medications delivered by the central pharmacy's courier. Within a couple of hours, Sam's condition improved enough to be released. Sareen was anxious enough about her mother–in–law and two daughters to brave the return dash through the storm. The splish splash of her flip–flops in the puddles pounded in her ears. Just beneath the ominous silence Sareen imagined a gun battle set to explode. Someone was looking out for her. She reached her home, breathless, just as she heard the diesel pulse of an approaching military jeep. The headlights hadn't caught her. Whew…

The Thai High Command had the unenviable task of policing a city of runaways. Most didn't make a habit of running, but some stole in and out at will. Khmer resistance fighters formed a convenient buffer between Thailand and the Vietnamese forces that had surged across Cambodia into Battambang province six years earlier. It was such a band that shook down Sareen's block one night; their black clothes and sandals made her suspect *Kmae Kahom*. Rifle–fire announced guerillas had come calling. Sareen pre–emptively opened her door. If it were barred, some thug would bust the bamboo rods and take reprisals for the lack of hospitality. A thief loomed like a massive shadow over Mother–in–law. "Give me thirty *baht* and I'll leave." She did. He did. Thirty *baht*, one dollar and fifty cents. A shotgun–toting strongman versus a quaking granny. Somewhere in Khao I Dang, it happened almost every night.

Violence shattered the shards of public propriety some Khmer

tried to piece together as the border crisis had settled into long–term relief mode. Kids clinging to their mom's sarong as a robber roughed up grandma got very mixed messages about deferring to one's elders. Respect was hard to come by. Strength wasn't in honour; it demanded honour.

On the other hand, Sareen held learning in high esteem. She wanted Sareang to succeed at school. Her daughter started a formal education at the age of nine, when the family returned from Sakeo. After a year, she passed to the next grade. Tiny for ten, Sareang was barely bigger than the seven and eight–year–olds. Half–day classes covered reading, writing and sums. There was one music lesson that altered both Sareen's view of the learned and her measure of her child. To traditional dance tunes, the children stood one by one, each singing a folksong. Sareang recognized one melody. She knew the words by heart, the *faux pas* lyrics of the politically incorrect Christians. "What!" The teacher wouldn't hear another bar. Her switch struck the little girl's thighs again and again. Sareen would never have learned of the incident had she not turned her daughter around when bathing her. Bruised welts healed faster than a humiliated soul. Sareen learned of other injustices. Primary pupils kneeling on spiny durian husks as punishment for some misdemeanor riled her. Before the face of the status–endowed teacher, however, Sareen couldn't find words to express her indignation. She suffered disgrace in silence, as did her daughter. Schooling lost its luster. By the time Samnang reached six, he had already been bitten by the anti–scholastic bug. Sareen caught him more than once hanging with the gawkers around the Bangkok-bound buses. Her son would meekly saunter out of the house, his book bag slung around his chest, but the texts stayed in the pouch and his Khmer literacy didn't approach proficiency.

Enforcing school attendance wasn't high on Sareen's list of priorities during the hot, humid season of 1988. Five and two–year–old daughters scampered underfoot. Chamnouer was hardly off the breast

as Sareen's fourth camp pregnancy was coming to term. Chhoeun had graduated from postal clerk to hospital porter, tired of the night shifts, and moved on to another aid agency where he assisted the handicapped. Bucking the family trend, he had also taken up English lessons, for which he had to pay out of his meager, in-kind earnings. Sareen's husband got more than he had bargained for out of Kha's private tutelage. Kha had a contact in Canada, a Vancouverite named Arnie. Representing Anglicans whose charity hadn't fizzled out under compassion fatigue, the Canadian wasn't an arms-length kind of operator. He showed up in Thailand, procured a Khao I Dang entry pass and met Kha's students, Chhoeun among others.

"Do you want to come to Canada?" Arnie asked Chhoeun.

"Yes."

"If that's what you want, you've got to learn more English. So does your wife. Your kids, too. Life in Canada is very difficult if you don't know the language."

Chhoeun needed Kha's translation to make sense of Arnie's advice that day. He needed it later in order to write a letter formally asking Arnie to find a sponsor for the Bous. Turn-around time for a letter posted in rural Thailand to make it to Canada and be responded to immediately could easily take four weeks. Day after day, Sareen's husband scanned lists at the post office. Weeks stretched into months and Sareen gave up hope. Half a year later, an envelope arrived. There, tidily typed, was the address of the Parish of St. John the Evangel, Edmonton, Alberta, Canada. *Essential English* Books One and Two had never prepared Sareen's husband for the content of that letter.

Nine years is a long time in a tunnel. Official sponsorship by strangers in a land faraway lit a light at the end. Hope flickered as Kha offered to tutor Sareen and Sareang for free. English was a commodity in Khao I Dang. It had its price and Sareen had nothing to offer in exchange. She took Arnie's instructions seriously, though, and accepted Kha's generosity. Language learning was primarily a series of literacy

lessons. After all, the Cambodians who taught the Khmer language in camp instructed Khmer children in reading and writing, not speaking. English classes tended to revolve around text as well. Sareen's first exposure to this sibilant–rich language was through twenty–six alphabetic characters whose names in isolation distorted the sounds they made in consort with each other.

Sareen recognized Khao I Dang encrypted in the English KD identifications that blared over the camp loudspeaker one evening. The announcement called specific identity card holders to appointments with the Embassy of Canada at the UNHCR office. KD 009741 meant Sareen, Chhoeun, his mother, Sareang, Samnang, Chamnan, Chamnouer and baby Chamnoun. The immigration officials depended on an interpreter for the most part. Chhoeun managed preliminaries, but relied on a fellow refugee for the in–depth questioning that focused on him as the head of the household. Sareen scrutinized the translator. Was he for or against her family? He held their lives in the balance. Even if they answered correctly, a mistranslation could screw them. If they answered incorrectly, he, who had interpreted countless such conversations, had the capacity to transfer better words to the ears of the *barang*. Sareen never stopped to imagine the stress the interpreters lived with. Ulcers plagued the self–critical, while all manner of criticism splattered the reputation of go–betweens when an application was rejected. Rejection normally being a top–down privilege, it was a rare refugee indeed who repudiated an embassy. It had happened. One young Khmer father apparently applied to America for the express purpose of telling off the superpower. He believed the Kissinger–era bombings had catapulted Cambodia smack into the hands of the anti–imperialist Khmer *Kahom*.

Suddenly Sareen snapped back to the present. She could hardly believe her ears. Mother–in–law was telling the translator she did not want to go to Canada. Staying in Thailand was her choice if the US wouldn't have her. Canada, she had heard, was too cold. "But, Grand-

ma," the interpreter intervened, "Canada has heated houses."

"No, tell the Thai my decision." The Thai were, by 1989, none too pleased to have parasitic neighbours from the east still stranded in go–nowhere land. In any case, the Thai weren't sitting in on this discussion.

"Why stay here? We are poor and we have no future. We must go." This was Dam Choum's officially recorded comment to the Canadians. Thank God the translator suitably spun *Yiey's* words. The interview wound down with further queries to Chhoeun.

"We'll update you," was the last comment from the embassy staff.

The status of their application was not clear to Sareen, but her husband was optimistic. He collected the maximum number of packing boxes and a suitcase. Such preparations roused the curiosity of their neighbours. All Sareen could say was they would be the first to know if the Bous got the *name–to–go*. There was no secret to the departure lists. When the pronouncement did come, two months after the interview, anybody with ears to hear learned the household of Bou Chhoeun had five days to bus–day. Sareen was lying with her baby in the hammock when the loudspeaker static settled, the announcer quit whistling and tapping on his microphone, and read her husband's name among others. Chhoeun set out alone to the UNHCR office. Sareen's bare heel pushed against the red earth to keep her hammock swinging. There in the shade, she swayed in silence. She swatted a fly circling Chamnoun's head. There was no use basing one's happiness on possibilities, not even probabilities. Contentment was grounded in the present or not at all. Sareen would believe she was going to the Refugee Processing Centre in Chonburi Province only when she was actually aboard a transit–camp–bound bus.

In contrast, Sareen's kids were anything but blasé about the move. They were bouncing off the walls long before their parents set their five boxes of belongings under the eaves. The houses of the departing were always up for grabs, but the home of a neatnik like Sareen was par-

ticularly appealing. She had asked around the block if anyone wanted the pots, blankets or mats the Bous were leaving behind. A couple of families were squabbling over her housewares as Sareen stepped out of the house in Block 4, Section 3, for the final time. Friends helped to lug the boxes and a single vinyl valise to the bus. Over 200,000 Cambodians had gone before her. It seemed to Sareen she had seen every departure. Abruptly the move was hers. All motion slowed. Seconds like days, minutes like weeks, hours like years. Women, children and the elderly squatted in queues during the loading of baggage. Men stowed whatever fit on the roof rack. Carry-ons bulged out of overhead bins. Wee ones piddled on the tarmac. Where was a biffy when you needed one?

Around the perimeter of the bus-boarding huddle, the still-left-behind gathered. Some scowled at Sareen. Why hadn't she extended a proper farewell? The least they had expected was a free celebratory meal hosted by the lucky listed ones. Sareen had nothing to say. For her, the specter of shame if the *name-to-go* had turned out to be illusory outweighed the embarrassment of deliberate impropriety. Perspiration beaded on Sareen's upper lip. It trickled along her sternum. The sun had peaked by the time the passengers settled on the plastic-covered seats of the blue and silver bus. Fingers pinched latches. Window panes lowered. Kids jostled closer to the breeze. *Leah son hai.* Good bye, Khao I Dang. Good bye.

WESTWARD: THE NAME-TO-GO

Chonburi Province abutted the Gulf of Thailand. Sareen had never seen a sea, but it influenced conditions at Phanat Nikhom Camp just forty kilometres inland. Rainy season afternoon squalls pelted the bus before it arrived at the transit centre, which still housed several thousand refugees being processed for third-country resettlement. Hearsay had it that discipline in Phanat was strict. As in Sakeo, Sareen

anticipated correctly that Buddhists would be put out by Christians. Personal beliefs, if a believer had any integrity, inevitably extended from private contemplation into public conduct. Block leaders represented area residents at temple events and solicited contributions for the monks. By not contributing to the *sangha*, religious dissenters fell into disfavour. In Phanat, security patrols included conscripts to nosy neighbourhood water brigades; they kept a close eye on everyone's activities. Even blood cells were under the microscope.

Canada was a stickler for health standards. Whole households were delayed for months, even a year, by positive results to tuberculosis screening. Treatment took time. In the cyclical rhythm of seasons, Sareen felt out of time. Fourteen years had passed since she had been free to determine where she would go, when she would walk, what she would eat, or how she would speak. Who she was and would be had been subject to the diktats of various powers: self-selected people's potentates, a communist monarch, warlords, autocrats, technocrats, and international bureaucrats. Freedom was a well-worn buzzword among migrants.

The Canadian Orientation instructor used it a lot. According to him, the flip-side of freedom was responsibility. Sareen learned she would enjoy lots of freedoms in the country that had chosen her. Would she be able to handle them? From week to week, the women and men in the CO class heard about Canadian ways. Almost all roads were open to anyone. Freedom of movement, yes! Yet Sareen pitied the solitary individuals pictured in privately owned cars zipping off to wherever they pleased; owning luxuries could never compensate for loneliness.

Photos of grocery stores astounded Sareen. What was more surprising was not her teacher's warning that she might find substandard produce, but that she should not eat wilted, discoloured or questionable perishables. The idea of throwing out food sounded rash. Money didn't grow on western trees, despite what some in the east believed.

Ah, money, a common topic in CO classes, which demystified $ and ¢ symbols. Lessons let the future Canadians in on strange marketing secrets such as fixing prices at some–dollar–digits plus ninety–nine cents. Computations proved the buyer was saving just a penny, but the large featured figures made it look like the seller slashed much more off the price. Shopping in Canada seemed a maze of customer–confusing tricks and taxes. On the upside, shoppers were allowed—even expected—to select their own merchandise. Sareen watched slides of a woman choosing and bagging her own onions, cabbage, tomatoes and oranges. No market madam sat or stood over the wares, pinky on the scale or freebie extra in the package. Could it be true?

Private property held additional amazements. Kitchens, whole rooms devoted to cooking and eating, were a novelty to many in Sareen's class. Gas or electric ranges looked dangerous. Whatever would one use an oven for? Another misunderstood indoor feature was the toilet. Such lovely porcelain basins were not suitable for soaking vegetables, in spite of the permanent supply of water. A rutabaga flushed had nasty consequences. Flushing seemed a fetish in Canada. What a lot of water someone had to haul! Surprise turned to disbelief at instructions to sit on toilets. Snickers at the idea of someone slipping in while squatting on the seat hid Sareen's incredulity. The copious quantity of paper Canadians sent down their sewers was barbaric, so much water and they didn't even wash their bottoms with every bowel movement. Sanitation was complex. Buckets and scoops to sluice off soap suds were not standard equipment in built–in tubs. Sareen saw women, bare shoulders and arms risq* rising above mounds of bubbles, bathing. It was quite the shock to realize some people removed all their clothing to shower. Indoor bathrooms supplied with hot and cold taps were quite a fantasy. Adapting to Canada was going to be difficult.

If there was one hurdle Sareen felt she couldn't cross, it was birthing in a Canadian hospital. Stories of long labour, isolated from family,

surrounded by strangers—men as well as women—who spoke strange tongues while poking and peeking at private parts, were too much. Sareen decided right then and there. No more babies. The medical examinations for the Bou family went well. Reports shuttled from Bangkok to Ottawa and back again confirmed everyone's health. Three days after C.O. ended, Sareen stashed the last of her family's earthly goods in airline–approved cartons. Eight bulky jackets she would long for when the first blast of air–conditioning hit her were sealed inside. The baggage, now boldly labeled for Vancouver, Calgary, Saskatoon or Edmonton, topped the bus. It was cool on October 20, 1989, when, clutching her documents from the International Committee for Migration and Chamnoun on her lap, Sareen rode out the camp gate.

Tapioca fields, yapping dogs, and *Rayban*–protected, helmetless motorcyclists whizzed by her window. Gulls circled in the noticeable calm before the wind rose, pushed heavy clouds against the coast and soaked the countryside. Bangkok was awash with light. Headlights, tail–lights, traffic lights, blinking, flashing, neon lights, too bright. Electricity distorted distance. Sareen couldn't distinguish anything outside the luminescent circles. Don Muang Airport beamed with cool fluorescence. Sareen shivered. She hugged her babies in the dazzling manufactured chill. Night was still night. Sareen watched the dark sky swallow the land, her second, as the plane rose, soaring toward sunrise, winging westward, to a third country.

Epilogue

Siem Seng, Savy Vonn and little Sytha settled in Edmonton on November 13, 1985. They were delighted when a second son, Seyha, and a daughter, Darlene, joined the family. Siem and Savy gathered their extended family around them. They arranged sponsorship of Siem's parents and brothers in 1989. Today, Siem has mastered a trade; she is a painter.

Chantha Kong, Oun Tes and their son, Roth, arrived in Calgary on April 7, 1986. Two daughters, Angela and Angelee, were born in Lethbridge. The family moved to Edmonton in 1988, where Chantha upgraded her education, earning a childcare certificate. She continues nurturing children as the operator of a day home.

Kimsonn Seng and Sarun Tuon, along with Nara, their first son, landed in Winnipeg on January 29, 1986. To reunite with family in 1987, they relocated to Edmonton, where Darley, Vannary and Melanie were born. Along with her sister, Kimsonn cared for their aging parents. Their children had the opportunity, rare among Cambodian–Canadians, to know their grandparents. Kimsonn is a painter.

Nareth Mom, her husband, David and John were welcomed to Edmonton by their sponsors and friends on September 12, 1989. Sons Joseph and Timothy soon arrived. Nareth upgraded her education and raised her boys after her marriage ended. She provides for her elderly mother in Phnom Penh, and is wonderfully supported in this

by Peter Mueller, who became her husband in 2006.

Chhorn Nhem, Prim Im, Peng, Sokha, Sokhea and Sokhom came to Edmonton on October 13, 1989. Son Peter came by Canadian citizenship naturally. Chhorn is a very proud grandmother. In 2008, after a 35–year separation, Chhorn located her mother and traveled to Cambodia to see her and to meet younger siblings for the first time.

Sareen, Chhoeun Bou and their children Sareang, Samnang, Chamnan, Chamnouer and Chamnoun landed in Edmonton along with Chhoeun's mother on October 20, 1989. Grandma was a treasure. Sareen cared for her until she passed away at the age of eighty–nine. Now Sareen, too, wears the honourable title of *Yiey*, grandmother. As empty–nesters, Sareen and her husband have returned to Cambodia several times.

Barbara Penner began listening to the stories of Cambodian, Laotian and Vietnamese refugees while working in Thailand at Phanat Nihkom Transit Centre from 1985 to 1987. She continues to meet storytellers of resilience and wit from all over the globe while teaching English as a Second Language in Edmonton.

Place of Rescue

Recognizing how far we have come and how blessed we have been, we are designating royalties from on-line and in store purchases of *To a Third Country* to an orphanage and AIDS hospice in Cambodia. We would like to introduce **Place of Rescue** to you.

Rescue is a non-government organization (NGO) registered with the Cambodia government since 2003. It began out of the vision of Canadian Marie Ens to provide good care for families living with AIDS and for orphans who lost their parents to AIDS.

It was at Preah Khet Melea Military Hospital in Phnom Penh that Marie met her first AIDS patient in 1994. Over time, simple homes were constructed for families living with AIDS. In the beginning some of the parents Rescue cared for died since they had no anti-retroviral drugs then, as they do now. The parents left their precious children with the Rescue team.

At Bek Chan, twenty orphan family homes were built around a grassy play area. Each house holds a "family" of ten children with a "mother" who loves and cares for them.

As time went on, Rescue realized that the Khmer Rouge and AIDS had robbed many elderly women of their children who would have supported them in their old age. Two "Granny" houses are now home to destitute women in their senior years.

Young women, abandoned in pregnancy, also need loving sup-

port. One by one they come to be helped during this difficult time. Most leave their babies as they depart to start a new life. Some of the babies have had AIDS and so have been admitted to the National Pediatric Hospital. The relationship formed with the medical staff has led to Rescue receiving other babies, infected from birth with AIDS, who were left at the hospital. At Rescue each care–giver looks after two infants.

Near the Thai border at Mongkol Borey, "House of Mercy" has been home to one hundred children since 2009.

Since 2010, Rescue Cambodia has been caring for over 300 children in two orphanages, along with many families living with AIDS, as well as a large group of grandmothers who have no family of their own left to care for them.

At www.placeofrescue.com, you can find up to date information and learn how you can contribute directly too.